LEONARDO

LEONARDO

A RESTLESS GENIUS

ANTONIO FORCELLINO

TRANSLATED BY LUCINDA BYATT

polity

First published in Italian as *Leonardo: Genio senza pace* © First published in Italy by Gius. Laterza & Figli, 2016. This edition published by arrangement with Grandi & Associati.

This English edition © Polity Press, 2018

The right of Lucinda Byatt to be identified as translator of this work has been asserted in accordance with Section 77 of the Copyright, Designs and Patents Act 1988

This book has been translated thanks to a translation grant awarded by the Italian Ministry of Foreign Affairs and International Cooperation.
Questo libro è stato tradotto grazie ad un contributo alla traduzione assegnato dal Ministero degli Affari Esteri e della Cooperazione Internazionale italiano.

Polity Press
65 Bridge Street
Cambridge CB2 1UR, UK

Polity Press
101 Station Landing
Suite 300
Medford, MA 02155, USA

ISBN-13: 978-1-5095-1852-4

A catalogue record for this book is available from the British Library.

Library of Congress Cataloging-in-Publication Data
Names: Forcellino, Antonio, author. | Translation of: Forcellino, Antonio. Leonardo.
Title: Leonardo : a restless genius / Antonio Forcellino.
Other titles: Leonardo. English
Description: Medford, MA : Polity Press, 2018. | Includes bibliographical references and index.
Identifiers: LCCN 2017043968 (print) | LCCN 2017044512 (ebook) | ISBN 9781509518555 (Epub) | ISBN 9781509518524 (hardback)
Subjects: LCSH: Leonardo, da Vinci, 1452-1519. | Artists--Italy--Biography.
Classification: LCC N6923.L33 (ebook) | LCC N6923.L33 F6613 2018 (print) | DDC 709.2--dc23
LC record available at https://lccn.loc.gov/2017043968

Typeset in 10.75 on 14 pt Janson Text by
Servis Filmsetting Ltd, Stockport, Cheshire.
Printed and bound in Great Britain by CPI Group (UK) Ltd, Croydon

For further information on Polity, visit our website: www.politybooks.com

CONTENTS

PROLOGUE

On 13 January 1490, the rooms of the castle at Porta Giovia, Milan, were brightly lit to celebrate a feast that would be chronicled as one of the most elegant of the Italian Renaissance, and certainly the most elegant at the Sforza court. Ludovico [Sforza, known as] il Moro, who had ruled Milan with an iron fist for over a decade, wished to honour the new duchess, Isabella of Aragon, granddaughter of the king of Naples, who had married Gian Galeazzo Sforza one year earlier: a legitimate heir to the duchy, yet deprived of all power by his uncle. The feast and its golden decorations were intended to silence the rumours that had circulated for over a year in the corridors of European courts regarding Gian Galeazzo's failure to deflower young Isabella, who was as pure and virginal in Milan as she was when she left Naples.

A hundred young maidens from the cream of Milan's noble families had been selected for the evening, accompanied by as many knights. In the palace chapel a tribune had been constructed to accommodate the guests and, facing it, a small stage, decked in satin cushions like a throne, where the ducal family sat with its most honoured guests. A powerful, hard-working city like Milan had not dedicated many occasions to such luxurious display in the past years, but now Ludovico il Moro intended to follow the example of his friend, Lorenzo de'

Medici, who had transformed festivities of this kind into an instrument of government.

This goes some way towards accounting for the amazement of the guests who, having climbed the stairs, found themselves in a room brightly illuminated by candles and whose walls were embellished with precious fabrics and verdant festoons interlaced with ribbons. At the back of the room a closed hemispherical object was just visible, raised on a platform. Many speculated that it was a huge egg, cut in half and covered over with a satin cloth. Curiosity stimulated glances and speculation among the guests, who were dressed in their finest attire. When the room was full, the pipes and drums struck up as the young duchess made her appearance (or perhaps it would be more apt to say her apparition), dressed in a white silk cloak that covered her gold brocade gown.

Giving everyone the time to admire her, Isabella took her place on the small throne. She wore such ornate jewels that the ambassador of the Este [rulers of Ferrara], whose account of the feast has survived, reported that he thought he was looking at the sun, such was the beauty of her figure and the magnificence of her 'Spanish' elegance. When the music struck up again she danced two very graceful dances with three young women from her retinue and for a few minutes she successfully rivalled the great Ludovico himself as the focus of attention. In honour of the duchess and of the Neapolitan court, he, too, had dressed in Spanish style, wearing a dark red velvet doublet trimmed with ermine and a black cloak lined with gold brocade on a white backing. It was an outfit that must have cost many thousand *scudi*, as many of the guests remarked.

The dancing continued for two hours, giving both Ludovico and Isabella time to savour the triumph of the occasion in full. Even the ambassador of the Grand Turk, who had ridden on horseback into the room and then sat on cushions at the foot of the throne, after the custom at his own court, delivered a message of good wishes and stressed that the Ottoman sultan did not usually send dignitaries to festivities organized by infidels, but that a special honour had been granted to the court of Milan and that of Naples.

Excitement among the guests reached a climax when the duke silenced the musicians and turned to look at the back of the room

– where, as if by magic, the silken cloth slipped off the enormous hemisphere, revealing a mock cavern lined with gold and stars, in imitation of the celestial vault. Cries of amazement rose from the room as the guests watched the seven planets in the sky light up with the signs of the Zodiac. It was a representation of paradise, whose beauty outshone the inventions of any painter who had previously tried to imagine it in colour. Starting with Jupiter, the planets were celebrating the young duchess's virtues in verses composed by Bellincioni, the court poet. Many in Milan found his compositions too flowery and specious, but that evening even courtiers with more sophisticated tastes found nothing to criticize. Even the expensive garments and jewels of the noble citizens faded into insignificance in an instant, as general attention was gripped by a scenic machine that appeared to be nothing short of miraculous.

Not that mechanical equipment of this kind was a novelty at Italian court festivities. For example, every Good Friday a representation of Christ's Passion had been enacted in Rome, at the Colosseum, for as long as anyone could remember, during which angels flew around a cross suspended from pulleys and chains that were prepared months in advance by the ingenious members of the confraternity of San Giovanni Decollato. But the mechanisms had always been quite visible in such plays, while at the Castle in Milan that evening nothing seemed prepared, no wheels jammed, the complex mechanics of the whole apparatus were so clever and so well concealed that their naturalness was disturbing. Many of the guests looked around the room, searching for the inventor of that extraordinary stage machine and the equally stunning masquerades.

The man responsible smiled quietly, satisfied at the astonishment he had kindled among guests of all ranks and from all parts. The inventor's name was Leonardo and he had been born 38 years earlier, in a small village near Florence. He had the body of an athlete, a physique as harmonious and well muscled as a Greek statue. His face was handsome, with exquisite, large eyes and a straight nose below evenly arched brows and a high forehead framed by hair whose well-tended curls fell onto his shoulders in tight ringlets. He took great care of his elegant appearance and, during his eight-year stay in Milan, he had already been noted for the grace and originality of his knee-length garnet

robes and the coloured stockings that emphasized his muscular legs. His reputation made him the best known foreigner in Milan, although no one knew his exact role at Il Moro's court. In the rigid hierarchy of the time, he was recorded as a member of the painters' guild, first in Florence and then in Milan.

Leonardo da Vinci, who was savouring his first public success in Milan that evening, was musician, engineer, sculptor, architect and painter, and it was in this capacity that he had offered his services eight years earlier to the duke of Milan, with a letter from Lorenzo the Magnificent, lord of Florence and his first patron. Over the past years he had won over the court and the city. Here he had created paintings of unparalleled beauty and hydraulic projects that would rationalize the canals around Milan; he had offered ideas for a new lantern tower [*tiburio*] over the city's cathedral, as well as designs for war machines that were still to be tested and machines of various kinds, designed to lift and transport heavy weights. His anatomical drawings and physiological studies lay in untidy piles; they were mainly written with his left hand and back to front, but in Milan they had already attracted their first admirers in these golden years. His, too, was the clay model of a huge monument to Francesco Sforza, Ludovico's father, which he was preparing in the large courtyard of the castle in order to cast the statue in bronze.

He alone possessed that acute spirit of observation that drove him to investigate every natural phenomenon, which he did often with confused and contradictory methods, but firm in his conviction that a single law must govern the universe and everything in it, small and large, whether it was water or women's hair, blood circulating through veins or lymph circulating through a tree's branches. His knowledge did not look down upon any field of application, and he had created the stage machine representing paradise in this magnificent ceremony with the same care he put into designing machines to throw bombards and to fly above the ground. That evening Milan, too, was his, and very soon letters would be dispatched post-haste to the other Italian courts lauding the marvellous mechanisms of paradise.

Happy in the wake of this celebrated and acknowledged success, Leonardo was already preparing a new theatrical machine for a comedy that would be staged in Mantua, *Orfeo* by Angelo Poliziano, during

which he would terrify the audience with a cavern that opened effortlessly to reveal Pluto emerging from the underworld, balancing on a sphere. His knowledge of weights and levers found in these theatrical machines an ideal way to impress the public at large. He succeeded in devising them by using his discoveries of how to balance weights and create mechanical cogs, because he made no distinction when applying this knowledge: the stage was as good as the battlefield as a foil for his genius. He moved like a magician between science and art, exploring with the same insatiable thirst for knowledge the mysteries of nature and those of the imagination, and in his omnivorous mind even he was perhaps not fully aware of the extent to which the former fuelled the latter.

His reputation as a painter was already well established in Italy, given that three years earlier Giovanni Santi, the father of Raphael – a young artist who would later come to rival him – had written a chronicle that singled Leonardo out as one of the greatest Italian painters. But by 1490 he already felt constrained by that reputation, and the atmosphere in Milan, so cultured and refined in every field of knowledge, was rapidly spurring him to delve deeper into many, perhaps all, of those fields, including mathematics – a new departure for him and a subject on which he would expend much of his energy from now on. Unfortunately the wondrous machines that amazed all Italy were among the few mechanical inventions that contemporaries had a chance to appreciate among the many he devised, imagined and partly created, in a process to which he devoted much of his life. Other inventions were intended to improve water flow and weightlifting, and many, the majority, were never even given tangible form: in the end the sum of his scientific genius proved dispersive and inconclusive. For the most part his mental exertions were confined to endless sheaves of paper that he never published, let alone ordered, before his death and that were largely dispersed soon afterwards. But, despite himself – perhaps precisely because during his stay in Milan he 'lost patience with his brush' [*impacientissimo al pennello*] – between an anatomy session and an hypothesis for a helicopter, Leonardo found time to paint a number of images that were so extraordinary as to embed his memory forever in the minds of subsequent generations. Since the volumes containing his studies were lost and forgotten immediately after his death, it was these

images, overlooked during his lifetime, that kept his memory alive until the time when, centuries later, his studies were again rediscovered and published. His codices had such an impact on European scientists in the eighteenth and nineteenth century that they soon laid the foundations for a formidable myth, which is still growing today.

It is a myth that has overshadowed the often troubled life of Leonardo, the man and the painter, who attempted to verify all forms of institutional knowledge against direct experience and was more diffident than many towards the academic establishment, with which he never identified himself. Leonardo provocatively proclaimed himself in his writings 'an unscholarly man' [*omo sanza lettere*] in order to highlight that a pathway to knowledge of the real could be found even outside the universities of the time, which continued to teach uncritically a form of knowledge codified by antiquity and by the church.

Part I

ILLEGITIMATE SON

1

THE SUMMER CHILD

On 15 April 1452, in the tiny hamlet of Vinci, not far from Florence, the peasant farmers were enjoying the scents of plum and apple blossom carried by the early evening breeze. In one of the roughly built stone and brick houses, a young country girl named Caterina was about to give birth to a boy who would be christened Leonardo.

By ten o'clock in the evening ('three hours of the night', as was said at the time), when her labour was over and the child was well, the midwives presented him to his grandfather, Antonio di Ser Piero da Vinci, an 80-year-old notary who was not wealthy but was nonetheless affluent enough to be the most notable citizen in the village. Antonio was the descendant of a family of notaries who had enjoyed prominence since at least 1333. He and his relatives owned a respectable house in the centre of Vinci, with an adjoining vegetable garden and a farm with some ten *stadi* of land nearby. From his tax returns [*denunzie catastali*] it appears that he also owned other, smaller farms that produced wheat, oil and wine. His total wealth, 1,400 gold florins, was deposited with the Monte Commune of Florence and yielded enough interest for a decent lifestyle. Antonio was happy with his new grandson. At his age he did not have many years for seeing his descendants, and he hastened to record the event in his family memoirs.

15 April 1452. My grandson was born, son of Ser Piero, my son, on 15 April, a Saturday, at 3 hours of the night. He was given the name Lionardo. The priest Piero di Bartolomeo da Vinci baptized him in the presence of Papino di Nanni Bantti, Meo di Tonino, Piero di Malvolto, Nanni di Venzo, Arigho di Giovanni Todescho, monna Lisa di Domenico di Brettone, monna Antonia di Giuliano, monna Niccholosa del Barna, mona Maria, daughter of Nanni di Venzo, monna Pippa (di Nannj of Venzo) of Previcone.[1]

However joyful the event and however welcome the birth of a baby boy, matters had not gone exactly as he had hoped: the child was not the son of the right woman and would remain 'illegitimate', a descendant who could not aspire to have full rights to the family inheritance, whether material or ideal. The previous summer his eldest son Piero, who was then a little over 20, had started his career as a notary in Florence, where he lived in a rented house. He had then come to spend the summer months at home in Vinci, and during those lazy hot days he had met and seduced a young peasant girl, Caterina, whose only defect, apart from being poor, was that she was exceedingly beautiful.

Piero had taken advantage of her without any qualms: she was, after all, a peasant and he was due to marry a Florentine woman of suitable social standing, Albiera di Giovanni Amadori. The sole justification for the passing affair was the couple's youthful exuberance and the beauty of those summer evenings in the cypress-scented countryside. Moreover, the seduction of a poor girl by a well-to-do young man was such a frequent occurrence in the countryside around Florence that it hardly deserved a mention. Indeed Ser Piero had married Albiera that same year.

For her part, Caterina received perhaps, in compensation, a small dowry from the old notary and was married to a local man about whom we know very little, but whose name did not bode well for a comfortable future. The man was called Acchattabriga ['Troublemonger'] and was the son of Piero della Vaccha – names that indicate humble origins and tricky temperaments. After her marriage, Caterina walked away from the da Vinci family and, judging by the silence of the sources, also from young Leonardo's life. However, not straight away: as was customary, she breastfed her baby son, whether in her home or in the

da Vinci household, for at least a year or two – just enough time for her to grow to love her son and then to suffer when he was taken away, because after that first stage the boy was completely entrusted to his father's family.

Leonardo was cared for by old Antonio, his 59-year-old wife Lucia, and his second son Francesco, who was just 17. Another daughter, Violante, had already left home to marry a certain Antonio from Pistoia. As an illegitimate son, the boy did not receive a normal education, which in a Florentine bourgeois family involved learning, from the age of seven, Italian grammar, basic mathematical skills, and above all Latin, which was essential for an administrative career and for access to classical books and manuscripts (all of these were still in Latin at that time). However, this lack of formal education, which undoubtedly affected Leonardo later in life, was a source of happiness in his early childhood, since he was freed from the burden of strict learning as laid down by the rules of scholastic institutions. The boy's rather eccentric upbringing at the hands of his grandparents and young uncle stimulated unusual avenues for his creativity and helped him to develop a lifelong curiosity for the natural world.

Leonardo spent his childhood in that house deep in the countryside, living with his aged grandparents and young uncle Francesco, who was uninterested in work of any sort, as Antonio noted in a later tax return: 'he lives in the country and does nothing'. Francesco's lazy lifestyle was a stroke of luck for the child, who benefited from much of his uncle's extensive free time because life in the tiny hamlet of Vinci did not offer many other distractions and also because, as the notary's son, Francesco was not expected to work on the land, like others of his age.

We know from later documents that Francesco was the only relative to have loved Leonardo (apart from his grandparents), so much so that he was even willing to challenge the strict laws governing inheritance for the sake of his nephew. It was probably he who taught Leonardo to read and write, indeed the latter's handwriting retained the typical notarial script of fifteenth-century civil servants, whereas school pupils at the time were already taught to write with the rounded hand whose flowery style epitomized the enthusiasm for humanist studies that had become so fashionable in mid-fifteenth-century Tuscany. School pupils were taught this well-formed handwriting with the same rigour

as they were trained in the rhetorical art of grammatical compositions – another trait that Leonardo's prose would never acquire, despite the artist's later efforts to fill the lacunae in his self-taught education. Leonardo's writing, learned at home in an isolated village, far from any school, lacked discipline. Moreover, although quite capable of writing with his right hand, the boy preferred to use his left and to write from right to left, something that only the Jews did at that time. If he had attended any ordinary school, this habit would have been punished and corrected, but as an illegitimate son he did not have to live up to any intellectual expectations and no one wasted time correcting him: writing was a game for him and his grandparents did not think that he would use it much in life.

As time passed the boy's upbringing became increasingly unusual and unorthodox. Occupied by his new marriage and by his career as a notary, Leonardo's young father had little time to spare. Moreover, the mere presence of the boy was a constant reminder of a painful problem that Ser Piero now faced: the lack of children. Albiera could not conceive and Leonardo's presence was an unspoken denunciation of her sterility. The years passed and Albiera and Ser Piero would have no legitimate heirs until Albiera's death in 1465, after 13 years of what cannot have been a happy marriage. In Florence as in the rest of Italy during the fifteenth century, marriage was above all a financial transaction that served to consolidate social alliances and to ensure the continuity of private wealth and family honour. A childless marriage was a useless marriage and the fault always lay with the woman, who was held to be responsible for the couple's sterility. However distant and confined to the small village of Vinci, the boy, who was growing up to be strong and handsome, was a source of sadness for Albiera and of embarrassment for Ser Piero: family reunions could not have been easy, either for the couple or for Leonardo. For the same reasons, the fact that the grandparents knew that another heir would not arrive soon increased their love for Leonardo, who grew up in their sometimes overly affectionate care.

The conditions in which the child was raised were very unusual. On the one hand, the absence of other children in the grandparents' household meant that he was alone much of the time; on the other, this was not helped by the gulf between him and other boys in the village, which

was due to the fact that the da Vinci family had to defend its standing in the rural community and certainly could not send this young grandson to work in the fields, like all the other boys of his age. Even if illegitimate, Leonardo was the son and grandson of respected notaries and, as such, stood apart from other village boys. A life of ease, freedom and solitude, albeit not lacking in basic education, was an ideal medium in which he could nurture a growing sense of curiosity in the surrounding world. But, on the other hand, what was certainly a painful relationship with his father and stepmother served as an equally necessary condition for the child's creative introspection to develop, shielded as it was in the arms of his grandparents, who undoubtedly loved him even if they failed to discipline him.

Vinci was a world suspended between domesticated and wild nature. The village lay on the edge of the wooded ravines of the foothills to the Tuscan Apennines, where farmed countryside gave way to large areas of wilderness. Olive groves, vineyards and fields of wheat occupied part of the hillsides between the crags, while the soft outlines of the woods were broken by rows of cypresses. The rest of the surrounding countryside was full of narrow gorges excavated by streams as they flowed downhill to join the Arno, the majestic river whose sediments had moulded the valley over thousands of years and presented the boy with landscapes of extraordinary beauty. Fascinated by the wilderness, Leonardo started to explore it during his solitary childhood. Later, in early adolescence and during the heady phase of puberty, he undertook these explorations of the world around him with growing enthusiasm, and his observations became more systematic.

There was something else that the strange family could offer almost in spite of itself, something that would mark the rest of the boy's life: this was paper, a material that was not lacking in a notary's household. Large quantities of paper were purchased by the da Vinci family, as is borne out by a credit note dated 1451 and signed by grandfather Antonio, which mentions, among other debts, the 12 *lire* that Piero owed the *cartolaio* Giovanni Parigi.[2] That paper, so precious to the notarial profession, must have been invaluable for the boy's solitary games and adventures. Paper was not readily available, especially not to poor children, but Leonardo must have had access to considerable amounts, if only in the form of waste paper and cut-offs.

By a lucky coincidence, the best circumstances conspired to develop the boy's genius: freedom, solitude and scraps of paper, the material on which he could give tangible expression to his thoughts and with which, early in childhood, he established a relationship that would remain unchanged for the rest of his life. Paper would become the principal medium through which he communicated with the rest of the world. Leonardo entrusted every observation, every memory to paper: whether in note form or as a sketch, his mind would project onto paper as if that were his alter ego, an extension of his self, a fetish that he could not be free of and with which he would be burdened to the end, passing from scraps to sheets of drawing paper and then to notebooks, and finally to the voluminous codices. His relationship with paper certainly stems from his unusual childhood in Vinci and paper was the best gift the family could have given him, much better than the social legitimacy his father would always deny to him.

Paper and ink became the boy's playthings and companions, and then a precocious marker of his talent as he gradually began to reproduce on paper the shapes of what he observed during his long, lazy days. The story told by Vasari about the dying Leonardo contains a kernel of truth that counterbalances and confirms the insight offered by his grandfather's accounts.

Nevertheless, in spite of the fact that he worked at so many different things, he never gave up drawing and working in relief, pursuits which appealed to him more than any others. When Ser Piero saw this and considered the level of his son's genius, he one day took some of his drawings and brought them to Andrea del Verrocchio, who was a very good friend of his, and urgently begged him to say whether Leonardo would profit from studying drawing. Andrea was amazed when he saw Leonardo's extraordinary beginnings, and he urged Ser Piero to make Leonardo study this subject; and so Piero arranged for Leonardo to go to Andrea's workshop, something that Leonardo did very willingly.[3]

In this passage Vasari cleverly transforms the moment when Piero makes a derogatory choice for his illegitimate son: the choice of a 'mechanical' career of painter instead of a 'liberal' career of notary, which would have been open to Leonardo if he had been legitimate. Leonardo's

experience offers a parallel to that of Michelangelo, who was also born into a very affluent family, but in his case the family had fallen on such hard times that they could not afford a liberal career for their son. In both cases Vasari turns a derogatory choice into one dictated by the forceful manifestation of talent, even if years were to pass before this talent would become public. At all events, what emerges from Vasari's account is that the drawings showed Ser Piero the direction of his son's career. The drawings that the boy had first experimented with on scraps of notarial paper opened the way to the workshop that would set him on his future path.

2

IN FLORENCE

We do not know the exact date when the boy moved from the small village of Vinci to the city where his father lived and worked as a successful notary. In all likelihood this happened around 1465, after grandfather Antonio's death, which also coincided with Piero's second marriage to a girl only a little older than Leonardo, a certain Francesca di Ser Giuliano Lanfredini. Unfortunately she could not have children either, and for this reason she was as unwilling as Albiera had been to welcome into the house the youngster born many years earlier from her husband's passing affair.

Certainly the change could not have been greater for a boy who was used to simple country life and the protected solitude of his grandparents' house. Coming to Florence was like arriving in a new world and, given his endless thirst for knowledge, the best of all worlds. In the 1460s the city on the banks of the Arno was living through a golden age. Forty thousand people lived there and the city resembled a single huge machine of beauty and productivity. The neighbourhoods were clustered around houses with traditional, tall medieval towers, fortified so as to host families that made up close-knit clans. But these were the families that, well over a century earlier, had invented a form of government and community life that was the envy of all Europe: despite its size, Florence was one of the busiest cities on the continent. With

remarkable foresight, the Florentines had developed a manufacturing system capable of exporting textiles across the world and made possible an accumulation of wealth that generated the leading banks for deposits and loans, with branches in every major European city.

Despite continuing social friction, the city was governed by a group of aristocratic families that held and controlled all government offices while endeavouring to maintain a balance and to remain united, cemented as they were by their common interest to withstand the strongest states on the peninsula – the Venetian republic, the Papal States and the kingdom of Naples, which were threatened, by turns, by the foreign influence of Spain or France. Hence Florence's survival as an independent state was linked to diplomatic balance and to the economic resources with which the city withstood external attacks.

Driven by an aim at internal expansion throughout Tuscany, in competition with the neighbouring cities of Pisa, Siena and Lucca, Florentine policy was ably guided by a family that had imposed its own hegemony over the others for some decades. The Medici were extremely wealthy bankers, skilled at forging alliances with major Italian states and the most influential families. Cosimo de' Medici, known as 'the Elder', the first to establish the family's dominion over the city, had died at Careggi in 1464, just before Leonardo moved to Florence. For 30 years Cosimo had enjoyed a de facto lordship over the city, broadening the bases of rule to the middle classes, which were easier to control. It was also easier to win their allegiance and curb the power of other leading aristocratic families, such as the Pazzi, who were also hugely wealthy and long-established.

Cosimo had shown immense skill in creating a form of government that appeared to be broad but was in fact discreetly controlled by the Medici family. Cosimo's son Piero preserved the Medici's hegemony for a further five years, and after his death the mantle fell on the shoulders of young Lorenzo (1449–92), who in the centuries to come would become the symbol of a form of rule in which unobtrusive influence merged with munificence and the promotion of those activities that benefited not only the family but also the state and all its citizens. This innovative policy generated in the city even greater intellectual fervour, whose fruits would soon attract the attention of the rest of the world. Cosimo had fostered the intellectual progress of the city with

conviction, by refining the culture of the elites destined to govern it, and had made a more or less conscious choice to augment the city's external influence by developing the arts.

First among the great politicians of the Italian Renaissance, Cosimo de' Medici had understood that the arts could be a formidable instrument of government. Some of his decisions in this direction owe much not just to skilful political design but to an intellectual perspicacity that remains unparallelled in Italian history. When the fall of Constantinople in 1453 brought about the immigration of the great intellectuals who had guarded the centennial presence of traditions, texts and ancient knowledge in that capital of the East, this triggered a rush for classical Greek philosophical manuscripts throughout Italy. Cosimo went one step further by asking the famous scholar Giovanni [John] Argyropoulos to teach at the Studio Fiorentino, Florence's university. From 1454 Florentines were able to learn Greek and study Greek philosophy.

For the first time these new scholars adopted a critical approach towards the ancient world: they looked at it not only as a model to imitate but, if need be, as a system that had been superseded and whose merits and defects could be assessed. But this valuation called for an approach that we would now call scientific, a rigorous knowledge of the texts and their authenticity that would become known as 'philology' and permitted the great humanist Lorenzo Valla to prove that the donation from Emperor Constantine to Pope Sylvester – an edict that provided the grounds for the church's temporal power in Italy – was a fake produced long after Constantine's death. Working at the behest of the king of Naples, Alfonso of Aragon, Valla demonstrated this by undertaking a detailed analysis of the text, which contained literary forms typical of the early Middle Ages.

Valla's philology was the most striking example of how learning could free people from centuries-old tyrannies and how politics could take advantage of learning. Cosimo was very closely linked to the court of Naples, where he had maintained considerable commercial interests; and he clearly understood the message well. As well as attracting leading intellectuals to Florence, in 1462 he commissioned Marsilio Ficino, his doctor's son, to translate some of Plato's works from Greek into Latin and awarded him a stipend from the revenues of his villa in

Careggi. Patronage of this calibre inevitably produced extraordinary results and the Studio Fiorentino became so famous during this period that even the Sorbonne in Paris would look forward to its new works as if they were gospel.

This intellectual passion, incandescent in its liveliness and innovation, spread from the Studio Fiorentino throughout the city and philosophical debate could be heard at every corner, in a form of generalized academy whose participants could be found in the Ospedale dell'Annunziata (dissection was practised there), but also on the shaded benches around the walls of the newly built great palaces. Such intellectual fervour did not produce abstract theoretical speculation but practical contributions to the lives and activities of all citizens, as the work of another famous professor from the Studio, Cristoforo Landino, demonstrated. This was the man whose Italian translation of Pliny's *Natural History*, the first of its kind, was enormously useful to Leonardo and other Florentine artists.

This freedom, which other states did not afford their intellectuals, fuelled freedom of thought in Florence, because in it there are also the roots of the city's commercial innovations. Even the shape of the city, its physical appearance, was radically transformed during the fifteenth century, as an expression of the rationality of this new thought. Its street plan, the design of its palaces, the rationality of its architectural details, all were the outcome of this reinvention of reality that stemmed from a new political discourse. The capabilities of the human mind took concrete form in Quattrocento Medici Florence in the materiality of objects, in the statues that filled every niche, in the bronze doors that were added to churches and in the paintings that adorned the walls of the palaces.

The critical analysis of the humanists who interpreted the classical traditions with new eyes sparked a train of thought that tended to imagine a future in which individuals invented their own destiny rather than being subservient to philosophical theories or theologies. Although humanists like Lorenzo Valla, Marsilio Ficino and Pico della Mirandola still formally celebrated the great classical schools of Platonism and Aristotelianism, their critical approach was completely new and their intellectual activity aimed to select philosophical thought on the basis of its ability to change the real world. Knowledge understood purely as

the contemplation of an unchanging and given universe was the norm of medieval culture, but the humanist intellectual movement that had its fulcrum in Florence precisely during the time when Leonardo was there broke with this tradition of theoretical philosophical systems; and this rupture gave rise to a movement of ideas and people that used every available means to search for a kind of knowledge that would be useful to humanity and could bring about change in a world regarded as motionless in earlier centuries.

Without examining the intellectual climate in which Leonardo immersed himself upon arrival in the city it is impossible to understand either the unique formation that the artist received or the specific goals he set out to achieve through the studies undertaken in the streets of his new *patria*. This sentiment, which was widespread among intellectuals and artists and filled the air breathed by young Leonardo, is connected to the magical and alchemical processes handed down by Florentine craftsmen. These should be understood not as esoteric practices but rather as techniques for the transformation of reality; and they had been preserved above all in artists' workshops and in the minds of entrepreneurs. The need to change the world was the common purpose that linked Florence's politicians, its intellectuals and its artists; together they formed a new community, far from the rigid forms that had governed for centuries the institutions responsible for passing knowledge from one generation to the next, the *studi universitari*. This merging and synergy of interests prompted the leading Italian scholar of Renaissance philosophy to write:

> The truth about the Renaissance ... lies precisely in the Vallas, Albertis and Polizianos, not to mention the Massaccios, Brunelleschis, Leonardos, Michelangelos and Galileos, and in all the artists, the poets, the philologists, the historians and the scientists, and in the political historians like Machiavelli and Guicciardini, and last of all in the prophets and reformers from Savonarola onwards.[4]

But, if all this is true of the Italian peninsula in general in the second half of the fifteenth century, it was in Florence that the process underwent a tangible acceleration, in Leonardo's presence, under the rule of the two great Medici, first Cosimo the Elder and then his grandson Lorenzo. Under

their government the statutes of the Studio Fiorentino were at their most liberal, as is shown by the status granted to anatomical dissection in order to ensure that *nullus potest esse bonus et perfectus Medicus nisi bene cognoscat Anatomiam corporis humani* ['no one can be a good and blameless doctor unless he is very familiar with the anatomy of the human body'].[5] It was a statute that openly acknowledged the importance of actual experience for the advancement of knowledge. Moreover, for Leonardo, it would serve as the fundamental basis for his future research and would provide a *modus operandi* to which he would always remain faithful.

Such a ferment of innovative energy in such a small space brought together the various factors involved in this process of change in a manner that was unparalleled in Italy. In this drive towards knowledge and transformation, towards the exploration of the real world, artists found themselves working alongside philosophers and academics, because artists had their own tradition of empirical knowledge of nature, their own methodology of approaching the sciences of transformation; moreover, they were, alongside the manufacturing industries, at the forefront of the process of transforming materials and the world around them.

It is no coincidence that the best example of this merging of intellectual speculation and empirical knowledge of nature was a Florentine, Leon Battista Alberti, whose works had reformulated and combined the knowledge contained in the classical texts of Pliny or Vitruvius with the skills accumulated by Tuscan artists in their workshops, as expressed by Cennino Cennini in his *Libro dell'arte* – a treatise that was half chemistry and half natural philosophy. The production of pigments and paints and the techniques used to represent images created a common ground between chemistry, physics and philosophy.

Alberti had summarized and reflected on the transformation of reality for the purpose of building the city, but also of reordering society and the family. Alberti was the intellectual who, more than any other, raised the question of the practical aims of knowledge, and his works were debated in Florentine artists' workshops and at university, in hospitals and in the intellectual circles that flourished throughout the city – so much so that philosophy became a topic of conversation under the loggia where the merchants met and on the banks of the Arno, or in the Studium [University] before it was moved to Pisa.

Florence became the city of machines that had started to change the world. It was the city where technology was gaining pace; it made the looms on which the finest cloth was woven. It was unique in Italy and admired throughout Europe. It produced the tools used to sculpt porphyry and, above all, to build immense works of architecture such as Brunelleschi's dome (on which an immense, gilded bronze sphere of unprecedented size was to be placed when Leonardo arrived in Florence) and the bankers' palaces.

Of course, the Medici, too, felt obliged to stay abreast of the competition. The most beautiful 'machine' that met young Leonardo's eyes upon his arrival was the Medici palace, which the architect Michelozzo had been commissioned to build for Cosimo the Elder. With its monumental but sober lines and especially with its rational layout, it alone signalled the faith that Florence placed in the capacity of reason and in the building techniques. The Rucellai palace had been designed by Leon Battista Alberti himself; it combined a nostalgia for classical forms with a refinement that was more suited to the city's richest bankers and their sober lifestyle. Likewise, across the Arno, the Pitti palace might also appear severe but rational at first sight, while the rational clarity of Brunelleschi's churches was entirely comprehensible, even to the eyes of peasants who arrived at dawn carrying their delicious Marzolini cheese – those *ravaioli* that Michelangelo would later arrange to have sent to himself in Rome.

The whole of Florence spoke of a new and rapidly changing world. Even the minor examples of painting and sculpture, no less marvellous than the great stories of the palaces, conveyed the same febrile pace of the city's expansion. The adolescent who had explored the woods around Vinci now explored the walls of churches and confraternities and the loggias of the merchant guilds. Giotto and Masaccio had brought the real world and real people into these buildings, giving their figures the same physical presence, the same expressions, the same clothes as they wore in the streets. In the Medici palace, on the chapel walls, Benozzo Gozzoli had painted the procession of the Magi with an elegance that no procession could ever have had in real life, even though from that year on (the painting was finished in 1459) the Medici themselves had tried to emulate its wealth and elegance in the processions they organized in the streets of Florence.

Leonardo was encountering a world that collected the exotic treasures of merchants who had travelled far and wide, bringing back likenesses of remarkable creatures, unheard of birds, and even skin colours of people who lived where the sun's rays burned incessantly. Several of the statues by Donatello and Brunelleschi were terrifying for their realism. Florence contained everything that the world had discovered by 1465, and what was not visible on walls or on painted panels was described in the codices kept in the library at San Marco. The library was visited by scholars from all over the [known] world, and Leonardo would soon join them to satisfy his eager thirst for knowledge.

Lastly, there was something else that had recently arrived and astounded even the city that had invented double-entry bookkeeping and other modern contraptions. The first Flemish oil paintings were brought to Florence in the packing cases of Florentine bankers who worked in Flanders. The first paintings by Rogier van der Weyden and Jean van Eyck had arrived during those years in the houses of rich bankers, and painters were able to observe how the pigments they themselves used would appear more luminous if mixed with linseed oil instead of egg white, as in tempera. These new colours were responsible for a second creation, because such brilliant hues did not exist in nature. All the reams of paper sold by Giovanni Parigi to grandfather Antonio would not have been enough for young Leonardo to record everything he saw in Florence. A new season was about to commence.

3

VERROCCHIO'S WORKSHOP

When young Leonardo joined his father in Florence, perhaps soon after 1465, after his grandfather's death, Ser Piero had already achieved an excellent social position in the city. Around 1469 he rented a house owned by the Wool Guild right in the city centre (where Piazza San Firenze now stands, a stone's throw from the Palazzo della Signoria). In 1470 Piero became procurator for the large convent of Santissima Annunziata and his tax returns for the following years clearly confirm that the family's property and wealth grew. The positions he held became increasingly prestigious and he soon started to work for the Florentine government itself in the Palazzo della Signoria. Even if Vasari was probably exaggerating when he described Piero as a friend of Lorenzo the Magnificent, there is no doubt that Leonardo's father frequented the right circles and knew the artists patronized by the Medici.

One of them was Andrea del Verrocchio, a figure who epitomized that brilliant Florentine society, midway between creative craftsmanship and the most advanced scientific research in Italy. Born in 1435 to a humble furnace worker, Andrea had become an apprentice goldsmith in one of the city's workshops, where he learned the complex procedure of handling molten metals and forming the clay models to be cast in gold. When the workshop where he trained was faced with a shortage

of work, Andrea switched to sculpture, being described as a *scarpellatore* ['stone carver'] in the *catasto* of 1457 [*sc.* the census of Florence and its subject territories made for tax purposes]. In his tax return of that same year, Andrea, who was not handsome but was a pleasant-looking man, made a disconcertingly honest declaration about his business and private finances. It reveals his extraordinarily compassionate nature as someone who not only refused to collect the small rentals owed by his tenants, but even justified their arrears by stating that they were so poor they could not afford to pay.

> I am owed as much by various individuals, poor people who never have anything. I find myself at the age you see and with little business. I used to work with the goldsmith but because there is no work I am no longer there. My said brother works with Romolo Cechi, weaver, and is an apprentice on a salary, and we cannot earn our hose.[6]

Nowadays we imagine that an artist's life must have been splendid in view of the fabulous legacy of the art that has survived, but in fact it was never free from the hardships of day-to-day survival. The workshop that Leonardo would join, about ten years after his earliest experiments with art, was a modest place in terms of equipment and earnings, yet it was at the cutting edge of technology for its day, at least with regard to metal casting. Many clues have survived of Andrea's good character: he appears to have dedicated his entire life more to others than to himself. He never abandoned his sister's orphaned children and never married, choosing instead to live together with his young pupils. It is indeed possible that this choice concealed a more ambiguous sentimental inclination, given that Andrea left almost all his inheritance to his closest pupil, Lorenzo di Credi, much to the fury of his own brother, who impugned the will. Despite such an unpromising start, Andrea was destined to make a profound mark on Renaissance art, even without taking into account the major contribution he made to young Leonardo's training.

Now that studies of the Florentine Quattrocento have moved beyond Vasari's legends and have returned to original documents, it can safely be said that the fame achieved by Andrea's pupil Leonardo has undermined and cast a shadow over that of the master. Indeed,

Andrea del Verrocchio was a man of such talent, endowed with such a broad outlook, that it is impossible to imagine Leonardo without him. The master's teaching and interests contained (almost) all the topics that would later be expanded by Leonardo. But this generous master deserves the greatest credit for having accepted and protected the young man from the countryside for many years, and for offering his own affection to fill the vacuum left by Ser Piero – who, although living only a few hundred yards from his son, never welcomed him into his house and effectively treated him as an outsider. In Florence, Leonardo also felt the heavy burden of his stepmother's sterility. Francesca di Giuliano Lanfredini, who was also from an excellent family, became Ser Piero's second wife in 1465; but, despite her youth, she was unable to have children. Not accepted at his father's house, Leonardo found family warmth and enthusiasm in Andrea del Verrocchio's workshop.

According to the story told by Vasari, now blended with the myths surrounding Leonardo, Verrocchio appears as a self-made genius who had virtually nothing to learn, because such genius manifests itself as a fully formed gift. Of course, nothing could be further from the truth. Starting from his humble beginnings as a *scarpellatore* and with nothing but his immense talent and a capacity for self-denial, Andrea embarked in the 1460s on a career that would be first recognized in Florence before he moved to the splendid and wealthy city of Venice – where he died while working on his most famous work, the equestrian monument to Colleoni.

In 1470, soon after Leonardo's arrival, Verrocchio's workshop was already the forge of artistic avant-garde initiatives in Florence, and the master was commissioned to cast one of the most representative works of the Florentine Renaissance: the bronze group of *Christ and Saint Thomas* in one of the external niches of Orsanmichele. Above all, it was representative because it was a major technical challenge: Verrocchio cast both the Christ figure (except perhaps the lifted right arm) and that of Saint Thomas in one single piece.

At the time, this was the hardest technical challenge for an artist, given that such large figures had not been cast in a single piece since classical times. Even Donatello, who had made large bronze statues, had cast the individual parts before cold-welding them together with the help of rivets. The problem of casting is that a layer of wax has to

be inserted between the plaster mould and the negative model made from refractory clay. Under the pressure of hot metal, the wax layer melts and flows out of special drainage vents, leaving space for the molten alloy to reach into all the corners before hardening. The task is extremely difficult because the metal has to be poured at extremely high temperatures and if it cools along the way many parts remain unfilled. In his model, Verrocchio highlighted the folded, plastic forms, creating any number of recessed surfaces that were much more difficult to reach than a smooth surface.

The apparatus that needed to be prepared for casting was one of those industrial machines whose success was based on an understanding of mechanics, physics and chemistry and on exceptional design skills. In spite of his humble origins, Verrocchio achieved a previously unparalleled level of engineering skills, so much so that his reputation immediately burgeoned and the Opera del Duomo [the Works Committee for the Cathedral] placed him in charge of completing the other masterpiece of Florentine engineering: Brunelleschi's cupola. In particular, he was commissioned to cast a huge bronze ball for the lantern.

Verrocchio's creativity and skill did not go unnoticed by the Medici, who commissioned him to carry out a number of high-profile public works, for example the funerary monument to Cosimo the Elder, the founder of the dynasty, in the church of San Lorenzo. In this work Verrocchio, the son of a poor furnace worker, interpreted the sober elegance possessed by Cosimo even in politics, and his complete absence of ostentation, by creating a superb interlaced grille, beneath which lies a simple but stark tomb that evokes the passage to the next world of a man of acknowledged public virtue. Here too the perfect technology of the casting is evident in the grille, which is made from carefully interlaced rhombi: an almost metaphysical image that allows a glimpse into an empty space symbolizing the everlasting void beyond death. In both of these bronze monuments Verrocchio achieved such perfection that there is an almost complete absence of the retouching and chiselling used by all artists before him to conceal their technical flaws.

The excellence of Verrocchio's casting technique during this period led him into a sector that seemed far removed from his core skills: ballistics. These were years when new types of firearms were being

experimented with and the secret of good casting was essential to their success. Therefore we should not be too surprised to learn from financial documents that, around the years when Leonardo, not yet 15, joined the workshop, Andrea Verrocchio was called upon to make military bombards, one of which – certainly not the first – would be delivered to Pisa in 1484.

Verrocchio's interests in engineering and ballistics are enough to explain Leonardo's interest in the science of firearms, a skill he offered to the duke of Milan. The origin of Leonardo's interests and knowledge can therefore be traced to Andrea's workshop, where the young man witnessed the creation of all those fantastic and wondrous new offensive weapons. The master founder's library contains some important literary texts that confirm the circularity among artistic ideas and general philosophical and literary ideas in Florence during this period, as well as the proximity and interaction between the various fields of knowledge. The short circuit between art, science and philosophy that sparked the mind of a boy freshly arrived from the Florentine countryside was triggered in Verrocchio's workshop.

4

DRAWING

Engaged as he was in complex works of engineering and sculpture, it is hard to believe that Andrea Verrocchio was also a master painter – and a very good one at that – but, once again, the documents remove any shadow of doubt and confirm beyond question Vasari's opinion. In his life of the artist, Vasari described him as an excellent painter, although father of too many sons (not only Leonardo but also Lorenzo di Credi, Botticelli and Perugino all emerged from his workshop). Verrocchio's influence on the last two is questionable and the subject of continuing and not yet conclusive research. However, no such doubts surround Verrocchio's artistic paternity of Lorenzo di Credi, and of course of Leonardo. According to his mother Lisa, in 1480 Lorenzo was 21 and a painter in Verrocchio's workshop on a salary of 12 *lire* a year. Four years earlier, according to a disturbing document to which we will return later, Leonardo di Ser Piero da Vinci also resided in Verrocchio's workshop; moreover, he is not mentioned in his father's tax returns, an indication that he lived in the master's workshop until at least 1476.

The workshop was very close to the Duomo and had formerly been used by Donatello. Verrocchio rented it because it was more suited to storing the casting equipment that Donatello had previously used for his statues. Other documents tell us that the workshop was also used for

the production of paintings even after 1480, when Verrocchio began to work on the monument to Colleoni in Venice, where he eventually moved and then died, in 1487. Verrocchio appointed Lorenzo di Credi as his universal heir, but not without having first provided dowries for his much loved nieces. To Lorenzo, Verrocchio also left a wardrobe of elegant clothes worthy of an affluent merchant, a saddlecloth, a *gabanella* [mantle, housecoat] of black *ciambellotto* lined with grey squirrel fur and worn long, in the Venetian style, a doublet lined with fox fur like those featured in many portraits of bankers, other *gabbane*, and enough fine linen for a good number of chemises. This humble *scharpellatore* had made good despite his origins, and this passion for expensive garments was perhaps the only luxury that he indulged in. Elegance would also play a role in the education of young Leonardo, for whom it was to become a lifelong idiosyncrasy.

Understanding how an artist could successfully combine such seemingly distant activities as bronze sculpture, the construction of bombards, and the painting of wood panels requires a closer analysis of the practical organization of the Florentine artist's workshop in the mid-Quattrocento, of which Verrocchio's is the most refined example.

In a *bottega* young apprentices like Leonardo were taught how to prepare the materials required for painting and sculpture. They learned the chemical processes needed to create pigments from natural ingredients: for example, they made verdigris by covering a child's chamber pot with a copper tile and then burying it until the ammonium in the urine corroded and transformed the stability of the copper, turning it a brilliant shade of green, which was excellent for painting the draped mantles of saints. They baked red earth at different temperatures until it turned into red lead and cinnabar; they dried lime until it became the beautiful 'bianco di San Giovanni', a special kind of lime white pigment, and they ground carbonized animal bones that had been repeatedly rinsed, producing the bone black used to define the shadows and eyebrows of the enthroned Madonna. They learned to pick up gold leaf and burnish it using a wolf's incisor, or to mix plaster with glue made by boiling up scraps of skin or the bones of small domestic animals.

They were shown how to smelt iron, too, in order to fabricate razors whose finely honed edge would leave a perfectly smooth surface on the layers of plaster and glue that were applied to wooden panels chosen for

their lack of movement after seasoning. The razors were so thin that they would hone the plaster without removing it from the panel, until the *mestica*, as the plaster mix was known, became as smooth and hard as marble, ready to receive the colour. But before applying the colour they had to learn about the various kinds of bird feathers used to make nibs and the animal fur used to make brushes: pig bristles were too stiff for applying a *velatura*, or thin glaze – it was better to use instead tufts from a grey squirrel or a foxtail. All this required a detailed knowledge of the natural world, confirming that the real crucible of scientific knowledge in the fifteenth century was the artist's workshop, all the more so if that artist was not only a painter but also one who cast statues and designed buildings.

The workshop that Leonardo joined offered him a worldly education and taught him the compendium of universal knowledge that had selected itself over centuries. Yet these were not the abstract theoretical systems taught at universities, but rather the tangible knowledge that moved and transformed the world. Extraordinary examples of these compendia or encyclopaedias of art and natural science *ante litteram* were the codices owned by a number of Florentines from the generation before Leonardo: in particular, Cennino Cennini's *Libro dell'arte* (which boasted direct descent from none other than Giotto) and Leon Battista Alberti's treatise *De pictura*, which had allowed specialist literature to make significant advances by drawing closer to classical works, above all to those by Pliny and Vitruvius.

All other knowledge was learned and communicated through the daily running of the workshop. In order to make a good brush, one had to know where to source the softest grey squirrel fur, the toughest quills from the hawk, the strongest pig bristles. The same was true of wolf's teeth, rabbit glue, and the rare lapis lazuli stone that was mined in mountainous areas described by geographers and transported by Arab and Jewish merchants as far as Ferrara, where Florentine artists would go to buy it. After Leonardo had observed nature in all its forms at Vinci, he encountered the next stage in Verrocchio's workshop: this was nature domesticated, exploited and in part explained with the intellectual instruments of the period. Now his interests could focus on the processes of transformation, something that would never have happened if he had attended a university course at Padua, where students

listened to experts speculate in Aristotelian and abstract terms on the formation of the earth and on the multiplicity of the heavens and stars.

At a more advanced stage, the Florentine apprentice learned how to depict space through the geometry of perspective and how vertical lines shrank as they receded in space, while horizontal ones converged towards a vanishing point positioned on an ideal horizon. It was a construction that bordered on intellectual speculation and, as such, had undergone detailed elaboration in the Florentine workshops of many Tuscan architects. In the mid-century, Leon Battista Alberti's *De pictura* had also provided a scientific explanation of perspective.

Leonardo also discovered something else in Andrea Verrocchio's workshop, something that the master himself had invented in order to perfect his drawing skills. Verrocchio used models of human body parts, and it seems very likely that he had started to perform dissections in hospitals in order to study in greater detail how the body worked before drawing it. Hands, torsos and legs, all modelled in clay, were then drawn under different lighting conditions and from different viewpoints in order to achieve a more credible depiction of the object. Verrocchio had also invented, or perhaps simply improved, a completely new way to study how garments would drape over figures. He dipped strips of linen in liquid plaster and then fashioned them into various styles over the wooden and clay models in order to study the hang of the folds and the light that played on them. To improve the drawings, Verrocchio shaded the paper with white, grey or blue pigment before highlighting every nuance in white, until he produced an astonishing degree of realism.

Verrocchio made the most beautiful drawings of the Quattrocento; and Leonardo was well placed to take the level already attained by his master one stage further. For a long period Leonardo's drawings so closely resembled those of his master that later scholars found it very difficult to distinguish the autograph works of each artist. The woman's head now in the British Museum, London [Plate 1] amply testifies to the virtuoso degree of realism achieved by Verrocchio using the *sfumato* effects of light, the composure of the lineaments and the naturalness of the anatomy. What is certain, however, is that his exceptional ability permitted him to oversee all the images produced by his workshop, whether in bronze, stone or paint. Such rigorous control gives a level of

uniformity to the output from the workshop and consequently makes it very difficult to identify the work carried out by his collaborators.

His drawings were so complete and detailed that, once transferred to the wooden panel, they could be coloured almost mechanically. Even the shadows were added to the preparatory drawing, in chiaroscuro, before the latter was transferred onto the panel, creating already at that stage a plastic effect, that sculptural relief sought by the master, which his pupils would merely fill in. Having been refined to such an exceptional degree of expressiveness, the drawing was the truly creative phase in Verrocchio's workshop – and also the controlling instrument that ensured a homogeneous production from the assistants even when the master himself devoted his time to sculpture, which he undoubtedly loved more than any other form of artistic expression.

Vasari prepares the ground for his eulogy of Leonardo by describing how Verrocchio abandoned painting on account of his pupil's astonishing ability; but today we know for certain that, when Leonardo joined the workshop, Verrocchio was already the greatest sculptor working in Florence. Yet it was Verrocchio's reputation as an artist that prompted Ser Piero to show him his son's drawings when the boy arrived in Florence; and the father's connections with the Medici would certainly have helped him to place Leonardo in Verrocchio's workshop, which was actively working for Lorenzo and his court in the late 1460s.

5

EARLY EXPERIMENTS IN THE WORKSHOP

Two documents attest to Leonardo's activity as a painter at the start of the 1460s. The first is a receipt for payment of his subscription to the Company of Painters on the occasion of their patron saint's day, Saint Luke. 'Leonardo di Ser Piero da Vinci painter owes, for the whole of June 1472, *soldi* 6 for the grace granted him for whatever debt he owed to the guild until the first day of July 1472.'[7] Dating from the following year is a drawing, his first known drawing – a view of the Florentine countryside. In the margin is written 'This day of Saint Mary of the Snow, on 5 August 1473' [Plate 2].[8] Aged 20, Leonardo was therefore active as a painter and a paid-up member of the Company of Saint Luke, living in Verrocchio's workshop, where he would remain until at least 1476. Yet we know nothing about his pictorial output. A few years younger than Leonardo, Lorenzo di Credi earned an annual wage of 12 *lire* while working in the same conditions ten years later. This was a very modest sum on which to live, even very frugally, in a place like Florence – where the maid whom the da Vinci family recorded in their *catasto* tax return of 1469 was paid a little less, 8 gold florins a year.

The production system organized by Andrea Verrocchio in his own workshop, which was heavily focused on the accuracy of the drawing and the perfect finish of its transposition to the panel, complete with watercolour shadows, makes it very difficult to identify the hands of

the various collaborators who clearly contributed to the paintings. The archival documents cannot help us here because good records exist only for a few commissions of sculptural works undertaken in the *bottega*, but not for paintings. The former were generally public commissions of some note, and the complexity of the casting, together with the size of the works, called for a more detailed financial outlay, which was recorded in the accounts. This is clear to see in the detailed documentation that has survived for the casting of the sculpture group of *Christ and Saint Thomas*, commissioned by the Mercanzia [the merchants' court] for its niche on the exterior of the church of Orsanmichele, which was gradually being embellished with statues commissioned by the city's guilds. These records allows us to follow in detail the phases of the bronze group over a ten-year period (1470–80). Yet the accounts bear no trace of the panel paintings, usually small devotional works commissioned by private individuals for their own homes.

For these reasons it is difficult to identify those paintings produced by Verrocchio's workshop during the years when Leonardo first arrived. In order to fill this gap, the legend, which is not without appeal and a certain ring of truth, has it that the boy's first role in the *bottega* was as a model. By comparing the traits of the beautiful bronze *David* [Plate 3] that Verrocchio cast for the Medici and that they sold to the Florentine Signoria with a portrait of Leonardo made subsequently by his pupil Francesco Melzi and conserved today at Windsor [Plate 4], many scholars believe that Verrocchio used his young assistant as his model. That Leonardo was always admired for his looks is well known. But this presumed portrait in bronze of the young man who had just joined the workshop cannot tell us much about his role in that context, given that it was common practice to make the younger members of the workshop pose for figurative compositions.

It is much more important to emphasize that, if no works can be unequivocally attributed to Leonardo himself by 1472, when he was certainly an independent painter and a member of the Company of Saint Luke, this is because, far from being the fully fledged genius he is purported to have been, he continued to take part in the work of the *bottega* just as he had earlier, and as other collaborators would also do later. The methods used in the *bottega* are quite clear, and today new diagnostic tools allow us to follow the executive phases of the

painting beneath the pictorial film and to analyse the components of each material – from the way the various pigments were mixed to the preparation of the painting and the medium used to thicken the colour. It is quite clear that the boy's job was to apply the various layers of plaster and glue (the *mestica*) onto the panels (usually made of poplar wood); these layers ensured a smooth base for the paint and were constantly honed in order to remove any roughness. Once the preparation had been finished, an impermeable priming layer of lead white [*biacca*] and linseed oil, known as *imprimatura*, was applied, to a depth of a few millimetres. But in Verrocchio's paintings (and later in Leonardo's own works) the preparatory drawing was transposed directly onto the *mestica*, before application of the priming layer. This yielded a reference point for monitoring the drawing, given that the *imprimatura* layer was transparent and the underlying drawing would have been visible when you went over with a dark pigment, applying it by brush.[9]

This particular way of working in the *bottega* – the extreme care taken to define the drawing after it had been transposed onto the panel – is important for the subsequent development of Leonardo's pictorial practice. Before it was transposed, the preparatory drawing realized by the artist embodied the truly creative phase of the entire process. Verrocchio would study the composition, perhaps with the help of his collaborators, until he had refined every detail. In the specific case of Verrocchio's workshop, this definition was so outstanding that some compositional 'innovations' would be replicated in several other works, or in different parts of the same painting.

A clear example of this repeated use of an anatomical detail that had been developed into a perfect equilibrium of shape can be found in the almost identical hands with curved fingers that appear in the two figures in the panel with *Tobias and the Angel* [Plate 5], and again in the *Madonna with seated Child*, now in Berlin (Gemäldegalerie). The same applies to the almost flat hand delicately placed on the chest, in a gesture of protection and amazement, which Verrocchio drew before sculpting it in marble in his *Woman with a Bouquet* in the Bargello, Florence, and which reappears in identical form in the angel on the left of the beautiful *Virgin and Child with Two Angels* at the National Gallery, London. Such gestures were studied and replicated in different media and now offer a stylistic key that helps us to recognize works

executed in his *bottega* – of course, alongside the compositions of faces and busts that follow the same logic of a repertoire intended to achieve excellence and be endlessly reproduced.

The constant reuse of details, after making them the subject of lengthy, painstaking study, reveals the difficulties that artists encountered in the second half of the fifteenth century when they represented the human body – a universe they were slowly and laboriously mastering in order to transpose it into paint with a naturalness that had been missing for centuries. The drawing was therefore a pivotal stage; it assured the appropriateness of the image. After transfer of the drawing, the stylistic key of the workshop, it was always the collaborators who completed it by following the master's instructions, by adding chiaroscuro to give tonal relief to the images and by going over the outlines of the figures and their drapes.

Both of these operations, which served to enhance the plastic and three-dimensional nature of the image, can be clearly seen with the help of infrared reflectography and are typical of Verrocchio's *bottega*. His passion for sculpture makes itself felt in painting through this very distinctive clarity of line and plastic relief. Only after the chiaroscuro and the graphics of the image were perfectly defined did the collaborators start the work of patiently applying the colour; and they did this by mixing pigments – which had been prepared earlier, in small glass jars or pottery bowls – with a yolk diluted in a solvent that made it more fluid (possibly the milky juice of figs or other specially chosen liquids).

This was the pictorial technique used in Florence when Leonardo joined Verrocchio's workshop: an executive and material process that produced the compact images typical of the artist's output. Pigment bound with yolk is very thick and does not allow special emulsions to be created using other pigments. This explains why a series of washes were applied that left the underlying layer partially visible, while also creating a material compactness and visible homogeneity. Contemporary treatises on painting recommended particular sequences of colour, which limited both the masters and the pupils in the practical execution of a work. When painting skin tones, for example, a natural green pigment, known as green earth, would be applied and then lightened by using the pigment mixed with red (cinnabar or vermillion) and by adding touches of lead white or lead yellow where it caught the light.

Such rigorous procedures make it easier to understand why it becomes so hard to identify the individual painters involved in the completion of a particular work of art. What is more, the sequence of these interventions is very often poorly understood by scholars. The collaborators were asked to apply the different grounds for the separate areas to be painted and not, as is often believed, to paint discrete figures, while the master intervened after that, refining the final surface with shading and more delicate details.

Now that the methodological process is clear, the documentary and material clues identifying Leonardo's earliest contributions alongside Verrocchio become more meaningful. The first painting in which Leonardo's hand was identified is the handsome panel of *The Baptism of Christ* [Plate 6], executed by Verrocchio for the church of San Salvi around 1470, when Leonardo was certainly active in his workshop and was on the verge of joining the confraternity of Saint Luke. Leonardo would have painted the angel on the left in this painting, according to an early sixteenth-century source (Albertini: 'in San Salvi an angel by Lionardo').[10] This fact was seized upon by Vasari, who then created the legend according to which Verrocchio, having seen the marvellous angel painted by his pupil, renounced painting in order to dedicate himself to sculpture. But the legend is completely unfounded, both because at that date Verrocchio had already completed major works of sculpture and because he continued to paint, flanked by his pupil Lorenzo di Credi, for the rest of his life – or at least until he moved to Venice, 14 years after this commission.

Nonetheless, both Albertini's and Vasari's attributions are confirmed beyond doubt by a stylistic analysis of the painting: the left-hand angel reveals formal traits and a physiognomy that are completely different from those of the angel on the right, and also of the other figures in the panel. The features are drawn in a much softer style, the edging line clearly evident in Verrocchio's figures is almost absent here, the tonal contrasts are softened, and the contrasts between shadow and light are almost non-existent; the face seems to be enveloped in an atmospheric mist that softens the details, leaving an overriding impression of gentleness. While the angel on the right has hair that is painted with lively brushstrokes of colour and the incisiveness of an engraving, the hair on Leonardo's angel resembles a cloud of golden reflections and the

wavy chestnut mass cascades onto his shoulders. Even the pupils are less charged with colour, giving the gaze an elusive sense of emotion rather than precise anatomical detail. But it is above all the contrasting depiction of the hair and its colour that confirms the impression that the two angels have been painted by different artists. To this strikingly different sensitivity to colour and light, one should add the presence of a prodigious manual skill in defining the daring foreshortening of the face, the curve of the nose, and the complex play of light between the brows, the line of the mouth and the chin.

This capacity to imagine and give such softness through paint can only be achieved by an artist with phenomenal manual and visual talent; but it also points to and illuminates the ambit of the research that would attract Leonardo throughout his life. In this painting we can say that, after years of apprenticeship, Leonardo superseded his master in the 'final' handling, if not of the entire image, then of some parts of it. Recent diagnostic tests have confirmed the intervention of a different hand, as suggested by the appearance of the painting. Verrocchio rose, in tempera painting, to a peak of excellence never before attained in Florence, but Leonardo's angel is finished in oil on a base of tempera, as is Christ's flesh and some parts of the landscape. What had happened?

We can put forward a number of hypotheses. As I already said, the mid-1460s brought to Florence, from Flanders, the first paintings that used a new technique of mixing the pigments: not with egg yolk and animal glues but with oil, whether linseed or walnut; and Leonardo had been carrying out detailed and exhaustive studies on these materials. 'Walnuts,' he wrote, 'are bound by a sort of thin skin that resembles the nature of the husk, if you do not remove it when you make oil, that husk will colour the oil, and when you put it to work the husk separates from the oil and floats to the surface of the painting, and this is what makes it change.'[11]

This new pictorial medium enabled effects to be achieved that were impossible with tempera, because oil has a different internal refraction and the pigment not only was enhanced, becoming less opaque and more brilliant, but could be more easily mixed on the palette in order to produce effects that gave greater depth on the panel. Tempera painting imposes a very rigid pictorial technique and conditions the final effect of the polychromy. Oil painting opened vast possibilities

that until then had not even been conceivable. The paintings from Flanders had a new depth of colour and timbres that were much higher. There are some reds and greens, and even a white, that reach an intensity unthinkable for tempera. Demonstrating a precocious curiosity and deep critical awareness, young Leonardo immediately grasped the potential of this new technique and was the first to try it out in his master's workshop, where he adapted it to putting the final touches on some figures already partially painted in tempera by his master (under the finishing layer of oil is the layer of tempera in which Verrocchio had started the painting).

From this moment on the boy became renowned for the diversity of the materials he was using and for his original style. The oil technique complemented the novelty of the pupil's style, above all his need to blend colours and shadows with greater softness. Leonardo appropriated the experiments with the *sfumato* technique that Verrocchio had developed to new levels in his drawings, thanks to his virtuoso use of red chalk and pencil smudged by hand; and he, Leonardo, now started to think of achieving the same effect with colours. Using very slight pressure to move the pencil across the paper, Verrocchio produced a transparent, misty shading, which he then emphasized by using brushes and his fingers to 'join' the pencil marks so that they formed a shadow. Besides, Leonardo's sincere appreciation for the delicate *sfumato* in Verrocchio's drawings is apparent from the fact that his early drawings are all but indistinguishable from those of his master thanks to his successful and unhesitating imitation of that *sfumato* without contrast.

Many critics still debate whether some female heads, like the drawing at the British Museum, are by Verrocchio or by Leonardo, confirming the extent to which Leonardo was indebted to his generous master. In these drawings, thanks to the possibility of shading chalk and watercolour using feathers, brushes, and even the finger, Verrocchio could achieve an effect of atmospheric softness that was impossible to reproduce on the panel with tempera because of its opacity and the need to use heavy brushstrokes filled with pigment. In the use of oil Leonardo glimpsed the possibility of achieving, in painting, the same light-filled softness that Verrocchio had obtained in his drawings. The discovery and use of this new technical possibility by the young pupil opened

an avenue of research that, from then on, would identify him as an independent artist and bring him in a very short space of time to the attention of the refined Florentine market.

6

EPIPHANY

For centuries it has been a tradition for Leonardo scholars to try to identify the artist's hand in other paintings produced by Verrocchio's workshop before *The Baptism of Christ*. The painting with the greatest number of 'clues' is a small panel of *Tobias and the Angel* [Plate 7]; it was painted towards the end of the 1460s, around the time when Leonardo joined the workshop as a boy. The image of *Tobias and the Angel* was very dear to Florentine bankers because it showed the successful journey made by Tobias to recover his father's money. These bankers, who had business branches dotted across Europe, often sent their own sons around the world and regarded this image as a good omen for the safety of these young travellers.

The composition reproduces the classic grouping used in Florence, which was also chosen by Pollaiolo, an artist in open competition with Verrocchio. The scene is not very successfully staged, owing to the sloping ground that makes the two figures of Tobias and the angel appear to slide rather than walk. This clumsiness is indicative of the efforts and difficulties related to the conquest of spatial congruity and encountered at the time in Florentine painting. These difficulties emerged above all from the attempt to produce a natural portrayal of several moving figures. The landscape is simplified, the sky clear save for the small, transparent clouds that float without moving, proof of the absence of

breeze. The figures are outlined through highly calligraphic lines that do nothing to define their rather ungainly anatomy.

The scene as a whole seems archaic, an expression of that simplification that Vasari, in his life of Verrocchio, would criticize as excessive 'hardness'.[12] But precisely for this reason it comes as something of a surprise to encounter two small details that conjure up the intervention of a young artist who painted differently, using an original manner, and who gracefully brought to life the dog and the fish that Tobias carries hanging from a wooden stick. The tradition that attributes these details to Leonardo is based on a decidedly weak argument: Verrocchio's inability to render in naturalistic detail any subject that did not interest him, whereas his young pupil would have announced in this very painting his profound curiosity for the animal world. This would not really have been enough to warrant the young and very inexperienced pupil's intervention in this painting. However, the two details and the singular style in which they are painted also reveal a technical specificity, since reflectography has shown that they were added at a very advanced stage in the painting's execution, over a landscape that had already been painted. The rapidly executed portrayal of the running dog, whose tufts of hair subside into uniform waves like those of a turbulent stream, has admirable freshness and undoubtedly raises the question of authorship. At all events, if this is truly Leonardo's first 'recognizable' contribution, it must date from the late 1460s, and therefore goes back well before the angel in the *Baptism*, where he demonstrates a maturity of execution that presupposes some years of technical practice.

Much more interesting is the case of the first painting that can be ascribed entirely to Leonardo, when he evidently started to paint independently, even if he was still part of Verrocchio's workshop. This painting is the *Annunciation* [Plate 8], a panel that is not easy to interpret – so much so that it was widely believed to be by Ghirlandaio and was only attributed to Leonardo after 1905, when some of Leonardo's drawings in Oxford were published, including a study of the angel's right arm [Plate 9].

On the one hand, the painting presents the characteristic softness and *sfumato* already found in the angel from the *Baptism*, thereby identifying a precise stylistic character, and on the other it shows the kind of ingenuity in the use of perspective that points to a young painter of

undoubted talent, but one who had not yet mastered perspective and spatial composition and was too unsure of his ability to construct a narrative told through images. For these reasons the painting can be dated to the early 1470s, when Leonardo was nearing the age of 20; and, for reasons linked to the corporation, it must postdate his joining the company of Saint Luke in 1472 – a date that converges with the stylistic findings and shows us the painter in the final stages of his training.

The painting renders a theme that was very common in Florence and central Italy. The kneeling angel, shown in profile in a small courtyard surrounded by a low stone wall, stretches out the right arm to salute Mary and to announce the birth of Jesus. Mary is a very young girl, intent on reading as she sits in front of the open door of a well-to-do mansion [*casa signorile*] whose door jambs and cornerstones with bosses [*pietra bugnata*] are typical of Florentine architecture of the period. The angel shows an almost perfect profile, while Mary is turned three quarters towards the viewer and looks in the direction of the angel without quite identifying its position, almost as if the girl was so surprised to find this presence in her flower garden that she could not pinpoint the winged messenger's precise location. Rather than through their eyes, their relationship is established through the counterpoint of their arms: the angel's right arm is outstretched, while Mary's left arm is drawn back in surprise, almost pushed by the former.

The scene is moved very close to the lower edge of the painting, towards the viewer, to leave room behind it for a beautiful aerial view of the landscape beyond the trees, a clear announcement of the landscapes with which the painter will be consumed later on. It is a transitional painting, in which everything is new but still tied to a recognizable practice. The landscape in the background is perfectly representative of this very early announcement of a new world in Italian painting – in the first instance the trees, whose profiles were so dear to the paintings of Verrocchio and Florentine artists: their clean, dark silhouettes were typical of the Tuscan countryside, especially the cypresses, the oaks and that symmetrically 'shaped' tree with pruned branches that had become so fashionable in Florence after Benozzo Gozzoli had introduced it into his orientalizing landscape of the *Journey of the Magi* in Palazzo Medici. In Leonardo's hands the tree is pruned so carefully that its precise

geometry makes it look more like fairground machinery, a land of coc-
caigne, than like a living plant.

Beyond the silhouetted trees, so familiar in Florence that almost
identical versions can be found in the backgrounds painted by Botticelli,
Ghirlandaio and Verrocchio himself, appears the vast, new and entirely
'Leonardesque' panorama, with two vanishing points that fade into
the mountains, which in turn almost blend into the sky. On the right,
an ancient seascape reveals a fortified city with towers and lighthouses
to guide the ships. On the left is a wild countryside crossed by a river
that winds far away towards the rocks and the misty sky – so different
from the clear Umbrian skies that marked the works of Perugino and
Raphael and persisted into the early years of the following century.
This landscape already contains the sense of completion found in an
entire painting, and it is perhaps the part to which Leonardo dedicated
most care because in the workshop where he accomplished his appren-
ticeship attention was focused on the definition of drapes and on the
poses of the limbs, while the landscape was simplified according a tradi-
tion that was by then centuries old.

The other extraordinary innovation of this painting is the strongly
androgynous figure of the Madonna, who looks more like an adolescent
boy than a Virgin. Her disconcerted expression is the most successful
part of the entire painting: there are no shadows to detract from the
regularity of those features and the scene seems to have been painted at
sunset, when the diffused light produces no contrast on the faces – as
Leonardo would later recommend in his [treatise] *Libro della pittura*.
There are no shadows on the angel's face either, but it is almost child-
like and its complexion is less luminous because the light, coming from
the top left, might have left the face in shadow were it not for the reflec-
tions of the white sleeves that throw highlights onto its cheeks. The
softness of the light is a very innovative element, as is the landscape
in the background. There are no overly sharp contrasts between light
and shade, everything is very serene and Mary's figure projects a faint
shadow over the threshold of the door, where the diffused light seeps
into the building and singles out a red cloth, an almost metaphysical
and disturbing presence.

The surprise of the annunciation is represented by Mary's raised
hand, an excellent example of the progress of studies on gesture that

is perfectly in keeping with the research undertaken by Verrocchio's workshop. The gesture has been studied in painstaking detail and the angle of each finger is well controlled, even if the pictorial technique and the colour seem less successful than the face. The other hand, stretched out onto a bookrest placed on a finely sculpted marble altar-piece, betrays uncertainty in the pose and is poorly joined to the arm and shoulder. The whole right arm seems to occupy the space awkwardly and lacks harmony, apart from having been lengthened in exaggeration. There is a complete lack of spatial control in the painting and this is its greatest weakness.

As many have noted, the perspective of the stone ashlar does not work well and the spatial sequence created by the marble altar, Mary's chair, the angel and the balustrade is rather incongruous. However, there was little alternative, given the boy's self-taught approach and the lack of perspective studies in a training workshop that specialized above all in sculpture. Normally an apprentice would enter the workshop around the age of six or seven years (Michelangelo certainly did so at the age of nine) and start to learn the foundations of perspective draw-ing. In Leonardo's case, talent meant that he was certainly encouraged to copy details, using an instinctive ability to draw from real life, but what is missing in his early works is the spatial organization that would have been learned through regular exercises in the workshop.

The spatial inconsistency in this painting would continue to make itself felt in the works that followed shortly afterwards. Young Leonardo's progress was erratic and his interest in painting was for the present focused on light, landscape and drapery, which began to acquire that monumental character that would mark all the master's subsequent paintings. The study of drapery in Verrocchio's workshop was a fundamental moment in an apprentice's training, as surviving studies by Leonardo and Lorenzo di Credi show. Verrocchio's other pupil, Lorenzo, who produced work of great quality, even if not at the level of Leonardo's excellence, clearly shows that Verrocchio's teaching method, using plaster-soaked fabrics draped over clay models, allowed the apprentices to make enormous progress there by comparison to other workshops.

The definition of the drapery was exceptionally important because the solemnity of the figure relied largely on the style of the clothes

worn, and these became a separate field of study [Plate 10]. It is diffi-
cult to imagine how this could have been otherwise in a city that owed
its centuries-old wealth to the production and international trade of
woollen cloth. In the *Annunciation* in the Uffizi, the Virgin's drapery is
displayed in a superfluous manner; it is spread even over the back of a
chair that we do not see – yet we sense that it is incongruous because
of its excessive width behind the Virgin's shoulders. It was this need
for solemnity that prompted the young artist to exaggerate the size of
the Virgin's enormous blue mantle (whose folds reveal a golden lining)
to the point where the girl would have found it very difficult to walk.
Even the red fabric that can be glimpsed inside the doorway may point
to a family of cloth merchants as the patrons of the painting. Lengths
of cloth, the foundation of Florence's wealth, were displayed in heaps
on the street or hung from buildings on 24 June, the patron saint's day,
alongside displays of gold and silverware, and in this case they embel-
lish the scene of the *Annunciation*. At the same time, the red fabric
and its brilliant tone add depth to the space behind the Virgin, on the
threshold of the house, which would otherwise have been rather uncer-
tain and awkward.

Another painting, a little later than the *Annunciation* and similarly
executed in Verrocchio's workshop, where Leonardo was acquiring
his own recognizable style, is the *Madonna of the Carnation* [Plate 11],
now in the Alte Pinakothek, Munich. This is a small panel painting
that would have been destined for private devotional use by a rich
merchant. The theme of the Virgin and child was the most recurrent
one in productions around the 1470s and its iconography was rigidly
fixed by numerous early models. Even in the fourteenth century, many
paintings show a seated Mary holding the child while offering him a
flower, as in Beato Angelico's *Pala di San Domenico* at Fiesole [Plate
12]. It was difficult for Leonardo to avoid the rigid iconography of the
time; yet the artist, who had now passed his twentieth birthday, had to
impose his own recognizable personality and style, which would set him
apart from other painters in Florence – the best known being Botticelli,
Ghirlandaio, Botticini, Filippo Lippi and Perugino.

Leonardo made a carefully pondered choice, which was to add to
the innovations that Flemish painting had introduced to Florence,
enriching them with that entirely Florentine capacity for realistically

portraying the human figure and its emotions. Mary is seated in a closed and dark environment, which allows for the outline of her figure to be highlighted, while behind her the scene opens, with a striking contrast of light, onto the countryside and, in the distance, a chain of mountains that had never been painted with such realism before. The figures of Mary and the child are, once again, pressed into the foreground and linked by a bond of affection that was new to the genre. Mary looks down, at the flower she is handing to the child, and her composure seems just a little animated by a spark of pleasure in the child's effort to grasp the flower. Contrary to the rigid earlier images that were still linked to a medieval solemnity, the child's gesture is entirely appropriate to a young infant and must have been observed by Leonardo as he watched mothers playing with their babies.

By observing real life, Leonardo left behind his predecessors' examples and gave a foretaste of a method that he would develop with enormous success in the years to come. With open, ungainly arms, the child leans towards the flower and tries to catch hold of it, before – we might imagine – squashing it and trying to put it into his mouth. This completely natural gesture was innovative in sacred paintings because, unlike in the scene depicted in the altarpiece by Beato Angelico, which is very close in time, here the child is not a miniature adult man who fetchingly mimes the act of grasping the flower but a real infant, still uncoordinated in his movements, who tries to accomplish what is for him a difficult task. We are looking at one of the first 'real-life' paintings of the Renaissance and at one of Leonardo's first successful attempts to capture and reproduce the natural world.

The chubby infant is shown in all his ungainliness as he raises his left leg in order to thrust his right arm towards the flower, while also pressing his right heel into the cushion that yields, creating deep folds. Only the infant's face shows more composure than a real baby would if engaged in such an arduous task. Everything else is in perfect accord with the action. Even his physical form matches the standards recommended by Florentine pedagogues: 'nourish the male infant well and dress him as you can, tend to him justly and honestly ... dress the female infant well, but she is not concerned about how she is fed, provided she is alive. Do not keep her too fat'.[13]

By creating a slightly forced spatial view (we are still at a rela-

tively immature phase of perspective study), the artist includes in the right-hand foreground a transparent glass vase filled with flowers that somewhat incongruously hides Mary's elbow. The transparency of the glass and the highlights on the flowers pay homage to the glass vases depicted in Flemish paintings at the feet of angels and Madonnas; these vases almost surpassed the figures themselves as a focus of attention. The vases in Hugo van der Goes' *Portinari triptych* [1473–8], which arrived in Florence a little later [1483], for example, steal the limelight from the child who is lying behind them on the straw.

The virtuoso portrayal of the transparent glass is repeated, to even greater effect, in the gathered veil that falls over Mary's breast and in the large jasper brooch fastening it, in which the painter shows the brilliant reflection of a ray of light from the window. To give even more drama to the 'light source' placed just above and to the left of the Madonna, as was customary in painting, Leonardo separates the Madonna from the landscape behind her by using that dark wall with twin double-arched windows that rested on elegantly slender marble columns. This allows the light to focus on the figures, creating a composition without distractions.

It was finally possible for Leonardo to construct the image through the use of light, thanks to the use of oil paints, with which he experimented freely in this painting. For instance, he increased the quantity of oil in the skin tones of the Virgin's face in order to refine it gradually, using a series of *velature*. The effects of light on bodily flesh would have been impossible to create with tempera, since the density of the medium produced a dry and compact quality of colour, which could be combined only in homogeneous blocks. With oil paint, on the contrary, the colour could be made to vary imperceptibly, producing an almost endless series of tonal shades. Leonardo was able to use these imperceptible gradations to reproduce the slightest shimmer of light, and above all to soften transitions in a way that tempera would never have allowed.

Some of the technical features of this work are extraordinarily important to our understanding of the evolution of Leonardo's painting. The shaded area of Mary's face, including her neck, suffers from excessive 'craquelure', which is very obvious when seen at close quarters. These exaggerated cracks, which are caused by the oil as it dries

(just like the cracks that appear on the soil after prolonged drought), are particularly evident due to the fact that too much oil was used to emulsify the pigment. Leonardo was experimenting with different ratios of oil and dissolved pigment, since he could not rely, in Florence, on a Flemish 'school' that was already skilled in the use of this medium. In the shaded part of Mary's face, the possibility of softening the slightly darker colour produced by the light prompted him to add too much oil to the mixture, and the polymerization of the oil resulted in the appearance of those highly visible cracks in the layers of paint.

The quality of the oil used would be a constant concern for Leonardo, and in the Codex Atlanticus he made painstaking observations on its preparation, aware as he was that even the husk of the seed could interfere with the purity of the final tone. But at the time of this painting his observations were still too elementary and he lacked the necessary experience. The mixture used to paint the elegant veil that fills the central part of the painting was much more successful, and its transparency allows the viewer to glimpse the underlying red of Maria's blouse in an extremely convincing manner. The same is true of the veil wound around her elaborate hairstyle: he blends the shape of her head into the background shadow by using small flashes of light.

This was a new concept in painting: objects, fabrics and bodies were no longer shown as they were in themselves, constrained by a linear drawing in an abstract catalogue, but as they were experienced, and their perception was filtered by the air and the conditions of the light. An enormous step had been taken towards realistic representation. Leonardo followed an identical process in the child's body: the outline drawing vanishes, making way for the minute tonal variations produced by the infant's soft flesh. The light strikes the baby's back, but the light reflected by his left leg and by the yellow fold of his mother's mantle lightens the torso and stomach sufficiently to show the liveliness of the flesh even in the shaded parts. The extremely delicate features of the young Madonna are also defined by the light and not by the drawing; the light smoothes the forms without ever being constrained by distinct shadows and hard profiles, as was often the case in paintings by Verrocchio and Leonardo's other contemporaries – all of whom remained captive to the drawing, which defined the physiognomy with clarity.

The only concession to the old way of describing the body with cal-
ligraphic precision is in the hand that offers the flower to the child: a
studied hand of such elegance that the gesture becomes almost artifi-
cial. The little finger is forcibly separated from the others, as is the case
in Verrocchio's statues, paintings and drawings, and it is possible that
the older artist helped the young maestro to define this detail of the
painting.

Embedded in the dramatic shadow of the wall behind, the image
is extended almost with the same chromatic and tonal values into
the countryside beyond the windows. The landscape that appears
beyond the dark caesura of the loggia marks a striking new attain-
ment in Leonardo's research. While the landscape in the *Annunciation*
still sought a compromise with contemporary paintings through the
abstract, dark outlines of the cypresses and oaks before losing itself in
the atmospheric description of the gorges, in this painting the landscape
reveals a new world: no longer the countryside of central Italy, stereo-
typed through the simplification of its elements and reconstructed by
bringing together various objects as if they were only a stone's throw
away, on a clear April day, but rather a truly natural view, almost
autumnal in taste, with a prevalence of warm plant tones dominated by
the cold colours of the snow-covered rocks. In this landscape Leonardo
seems to attain more freedom of invention, as if he were less con-
strained by the workshop tradition that obliged him, for example, to use
that 'elegant' but dated gesture of Mary's hand offering the flower. The
natural landscape, created not through the drawing but through rapid
movements of the brush point, is an invention that was his very own,
because it is not described but solely perceived. There are no silhou-
etted trees, but woods and green reflections. There are no mountains
hanging like backcloths against the sky, but a disaggregation of rocks
and colours that soften up from grey to white and then fade into the
milky sky, empty of colour and place.

The place was in his mind, where he endlessly reconstructed the
effects of his natural observations, trying to define an image that no
longer described a place but gave the impression of being inside it.
The artist's lack of interest in the codified description of landscape is
such that he not only reproduced a non-existent place but also matched
the background colours to the Virgin's clothing in order to create a

perceptive 'echo', linking what was on this side of the dark barrier with what was outside it. The warm base of the countryside is a striking reference to the yellow lining of the mantle gathered around Mary's legs, and the pale bluish grey ring of mountains recalls the greyish blue veil over her blouse. In this way there are not only tonal but also chromatic harmonies within the painting, and the landscape allows the viewer to enjoy the painting without interruption.

The innovations of this painting were such that the young artist's reputation in the city was immediately assured and his work began to acquire an increasingly personal character, as is shown by another painting that can be dated between 1472 and 1475: the *Benois Madonna* [Plate 13]. Indeed many scholars date this painting before the *Madonna of the Carnation*, but owing to its radical composition it should, in my opinion, be placed after it. Like the *Madonna of the Carnation*, this painting was also produced for wealthy patrons and intended for private devotion, and it pushes the innovative boundaries of the earlier painting still further forward, definitively settling Leonardo's account with the legacy of his master, Verrocchio.

Everything that was said about the spontaneity of the infant's gestures in the previous painting is also true of this small panel, where, with touching concentration, the infant Jesus is intent on grabbing the blossom that his mother offers him. Using his left hand, the child tries to keep his mother's hand still and to hold on to it as he grasps the little flowers with his right. Here too the left leg presses strongly against the right, trying to attain the balance needed for the child to reach up. But – unlike in the previous painting, where Mary is an unmoving participant with a composure that is traditional but also artificial – here the young woman takes part in the game, smiling and forging a strong emotional bond with her son, underlined – which is also a new departure – by the identical chromatic treatment of their skin; it is almost as if they were a single body with a single smile. The Virgin's other hand, which holds a sprig – perhaps the one from which she has just picked the flowers – has a completely natural pose, a gesture that overrides, once and for all, the studies accomplished in Verrocchio's workshop on the elegant (but arid) gestures in sacred paintings.

The much more foreshortened figure of Mary, her slightly tilted head, and the way her body leans a little to refrain the impetuous

movements of the child, a real imp who bounces energetically, are the miraculous achievements of an artist who undoubtedly studied the model in real life, as some of his rapid sketches demonstrate – and they capture the scene with the expressiveness of a snapshot [Plate 14]. The concision and speed of these sketches indicate that Leonardo must have spied on peasant girls outside the house, as he often did, while they played with their children, distracted them with small twigs but also watched that they did not catch these twigs, as the movement of Mary's left hand seems to suggest.

For Leonardo, painting this domestic scene was like opening a window in a room that had been closed for centuries and letting it fill with the air, scents and sounds of real life. Instead of the symbolic representation of maternity, he portrayed the affectionate playfulness of a mother and her child. Here too the main instrument used to breathe life-giving air into the painting is the light. There are no chromatic distractions, since the palette centres on greys and browns that range from the golden yellow of the sleeve to the blue of mantle and blouse, then it returns to the suffused gold of both the mother's and her son's hair. The colours are censored to allow light to play a leading role.

As evidence of the fact that the painting closely follows its predecessor, we can point to a series of conclusions and clues that were only glossed over in the former. Leonardo was obsessed with his line of research and would not allow distractions. In the first place, thanks to a more mature technique and better control of the oily emulsion, he prevented excessive craquelure. He found a way – one that suited his expressive requirements – not only to make linseed oil but also to mix it with the pigments. In the brooch, which is identical to the one in the former painting, he could now achieve a perfect reflection of the light from the open window facing the Virgin – a Flemish trick that the young artist, still not much over the age of 20, could not resist including. Another important innovation was the increased contrast between light and shade; throwing some areas of the figures into dense shadow makes the view more realistic, even if it partly hides the image. It is as if the shadow started to grow denser, stealing space from the light; and this is a characteristic that Leonardo's painting would follow with increasing decisiveness up to its peak in *The Virgin of the Rocks*.

The first impression made by this painting is that there is much

more distance between it and the Florentine Madonnas than one perceives when looking at the *Madonna of the Carnation*, and this way of concentrating the shadow also forces the elimination of the landscape, leaving space in the top right-hand corner for a single open window – a mullion window again, but without the slender column. Only the sky is visible is through the window, so that nothing disturbs the intimacy of the scene into which we have been almost secretly introduced: taking a miraculous break from her standard portrayal, Mary abandons her sacred composure and dedicates herself to her son's happiness, unaware of the painter's gaze.

The air, breath and movement that, according to Vasari, Leonardo brought into painting are all here, in this minute panel painting that measures just 49.5 × 31 cm.

7

BURNING YOUTH

In his early twenties the young man from Vinci was still living in Verrocchio's house, with Lorenzo di Credi and the other apprentices. Within a very short space of time Leonardo's prodigious talent had attracted the attention of the city and he became a leading figure on the artistic scene, which included some of the greatest names of the century. Most of them produced Madonnas for the private devotion of rich merchants. The fact that Leonardo completed two Madonnas should in fact be seen as an open challenge to other masters of this most fashionable genre. With a remarkable sense of professional competition, Leonardo identified the topic that was most commonly requested from painters and had the courage to radically transform and renew it, demonstrating his artistic superiority through straightforward confrontation. He could not have chosen a better moment to launch himself professionally, and closeness to his newly acquired family seems to have lessened even the suffering caused by the family he never had. It no longer mattered that his father Piero hardly showed him any affection and refused to acknowledge his legitimacy although he still had no legitimate heirs.

Florence was living its years of greatest splendour under the rule of Lorenzo the Magnificent. It had been a severe city, but during this period Lorenzo was turning it into an elegant and joyful showcase for

the Italian humanist revolution. The need to control the accumulated wealth of private families tended to delay the onset of maturity and youths did not reach adulthood and legal emancipation until they were 25; as for marriage, well, there was still time: males from elite households often married when they were around 32 years old.

This was a city where public power lay entirely in male hands and the percentage of orphan girls who died was so much higher than that of male infants that there are grounds for lending an ear to the suspicions raised by many modern scholars regarding the widespread practice of female infanticide. Moreover, women were allowed very limited rights before marriage – and even afterwards. Under the law, the preservation of capital called for a strict imposition of male rights. The clearest sign of the legal marginalization of women was the custom that, if widowed, a woman would return to her father's house, leaving her children with her husband's family. Florence was not an easy city for all of its citizens: it was a free city only insofar as it was rich, but the preservation of that wealth called for sacrifices and a rigorous discipline.

This atmosphere appears to have given an advantage to Leonardo, who had little interest in women even at an age when, for many men, they are the sole reason for living. Soon after he first came to this festive city from the countryside, Leonardo attended some of the most fabulous ceremonies staged in Italy during the period, such as the two public 'jousts' organized by the Medici. The first, on 12 February 1469, was held in Piazza Santa Croce, with a reluctant Lorenzo as the star performer. Lorenzo's garments were embroidered with so many pearls that he could barely move and a chronicler with a particularly keen business eye gave a detailed valuation of the cost of these and other jewels on his person; there were 2,000 ducats' worth of diamonds on his cap alone. In the eyes of a boy newly arrived from the countryside, this was a dreamlike vision.

The second memorable joust in which Leonardo himself might have participated – albeit indirectly, by drawing or designing some of the Medici banners – was held on 29 January 1475. On this occasion the lead role was taken by Lorenzo's brother, Giuliano (1453–78), a man widely known for his extraordinarily good looks. The joust was held as part of the festivities for an alliance with Venice, and the captains of the Parte Guelfa were responsible for the organization. However, in this

subtle game of self-celebration, homage was being paid above all to the power of the ruling house. Giuliano entered an enclosure that had been set up at Santa Croce; he was preceded by nine trumpeters wearing rich livery blazoned with his coat of arms and by a page bearing his standard. Another two horsemen followed who were due to joust at his side, together with a retinue of twelve young gentlemen, three pipers and four pages, including Lorenzo's young son, Piero (1472–1503), who made his first public appearance at the age of three.

Giuliano appeared wearing on his head a garland made of silk and feathers and held in place by a precious *balascio* gem: a ruby-coloured spinel that was highly sought after at the time. When he arrived in the piazza, the effect was astounding. His trim body did not offer sufficient space to display the wealth of the Medici, and therefore his grey horse Orso, which was at least as famous as its master, especially after this appearance, was decked out with 'two huge dragon wings, all embroidered with pearls and silver, and in the place of the eyes on those wings were 24 *brochette* with gems and pearls of great value'. But Giuliano's true, incomparable refinement was shown through the indifference with which, during the joust, he lost the pearls that had been on his shield. These had been embroidered to form a Medusa head, which clearly petrified the Florentines without any magic or charms but simply through its dazzling wealth: 'the head of Medusa filled the entire background of the shield. There were pearls weighing about ten ounces, and he jousted with it and lost all of them.'[14]

Feast days in a republic of bankers offered the opportunity to bolster the communal spirit and were public occasions because, at least in appearance, the republic had no princely court. As tools of propaganda, these Medici ceremonies were focused entirely on the population and created occasions that did not exist in any other parts of the world. This was also true of festivities whose tradition predated the Medici: the feast of Epiphany, for example, with its splendid procession of the Magi, was organized every year by a lay confraternity based at San Marco, but this event, too, became an occasion to celebrate and show off the family's wealth. Following in the footsteps of his father and grandfather, Lorenzo rose to the highest office in the confraternity and the brethren of the Magi accompanied the corpse at his funeral in 1492.

As the annual procession was leaving San Marco, the precious gems

and fabulously rich fabrics worn by the kings with their retinues of servants completely eclipsed the religious significance of the Epiphany and the procession became instead a sanctification of wealth and luxury. The Medici's fascination with this scene was such that Cosimo asked Benozzo Gozzoli to paint the *Journey of the Magi* in the chapel of the new palace built by Michelozzo; and naturally Lorenzo, the appointed heir of the dynasty, appeared among the kings in the fresco.

Lorenzo took the family's reputation for magnificence very seriously and, while his grandfather, Cosimo the Elder, had been very prudent when organizing public festivities and had emphasized the fact that they were held to honour the city and not the family, his grandson could barely curb this desire for self-celebration. The well-oiled system that Cosimo had established in order to keep the city under firm control – namely through the selection of those who were put forward for elective office – seemed all too stable. However, Lorenzo failed to understand that this constant ostentation of power and wealth, which delighted and enslaved the people, fuelled the jealousies of the great rival families, which had competing if not better claims not only to the responsibilities of government but also to the organization of public festivities.

Among the families most opposed to the extraordinary power of Lorenzo and his family circle was that of the Pazzi, who for centuries had been charged with the organization of another ceremony much loved by the Florentines. This was known as the feast of the 'explosion of the cart' [*scoppio del carro*]. A Pazzi ancestor who had been on crusade and present at the conquest of Jerusalem had shown such courage by being the first to scale the walls of the city in 1099 that Godfrey of Bouillon had presented him with some small stones from the Holy Sepulchre. These had been housed ever since in the Florentine palace of the Pazzi family; and every year, at Easter, they were used to strike the spark that lit the flame of the paschal candle in the cathedral. To celebrate the occasion, the flame was carried around the city on a cart, followed by a long procession, up to the church door.

Then there was the feast of Corpus Domini, which was also a great opportunity for self-celebration because the long procession offered a chance for the city's elite to hang its finest tapestries and embroideries from windows along the route. The feast day of the city's patron saint, Saint John or San Giovanni, was another, particularly because, in

Florence as in many other places, this saint inherited the pagan celebrations for the summer solstice. During these celebrations, which lasted for three days, the city literally went into a frenzy and every male aged 15 and over had to carry to the Baptistery a candle or a cloth banner, all of which were subsequently sold. On San Giovanni's day the procession wound around the old city walls and, according to the chroniclers, it might well have been a pagan celebration, judging by the magnificence not only of the garments worn by the clergy and of the confraternities in the extremely long procession that carried the relics around the city but also of the precious goods displayed by artisans in front of their shops and by rich families under their loggias or at the entrance to their palaces. It was almost as if the procession intended to invoke the patron saint's blessing on the prosperity that had accumulated within the city walls. This was the true attraction of the feast: the profusion of wealth, ostentatiously displayed by citizens from all walks of life:

> it is worth seeing the paving stones of some streets almost entirely covered by carpets, the walls adorned by hangings; on one side are expanses of silk woven with gold and silver threads, on the other ornaments embellished with gems and silver and gold vessels in a thousand different shapes. Further on are gold spheres and precious stones mounted on gold chains or massive silver ingots. Elsewhere there are bundles of fabrics in different colours and, around the vegetable market known as the Old Market, you will find precious garments for men and women lain on the ground or hanging from ropes.[15]

The tradition of public festivities celebrating the city's prosperity clashed and often competed with the Medici's organization of celebrations – so much so that Lorenzo's distinct coolness towards traditional urban feasts, which appeared to resist the Medici's monopoly on taste and wealth, did not escape his most observant friends. Some of them reprimanded him for his scant interest in creating ephemeral architecture to celebrate the patron saint. In 1472 Luigi Pulci sent Lorenzo a letter that has all the hallmarks of a genuine reproach:

> and I wondered somewhat at your attitude when you so categorically declined to provide for it [the feast of San Giovanni], given that you

are a citizen and an affectionate supporter of the *patria*, of which the
Baptist is also the protector and we must pay him due honour. And if
through some mishap we happened not to be on time, you'd see how
he could manage without us.[16]

But Lorenzo did not listen to reason and the general political situ-
ation was very favourable to the city, which he was by then regarding
as his own. But other leading families harboured discontent, as they
understood only too well how this continuous self-representation
masked a substantial drop in public participation in government, while
it curried favour among the least affluent classes – only to make them
even weaker and more obedient.

Exactly at the time of Lorenzo's rise to power, Florence found
itself playing a crucial role on the chessboard of Italian politics, where
external threats were urging strong internal cohesion. In 1470, when
Leonardo was just 18, the Ottoman ruler Mahomet II conquered from
the Venetians the island of Euboea [formerly known as Negroponte in
the modern era] and within the space of a few months drew dangerously
close to the coast of Italy, becoming a new and terrifying threat to the
litigious states of the peninsula. The kingdom of Naples, which, of all
European states, was the one most exposed to the Ottoman attacks,
promoted a Holy League against the infidels and asked Venice, Milan
and Florence to join in order to convince the pope also to take part.
This alliance was a major turning point for Florence and for the Medici
because it offered security against Venetian meddling and also against
the papacy, which was always ready to expand its states at the expense
of what was essentially the last republic in Italy (except of course for
Venice, which had established bases and possessions throughout the
Mediterranean).

In short, Florence, which had close relations with Milan and Naples
thanks in large part to the Medici, enjoyed a relative stability and
Lorenzo was able to dismiss any concerns prompted by the jealousies
of other leading families. The city was living through a golden age.
The situation seemed peaceful enough and the 15,000 ducats requested
by the king of Naples to arm the League against the Turks were more
or less equivalent to the jewels worn by Giuliano and his horse at the
legendary joust of Santa Croce.

Lorenzo also took decisive action to quash the occasional rebellion of a subject city, as he did in Volterra, which had tried to rebel, taking with it the valuable alum quarries. Retribution was entrusted to the duke of Urbino, Federico da Montefeltro, who was richly compensated for putting the city to the sack. Any internal opposition to the massacre was skilfully silenced, and blame was laid squarely on the duke, who had an impetuous and greedy nature. The Medici family's tradition of patronage was restored through the establishment of a sort of artistic academy in the gardens of San Marco, a green rectangle in the city centre where Lorenzo displayed the classical statues found by his agents all over Italy and where he brought together poets, philosophers and, above all, artists.

There could not have been a better place for a young artist to enjoy life and Leonardo had no shortage of distractions, in his own way. The picture of unbridled hedonism painted by Florentine chroniclers from the 1470s helps us to understand the freedom with which the young artist, free from any family restraint, launched himself into that frenetic lifestyle, with very risky consequences for his future.

8

THE ACCUSATION

Leonardo's artistic output between 1472 and 1476 is very scant and no works have survived that can be ascribed to him with any certainty, apart from the few that have been examined to date. In those years the young man appears to have dedicated himself to his studies, to his experiments, and to... bad company.

On the morning of 9 April 1476, an anonymous denunciation was deposited in the box used for this purpose by the Office of the Night (its full title was Ufficiali di notte e Conservatori del onestà dei monasteri) accusing Leonardo and some other young men from good families of sexually abusing a goldsmith's apprentice who was only 17 years old:

> I notify to you, the Night Officers, that it is true that Jacopo Saltarelli, blood brother of Giovanni Saltarelli, lives with the goldsmith in Vacchereccia opposite the basement shop; he dresses in black and is aged 17 or thereabouts; the said Jacopo is involved in many miserable matters and allows those who ask him to satisfy themselves in similar sinful acts, and in this way he has committed many things, namely served several dozen individuals, whose identities I know, and in the present letter I will mention some of them. Bartholomeo di Pasquino goldsmith, who lives in Vacchereccia, Lionardo di ser Piero da Vinci, who lives with Andrea del Verrocchio, Baccino doublet maker, who

lives near Orto San Michele ... Lionardo Tornabuoni known as Il
Teri, dressed in black. These men have committed sodomy with the
said Jacopo, and I swear to that.[17]

The denunciation was analysed by the officers, but they only issued a
warning on the following 7 June. The social position of the accused, in
particular young Tornabuoni and Leonardo, the son – albeit illegitimate
– of a notary working for the Signoria, made it advisable for the censors
to limit themselves to a response that would bring no particular conse-
quences. While male homosexuality was quite widespread and tolerated
in the city, its brazen display certainly was not.

The gravity of the facts appears to be linked to the age of the boy
abused by the men named in the accusation; and from the latter emerges
also a certain ostentatious exhibitionism, namely in the 'black' clothing
deliberately highlighted by the anonymous accuser. Black dress was a
sign of elegance in Italian medieval and Renaissance fashion because it
was particularly costly to produce black cloth; earlier sumptuary laws
had even banned the wearing of black cloth, reserving it for the highest
ranking members of society. By dressing in black, the boy who was the
focus of this homosexual group was clearly displaying an affected and
inappropriate elegance, like young Tornabuoni, although the latter
would have been allowed greater liberty on account of his social status.
We know that Leonardo, too, drew attention in public through his
elegant dress no less than through his handsome looks, even if he pre-
ferred colours to black cloth – and certainly that 'pink, knee-length
gown' known as a *pitocco*, in which he was seen crossing the city.

The document containing this detailed accusation of sodomy high-
lights the existence of a semi-clandestine but recurrent practice that
involved a network of adults who repeatedly abused a young boy. The
boy was certainly consenting, but too young to assume sole responsi-
bility for such goings on. The story is neither new nor original: men
who shared so-called 'deviant' sexual orientations organized themselves
and exchanged information in order to minimize the risk of discovery.
In this case, they were artisans acting within their own social circle,
protected by the solidarity of their class and by their common inclina-
tion. Young Jacopo was an apprentice in a goldsmith's workshop, and
the first man named in the accusation was a goldsmith living in the

same street, who had no doubt been able to ascertain whether the boy was willing. The next name is that of another tradesman, a doublet maker or tailor who served the wealthy merchant class; and then there is Leonardo, who in many ways was also linked to this environment, given that he was living in the house of Verrocchio, another artisan. Florentine society was rigidly structured into familial and corporative clans (and all were unquestionably out of bounds to women).

The world Leonardo lived in was a strictly male one, and his closest relations were with Verrocchio, Lorenzo di Credi and, in this period, perhaps Botticini, another artist in the workshop. The extremely close ties that would unite Verrocchio throughout his life to his pupil Lorenzo di Credi, both of whom were devoted to art with a dedication that excluded marriage, suggest that in Leonardo's new adoptive and professional family there might have been, if not complicity, certainly tolerance for homoerotic relations. Moreover, this tolerance continued to pervade artistic circles until at least the middle of the following century. Here is not the place to explore further this supposition of homoerotic relations or cover-up that stemmed from inside Verrocchio's workshop, but the scarce documents that have survived attest to the fact that, already recognized for his outstanding talent as a painter at the age of 25, Leonardo was not particularly productive, lived in his master's house, and frequented a circle of homosexuals who sexually abused a youthful 17-year-old male prostitute.

The light, or perhaps the shadow, that this denunciation throws on the artist's young adulthood is not an element to dismiss as prurient curiosity or as an insignificant invasion into his private life, because neither Leonardo's creative life nor his art can be fully understood without taking his sexual inclination and this predilection for very young boys into account. His style was already marked at this stage by his fascination for adolescent ambiguity, for those indefinite forms, neither too masculine nor too feminine, of adolescents of both sexes, which are also transposed to their emotional attitudes, the real fulcrum of his poetics. An exploration of Leonardo's sexuality for the purpose of gaining a better understanding of his artistic taste is a very insidious undertaking, given the lack of documents available, but one extremely important step in this direction was taken a century ago, by none other than the father of psychoanalysis, Sigmund Freud, in a study that remains

memorable for its rigour and accuracy. A fresh look at that study and at Freud's brilliant intuitions is facilitated today by the new documents on Leonardo's life that have come to light.

9

THE KITE AND THE VULTURE

Freud's study of Leonardo's sexuality starts with the memory of a dream that Leonardo recorded in the Codex Atlanticus: 'To write so clearly of the kite would seem to be my destiny, because one of the earliest memories I recall is that, while in the cradle, a kite flew to me and opened my mouth with its tail and struck me many times with its tail inside the lips.'[18] Leonardo recorded this memory long after the events mentioned in it and Sigmund Freud interpreted it as a homosexual fantasy, in particular a fantasy of oral sex, a reading that he supported by appeal to the strong ancient symbolism that, in Latin countries, associates the male member with birds; and indeed in Italian the word 'bird' [*uccello*] is the most commonly used slang term for 'cock'. The analysis also relies on a graphic slip in an anatomical drawing of copulation made by Leonardo in which the man's foot is not in the right position – a striking omission for such an acute observer.

From these details Freud identified a clear homosexual tendency in the artist; but, being himself a victim of his times, he presented constant excuses for having examined so vile a matter, which he feared might despoil the image of a man who was perhaps the most beloved western genius of modern times; and he came to rather dubious conclusions regarding the way these inclinations were effectively manifested. According to Freud, Leonardo sublimated his homosexual inclination

and renounced any 'action', using the inclination instead as the driving force of his creativity. In adolescence his libido translated into an impulse for knowledge, investing nature itself and therefore his painting with its erotic charge. Freud went even further by relating the dream, or fantasy of oral coitus, to Leonardo's love of his mother, because in the German translation that Freud used the word 'kite' had been translated as 'vulture', and this bird was seen by the Egyptians as a symbol of maternity. Freud put considerable effort into showing that Leonardo was aware of the 'mother–vulture' symbolism and that his dream therefore invoked a homosexual drive and merged it into his desire for maternal love.

The translator's mistake led Freud to draw even more ambiguous conclusions by interpreting the shape of one of the artist's greatest masterpieces (*Saint Anne*, in the Louvre) as the outline of a vulture, a reference used by the artist to evoke his maternal desire. (In order to substantiate this hypothesis, Freud was obliged to bring the date of the painting forward, before the *Gioconda*, a chronology that is now decisively rejected by the documentary evidence.) In the correct interpretation of Leonardo's 'dream', this association between mother and vulture has no place, as Freud himself realized, to his great disappointment, when he discovered his misunderstanding. If Freud had been able to read the exact name of the bird, without resorting to ancient Egyptian symbolisms, which were perhaps unknown to Leonardo himself, Freud would have found traces in the Codex Atlanticus of a much more worrying association: that between the kite and the father, Ser Piero, who was by no means a positive model for the artist.

By appropriating an ancient symbolic tradition summarized in a book called *Fior di virtù*, Leonardo noted that the kite was the symbol of paternal egoism in that the bird does not tolerate the happiness of its offspring and, when it see them thrive, it pecks at them cruelly and makes them suffer. 'Of kite it is said that, when it sees its offspring grow too fat in the nest, it pecks at their sides and keeps them without food.'[19] In the light of this passage, Freud's intuitions regarding the homosexual fantasy seem more fitting when directed at Leonardo's relationship with his father, which was undoubtedly very difficult, as is confirmed by the almost complete absence of documentation on this relationship in the huge mass of writing and daily notes left by Leonardo. The fact that

Ser Piero paid no attention to his illegitimate son provoked an unre-
quited desire for love and attention that might have underlain the boy's
homosexual orientation. Indeed, one of the most accredited interpreta-
tions relates homosexuality to the father's distance and hostility, which
prevents the son from identifying with a paternal model and prompts
him towards the female model, one that offers protection and perhaps
too much love, as the elderly grandmother Lucia might have given to
the child entrusted to her care.

What is worth underlining here is that, unlike in Freud's hypothesis,
the clues left by Leonardo point to a homosexuality that was transposed
into real life and proved satisfying. Leonardo was a man of courage
not only in his scientific observations but also in his way of life, and
among the great artists of the Renaissance he seems to have had the
most mature and open relationship with his own sexuality, express-
ing it without too many problems. He studied it as a scientist and as
an anthropologist, as is borne out by his drawings and by the notes in
the codices, written in ironic, idiomatic language, as was the custom of
the time, without too much false modesty: 'The man desires to know
whether the woman will concede to his lust, and understanding that she
will and that she desires the man, he asks her and enacts his desire, but
he cannot know this without confessing, and by confessing he fucks.'[20]
This ease enabled him to talk about sex with the same detachment that
he shows towards all natural phenomena, often with an ironic compla-
cency about the desire that moves the world, which he displays in some
of his witticisms:

> A woman was washing clothes and the cold had made her feet very red.
> A priest who was passing by asked with admiration where such red-
> ness came from. The woman immediately answered that it happened
> because she was on fire below. Then the priest put his hand on the
> member that made him more of a priest than a nun and, approaching
> the woman, he asked her, in gentle and submissive tones, whether she
> would be kind enough to bring a little light to that candle.[21]

Unlike many other artists who were tormented by their homosexu-
ality, for example Michelangelo, who never allowed himself to make
comments or be open in this respect, Leonardo seems to have readily

understood the impulses that prompted both him and others; and, as we shall see later, it cannot be ruled out that one of the reasons for his fierce conflict with Michelangelo was this very different way of experiencing the artistic condition, part of which was their own sexual orientation. In this, too, Leonardo was well ahead of his time, as he appears to have had a clear awareness of sexual impulses and of the darkest inclinations. He alludes to this with extreme frankness in one of the passages written for his treatise on painting, the *Libro della pittura*, in which he shows full awareness of the erotic power of images, including those apparently intended for worship. This awareness did not lead him to avoid such power; instead it seemed to prompt him to render sacred images, like that of *Saint John*, deliberately seductive. This painting became a despairing focus of Catholic criticism in past centuries because, unable to ignore the strongly homoerotic power of the image, it could not understand how an artist in fear of God, as Leonardo had been portrayed, could be persuaded to paint such provocative works of art. This criticism overlooked the fact that, without such sentimental ambiguity, Leonardo would never have created the masterpieces in the first place.

The sole purpose of this long digression on Leonardo's sexual orientation is to set in a more realistic context the life of the young artist at the time of the anonymous denunciation that defamed him in the eyes of the city and his family and to make more comprehensible that free and easy-going lifestyle, which seduced contemporaries almost as much as the beauty of his paintings. While Michelangelo was reputed to be 'fearsome' on account of his churlish manner no less than for the greatness of his art and intimidated even his friends and acquaintances, who would not dare to approach him, Leonardo was always welcoming and pleasant to talk to, showing his peaceful nature and a predisposition to enjoy life to the full.

In a city like Florence, which was focused on the accumulation of power and money, Leonardo came across as an eccentric nature lover, a young man who, despite not having much ready cash, thought nothing of buying caged birds in the marketplace simply for the pleasure of setting them free and watching them take flight. He did not hesitate to renounce meat dishes out of the love he felt towards animals, a feat that was truly unique at the time; it was in fact so singular that a well-to-do Florentine merchant journeying to India had no qualms about

comparing 'his' Leonardo with the gentle inhabitants of that region, who would not eat the flesh of animals out of conviction that in their lifetime those animals had embodied the souls of the dead. Leonardo's way of life, his eccentricity – and even his sexual habits, which were deemed so aberrant by the anonymous writer of the accusation – in no way diminished the admiration that had spread through the city for his early works. The merchants of Florence were too cultured and pragmatic to be influenced by abstract moral rules and too well acquainted with human nature, whether in artists, in popes, or in condottieri, to make harsh judgements about their sexual preference.

Florence was a free city where every action was weighed mainly against its consequences for the common good, and Leonardo was destined more than anyone else to increase the city's glory in the eyes of the world.

Almost as if to reiterate the complete confidence placed in this eccentric and brilliant young man by the city government, just over a year after that accusation, the Florentine Signoria commissioned him to produce a painting for the chapel of San Bernardo in the Palazzo della Signoria, the city's most iconic building. Without having accomplished any other public works, which would surely have been recorded, Leonardo won the challenge against his fellow artists, Sandro Botticelli, Domenico Ghirlandaio, Antonio del Pollaiolo, and even Verrocchio, all of whom were working in the city during this period but none of whom, as far as the Signoria was concerned, could match the talent of this original youth.

10

OTHER DISTRACTIONS

The panel commissioned by the Signoria would never see the light of day because Leonardo could not finish it. To start with, the work was delayed by decidedly unusual political circumstances. Three months after signing the contract in January, Leonardo was paid 25 *fiorini larghi* to begin the work, but the city, the Signoria, and even the Palazzo where the painting was to be be hung were struck by a terrible event.

Lorenzo de' Medici himself was aware that the dissatisfaction caused by his family's 'tyrannical' hold over the city had spread insidiously among some of the most powerful Florentine families, and he took steps to hold in check his enemies' mood of discontent with a complicated policy of alliances. The Pazzi family, which was perhaps even richer and certainly older and of higher standing than the Medici, had reached a tipping point at which matters could no longer be tolerated and, in conjunction with the new pope, Sixtus IV della Rovere, who also had reasons for opposing the Medici, decided to take action. Urged on by the animosity of one of the heads of the family, Franceschino dei Pazzi, a plot was orchestrated that deliberately chose to ignore the fact that Bianca, the sister of Giuliano and Lorenzo, had married a member of the clan, Guglielmo dei Pazzi.

The day chosen for the elimination of Lorenzo and Giuliano was Sunday 25 April, and the place was none other than Florence's cathedral,

Santa Maria del Fiore. The sanctity of churches at that time was no obstacle to murder and other crimes, even on holy festivals. Only two years earlier, the duke of Milan, Galeazzo Maria Sforza, had been assassinated on Saint Stephen's day while walking into the cathedral of Milan, where he was about to attend Mass. The Florentines, with an eye on being first in all their endeavours, decided to assassinate the two Medici brothers right inside the church; and, at the agreed moment (it appears that the signal was given by one of the priests celebrating Mass!), they and their henchmen attacked Lorenzo and Giuliano with daggers. Giuliano, the good-looking and enterprising horseman admired in so many jousts, died on the spot. On that particular day a leg injury that bothered him prevented him from wearing his chain mail vest under the doublet and from carrying his famous war dagger, from which he was never separated. Lorenzo, who had no time for jousts and was less of a fine figure, was only injured and had the good fortune to be saved by his friends, who carried him into the sacristy.

The conspirators were convinced that they could raise the city against the Medici, but when they ran and rode through the streets, crying liberty, the people turned on the Pazzi and their followers because they loved the Medici and did not feel the burden of their tyranny. Before long the whole city was in uproar, chanting its support for the Medici in a unanimous cry: *palle, palle*. The reference was to the family's coat of arms: even then, images and their message were a speciality of Florence. Some of the plotters rushed from the cathedral to the Palazzo Vecchio, just 200 metres away, but that short moment of uproar enabled the loyal Medici supporters inside the palace to realize that something was afoot. The doors of the palace were barred and a barrage of stones rained down from the windows. The situation immediately turned in favour of the Medici and within a few hours most of the conspirators were captured and killed, together with many others who had inadvertently found themselves on the wrong side. Lorenzo rid himself of the plotters and their supposed friends with the same ruthlessness he had shown when dealing with the insurrection of Volterra, showing no regard for the close family ties created by his sister's marriage.

Florence was implacable in the defence of its own liberty and government. Hanging corpses often made a macabre spectacle at the city gates; but on this occasion, in an unequivocal message, many of the

plotters were hanged from the windows of the Palazzo della Signoria and were left there for days before being cut loose and allowed to fall to the ground below. The worst fate was reserved for the archbishop of Florence, Salviati, an active member of the conspiracy. Without a second thought for the censure of excommunication (which promptly arrived from Rome), Lorenzo's supporters hanged him, together with his brother and another relative who was completely unaware of what was happening.

The furious reaction of the Medici and their supporters was unstoppable and, according to an account given by Francesco Guicciardini, 'over fifty were hanged that day; never had Florence seen a day of such distress'.[22] Paradoxically, however, the Pazzi conspiracy proved a great political success for Lorenzo, who had been in economic difficulties and would have started to lose his power to influence the city. Instead, after the conspiracy, he found his government stronger, having eliminated both his rivals and, as Guicciardini cynically noted, his handsome, braggart brother Giuliano, with whom he would have been obliged to share the family inheritance:

> This tumult was particularly dangerous for Lorenzo . . . but it increased his renown so much and proved so useful that that day can be said to have been most lucky for him . . . the people took up arms for him and, doubting that he was still alive, they ran to his house shouting that they wished to see him, and he appeared at the window to the enormous joy of all, and finally on that day they recognized him as lord of the city.[23]

Where he had not succeeded alone, he succeeded through the stupidity of his enemies, given that after that event he was not only permitted a personal armed guard (an aberration in a republic of equals) but also able to tighten the reins of control still further, now that he was the sole master and arbiter of a city where no one would dare to rebel again, at least in his lifetime.

Leonardo, who had also become part of Lorenzo's household, lived and worked a few metres from the cathedral and was able to follow the conspiracy at close hand. It made an impression on him and he was also able to make drawings using an approach characterized by the same painstaking attention he applied when chronicling the turbulent

forces of nature, a tempest, a downpour or a flood. If it is to histori-
ans and chroniclers that we owe the precise details of the event, it is
to Leonardo that we owe one of its most pathetic visual testimonies:
a sort of snapshot, drawn in pen on paper, accompanied by a brief,
synthetic caption: 'beret in tulle, black satin doublet' [Plate 15] – so
detached in tone as to be cynical. The hanged man swings lifeless from
the Bargello, his eyes hollow from the suffering and maltreatment prior
to public execution (unlike Archbishop Salviati and his accomplices,
he was hanged from the windows of the Bargello), and he is wearing
Ottoman garments that are described in detail by Leonardo, together
with the beret that still covers his head. The man is Bernardo [Bandini],
one of the leading plotters – and perhaps the most hateful, because he
had accompanied Franceschino dei Pazzi to Giuliano's house on the
morning of that fateful April Sunday.

Giuliano was not feeling very well and had decided not come to
Mass. His absence risked upsetting all the plotters' plans. However,
they convinced him to follow them to the cathedral and everyone
noted how, on the way from Palazzo Medici to the church, Bernardo
embraced Giuliano several times – not out of affection, as a naïve
onlooker might suppose, but in order to check whether he was wear-
ing the chain mail vest under his elegant doublet. It was Bernardo, too,
who stabbed Giuliano, leaving him dead on the consecrated floor. In
the tumult that followed he had managed to flee from Florence and
take refuge in Istanbul, where a year later the Medici's agents tracked
him down and brought him to Florence; there he was hanged on 29
December 1479, in his Ottoman garb, under the satisfied gaze of the
Florentine people. Leonardo recorded the tragic sensationalism of that
event with cool detachment. The sketch was never used in a painting
but chronicled an event, one that was neither more nor less complex
than many others drawn to the artist's attention by people and nature.

The addition of that note is the first in a lengthy journey of intro-
spection that Leonardo embarked on precisely at this time and that
was to take him far from painting – and, in the coming months, also
far from the panel commissioned by the Signoria for the chapel of San
Bernardo, about which no more would be heard. Among the sheets of
notes that Leonardo began to collect and preserve and that ended up
forming what we know now as the Codex Atlanticus in the Ambrosian

Library, Milan, is a list of names – not of painters or patrons, as you might expect, but of the most famous Florentine scholars. It includes professors of arithmetic, doctors, students of physics, and even that Messer Giovanni Argiropulo – John Argyropoulos – regarded as the greatest scholar of Aristotle, who had been invited to Florence by Cosimo de' Medici after his flight from Constantinople. The list marks an important moment in Leonardo's life. He now realized that he had to provide a stable structure for the desire for learning and knowledge that had consumed him since boyhood and that his apprenticeship in Verrocchio's workshop could no longer satisfy.

Now he needed to raise his sights and pit his learning against that of the universities and their professors. The cultural dynamism of Florence had had an effect on the young man, who was now nearing 30. Although his first steps in painting had made him famous in the city, he felt attracted to more distant goals. To reach those goals, he had to embark on a path of self-taught learning. The people on the list might have given him concepts or books he deemed important. The list of names circumscribes a list of skills to which Leonardo now turned: 'Quadrant belonging to Carlo Marmocchi, Messer Francesco Araldo, Ser Benedetto da Cepperello, Benedetto of the Abacus, Maestro Pagolo doctor, Domenico di Michelino, El Calvo of the Alberti, Messer Giovanni Argiropulo.' Carlo Marmocchi was a well-known astronomer; Francesco Araldo was Francesco Filarete, herald of the Signoria and an intimate friend of the greatest intellectuals of the time; Maestro Paolo, doctor, was Paolo del Pozzo Toscanelli, a mathematician and scholar of comets, as well as a close friend of Alberti and Cardinal Cusano; the man known as 'Calvo de li Alberti' formed part of the family of Leon Battista Alberti, who was already an important reference point for Leonardo because he was the first person in Italy to unite philosophical and theoretical humanist culture with the practice of architecture and painting, merging the different sectors of medieval knowledge. Lastly, Argyropoulos was Aristotle's translator and commentator, mentioned earlier.

Leonardo started to collect the works of university scholars, with whom he would always have a conflictual relationship, challenging them to competitions but also noting their distrust. This conflict would goad his pride, urging him to acquire, in a somewhat disorderly manner, the

appropriate means for his inquiries into the natural world. He began to study Latin so as to be able to read books and embark on a rigorous verification of the entire scientific tradition inherited from the classical world, on which others were already working. His lack of schooling made itself felt, and Leonardo knew that he had to make up for lost ground without delay and at all costs. Unfortunately his burgeoning interest in pursuing such a wide range of scientific topics meant that he lost interest in the commission from the Signoria, which had been the envy of all his fellow artists. Torn between the need to expand his own theoretical knowledge, an impulse he could not resist, and the need to make a living from paintings, Leonardo struggled to do both. It was an arduous task.

11

THE NEW HUMANITY

The group of paintings completed in the second half of the 1470s includes a panel painting of *Saint Jerome in the Wilderness*, now in the Vatican Museum [Plate 16]. The work is unfinished, and this offers a chance to understand more clearly the composition process used by the artist at this date. The saint is shown in the act of striking his breast with a stone, on his knees in a rocky landscape, as Italian painters always represent him. Facing him and with its back to the viewer, a lion observes him in silence, turning its head with its mouth open, as if to rebuke the saint for the ugly, self-destructive act he is performing.

The composition follows Leonardo's Madonnas, both the *Benois Madonna* and the *Madonna of the Carnation*, indeed particularly the latter, by placing a black rock behind the figure so that it emerges from the penumbra, thereby also creating two landscape vistas right and left. In the first we glimpse an urban landscape, a church that might be that of the Nativity at Bethlehem, where Saint Jerome would have spent the last years of his life and would have been buried. On the left is an airy scene closed off by tall, rock-like mountains that seems entirely unrelated to the panorama on the right.

The colour has been applied only to a small part of the painting, namely the left-hand landscape and the rocks behind the saint, and the ground. It is as if Leonardo deliberately wanted to dispense, at least

initially, with the broad expanses of colour in order to concentrate in greater detail on the figure at the centre of the composition. Here the artist has elaborated the study of chiaroscuro directly on the preparatory drawing, as he was taught to do in Verrocchio's workshop, in order to give plastic relief to the figures even at this stage. In this case the chiaroscuro highlights a detailed study, both anatomical and physiognomical, which is as expressive as a finished painting.

The unfinished nature of the panel offers an insight into Leonardo's research process and justifies its long gestation. In the preparatory phase, the stage at which all his contemporaries simply transposed the drawing onto the panel, Leonardo did everything within his power to control, deepen, study and perfect the ideas he had already developed earlier – first in small sketches, then in the preparatory cartoon, which was executed at the same scale as the painting. The chiaroscuro used by Leonardo to define the image of Saint Jerome cannot be called preparatory to the painting: it is the painting. Leonardo used this phase to define in full the psychological expression and the anatomical tension of the body and of the individual muscles. The drawings that were sketched on paper and then repeated on the cartoon and transferred to the panel were no longer enough. Instead Leonardo embarked on a new creative process on the panel, where the light was studied afresh in relation to the elements that started to emerge, such as the rocks, the trees and the sky – elements that, not by chance, we will find more fully defined also in the next unfinished painting, the *Adoration of the Magi* [Plate 18].

Each phase of a painting's growth corresponds to a new phase in the redefinition of the image. Once the base of the sky and the rocks behind Saint Jerome had been painted, the light and shade on the figure had to be restudied and altered before moving to the stage of colour, since its transparency would again change the chromatic tone of what had already been defined in chiaroscuro. Moreover, this new way of painting, which attempted to portray aspects of nature and humanity that no one had ever revealed before, concentrates on the psychological traits of the personage. If we compare Leonardo's *Saint Jerome* with other paintings on this subject from the same period, for example Giovanni Bellini's *Saint Jerome in the Desert* in the Uffizi [Plate 17], we note immediately that Leonardo has removed from the painting

everything that interferes with the saint's suffering and with the placid lion, who has become more of a pet dog. The painstaking narrative of contemporary painting has completely disappeared. Here the artist is not interested in showing grasses, stones, trees, buildings, hills, rivers and clouds, set out like an abacus around the saint who prays and self-flagellates. The whole drama of that suffering is concentrated solely on the outstretched arm and on the neck that instinctively moves away from the blow he is about to strike.

The action is very theatrical. The exceptionally long right arm stretches back to build the momentum to strike, while the left hand delicately lifts the ragged cloak from the chest, so that the stone can inflict a more painful injury to the flesh, reduced as this is, through penitence, to a meagre casing that envelops the bones. The portrayal of the penitent Saint Jerome is among the most violent images of the Renaissance; and it closely follows the text of *The Golden Legend*, the main source used by Italian painters of the time for the lives of the saints. Saint Jerome, having withdrawn into the desert, continued to be troubled by lustful visions:

> All the company I had was scorpions and wild beasts, yet at times I felt myself surrounded by clusters of pretty girls, and the fires of lust were lighted in my frozen body and moribund flesh. So it was that I wept continually and starved the rebellious flesh for weeks at a time. Often I joined day to night and did not stop beating my breast until the Lord restored my peace of mind.[24]

Leonardo retraces with precision the saint's dramatic rebellion against his own desires, and he does so through the man's emaciated body and the desperation of his expression. Given that this desperation is chiefly shown through the facial expression, Leonardo does not hesitate to rid the face of the beard that for centuries had been a key attribute in the representation of the saint and would soon become so again. The scene is a perfect psychological study of an ongoing drama and, since mortification of the flesh is a pivotal aspect, the study of the body is painstakingly accurate. The saint's right leg is already perfectly turned by the chiaroscuro that highlights the tendons and tibia. Such clearly delineated anatomical details invite the supposition that

Leonardo had begun to frequent the city's hospital mortuaries by this time.

But that exaltation, in the painting, of a cruel mortification of the flesh reveals other meanings as well. The painting can be dated to the time of Leonardo's denunciation for sodomy, which almost certainly elicited from his father calls for the moderation, if not mortification, of his sexual impulses. It is legitimate to wonder whether to some extent Leonardo identified with Saint Jerome's attempt to cool his own sexual desires and whether, in short, the painting is the outcome of the artist's identification with the penitent saint, in flight from the temptations of the flesh. This seems unlikely. The portrayal of the saint is like that of a plant: perfect, rigorous and detached. Sensuality, which in Leonardo's life and art is the true driver of his creativity, is concentrated – or rather explodes – in the lion stretched out at Saint Jerome's feet, with its soft profile and a tail that invades the entire visual field, forming an exaggerated curve that epitomizes the sensual beauty of nature that the poor saint was trying to fight off. The presence of the lion, which is a focus of the painting as much as the saint is, draws the artist's and the viewer's attention to the centrality of that nature from which Saint Jerome tried to escape. It is as if Leonardo, through the excessive space and prominence given to the lion, wanted to distance himself from the superstitious tensions that still permeated fifteenth-century theology.

The painting was never finished and has survived to the present as a superb sketch: a sketch so perfect that it discouraged any attempt to complete it. It passed intact through the hands of countless collectors, until it was mentioned for the first time in Rome, in the residence of Cardinal Joseph Fesch – who, according to a rumour started by himself, allegedly found it chopped up in a second-hand shop whose owner was using the upper part as the seat of his chair!

Another small painting dating from this period helps to explain the success that Leonardo enjoyed in Florence without having ever completed a major commission. This is a panel of just 38.8 × 36.7 cm, on which is painted a three-quarters portrait titled *Ginevra Benci* [Plate 19]. Ginevra Benci (1457–1520) was a wealthy young woman from Florence who dabbled in poetry and was a great admirer of Petrarch. The portrait was probably commissioned by her Platonic admirer, Bernardo Bembo.

The intellectual exchange between men and women formed part of an elegant game in Florence, the city where Neoplatonism became a genuine cult. Even Lorenzo de' Medici had appeared at the famous joust of 1469 in Santa Croce sporting the colours and emblem (a garland of violets) of Lucrezia Donati, a lady to whom he was united in 'Platonic love', given that she was married to Niccolò Ardinghelli. Similarly, Ginevra married Luigi di Bernardo Niccolini in 1474, but her friendship with Bembo could be celebrated in a portrait filled with poetic allusions.

The young woman is shown in a three-quarters pose, very close to the viewer and standing against a juniper bush, which alludes to her name (juniper–Ginevra). On the reverse is a sophisticated emblem that alludes to her virtues and to Bembo's motto: a palm leaf wreathed with laurel set on a porphyry base. The scroll linking the two fronds also winds around a sprig of juniper on which is written in capitals a Platonic motto, *Virtutem forma decorat* ('Beauty is the adornment of virtue'), a clear reference to the young woman's intellectual virtue while her beauty is a secondary ornament. However, in the light of the latest diagnostic tests, the words on the scroll were originally *Virtus et honor* ('Virtue and honour'), which is Bembo's motto, and this appears to confirm that the painting was commissioned by the young woman's admirer rather than by her husband.[25]

The obverse and the reverse of the portrait are painted using two different techniques – oil and tempera respectively – a fact that has raised many questions concerning the possibility that someone else painted the back, given that it is also much less refined than the front. The painting poses many other problems and Leonardo's authorship was not universally accepted until a few decades ago. When the earliest records of the painting came to light, it formed part of the collection of Prince Venzel of Lichtenstein, in Vienna, in 1733. Then it was attributed to Cranach, which is not unreasonable given that stylistically it was closer to 'Netherlandish' portraits of the period than to Italian ones.

Above all, the landscape to Ginevra's right is far removed from the landscapes on which Leonardo had worked in a clearly recognizable style as early as in his *Annunciation* and then in the *Benois Madonna*, and that reappear in almost identical form in his later works. The

two bell towers with exaggerated spires and the tops of the simplified rounded trees, as well as the clean line of the horizon, have nothing in common with Leonardo's complex landscapes, with their *sfumato* effects. Likewise, the coldness of Ginevra's face certainly contrasts with the faces of Leonardo's Madonnas; but here we are looking at the artist's first 'lay' portrait, and the girl's ascetic features and moonlike pallor (which are attributed to her by other biographical sources) may have played a role in her strange expression. On the other hand, the extraordinary depiction of the bush behind her, the search for depth and the naturalness of the light that filters through the needle-like leaves of the juniper bush are unmatched at this date by any Flemish painting. The same is true of the beautiful portrayal of the chestnut curls, which, with their sparkling light and natural waves, are absolutely the same as the hair we will find again in the angels of *The Virgin of the Rocks* in Milan (1483–6).

All in all, this is an original test of Leonardo's skills as a portrait painter, succeeding in open competition with the Flemish portraits of Memling, Petrus Christus and other painters – portraits that the Florentine merchants were beginning to bring into the city from their Hanseatic branches and that revealed, above all in the perfect technique of *sfumato*, a new and fascinating world. The new technique using oils, which the Flemish mastered to perfection, and the almost obsessive attention to natural description enabled Flemish painting to reach heights of realism at this period that were unknown in Italy (except to artists like Antonello da Messina, who immediately adopted the northern techniques). At the same time, these traits also constituted the limits of this form of painting, too heavily dependent on painting from real life and incapable of transposing the image into that 'ideal' dimension that transfigured nature and people, making them much more attractive than any degree of realism. This idealized and intellectualized vision of the world had been typical of classical antiquity and continued to be attempted in sculpture (for example in the statues collected by Lorenzo the Magnificent in the gardens of San Marco, to which Leonardo had access) and through the humanist Renaissance. The persistence of ancient ruins and sculpture throughout Italy prompted artists to represent a 'heroic' human figure, far from the simple natural state. In his portrait of Ginevra Benci, Leonardo created a balanced fusion of these

two facets, outdoing the realism of the Flemish portraits (particularly those by Memling) while also giving the young woman a personality and a psychological depth that went well beyond a mere narration of her physical features.

Ginevra's features are exalted through the superb contrast of light and shade created by the bush behind her: this is a technique that had already become associated with Leonardo's work, and it recalls the two Madonnas as well as Saint Jerome, painted in this same period, all framed against the dark volume of the background. While the juniper bush offers an opportunity to surround the half-figure in darkness and to enhance the light that shines on her, on the other hand there are flashes of light around the edges of the girl's bust, and they give the idea of a completely new sense of spatial depth. Furthermore, the bush is an exemplary demonstration of outstanding technical skill, since Leonardo uses different shades of green. Some of the leaves are painted in strokes that are as sharp as graffiti, in a brown, almost black colour that stands out against the pale sky to exalt the contrast in light, while in the central part, nearer the head, the tone is closer to black. Other leaves are shown in different gradations of green and brown, giving the impression that the light moves between the sharply pointed leaves, right into the heart of the bush. This is clearly seen close to the girl's left shoulder, where the light shines through a small opening between the branches onto the flesh and creates a slight but most evocative reflection on her shaded neck.

The darting lights of the needle-like leaves merge and expand into brilliant highlights on the curls, creating an extraordinarily atmospheric effect and a diffuse, golden light around the young woman's pale, unmoving face. But where Leonardo far surpasses Flemish realism is in the definition of her features. Here the brushstrokes are softened, making the outline of the mouth, nose and eyes unnoticeable and creating the impression of a slight haze that allows the woman to blend completely with background around her. Her detached and pensive expression, almost reflective, one might say, depends not on the drawing but on these elusive features. The shape of her lips is defined by the light that touches them without ever forming a distinct outline, as happens in all the Flemish portraits. The same is true of the shape of her nose and eyelids; these are formed through brushstrokes of colour that

create an almost imperceptible variation in light. The facial features have been transposed to the panel from a preparatory cartoon, because traces of pouncing dust are visible along the lower edge of Ginevra's right eye, which also has a clearly enlarged iris. Once the drawing was transferred, however, Leonardo completely transformed it, using light and shade, and erased all the sharp outlines. Another evocative innovation made by Leonardo here concerns the way the bust and face are angled towards the viewer.

According to Florentine tradition, female portraits were painted in profile, while male ones were shown in a three-quarters view. Some have suggested that the custom is linked to a tendency to reduce the woman to her exterior appearance, to the beauty of her lineaments, while in the man's case preference was given instead to character – a psychological entity that could be communicated more readily through the importance accorded to the gaze in a three-quarters portrait. But Flemish painters preferred to paint women, too, from a three-quarters angle, positioning the sitter's bust diagonally across the composition. Leonardo adopted and modified this innovation by positioning the bust in a three-quarters pose but making the girl's head turn slightly towards the viewer, which gives the figure an inner dynamism.

The portrait appears to have been cut across the bottom, where some scholars have suggested that her hands would have been painted, lightly touching her chest, as in Verrocchio's statue *Lady with a Bunch*. This would have placed the portrait in a Florentine iconographic tradition dating from the last quarter of the Quattrocento. It has been suggested that a drawing of hands now in Windsor Castle [Plate 20] is linked to this painting. In this case, the gesture would have made this cultured and beautiful Florentine girl even sweeter and more graceful, showing how perfectly Leonardo captured the new desire to communicate her intellectual qualities and her reflective and poetic personality, which goes deeper than graceful beauty. The evident discrepancy in the quality of the childish landscape to the woman's right can be explained if Leonardo worked with a collaborator – whose presence may even have been stipulated by the patron for the purpose of ensuring that the portrait was finished and of minimizing the consequences of the slow pace for which the artist was already renowned. However, this hypothesis is important from a biographical point of view, too: it would show that in

the mid-1470s the young artist was making considerable efforts to set up the customary artist's workshop in Florence. These efforts would soon be interrupted by other projects.

In March 1480 Leonardo was commissioned by the Dominican monks of San Donato a Scopeto, a large monastery just outside Florence, to paint an altarpiece for their church. Clearly they were not put off by the fact that the artist had not completed the major painting commissioned two years earlier by the Signoria of Florence for the chapel in the Palazzo della Signoria. But, after they waited for some time, Leonardo's inconclusiveness must have started to concern them and in July 1481, 14 months after the first agreement – an interval of time that would certainly have been sufficient for another artist to have completed the painting – they decided to protect themselves against further risks by drawing up a new agreement. This document has survived and it is strangely worded, unless it is read in the light of what it must have been like to deal with such an extraordinary painter who was so intolerant of rules imposed by others. The contract reads as follows:

> Leonardo di ser Piero da Vinci undertook to paint our altarpiece for the high altar at the end of March 1480, and he must have completed it within 24 months, or at most within 30 months, and should he not do so he shall forfeit whatever he has done of it, and it shall be our right to do whatever we want with it; for this he shall receive a third of a property in Val d'Elsa, which belonged to Simone, father of Brother Francesco, who bequeathed it for this purpose.[26]

In short, the monks must have seen the early stages of Leonardo's work and appreciated the marvellous painting that can still be seen in the panel of the *Adoration of the Magi* at the Uffizi in Florence; but, given that the artist was making little progress, at a certain point they decided to draw up a new agreement that guaranteed their right to take what had been done, to pay a set price for it, and to have it finished by others. Reading between the lines of the new agreement, it seems that Leonardo was unable to meet the financial conditions set out in the initial contract, under which the artist was charged for the colours and the gold, and also for a dowry deposit for a girl in Florence. During the months after the second agreement, Leonardo still played for time

by painting for the monks a 'clock', which they paid for by sending him some faggots of wood and sticks. In August they also gave him an advance payment for colours, in the hope of helping him to finish the work:

> Lionardo da Vinci painter owes on 25th of the said month [August 1481] *lire* 4 *soldi* 10 for an ounce of blue worth *lire* 4 per ounce, and for an ounce of *giallolino*, which we bought from the above at the Ingiesuati, as is recorded in the marked Journal.[27]

The colours purchased for Leonardo allow us to guess that the preparatory phase was finished and that he was about to start the actual painting. The blue bought for the artist (30 grams) is undoubtedly the precious ultramarine blue made by grinding lapis lazuli. The semiprecious stones were brought from Persia and broken up, purified and sold in Italy by the Jewish merchants in Ferrara and, in this case, by the Ingesuati, monks at a monastery outside Porta a Pinti in Florence that, like many other monasteries in the region, had specialized in the production of works of art (it was particularly famous for its windows) and must also have refined pigments. The other colour, the *giallolino*, was a yellow that was produced above all in Naples by adding lime to ammonium salts and antimony sulfide, both widely found in the tufa around Naples. It was clearly much less costly than the precious ultramarine blue.

Unfortunately for us, after such a long journey, neither the *giallolino* nor the ultramarine blue reached the garments of the wonderful Madonna that Leonardo had surrounded by kings and horsemen, horses, dogs, and even an elephant. Instead, like Saint Jerome, she remained imprisoned in the greys of the preparatory sketch. Even though those greys and blacks had already made her more intriguing than she might have been if she were covered in blue and gold, the patrons expected the panel to be completed and they coaxed the temperamental painter with every possible enticement, even sending him a barrel of red wine (*vino vermiglio*) after the vintage – which of course produced no result whatsoever.

Less than a year later, Leonardo was in Milan, at the court of Ludovico il Moro, and this wonderful sketch remained in Florence.

Yet its beauty was such that not even the monks would summon the courage to have it finished by other painters. As well as being monks, they were also Florentines, and their refined taste in art surpassed that of a reigning monarch in any other country. Seeing more talent in that sketch than in any other finished work, they kept it as it was, in their monastery and in their church, until both were caught up in the political upheaval of 1527 and were razed to the ground, to guarantee the safety of the city. This measure was in all likelihood passed by Michelangelo Buonarroti, then governor and procurator general of fortifications for the republic; but, as a good Florentine and great admirer of all forms of talent, Michelangelo ensured that all the works of art in the church were carried to safety in Florence. The magnificent panel has therefore arrived intact to the present, just as Leonardo left it while he was enjoying the wine from the grape harvest of 1481.

The panel is square and measures 243 × 246 cm. It is not a very common shape, and this, too, must have played a role in suggesting the complicated scenic and perspective composition through which Leonardo summarized and surpassed all the knowledge of geometry that the city had accumulated over the past forty years. The panel is made up of ten planks joined together vertically, while a cross-shaped reinforcement is a later application, as the recent restoration indicates. This restoration has revealed the details of the execution and their sequence. The panel was covered with increasingly thin layers of plaster and glue, which were then shaved in order to obtain a surface that was as smooth as possible. The oil-based *imprimatura* layer was then applied to the prepared surface in order to reduce the absorbency of the oil used to mix the pigments and to yield the best surface for the paint film.

Leonardo then began to construct his composition on this underpainted layer, the *imprimatura*; at an earlier stage he would have made detailed studies for it, of which sketches survive in various collections, but the whole is reformulated on the panel, as the numerous alterations [*pentimenti*] and variations confirm. The figurative schema is apparently very simple: at the centre of the square is Mary's head, around which are placed, like a rotating vortex, a first array of figures, who jostle to find space where they can see and adore the child held on his mother's knees. A second scene, almost from another world, is represented in

the upper part of the painting, which is arranged around a perspective centred just above Mary's head, so that the viewer seems to be standing above the scene's protagonists, perhaps by climbing onto higher ground in front of them or, an interesting idea that cannot be proved, as if the artist or the viewer were entering the scene on horseback. The two halves of the painting seem to have been constructed using a very different compositional logic, which corresponds to a different phase of development.

In the upper half, however elaborate, the scene follows the representative scheme of Florentine perspective compositions that had become fashionable by the middle of the century, while the lower half anticipates, in the spatial (and emotional) relations between the figures, the Leonardesque compositions of *The Last Supper* and, later, those of Raphael and the other great painters of the High Renaissance. The construction of the 'perspective square' in the upper part of the painting stands out for its exceptional, almost maniacal detail, and thanks to the numerous sketches that have survived (the most extraordinary being the one in the Uffizi, Plate 21), we know that Leonardo made an obsessive and highly detailed study of the geometric layout of the scene, dividing the boundary line into equal segments that coincide with the surface of the painting closest to the viewer and working these segments back to the vanishing point on the horizon, so that the perimeter of each element of the complex architecture that develops vertically can be positioned with great precision in this cone-shaped grid. These lines all converge on a single vanishing point and are in turn crossed by a parallel grid of lines that decreases in width as they approach the horizon.

In this way the artist has constructed the plan for a perfect scenic machine, which is then used to create the architectural elevations. By building this detailed system of perspectives into the scene, Leonardo has put to rest once and for all the spatial incongruities that appear in his earlier compositions, in particular the *Annunciation*, where the perspective scheme is rather vague. In a city like Florence, this kind of mistake was undoubtedly the butt of much criticism from the artistic community; and here, with the expertise of a consummate architect, Leonardo demonstrated his ability to represent any spatial form.

The palace in the background is shown under construction, and is highly original. Two steep, narrow stairs lead to a raised floor where a number of workmen carry out typical building work. They carry sand and buckets of cement, they lean across, they labour and talk. In the centre, between the two stairs, are three open arches whose uprights we glimpse through the archways under the stairs. It is a play on transparency that makes the space elusive and uncontrollable, in spite of the complex geometrical framework.

But the real novelty of this painting lies in the separation and different psychological tone of the two representations – because these are two representations: the lower part of the painting and the upper part. In the former, in a way that was completely new to the tradition of central Italy, Leonardo stages an adoration entirely centred on the 'theatre of the emotions', on body gestures and facial expressions, on a close dialogue between figures who express wonder, adoration and enchantment and communicate these states among themselves, bringing to life a realistic 'snapshot' of the revelation of divinity, an 'epiphany' more than an adoration. Leonardo captures the precise moment when the child is shown to the Magi and their followers, a crowd of men terrified by divinity. The three figures in the foreground prostrate themselves on the ground and seem too scared to approach the child even on all fours, but in this way they do not block the view of all those behind them, which would have happened had they been standing. The arrangement of the various postures is designed to ensure the best visibility of all the figures, as in a posed photograph.

The child stretches out his hand, in curiosity, to grasp the vase offered by the old king, while with the other he plays with his hair. Perhaps there is here a hint at benediction, as in earlier representations, but always through those infantile and poorly coordinated gestures. Mary looks on, gratified and humble: she is the true protagonist of the painting and her calm, unshakeable posture quietens the emotional vortex that whirls around her. She alone knows the secret of that birth. All the figures around her mime the astonishment of the revelation. All except one: the first person on the left of the painting, the most finished figure, the one that shows the most advanced stage of painting, on which the artist has lavished most care and thought. He is a strong man, in the prime of his years, younger than the old Magi and many of the

other observers. He has started to lose his hair but still has a weighty physique, an authoritative presence capable of striking fear. Not only does he stand apart from the others, closed in his worried reflections, but he is completely enclosed in himself, in a dark cloak that highlights his powerful anatomy. His prominence in the scene leads us to identify him as Saint Joseph, who is almost always present in paintings of the Adoration; but in this case he is placed in an unusual position, right on the edge of the central scene, despite the fact that he is one of the main characters. His centrality in Leonardo's creative process is confirmed by the fact that he is the most carefully studied and the most realistic figure in the painting – an unusually young and beardless Saint Joseph, seemingly between 50 and 60, as Michelangelo and Raphael would remember him, along with many other later painters.

How can this peculiar choice of a father figure be explained, except through reference to the artist's relationship with his own father? This is the man whom we imagine Leonardo might have seen as the terrible Ser Piero: aloof, strict, authoritative and, above all, distant. A preparatory drawing of this figure might be the sketch that is now in Windsor (RL 12555r), dating from the same years as this painting. Is it perhaps a portrait? The appearance, leaving aside the advanced baldness, is very close to that of Leonardo in the Turin drawing, which is thought to be a self-portrait from after 1505 [Plate 22], and to all the likenesses of Leonardo as an old man; but we cannot see it as a self-portrait at this date (Leonardo was a young man of 30). The man is the only person who is not astonished but concerned, and he occupies a highly unusual place in the scene.

In the absence of further proof, this suggestion regarding the autobiographical nature of the painting cannot be taken further, although its rejection would require us to find Saint Joseph among those present, and in particular to explain the identity of this character who, quite clearly, is neither one of the Magi nor a simple onlooker. If we accept that this man might be Ser Piero, Leonardo's father, then we admit that by the end of the artist's time in Florence his father's presence had become a real obsession, to the point where it physically invaded Leonardo's compositions.

The autobiographical nature of the painting might have prompted the dramatic changes that the composition shows vis-à-vis traditional

Florentine iconography, which had developed a proper cult for this scene. As we had occasion to see, the procession of the Magi that wound through the streets of Florence on the feast of Epiphany celebrated the wealth of the city and of its families after the Catholic tradition. The processions organized by the confraternity of the Magi became so spectacular that in 1468 the entire city took part in the representation and introduced a significant innovation: a procession made up almost entirely of youths, who on this occasion wore the costumes and masks of their fathers, as if to confirm the pact of intergenerational exchange and continuity.

In these costumed processions, and in the paintings commissioned from artists, pomp was a fundamental element of the representation. The Florentines were accustomed to gauging and pricing each length of fabric, each single jewel, thanks to their pragmatic and entrepreneurial spirit. In his personal memoirs [*ricordi*], even Lorenzo the Magnificent, with the mentality of a prudent merchant, felt obliged to include the estimated cost of the spectacles he had attended out of duty, without any enthusiasm. Lorenzo preferred the more refined entertainment of art and music to fake battles. In his *ricordi* he notes, with resignation, his participation in knightly jousts: 'to perform and join with other Jousters on the piazza of Santa Croce with great expense and great pomp, on which I spent 10 thousand *fiorini di suggello*.'[28] Luxury and wealth had to be displayed in the appropriate places, and no place was more appropriate than the spectacle of the *Adoration of the Magi*. Benozzo Gozzoli's frescoes in the chapel at Palazzo Medici provide a catalogue of contemporary luxury with a detailed description of each gilded stud on the horses' trappings, the gold-thread embroidery on the damasks worn by the kings, the pearls and fine fabrics worn by each individual. More moderate was Botticelli, who in the *Adoration* painted for Gaspare Lama in 1472–5, which Leonardo certainly knew, did not forgo the gold and the accurate display of elegant clothing. Leonardo omitted the gold, the damasks and the pearls and focused instead on the theatre of gestures, where any forced naturalism would have been a hindrance.

The exotic setting of the scene taken from Voragine's *Golden Legend* is also very innovative. The ruined palace behind Mary is that of King David, Christ's forebear, which is now being rebuilt because Christ's

advent would lead to the reinstatement of the House of David. Even
the rather surreal presence of two trees behind the Virgin announces
the flourishing of the Christian era. The strongly symbolic value of
this flourishing is emphasized by placing the tree on the rock right
behind the Christ child, as if the tree's roots drew force from the new-
born divinity.

Less easy to interpret and less common are the extremely violent
battle scenes taking place inside and outside the palace. A well-known
tradition in Florence in those years stated that the Magi had fought one
another in a fierce battle before Christ's advent and then made peace
when they heard the news of his birth. If this is the motif to which the
battle scenes allude here, it is also true that the space occupied by the
battles in the painting can be explained through Leonardo's passion
for scenes of action and fighting on horseback, which would reoccur
constantly in his later work. Knights and horses combat and pursue
one another right across the upper part of the painting, between the
palace arches and in open countryside, bringing their fury to the edges
of the circle of figures, who seem to crowd closer together in order to
protect the scene of calm adoration. The contrast between the brutal
times prior to Christ's advent and the peace that his birth would bring
on earth could not be rendered more effectively than by turning a tra-
ditionally static representation into a 'historical' one, as Leon Battista
Alberti had advised in his treatise *De pictura*; and this confirms that,
even at this date, Alberti's treatise was the polar star that guided all
Leonardo's research.

The effect is surprising. The contrast between the two scenes is
resolved without awkwardness. The representation becomes so
dynamic that we are constantly obliged to 'reread' it in each direction,
without finding an end other than in the immobile centre of Mary's
body, the apparently untroubled harbinger of the entire event. The
diverse expressions on the faces of those, young and old, who surround
the central scene also become a dynamic narrative and a catalogue of
psychological attitudes, even if some poses, like that of the old man on
the right, who shields himself from the divine light of the Christ child,
appear in many other paintings of the period. The same is true of the
exotic animals that Leonardo introduces into the painting and that
often appeared in representations of the orient imagined by painters.

On the right, an elephant wanders off in the background, and a lying dromedary appeared in a preparatory sketch; but it is the horses that fill the scene with their elegant movements. Leonardo was so fascinated by these animals that he failed to make room for others; even the ox and the ass are relegated to the far right-hand side of the painting, as if in a pure concession to the biblical description, while all the space is reserved for the horses, who penetrate the circle of figures close to the Magi and even appear to show a gratified admiration.

12

LEONARDO'S TECHNIQUE

Owing to its unfinished condition, the painting holds the key to the creative world of the artist and his technical processes. A careful study of this interrupted painting helps to provide a plausible basis for that legend that sees the artist as being slow but does not understand the reasons for this slowness. Leonardo is not slow because of his desire to execute the work to perfection. He simply protracts the creative process indefinitely, unlike other artists, who limited the creative phase basically to preparing the drawings. The many preparatory drawings of this painting that have survived, and in particular the two in the Uffizi [Plate 21] and the Louvre [Plate 23], assure us that Leonardo made painstaking preparations for the composition, to the extent of defining details that no other painter worked on in this preparatory phase. However, as we will see, these efforts were in vain because, having transferred the drawing to the panel, Leonardo continued to modify essential parts of the composition, reinventing them and starting a new phase of study, on the painted surface, which for him was critical. This was a phase that could last for years.

The preparatory drawing was transferred onto the plastered panel and then a transparent undercoat [*imprimatura*] was applied, leaving the drawing visible, so that it could be retraced with a brush dipped in dark colour. Once the drawing was gone over, the edges of a large

square were drawn, which the artist used first of all to define the architectural layout. This layout was realized through direct incisions, angles and compass, and with their help the architectural perspective of King David's palace and the area in front of it were redrawn, as if on a sheet of paper. The cartoon was then transposed onto the lower part using pouncing, together with the principal figures in the group: the Virgin and child, the Magi, and the other figures around them. This first light drawing, consisting of pinpricks of dust, was given greater consistency using a fine line traced in charcoal pencil, which was in turn darkened with a watery brush. Slight adjustments to the folds of garments and to the outlines of limbs and profiles were made during this passage from dust to pencil. These were again altered when the lines were gone over with darker brushstrokes, both wider and more pictorial.

Then, on the basis of a drawing that was already pictorial, the study of shadows commenced, with darker watercolours that gradually defined the interior space of the painting, as happens in a monochrome painting. Leonardo learned this transition in Verrocchio's workshop, where the shadows were also refined in watercolours to give relief to the image. But here he went much further, slowly defining a perfectly expressive image through shading, in a way that can be done only in monochrome paintings. At the same time, especially in the upper part of the painting, he began a different and more creative phase of recomposing the scene, which he started to people with possible figures in the gaps between the architecture (although not without having first changed it, as can be seen from the steps of the base to the left, between the horses' heads). Many of these moving ghosts were not drawn on the cartoon but added freehand, during a period of observing and studying the painting that could last for months.

The artist used the panel like an enormous sheet of drawing paper and first outlined some of the figures using very fine lines, probably in charcoal or pencil. Many of these figures would then be covered by others, or by other parts of the composition. The tree in the centre of the painting, for example, covers a figure that was originally drawn in rapid pencil lines. This 're-creation' of the image accounts for those long production times, which sometimes lasted for years, while the artist gradually peopled the painting with figures and decided which

would survive in the final version. The same is true of the compositional details, such as individual gestures or limbs.

The process can be seen clearly in the two horses fighting each other (with greater conviction than the two warriors riding them) on the right of the painting, beside the stables. The two horses were first sketched lightly in profile, and then these profiles were changed: the rear hooves of the horse on the right change position completely and its neck and head are defined in two different ways, so much so that in its present state the horse still looks as though it has two heads [Plate 24]. Over time and after careful reflection, Leonardo chose which of these positions would become definitive by adding watercolour to the part that needed to be seen by the viewer and leaving in profile the part that would be covered by a layer of colour and then eliminated. The front hooves of both horses clearly explain the process of development. The front legs were initially drawn in a profile that did not define the succession of layers, and only at a later stage were the legs of the left horse watercoloured, in order to define their respective perspective positions. It was an unusual choice, also with regard to the medium used to define the image: never a clear line, as used by all other Florentine painters of the period, but a soft outline with a brush barely dipped in black. The slow definition of the image was accomplished within the composition as a whole, which took shape gradually but over an extremely long time, because the work was constantly open to changes.

Having defined the key aspects of the composition, Leonardo then concentrated on the light and on steadily darkening the body masses. This, too, was an open process: it is as if Leonardo was not convinced by the study of light displayed in the drawing and wished to re-create it using the original dimensions and placing the figures in real space, just as Verrocchio used to make clay models that he would then drape in fabrics and illuminate with candles or natural light. Leonardo performed the same mental operation by scrutinizing the figures on the panel, in their final sizes, and imagining them in real space. Other artists restricted themselves to finalizing every aspect of the image on the preparatory drawing; and they used fixed and rigid schemes for lighting. The light came from the top-left corner, sculpting faces, bodies and garments in the same way.

Leonardo set all this aside and wanted to compete with nature, re-

creating the light without passing through an abstract graphic scheme. This also helps to explain why he never used a distinct line, either in his drawings or in his paintings. That line was an intellectual abstraction, invented over centuries by artists, architects, geographers and anyone who had to represent the universe, while Leonardo wanted to re-create the universe in painting. Day after day, Leonardo defined his figures with the help of a dark colour, which not by chance was referred to in contemporary terminology as umber or as natural earth. In this process it was precisely the umber, the monochrome wash, that was used to select those areas of the painting that were intended to be seen or to vanish.

In this respect it is worth noting the gradual definition of the figure on the far left of the painting, the one holding onto the pillar that supports the arch and looking at the horsemen who arrive from behind. The figure is shown in transparency against the outline of the pillar; but then Leonardo darkened the uncovered profile of the figure, thus creating a credible spatial development of the detail and producing a clear perception of the relief of the man's body against the pillar. The same happens with every detail.

The light must focus on the Virgin because it highlights her centrality. In order to achieve this, Leonardo started to darken everything around her, the ground, the rocks and the figures, thus creating that luminous and dramatic focus in which the Virgin and the child shine for now with evanescent light. Indeed, during this phase he had already achieved a sublime emotive and formal result, even before applying the colour. Later he would have to maintain the balance of this luminous drama in colour, for which he always used very low tones. But this process had negative consequences for his creativity, because the sensation of having obtained his goal at this phase made him lose interest in the painting and in the monks, in art and in Florence. He was prompted to pursue instead more distant goals. The *Adoration of the Magi* would remain at this stage for at least two years, until the moment when Leonardo decided to abandon Florence for Milan in 1482.

Part II

IN MILAN

13

VIRGINS AND LOVERS

Italy enjoyed a period of relative tranquillity between the middle and the end of the fifteenth century, thanks to a delicate balance of power maintained by the five main states of the peninsula: the republic of Venice, the duchy of Milan, the republic of Florence, the kingdom of Naples and the Papal States. It was in each of these states' interest that no one state should outdo the others in power and hegemony. In particular, Florence and Milan built a strong alliance in the 1450s that aimed to curb the ambitions of Venice, the most powerful of the Italian states and the one that harboured expansionist plans.

Cosimo de' Medici's alliance with the Sforza dukes of Milan had even been tinged over time by a faint hue of friendship. The most famous feast organized by Cosimo the Elder in Florence was held in April 1459, to mark the visit of Pope Pius II (not exactly a friend of Florence) and that of the duke of Milan's son, Gian Galeazzo. On 29 April a joust was held in Piazza Santa Croce, and on the next day a *ballo* on the piazza of the Mercato Nuovo. The young Galeazzo Maria was so impressed by the elegance and wealth displayed at these ceremonies that on that very evening he wrote to his father, giving a detailed account of the wonderful sights he had seen:

You should know that at the first [ceremony] there were about 150 women, all wearing jewels and highly ornate dresses, some made of gold cloth, some of velvet, some of damask, some of silk or other fine fabric. None was wearing plain cloth, and among them were about fifty who wore high headdresses in the French style, all embroidered with pearls and silver, with such grace and elegance as is hard to describe.[1]

Precisely thanks to occasions like these, the Florentine Signoria served as a model for a state like Milan, which was richer but less refined than Florence. The alliance between the two states withstood the violent disorders that led to Galeazzo Maria Sforza's assassination on 26 December 1476, an act that was so brutal that it won a place of honour among the blood feuds that accompanied the power struggles between families during the Renaissance. On Saint Stephen's day, Duke Galeazzo

was killed in Milan by Giovanni Andrea da Lampognano; and because he left a young son called Giovan Galeazzo, it was doubted that his subjects would not make some movement, which would have been a great displeasure to the city [of Florence] on account of the friendship and union that had been in place with that house for so long, and for the safety and reputation that our state derived from it in all circumstances.[2]

The person who describes these events was Luigi Guicciardini, nephew of the Florentine ambassador who was immediately sent to Milan, and therefore his account of that friendship is particularly trustworthy. Events in Milan continued to be turbulent for a few more years. Galeazzo's widow, Maria, turned out to be so unconcerned by the business of governing the duchy that she relied mainly on a loyal Calabrese secretary, Cecco Simonetta. His actions were not welcomed either by the people or by the court – and, above all, not by Galeazzo's brother-in-law, Ludovico Sforza, known as Il Moro, an energetic and strong-willed man who soon saw the possibility of getting his hands on the duchy of his nephew, Gian Galeazzo (1469–94). The latter had been the pride of his father's eye and had been képt close to his father ever since infancy, instead of being sent to his wet nurses. However,

Gian Galeazzo was not a forceful character and no match for his uncle.

Back in 1471 the youth had been betrothed to his cousin, Isabella of Aragon (daughter of Alfonso of Aragon, the duke of Calabria, and of Ippolita Maria Sforza, the sister of the assassinated duke and therefore also Ludovico's sister). The marriage with the Aragonese princess represented a life insurance for the young man, but Ludovico was clever enough to neutralize it by avoiding an overt usurpation of the duchy. After killing his sister-in-law's advisors, he proclaimed himself regent and gradually took control of the city, thereby effectively robbing Gian Galeazzo of all authority. His mother, Bona of Savoia, seems to have possessed neither great acumen nor high moral standards, if we are to take Francesco Guicciardini at his word. He blames her for Il Moro's usurpation:

> Ferdinando of Aragon, king of Naples shared the same inclination for the common peace. He was a very sagacious prince, and highly esteemed; though formerly he had often demonstrated an ambitious and turbulent spirit. At this very time Alfonso, duke of Calabria, his eldest son, incited him to resent the injury done to Giovanni Galeazzo Sforza, duke of Milan, who had married Alfonso's daughter. Having reached the age of 20 but being of inept mind, the duke had been excluded from the administration of all public affairs by his uncle, Lodovico Sforza, who, by reason of the weakness and dissolute behaviour of Bona, this young prince's mother, took him under his tutelage.[3]

From 1480 on the government of Milan was therefore in the hands of Ludovico il Moro, but his rule only had temporary legitimacy and therefore he was obliged to use his political skills to control the duchy while the legitimate heir was still alive and well. Moreover, Gian Galeazzo had the protection of the Neapolitan court, which aspired to see Isabella fully recognized in her role. The illegitimacy of the Milanese government would remain a thorn in Ludovico's side throughout the period of his rule, and he was forced to preserve his influence through shrewd and intelligent political manoeuvring as well as to resort to full-scale cultural propaganda in order to secure his reputation as a true Renaissance lord at his nephew's expense.

Having eliminated his most dangerous enemy by executing Cecco Simonetta in Pavia on 30 October 1480, Ludovico consolidated his power and his image by transforming and modernizing the court. For this purpose he summoned to Milan the best artists and intellectuals; the idea was to give a territory that was very productive and well administered the prestige of being a centre of cultural civilization. The area around Milan was rich in manufacturing industries, which had burgeoned after the introduction of the silkworm (the *morón* that some believe gave Ludovico his nickname, Il Moro). Moreover, the economy benefited from a well-developed system of water transport on canals [*navigli*] that was unmatched in Italy. The textile industries of wool, linen and leather flourished, as did the manufacture of arms and metal goods. All these activities had been encouraged through the careful policies of Ludovico's father, Francesco Sforza, who had seen the potential of a fertile territory at the crossroads of the major European trade routes. To judge from contemporary accounts, the area seemed an earthly paradise to travellers:

> Coming down from the mountains you see the plain of Lombardy which is one of the most beautiful and richest in the world and the most populous. Although it is flat, it is nonetheless difficult to ride across because it is full of ditches, even more so than Flanders. But it is much better and more fertile, both in good crops and good wine and fruits, and these lands are never at rest.[4]

The hard-working nature of the inhabitants was already a distinctive characteristic of the region, which was also very advanced in terms of bureaucratic administration. While Francesco Sforza had rationalized and stimulated the economy and the manufacturing guilds, Ludovico wanted to build a capital city that would rival Florence and Venice for its beauty and culture. He did so by promoting the universities as well as the city's artistic and architectural achievements. From the 1480s Milan would become a city of 'immigrants' whose role was to bridge the cultural divide that separated it from Florence, whose university, the Studio Fiorentino, had been regarded with interest for decades, all throughout the known world. From this viewpoint, it is not surprising that Leonardo decided to try his fortune here.

Among other things, Ludovico's interest in war was far greater than that of the Florentines, who were accustomed to ruling through the strength of their banks rather than through armies. Ludovico had occupied Milan by marching in at the head of an army, which conquered in a short time a number of strategic fortresses in the duchy. He was a military commander capable of assessing the efficacy of offensive weapons. In 1480 Leonardo believed that he could offer a number of excellent ideas on the art of war, including 'secrets' for military machines and fortifications; he began to develop them while working in Verrocchio's workshop, where the best quality bombards were cast. Leonardo was also a good musician and, according to Vasari, he and his friend Atalante Migliorotti were sent to Milan by Lorenzo the Magnificent in 1482 to present a beautiful lyre to Ludovico.

The strange letter of introduction sent by Leonardo in the hope of being engaged at Ludovico's court has survived from this visit. Contrary to expectations, the painter (and it is only as a painter that we know him up to this date [1482]) presents himself to Il Moro as possessing a range of different skills and mentioned the one for which he was famous, talent as an artist, only at the end of the letter. Luckily the minute of the letter has survived in Leonardo's Codex Atlanticus, otherwise its extravagant nature might have passed for the invention of an imaginative novelist:

> I shall endeavour, while intending no discredit to anyone else, to make myself understood to Your Excellency for the purpose of unfolding to you my secrets, and thereafter offering them at your complete disposal . . .
>
> 1. I have plans for very light, strong and easily portable bridges with which to pursue and, on some occasions, flee the enemy, and others, sturdy and indestructible either by fire or in battle, easy and convenient to lift and place in position. Also means of burning and destroying those of the enemy.
>
> 2. I know how, in the course of the siege of a terrain, to remove water from the moats and how to make an infinite number of bridges, rafts and scaling ladders and other instruments necessary to such an enterprise. . . .
>
> 4. I have also types of cannon, most convenient and easily portable,

with which to hurl small stones almost like a hail storm; and the smoke from the cannon will instil a great fear in the enemy on account of the grave damage and confusion.[5]

It was only at the end of this long list of military services (nine in all) that Leonardo mentioned his artistic skills, which, he suggested, Il Moro could use in times of peace, almost as if these skills would serve to fill in the time when Leonardo would not be engaged in what was his true calling – the military arts. We find that, although Leonardo had produced no sculpture in marble or bronze, and indeed had not even completed a major painting except for the small portrait of Ginevra Benci, he felt able to offer painting, sculpture in marble and in bronze, and even the design and realization of architectural and civil engineering works – all activities that had not even featured in his life until that moment:

> In time of peace I believe I can give as complete satisfaction as any other in the field of architecture, and the construction of both public and private buildings, and in conducting water from one place to another (both for offensive and defensive purposes).
> Also I can execute sculpture in marble, bronze and clay. Likewise in painting, I can do everything possible as well as any other, whosoever he may be. Moreover, work could be undertaken on the bronze horse which will be to the immortal glory and eternal honour of the auspicious memory of His Lordship your father, and of the illustrious house of Sforza.[6]

This penultimate paragraph of the long letter addressed to Ludovico il Moro contains the key to understanding the principal reason, among many other possible ones, for Leonardo's decision to move to Milan. Having slowly usurped the duchy from his nephew, Ludovico now needed to assert himself in the eyes of his subjects as the true and legitimate heir of the house of Sforza, overshadowing 16-year-old Gian Galeazzo, who was confined to a pleasure garden in Pavia where he passed his time playing with women and fountains. Ludovico's father, Francesco Sforza, was the founder of the Milanese duchy and had been truly loved by his subjects because he introduced reforms and sup-

ported the needy; he built the Ca' Grande hospital, a building that was one of the largest in Europe at the time; he embellished and renovated churches and widened the streets and roads to encourage trade, all of which elicited the devotion of the Milanese. For Ludovico, the erection of a monument dedicated to the father of the fatherland would emphasize his direct descent from him and would therefore embody this dynastic continuity.

The monument was crucially important to Il Moro's propaganda and represented the first step towards seducing his subjects. At the time, bronze was considered more prestigious than marble and Verrocchio, for example, had moved from Florence to Venice in order to cast the bronze monument to Colleoni. Moreover, the importance of a bronze statue was directly proportional to the difficulty of its realization. In Italy it was not easy to find an artist who could work in bronze and Verrocchio was one of the few, as he had shown with the almost perfect casting of the sculpture group *Christ and Saint Thomas*, which he had recently completed for the niche of the Mercanzia at Orsanmichele in Florence. Leonardo had certainly been present at the time and may have actively participated in the realization of this bronze group; and now, in the eyes of Ludovico, he put himself forward as Verrocchio's heir.

Following a well-trodden path to emancipation, one that was taken by many pupils at the time, Leonardo challenged his own master by creating a work (or at least attempting to create it) that was identical in subject matter to the one that had made the master famous, in order to show his own superiority and to surpass the master in the eyes of patrons. This risky transition may have been possible thanks to the help of Lorenzo the Magnificent, to whom Ludovico turned for advice, given that the Medici and Florence formed the main artistic centre of Italy – and certainly the only one where bronze sculpture groups could be cast at that date. Verrocchio himself may have supported Leonardo's candidature, too, since he could not aspire to that work himself. Leonardo committed himself to a series of works in spite of his lack – or relative lack – of experience, an act that required him to take his courage in both hands. In addition to the equestrian monument in bronze, which he must have told Lorenzo the Magnificent about, he also proposed ballistic products, again on the basis of his experience

of the bombards produced in Verrocchio's workshop. None of Andrea Verrocchio's pupils had moved in this engineering direction, neither Lorenzo di Credi, who was absorbed in his work as a painter, nor Botticelli, Botticini or Perugino, if it is true that he too spent time in the workshop.

From 1480 onwards Verrocchio was engaged by the republic of Venice to create and, above all, to cast the bronze monument dedicated to Bartolomeo Colleoni, which was intended to celebrate Venetian military valour. The commitment absorbed much of his time and resulted in his making ever more frequent visits to Venice. Ludovico il Moro, who was in open conflict with Venice both politically and militarily, wanted to compete at an artistic level by erecting a monument to Milan's own condottiere; therefore it was natural that he should approach Leonardo, once Verrocchio's pupil but now increasingly in open competition with his former master, especially as the two equestrian bronzes were due to be completed at about the same time. It was this gesture of open competition that finally triggered Leonardo's intellectual emancipation from his master. However, there is more to be learned from Leonardo's reckless professional move. If the artist had the courage to offer these skills to a man like Ludovico il Moro, and if these skills were seconded – as indeed they were – by Lorenzo the Magnificent in a political relationship involving the two leading heads of state, then we must necessarily assume that Leonardo had, at least in theory, developed these skills.

From the timing of these events we can deduce that in 1482 Leonardo da Vinci, now aged 30, must have spent years studying ballistic engineering, casting techniques, hydraulics and civil engineering. Even if no trace of these endeavours has survived, we must also assume that in Verrocchio's workshop, where Leonardo lived at least until 1476, the year in which he was accused of sodomy, he must have developed precisely these skills by dealing directly with the casting of the statue of *Saint Thomas*, which was cast [*gittata*] much later than that of Christ, namely around 1480, when Verrocchio was already working on the Colleoni project.

Therefore, the procrastinating, inconclusive artist who drove his patrons to despair had at least one good reason for behaving in this way, namely that he had dedicated himself to ballistics and casting.

Moreover, of all of Verrocchio's pupils, he was the one chosen to work on the casting operations, both on bombards and on statues, and consequently this activity was known to Lorenzo de' Medici, if not to others.

Lastly, Leonardo's choice to emigrate to Milan must have been influenced by two other factors: first, the circumstances resulting from the denunciation for sodomy were hardly favourable, and, second, the fierce competition among artists, coupled with the increased productivity of the workshops of Botticelli, Ghirlandaio, and Pollaiolo, filled the market with a rapidity that left out the reflective Leonardo, who was struggling for years with one single work without even managing to complete it. In a competitive and productive climate like that of Florence, Leonardo's chances of survival were slim, and indeed his first major commissions had both been failures. Nothing had been seen of the altarpiece for San Bernardo's chapel in the Palazzo della Signoria and only a sketch existed of the *Adoration* commissioned by the monks of Scopeto. Although the latter is now regarded as a work of extraordinary beauty, the disconsolate monks must have regarded the painting with considerable dismay because, although beautiful, there was not a trace of colour on the panel, and for them painting was above all a blaze of reds, blues and gold.

In the light of these remarks, Leonardo's decision seems to have been a masterstroke in professional terms, but also a move that sought a practical outlet for the scientific interests he had cultivated in Florence, in that crucible of ideas and people where the highest expression of Italian humanism emerged precisely from the artists' workshops.

Waiting to welcome him, at the foothills of the Alps, was a land that was rich, fertile and hard-working: it seemed that the only missing ingredient for it to flourish was his genius.

14

AT LUDOVICO'S COURT

Leonardo's move to Milan, which took place between the end of 1482 and the early months of 1483, was a success both for him and for his patron Ludovico il Moro. Within the space of a few years the artist's name appeared in a text by the poet Baldassare Tacconi that praised the wonders of the 'colossal horse' Leonardo had created: it was standing, an astonishing seven metres high, for all to see in the old courtyard of the Sforza Castle around 1493. But the work was not progressing as well as the poet hastened to celebrate, perhaps with excessive optimism. The project for the huge equestrian monument in bronze is without doubt the key reason why Leonardo came to Milan, although we do not know precisely when he started work on it. His sketches can be dated approximately to the second half of the 1480s, and by July 1489 we know for certain that matters were not going smoothly and that the first in a series of failures that would weigh on the artist for many years to come were looming on the horizon. The Florentine ambassador in Milan wrote directly to Lorenzo the Magnificent to ask for other artists who could successfully complete the project, because the duke had told the ambassador that he doubted Leonardo would be able to do so alone. The letter is quite clear in this regard:

The Lord Ludovico has in mind a worthy tomb for his father and he has already ordered Leonardo da Vinci to make the model, namely a huge bronze horse mounted by Duke Francesco in armour; and because His Excellency wishes to make a work of a superlative nature, he has asked me to write to ask you to send one or two *maestri* more suited to this work; and although he has commissioned Leonardo da Vinci to undertake the work, I do not think he is truly confident that he knows how to complete it.[7]

These circumstances revealed Leonardo's excessive self-confidence in all its fragility. He would never lose it until his dying day; it remained apparently unshakeable even after the worst failures and would constantly lead him to embark on endeavours he was unable to complete. The colossal equestrian monument, for which the artist was certainly paid a stipend by Ludovico, ran the risk of shaking him for good. The clay model was displayed in public four years after this date, in the courtyard of Castello Sforzesco, and it immediately became one of the city's artistic wonders. However, every attempt to cast the model in bronze ended in failure. Leonardo studied machines and moulds to use during this process, and they are in themselves technological and aesthetic masterpieces, like the casting mould that appears in the Madrid II manuscript [Plate 25], where the head of the colossal horse is shown encased in an armature intended to assure the even distribution of the molten metal. But the beauty and aesthetic perfection that emerge from Leonardo's projects, and from the drawings of his inventions in general, were unfortunately not enough to make them functional. It becomes clear that, by lavishing so much attention on the graphic representation of his ideas, he confused the perfection of representation with the actual possibility of realizing the idea that underlay it.

The clay model stood in the courtyard as a monument to the artist's unrestrained ambition until the French, who captured Milan in 1496, started to use it for shot practice, shattering it to bits. Also during the siege, the metal that had been put aside to cast the giant horse was used by Ercole d'Este to cast cannons, and this monument to war was devoured by the brutality of real war. Fate would see to it with cynical frequency that art and war were closely entwined in the Renaissance and, barely ten years later, the same would happen to the statue of Pope

Julius II cast by Michelangelo in Bologna. Here too the transformation would be brought about by Ercole d'Este, who turned the pope's statue into an enormous bombard nicknamed, with mischievous irony, 'La Giulia'. But Michelangelo had at least succeeded in casting the statue, while all that Leonardo did was to plan the casting without ever completing it (indeed, only a few years later, this was an accusation that Michelangelo actually brought against him).

All that is left of Leonardo's endeavour are the wonderful drawings that reveal the extraordinary originality with which he approached the sculpture. The first design, inspired by classical literature and Roman coins, shows an enormous horse rearing on its rear legs, mounted by a rider whose curved body follows the animal's imposing movement. Such a dynamic sculpture would, of course, have been hugely difficult to create, both because of the narrow support – it consisted only of the rear hooves (albeit strengthened, as is clear from the sketches, by a trunk supporting the right front leg) – and because the distance between the tip of the sculpture and its lowest part was so large that molten bronze poured from the top could not have reached the lowest areas without cooling on the way. In his preparatory technical drawings, Leonardo appears to have preferred casting the horse sideways, using an enormous number of sprues and entry channels. Unfortunately he never discovered whether that network of channels, a work of art in itself, would have worked. The war recaptured its own monument.

15

THE VIRGIN OF THE ROCKS

If the war machines were a fanciful promise, the paintings and drawings that Leonardo brought to Milan were a marvellous reality, and it was these that came to fruition at the Lombard court.

He had barely had time to organize his new house when he was offered a contract, in 1483, to paint a large altarpiece for the chapel of the Immaculate Conception in the church of San Francesco Grande, in the centre of Milan. The Milanese confraternity of San Francesco had been set up in 1479, and the chapel was completed the following year. The Franciscans enjoyed a prominent position in Milan and the Marian cult was celebrated with great devotion in this confraternity, all the more so because a Milanese theologian (Bernardino de' Busti) had perfected the office for the Feast of the Immaculate Conception that was approved by Sixtus IV in 1480. The decoration of the chapel was therefore a matter of considerable importance, and the panel that Leonardo was commissioned to paint would be inserted in a large wooden structure resembling a small temple, which had been carved in 1482 with relief motifs and decorated compartments. Leonardo was asked not only to produce the central panel but also to gild and paint the carved reliefs.

The contract that was drawn up with the members of the confraternity was very detailed, especially with regard to the materials to be

used, and, as was customary in the Middle Ages and the Renaissance, these materials defined the value and importance of the painting. Chief among them was the gold leaf, which had to be purchased from the confraternity itself, and the precious ultramarine blue, the crushed lapis lazuli that represented the most prized element in a celebratory painting. The contract also stipulated the type of medium to be used in painting the Virgin: oil. Oil had to be used to paint the mountains as well, a detail that tells us that the theme and the type of painting had been carefully studied by the monks before its execution. It also reveals that, in the late fifteenth century, oil painting was recognized as a much more precious and refined form of art than painting in tempera, which by then was regarded as obsolete, in northern Italy above all.

Rumours of the artist's legendary slowness and his difficulty in finishing works must have reached the Franciscan monks, since the contract was drawn up with Leonardo and two other Milanese artists, Ambrogio and Evangelista de Predis. The presence of no less than two others who would work alongside Leonardo must have offered a good guarantee for the work's success, or at least for its completion. Leonardo accepted the collaboration, aware that the work would decide his future in Milan, and indeed he was already overwhelmed by so many new interests and speculations that the presence of these two painters would have lessened the burden of work and ensured that he would have time to dedicate himself to other matters. The panel was completed, miraculously and with astounding results, within the space of a few years, certainly by 1486, but fate decreed that patrons would not be satisfied with Leonardo, even in Milan. The painting was so beautiful that the price of 200 ducats agreed before its realization was deemed completely inadequate. The extraordinary success of the painting prompted Leonardo to demand an additional payment, which the confraternity refused to pay in full. Indeed, they only agreed to pay an extra 25 ducats. But then a purchaser, we do not know who, offered to buy the work for an additional 100 ducats – half as much again as the original contractual price.

This dispute is indicative of the changing relationship between artists and their patrons during the Renaissance, because that 'additional fee' referred to, and claimed payment for, something that gave value to the work over and above its craftsmanship and the valuable materials

used (gold and lapis lazuli): the talent of the artist, which was becoming emancipated from the purely mechanical aspects of the work. At the same time, the dispute confirms that Leonardo's position in Milan was much more than that of an artisan, be it one of the highest level. Confronting a patron with a demand of this nature would have been unthinkable if Leonardo had not been able to rely on the support of his protector, Ludovico Sforza, whom some scholars have identified as the anonymous collector who offered to buy the painting for so much more than the original price. Ludovico was aware of the value of the painting and of its political use, and he wanted to buy it as a gift, perhaps for his nephew Massimiliano or for the king of France, as is suggested by a letter written on 13 April 1485 by Duke Gian Galeazzo Sforza to Maffeo Buglio, the Sforza ambassador at the court of the Hungarian king, Matthias Corvinus:

> and since we have heard that His Majesty takes great pleasure in fine paintings, particularly those that are of devotional subjects, and given that there is an excellent painter here, whose genius we have had occasion to experience as being without par, we have ordered the said painter to make an image of Our Lady that is as beautiful, excellent and devout as he knows how, sparing no expense and he is currently engaged on the work, and shall do no other until it is finished, when we shall send it as a gift to His Majesty.[8]

At all events, Leonardo succeeded in selling the painting and undertook to paint another one that would be installed in the chapel only in 1508, over twenty years after the first commission. This accounts for the existence of two almost identical versions of *The Virgin of the Rocks*. The first to be painted, and certainly the one in which Leonardo himself was most directly involved, is now in the Louvre, Paris [Plate 26]. The second, in which Ambrogio de Predis played a greater role (his brother, Evangelista, had died in 1490), is now at the National Gallery in London [Plate 27].

The first painting shows the Virgin in a rocky landscape as she stretches out her right arm to bring the infant Saint John (whose hands are joined together in prayer) closer to the Holy Child seated at her feet. Mary's other hand extends into empty space with magnificent

perspective foreshortening, as if to underline the solemnity of the
moment through that suspended and elegant gesture – an invitation
to keep silence that is addressed within and outside the painting. On
the right, the scene is closed by an angel whose left arm supports the
infant Jesus so that he does not fall into the water flowing just beside
the child, while the other hand points to the Baptist, who is slightly
turning his head towards viewers, to enchant them with his magnetic
gaze and otherworldly beauty. The landscape is barred in the centre by
a rock that forms a natural arch, opening to the left and to the right into
two aerial perspectives whose luminosity breaks the slightly menacing
penumbra that envelops the Virgin. The landscape is painted with a
subtlety that makes it a protagonist alongside the figures themselves;
and it gave Leonardo an opportunity to give visible form to his observa-
tions on the formation of rocks.

The presence of the angel and of Saint John, who were not frequently
Whoever admired the painting at the time and in the place of its
execution could see represented, in a wonderful evocation, the many
legends that had spread throughout central Italy in the second half of
the fifteenth century around the cult of Mary Immaculate. The devout
would place themselves under her protection during times of plague,
the worst scourge of that period – and indeed the population of Milan
was about to be struck by an epidemic of the plague in 1485. The
Virgin, who is shown presenting a young cousin to the infant Christ
with the typical gesture of medieval presentations, coaxing him forward
with her arm and protecting him with her cloak, is the apparition con-
jured up in the Song of Songs ('O my dove, in the clefts of the rock, in
the covert of the cliff, let me see your face', 2.14) and indeed nothing
could evoke this most popular passage in Christian devotion better than
the contrast between the young woman who gently bows her face, as
doves sometimes do, and the rugged landscape behind her. It is a con-
trast that also alludes to the dialectic between a world before grace and
the apparition of grace through the immaculate conception of Jesus.

The presence of the angel and of Saint John, who were not frequently
included in earlier representations of the Immaculate Conception
(although it has been rightly noted that Mino da Fiesole had repre-
sented Mary, the infant Christ and Saint John in a bas-relief carved for
the Cathedral of Fiesole at the end of the 1470s), can be explained with
the help of a popular account in one of the early gospels (James, 17–22),

which tells how, on the flight to Egypt, Mary and the baby Jesus met the young Saint John, who lived in a cavern in the wilderness, protected by the angel Uriel. By definition, landscapes with hermits are rugged and inhospitable, and Leonardo's representation is linked to this iconographical tradition, showing the rocky grotto where Mary found refuge and where the future Baptist lived in solitude. The presence of water in the foreground of the painting, into which Jesus seems almost ready to fall but is held back by Uriel's caring hand, alludes to the future baptism, and in one of the first paintings on which Leonardo worked Christ and Saint John the Baptist met on the exposed bed of a river.

But the presence of the young Saint John was significant to the Franciscan patrons in other ways too. The first name of Saint Francis was Giovanni [John], and the Baptist was particularly dear to the saint from Assisi. The rocky landscape also alluded to Saint Francis because it was among the rocks of La Verna, the Umbrian mountain close to Assisi, that Saint Francis received the stigmata that brought him closer to Christ. The allusive motifs of the surroundings were therefore extremely important for the story that Leonardo wanted to tell, because the altarpiece was intended to be not only a static representation but also a story; it captured and stopped the image of an event unfolding before our eyes, as is underlined by the gaze of the angel, who looks out towards the viewer with his index finger pointing towards the young Saint John.

The other inanimate presences also add to the celebration of the virtues of the Virgin Mary Immaculate at the centre of the painting. The water behind Mary is the water invoked by the early Marian exegetes, who linked her name to that of the sea; and thus, just as all rivers flow into the sea, so all grace meets in Mary, whom the preachers evoked as 'a vein of the purest water'. Other allusions to the Virgin's grace and to her story have been highlighted – with varying degrees of success – by the scholars who have interpreted the painting. The palms on Mary's right recall an exotic setting (Egypt) but also Mary's glory, while the lance-shaped leaves of the irises by Saint John's feet allude to the daggers that would pierce the Virgin's heart at the time of the crucifixion. This interpretation of *The Virgin of the Rocks* as 'the Virgin of Sorrows' has been argued by authoritative theologians and scholars, but the context for which the panel was intended leaves little doubt that Leonardo

wished to show an episode in the life of the Virgin Immaculate and that this interpretation would be evident to his patrons and to others who saw the painting.

These devotional aspects of the painting, designed to meet the patrons' requirements, were set out in considerable detail in the contract drawn up in 1483, but they only partially reflect Leonardo's interests. His attention and his greatest efforts were concentrated not so much on *what* had to be shown as on *how* to show it, and it was here that the artist's interests become clear, focused as they were at the time on natural sciences and, above all, on the theory of shadows, starting with his studies on optics and the propagation of light.

Turning to the scientific significance of the painting, it has been widely emphasized that the depiction of the rocks corresponds to an exposition of Leonardo's theories on how mountains were formed and on the life itself of the earth, which, as he wrote in his notebooks during these same years, he associated with that of the human body, where the rivers were the veins and the rocks were the bones. Using painting to anticipate, as usual, results that he would reach through a more systematic analysis in his codices, in *The Virgin of the Rocks* Leonardo notes with painstaking care his views on the transformation of rocks and his theories concerning their formation. The grotto that serves as meeting place between the Virgin, the Holy Child and the young Saint John is a catalogue of the most complex rocky formations,

> produced by the intrusion of an extremely hard igneous rock, diabase, into a soft layer of sandstone, one of the most commonplace sedimentary rocks. Both diabase and sandstone seem to be weathered by atmospheric agents, and Leonardo has precisely shown how the surfaces of the two rock types have been eroded in different ways as a result of their different hardnesses.[9]

His scrupulous observations of rock structures made during trips to the mountains around Milan allowed him to paint the precise rounded formation left by erosion in the soft sandstone, in contrast to the sharp splinters of the hard diabase. And, as if that were not enough, even the plants growing among the rocks conform to the precise laws of biology that Leonardo had observed and understood. At the lower left-hand

corner, beside the pool of water, he painted a yellow iris (*Iris pseuda-corus*), which grows close to water, even if he has given the lower part of its lanceolate leaves a spiral form. Much further from the water he painted a palm (genus *Raphis*) that grows in dry conditions. The other plants identified by scholars all have a symbolic value, but at the same time, among the various possible symbolic representations, Leonardo chose those plants that conformed to the geological nature of the site and to the chosen season (March–April). Thus he replaced the roses, which symbolize the purity of Jesus, with a bunch of primulas (*Primula vulgaris*), and again beside the child, he painted anemones (*Anemone hortensis*), which traditionally flowered on Mount Calvary under the Cross, where drops of blood fell from Christ's wounds. Nor could the millenary symbol of the resurrection be left out of the painting: that is the acanthus plant (*Acanthus mollis*), which grows in abundance under Saint John's feet. Lastly, to reinforce the allusion to the image of Mary as a dove among the rocks, Leonardo paints a prominent and well-lit clump of aquilegia (*Aquilegia vulgaris*), commonly known as 'colum-bine', as a reference to the previously mentioned passage from the Song of Songs.

Of course, it was not Leonardo's botanical and geological exper-tise that made the painting so astonishing that its value went up by over a half. Whoever saw the panel in the artist's studio around 1490 would have had the impression of encountering something that had not been seen before, in Italy or anywhere else: the beauty of the faces, certainly – the Virgin was almost an angel herself, given her youth – the regular physiognomy of the oval but sweet and rounded face, the three-quarters pose of the beautiful Uriel, from whose pointed finger one might almost expect a ray of light to suddenly emerge; the golden hair of both, with even curls that frame the face in pure light, so soft and radiant is its colour. Such naturalness had never been seen before in the positions of Jesus and Saint John, two infants, little over a year old, whose arms and legs still had that chubbiness that was so prized by parents and pedagogues at the time.

Another element that had never been seen before was the light, which presented the scene in the painting in an entirely new manner. Here there is no sharp contrast between shadows and lights and it is always difficult to see the line between them. A clearly defined border

must never be perceptible between light and shade because this gives the image a wooden – today we might say calligraphic – appearance, which was a characteristic of almost all the paintings of contemporary Florentines. Here the transitions between light and shade are perfectly softened thanks to a refined pictorial technique. But it was not merely an extraordinary manual talent that made these transitions so beautiful. Underlying this talent was Leonardo's theory of optics, which enabled him to understand that the body reflects light in its own way and that, even in areas in shadow, there are secondary lights that round out the volumes, making them visible. This happens especially if, instead of the midday hours, when the light is strongest, especially outside, one chooses to study the models or make them pose in late afternoon, when the light starts to soften, and in an enclosed courtyard permeated by reverberations. In that atmosphere faces look more beautiful, the physiognomic contrasts are mellowed, and no one looks ugly or cross. Light pervades the painting and guides the eye first to the figures and then, after the dark caesura of the rock skilfully placed behind Mary's pyramidal outline, it bursts out again in those two wide clefts that lead to a far-off sea, where the snow-covered rocks vanish into the atmospheric mists. On the other side, the view into the grotto places a rocky pillar at the centre around which the light revolves, deepening the penumbra that plumbs the depth of the cavern.

It was a theory that turned into practice under the astonished eyes of the Milanese, rich and poor, lay and devout. But this theory of shadows involved a new and revolutionary theory of colours. Leonardo had noticed that colours do not exist alone but only in relation to light, and that it was only in full light that colour reached its fullest tonal saturation, while its tone faded in shade and the stronger the shade the less bright the colour became. The theory of tonal painting overturned the late fifteenth-century techniques, which were operating through abstract juxtapositions: a red mantle was always red, regardless of whether it was in light or in shadow, and in the latter case it would be covered with a light layer of black or brown: 'The quality of colours will be ascertained by means of light and it is to be judged that where there is more light the true quality of the illuminated colour will be seen.'[10]

In an attempt to explain his discovery, Leonardo defines it as a chromatic perspective, because colours fade according to the intensity

of shadow just as, in a composition in perspective, heights diminish in proportion to drawing closer to the vanishing point on the horizon. These principles were based on Leonardo's experience and did not by themselves guarantee the success of the painting, because, as usual, it is impossible to distinguish between the role played by science and that played by art in the artist's work. Certainly in art he reached heights that were entirely satisfying, and it is difficult not to suspect that, merely by organizing the results he had achieved through his pictorial sensitivity, Leonardo derived the optic principles that he then attempted to order into analytical theories in his writings. The sense of an airy, soft atmosphere that pervades the scene is the result of his visual sensitivity; light, shadows and colours can be studied in depth, but they will not guarantee the result achieved in the painting. If Leonardo had had access to a realistic set such as the one seen here and if, paradoxically, he had been able to re-create the light of the painting, the results would have been very different.

Although mentally the artist needed to order his sensations and to convince himself that he was following a rational theory that he had just discovered, in reality he was moved by the pure strength of his imagination. The perfect choreography of Mary's foreshortened left hand and the unusual length of Uriel's right hand, as well as their protective gestures towards Saint John and the infant Jesus respectively, form a *commedia* of emotions that moves the viewer owing to its perfectly calibrated gestures. The same can be said of the intervention of the openings in the rock, which only the artist could have imagined: they are small enough to distract the viewer's eye towards the light while redirecting it back again and again towards the Virgin's face.

It is no coincidence that, beyond all theories of light and colour tonalities, the preparatory drawings that have survived from Leonardo assure us that his creative impetus focused precisely on the perfection of these gestures. For example, the Windsor drawing [Plate 28] shows the study of Uriel's gesture refined to perfection. The sublime elegance of this gesture can only be grasped from the drawing. It is worth dwelling on the actual pictorial method through which Leonardo achieved such exceptional results of form. While *The Virgin of the Rocks* in the Louvre has not yet been subjected to a detailed analysis through the new diagnostic techniques, its 'twin' in the National Gallery has been,

and the results can certainly be extended to it, since it is unthinkable that Leonardo would have changed his pictorial technique within the space of a few years.

Judging from what we know of Leonardo's procedure at this time, he prepared the poplar planks using a coat of smoothed plaster and glue, onto which he then transferred the drawing from the preparatory cartoon for the first time; then he went over it with a brush dipped in black pigment. In this phase he had good control of the composition and could check the suitability of the poses, gestures and proportions. Immediately after this, Leonardo covered the entire panel with an *imprimitura*, namely a greyish, transparent priming layer composed of oil, lead white and charcoal pigment. This had the dual aim of saturating the plaster and glue and rendering them impermeable, so that subsequent coats of oil paint were not patchily absorbed; at the same time, although the preparatory drawing was partly obscured, it was sufficiently visible and could be retraced with a second preparatory drawing, or even changed if necessary. At this stage the artist retraced the preparatory outline in a darker and heavier medium and then applied a second *imprimitura*, which also contained yellow, in order to create a base that gave a uniform tone to the painting and contributed to its final unity of colour. On this second, coloured priming layer, which was essential for defining the overall chromatic result, the preparatory drawing was, again, retraced using brushstrokes of heavier paint that, in the case of *The Virgin of the Rocks* in the National Gallery, contain yellow, natural earth, brown and black.

The study of the shadows started at this stage and contributed to the progress of the actual painting itself. Since Leonardo was aiming for a final tonal unity, one that softened the contrasts between colours, achieving expressive relief even in monochrome helped the subsequent phase of colouring, which would be limited to very transparent glazes; in substance, these *velature* coloured lightly both the shadows and the highlights, which had already been finalized using the yellow and black oil monochrome, so at this point the volumes were fully defined. It would be more accurate to talk of a monochrome painting than of a second preparatory drawing, which the artist used to finalize the image. This was the base on which Leonardo then proceeded to paint, using the actual colours, diluted either in linseed oil or in walnut oil, depend-

ing on his need for various densities of medium and for drying times that varied accordingly.[11]

These tests have revealed the extraordinary simplicity of the chromatic blends used by the painter. Given that the relief and, in essence, the image were already defined though the monochrome preparation, complete with an accurate study of the transition from light to dark, the colour *velature* are extremely simple and are applied in a few transparent layers. The sky, for instance, consists of an initial layer of lead white and azurite that already gives a blue tone, and it is then finished simply with a light glaze of precious lapis lazuli blue. The result of tests on the flesh areas is surprising: they reveal a mix of lead white, a touch of vermillion, red lake and sometimes black in the deepest shadows, or brown earth. These are the pigments used by all painters in central Italy and they show that, contrary to the many suppositions and legends regarding Leonardo's pictorial technique and his *sfumato*, he did not have a special technique of painting but simply used the current one in a very special way.

Technically, the true singularity of his painting is the accuracy of the monochrome drawing that he had learned to use in Verrocchio's workshop and that allowed him to control the entire painting, in terms of the light rather than tone. Leonardo paints with shadow what all the others paint with colour. The outcome of *The Virgin of the Rocks*, now in the Louvre, was a very new combination of tone and light, one that would harden, as we shall see, in the copy made for the confraternity because in this second painting Leonardo did not put the same commitment and the same degree of presence as he did in the first.

16

PORTRAIT OF A LEGEND

Beauty, elegance and intelligence are qualities that admirers are willing to recognize in the powerful and, even more, in anyone who is an object of desire for the powerful. Adulatory and elegiac texts enjoyed considerable success at the Renaissance courts, so much so that suspicions often arose regarding their sincerity. It was a different matter when these qualities were recognized by enemies who surrendered to the fact that such attributes formed an obstacle to their designs and to the attainment of their interests. The beauty, intelligence and elegance of Cecilia Gallerani, the young favourite of Ludovico il Moro around 1490, were not the result of courtly exaggeration, given that these gifts were acknowledged by the Ferrarese ambassador in Milan, Giacomo Trotti, who in 1490 described her to his master, Ercole d'Este, as being 'as beautiful as a flower'. Ludovico il Moro was passionately in love with her and could not bring himself to marry Ercole's daughter, Beatrice d'Este, to whom he had been betrothed *per verba* since 1480. Beatrice was not very beautiful, nor did she possess courage – like her sister, Isabella d'Este. Isabella was renowned for her extraordinary personality; indeed she was so unconventional that she maintained a long and affectionate friendship with Gallerani after the latter had left the Milanese court, thus leaving the way clear for Beatrice, who settled there in 1491.

Cecilia was a girl of bourgeois origins, the granddaughter of a Tuscan exile and Ghibelline supporter, Sigerio, who had left Siena to move to Lombardy. Cecilia's father, Fazio, held various administrative positions at the Sforza court and had a number of sons who embarked on ecclesiastical and administrative careers. He died on 5 December 1480, aged 66, leaving six children, two of them daughters: Cecilia and Zanetta. Cecilia had Latin, a rare accomplishment at a time when girls were taught to read and write just enough to be able to correspond and, if necessary, give orders for the running of a household. She also had a great passion for literature and poetry, even composing verses that were never made public but were well known in late fifteenth-century Milanese literary circles. The time had not come for the public consideration of female creativity, but Cecilia was opening the way to the poetesses of the following generation: Vittoria Colonna, Veronica Gambara and the others. The lack of public acclaim played in her favour: it exempted her from the competition that oppressed male poets, who were compelled, like Bellincioni, to challenge one another in rhetorical and artificial compositions that did nothing to improve the quality of their work.

Cecilia's innate grace and her genuine love of literature soon made her the doyenne of letters at the Sforza court in the late 1480s, when she was barely 17 years old (she was born in 1473). She managed to keep this position even in the 1490s, when she was no longer Ludovico's lover and married, in 1492, Count Ludovico Carminati of Brambilla, known as Bergamino, with whom she had three sons. Cecilia's affair with Ludovico il Moro dated from around 1487–8, when she was little more than an adolescent, and continued until 1491, when she gave Ludovico a son, Cesare. This relationship caused considerable concern to Ercole d'Este and did not help Ludovico's political position, since he could not renege on his betrothal to Beatrice without risks. Beatrice, on the other hand, even after she had moved to the Sforza court with considerable ceremony, did not tolerate the presence of her rival, whose charms were still all too apparent. Beatrice's jealousy was matched by Ludovico's intolerance, as he continued to court Cecilia, showering her with benefices, helping her brothers and even offering her the lands of Saronno as a farewell gift in 1491.

Renaissance society was prudent and tolerant in distinguishing

between amorous relations and matrimonial ones and in accepting the former – the latter were almost always the product of political alliances – provided they were contained within formal limits. However, Ludovico showed a tendency to overstep these limits, blinded as he was by genuine love for his young favourite. For example, after marrying Beatrice at a sumptuous ceremony held at the Castle of Pavia on 17 January 1491, the future duke of Milan showed complete lack of tact by gifting the same dress to both women. We can imagine the pride with which Cecilia displayed the precious love token in public and Beatrice's irritation at having to endure public comparison between herself and this beautiful rival, whose looks were naturally enhanced by such a garment. Blinded by jealousy, Beatrice wrote a letter, dated February 1492, in which she stipulated that Cecilia should no longer wear the dress, threatening that, if this were to happen, then she herself would no longer wear it either. The ban and destruction of Cecilia's dress may have resolved the problem of the unequal comparison between the two women, but Beatrice could never destroy Leonardo's portrait of Cecilia, which presents her not only for Ludovico's delight and lifelong admiration, but for that of the entire world ever since [Plate 29].

We do not know the exact date of the painting, although it was praised in superlative terms by the court poet Bellincioni in a sonnet published in 1493. However, Pietro Marani offers good grounds for dating it around 1490, when Cecilia was still about 17 and her adolescent beauty was made irresistible by her refined intelligence.[12] The structure of the portrait is radically innovative by comparison to that of other female portraits from the last quarter of the fifteenth century, which tended (above all in Florence) to show the sitter in profile or in a three-quarters pose, as in the Flemish style of painting, which was highly appreciated in Milan; it was epitomized in the portraits by Antonello da Messina, which Ludovico il Moro himself had brought to the city. Enamoured of Antonello's style and knowing that the Sicilian painter had a workshop in Venice at the time, Ludovico had used his brother, Galeazzo Maria Sforza, as an intermediary to ask the Milanese ambassador in the lagoon city to engage the Sicilian painter and bring him to Milan.

Ludovico's admiration for Antonello da Messina (1429–79) not only suggests what models Leonardo may have used as the basis for

his portrait of Cecilia but confirms Ludovico's artistic taste, an essential condition to stimulate the artist's creativity. What had drawn Antonello's paintings to the attention of many collectors was on the one hand their astonishing realism – the artist's ability to reproduce the models' physiognomies almost without showing the effort and artificiality of painting on the panel – and, on the other, their successful attempt to reveal, simply through facial expression, the psychological character of the individuals portrayed [Plate 30]. The use of oils, a painting technique that Antonello brilliantly mastered, allowed him to create soft and very natural transitions between colours, and there are no visible lines between the various tonalities and degrees of shadow. This closely resembles what happens in real life; moreover, the absence of background enhances the animated gaze of the figures, offering greater psychological insight. The painter focused all his research on this gaze, and his portraits stare out at the viewer unabashed, provoking sensations and emotions that are sometimes disturbing.

It seems natural to imagine that Ludovico showed Leonardo the portraits by the painter from Messina, whom he so admired, and asked him to pay heed to this manner of painting. Leonardo knew how to do this superbly but went well beyond Antonello's psychological naturalism, because his Florentine roots prompted him to accentuate the idealistic aspect of [Cecilia's] painting. He included a dark background, although luminous in some respects, so as to concentrate the viewer's attention on the model; but the light in which he bathed her seemed to emanate from within rather than fall on her from outside. The static pose of the slightly foreshortened three-quarters position receives movement from the bust's twisting towards the viewer and from the head's turning even more radically away from the bust. Cecilia turns to look not at the viewer but at something that is approaching from behind her, perhaps just a thought or a memory, because her gaze seems lost in space, not alert as it would be in front of a living presence.

The young woman holds an ermine in her arms, and this creature is key to unravelling the symbolism of the portrait. It stands for uncontaminated purity and, according to medieval legend, it will waste away rather than dirtying its white coat. The ermine was also Ludovico il Moro's heraldic symbol, and Leonardo himself had sketched an emblem with an ermine for the duke. Lastly, as many scholars have

noted, Cecilia's surname, Gallerani, alludes to the Greek word *galē* ['weasel'], which designates the small animal prized for its coat. Cecilia cradles it in her arms and the creature is seduced by her distracted caresses, like the mythical unicorn that let itself be stroked by virgins.

Cecilia's garments and hair are typical of what was in vogue in Milan at the time; they are influenced by Spanish fashion, like the silk cloak that rests on her right shoulder and is tied at her waist. According to an inventory of her wedding trousseau, Cecilia owned at least 15 – more than Beatrice herself. Round her neck she wears a black necklace that highlights her pale skin and delicately reflects the gleams of light, expertly calibrated both in the part exposed to the light and in the penumbra. Her hair is caught in a gauze cap tied under her chin, while the rest falls onto her shoulders and is gathered into a thick plait.

By overcoming the naturalism required of the portrait, Leonardo gives it a gentleness that natural imitation alone could never have achieved. Painted in transparent layers of colour, the girl's face contains no shadows to spoil the perfect oval of her cheeks, nose and chin; with its compact inner luminosity, her face resembles a precious gem. There is virtually no sign here of the line: that 'drawing' line, which was the key to Tuscan figure painting, has no place in a painting constructed through elusive passages of light. Cecilia's silky skin is barely dusted by light ripples of shade and colour that exalt the geometric regularity of her features; here the forced anti-naturalistic approach is quite evident and clearly separates Leonardo from Antonello da Messina and Flemish painting. Her nose is only hinted at in a faint darkening of the profile, so elusive that one wonders what brush Leonardo could have used to trace that impression of shade – which, miraculously, restores classical pride to the profile. The shadow of her eyelids is slightly more marked and follows the curve of the eye sockets, highlighted by the paler tone of the skin around the eye.

But it is in the mouth that Leonardo, after lengthy studies, success-fully created his first peerless masterpiece of pictorial *sfumato*. Cecilia's lips are barely suffused with a hint of darker pink and they lift slightly in a delicate smile, or rather in the impression of a smile, suggested by the slight emphasis given to the shadow at the corners of her mouth and to the two highlights on the right side of the upper lip. These almost imperceptible touches of colour, for which the artist must have used

vair brushes containing just a few tail hairs, manage to convey vibrancy to that elusive smile and to the anxiety that surfaces on Cecilia's face; and it surfaces only to be banished, as her mind brings a sensation of peace and serene abandonment, if not true happiness, expressed in ways that befit her elegance.

This sensation of calm is underlined by the presence and physiognomy of the creature, which, thanks to the painter's magical distortion (of which we are almost unaware), is humanized to the point of resembling the girl who has subdued it. We would never have expected an acute observer like Leonardo, 'scientific' to the point of obsession, to produce a representation quite as an unnatural as the ermine held in Cecilia's arms. The animal's paws do not resemble those of a real ermine, and its profile recalls a dog more than an ermine. This distortion [*forzatura*], which is almost unnoticeable thanks to the artist's expertise, is purely a 'mental' ploy used by him to draw the animal closer to the girl and to pass not only the symbolism of chastity, beauty and elegance from one to the other, reinforced as it is by their physical resemblance, but also an estranged beauty that relegates both to a slightly oneiric dimension. Natural verisimilitude, which Leonardo coveted through his empirical studies, was only a starting point in the process of revealing an ideal sentiment, which overcomes natural reality and gains access to a superior world in which only the artist, not nature, can be the creator.

The portrait had a dazzling effect at the Sforza court; even the poet Bellincioni set aside his usually superfluous rhetoric and captured the novelty of its creative process in a sonnet:

What are you angry with? Whom do you envy, Nature?
It is Vinci who has portrayed one of your stars;
Cecilia today is so beautiful that
Her lovely eyes make the sun seem like a dark shadow! . . .
Whoever sees her like this, although it is too late
to see her alive, will say: This shall suffice for us
now to understand what are nature and art.[13]

From then on, the theme of a challenge between artist and nature would engage all Renaissance artists and art critics. Moreover, what

the portrait of Gallerani demonstrates is the artist's absolute autonomy from natural representation – even in an artist like Leonardo da Vinci, who has always been seen as having an obsessive urge to penetrate the secrets of nature. On the contrary, Leonardo uses his research into nature only to give credibility to the representation of an idea that belongs in a world that is above the natural one, the world of the mind and of human inventiveness. Leonardo's ability to surpass nature and to glimpse into what nature reveals, in this case Cecilia's soul and her personality, seems to have been clearly understood by Cecilia and by contemporary collectors, as we learn from a letter written by Cecilia a few years after the portrait was painted and sent to Isabella d'Este. Isabella was the sister of Cecilia's former rival, Beatrice, but this fact certainly did not prevent her from appreciating Gallerani's spirit and Leonardo's talent in portraying her.

Isabella, who was a passionate collector, had heard astonishing rumours about this portrait even in Mantua, where she lived; and she asked Cecilia to lend it to her so that she could admire it and compare it with the portraits painted by Bellini and other artists from the Veneto. Cecilia, who was at the height of her fame, willingly lent the painting to Isabella and sent an accompanying letter that reveals her perfect understanding of Leonardo's art and of his ability to capture the quintessence of her personality and to reveal it more clearly than herself, in flesh and blood. This process whereby the artist surpasses nature, started by Antonello da Messina and carried to new heights by Leonardo in the portrait of Cecilia, would reach its apex a few years later, in Raphael's portraits. It would also find its perfect critic in the words of one of the most astute observers of the mores of his time, Baldassarre Castiglione, who, commenting on Raphael's portrait of Bernardo Navagerio, wrote that it resembled Navagerio much more than Navagerio resembled himself. Cecilia's letter to Isabella in 1497 anticipates that comment, marking the ideal progress made by Italian artists in challenging nature:

> My most illustrious and most excellent, most honoured Lady. I have
> seen what Your Ladyship has written regarding your desire to see my
> portrait, which I am sending you, yet I would send it more willingly if
> it resembled me. Your Ladyship must not believe that this is the result
> of a failing of the master, whom I truly believe to have no peer, but

only that this portrait was made at such an immature age that I have since changed completely in appearance, so much so that, seeing it and myself together, no one would judge that it had been made for me.[14]

Even if the modesty that emerges from Cecilia's letter simply attests to her elegant courtly manners, her words were prophetic to the extent that the portrait has far surpassed her natural life and has consigned her to the imagery of later centuries as one of the most fascinating women to appear on earth.

17

ANONYMOUS PORTRAITS

There are two other portraits that are attributed on good grounds to Leonardo during the same years as the portrait of Cecilia: *Portrait of a Musician* [Plate 31], now at the Pinacoteca Ambrosiana, Milan, and the portrait of a woman today at the Louvre, generally known as the *Belle Ferronière* [Plate 32].

According to some, the first painting was completed in collaboration with Antonio Boltraffio around 1485, four years before the portrait of Cecilia, and it is said to represent his friend, Atalante Migliorotti, a musician and actor with whom he had left Florence. Not only was Atalante a talented musician; he was exceptionally handsome as well. There is no direct documentary link between the portrait and Leonardo, except for an inventory of the collection of Galeazzo Arconati that dates from 1637 and catalogues it as a painting by Leonardo. Although the painting has been accepted as autograph by most modern scholars, it is difficult to reconcile it with Leonardo's style on account of the emphatic contrast of the face – emphatic, that is, both in colours and in chiaroscuro – which clashes sharply with Leonardo's soft manner, already seen in the portrait of Ginevra Benci. Unlike in all the other paintings by the artist, the outline of the profile is very visible, so much so that it would be very easy to create a graphic relief – and the result would be very expressive, too. The pose is quite rigid, the edges are traced using a fine

dark line, and even the hair seems compact and stiffly curled – not like the softly gentle cascades on the angel from the *Baptism*. The eyelids, especially the upper ones, are edged with a continuous dark line that dampens the expression and takes the softness away from the physiognomy and the gaze, leaving them stiff, as in an automaton.

The light to which the sitter is exposed is very different from the indirect light that Leonardo loved and could theorize with great clarity about. It is a harsh light, which draws only some features out of the darkness, almost completely eliminating others. The brushstrokes, which are distinct and full, strongly mark the outlines of the eyelids, the nose and the mouth, and in the slightly melancholic expression there is nothing of the mystery that is evident in other portraits by Leonardo. The colour contrasts are accentuated; the dark chestnut eyes and the brilliant red lips are far away from the faint traces of colour that play on the features of other characters. The clothes seem excessively simple, in broad blocks of colour without any careful study or surprises, even if its present condition may in part be due to a heavy-handed restoration. Even if Leonardo did contribute to the planning of this painting and played a role in its execution, another artist worked on it, moving it further away from the pictorial poetics of the master – if by 'pictorial poetics' we understand a precise way of re-creating the image and placing it in space and light without ever exaggerating the tone of the shadows and the chromatic contrasts but, on the contrary, allowing the face and the expression to emerge from the effects of the light and from the substance of the fabric, be it textiles or tissues of the body.

The painting of the *Belle Ferronière* is very different. This portrait of a woman, made on a walnut panel measuring 63 × 45 cm, dates from around 1490 and is therefore closely associated with the portrait of Cecilia. Again, there are no documents to confirm that the painting came from Leonardo's workshop, but it is universally accepted as an autograph painting of the master's. It was present in Francis I's private apartment at Fontainebleau together with other Italian paintings, including Leonardo's *Virgin of the Rocks* and *Saint John*. Later records of the painting in French collections – in Paris in the late seventeenth century, at Versailles in 1692, and finally at the Louvre by the end of the eighteenth century – confirm a long tradition of attribution.

The title is inspired by the cloth band worn by the model around

her head, with a tiny gem in the centre. Even if the pose is more static than that of Cecilia, the image receives added dynamism from the woman's elusive gaze, which moves beyond the viewer, to fix, with measured concentration, something approaching from the other side of the balustrade behind which she shelters. The physiognomy of the woman, who is elegantly dressed, is much more sensual than that of Cecilia Gallerani, but the skin is rendered with equal delicacy in both paintings. The *Belle Ferronière* has a mouth that, like Cecilia's, is formed through the slight infusion of pink on the lips, while its expression relies on the play of shadow and light.

From a theoretical point of view, the painting is surprising for the reflected lights that Leonardo creates in the shaded areas of the face. By this date the artist had reached an advanced stage in his study of optics, where he explored the effect of lights reflected on solids. Here the direct light that falls on the right-hand side of the face is just slightly more intense than the diffuse light that a reflective surface radiates onto the neck and left-hand cheek. The light is so diffuse that it is almost impossible to see any contrast in the necklace around her neck, which hangs with perfect symmetry in the centre of her breast, well hidden by the velvet and silk chemise embroidered with gold thread, in a pattern of entwined palm leaves and flowers. The border of the hairnet of silver threads can just be seen on her head, gathering the upper part of the plait that peeks out from behind her shoulders and neck.

From a pictorial point of view, the painting seems more mature than that of Cecilia Gallerani, because the tonal harmony (which reinforces the effect of the *sfumato*) is much more effective than in the earlier portrait, where the colours were brighter and more contrasting. The woman's face, as well as her hair and clothing, are all coloured in warm tones, with a filter verging slightly towards red and gold and thus creating an overall vision that is highly seductive and, once again, unrealistic. The tonal unity achieved by using different nuances of red all over the painting produces a rosy haze in which the intimate and dim atmosphere of a domestic interior takes shape. Here again, the lines defining the outline of the nose and eyes have vanished. The upper eyelids are faintly marked by shadow, but the lower ones are almost indistinguishable, except through the warmer tone visible against the white of the eye.

Leonardo carries here much further this process of eliminating the

drawn line; he is no longer interested in describing the model but rather in creating a visual impression. The material consistency of the individual elements of the image starts to melt, as if seen through a rose-tinged glass. Only the light defines the differing intensity of matter, and only light describes the hair (now almost entirely absorbed within a single golden brown mass), the pale skin on shoulders and face, and the fabrics, which lose their tactile quality to become pure, soft colour. The most original effect of this new form of painting, imbued with infinite gradations of light, is apparent in the joining of the chin to the slightly shaded neck, where a thin strip of paler skin, almost a reflection from the shoulder, is used to outline the very gentle curve of the jaw and fades away as the hair starts to curve, highlighting a slight crease in the skin that is smoothed out at the front of the neck.

That sensation of an unfathomable quality in the gaze is created by the luminosity of the woman's eyes; it uses a technique that is more sophisticated than that used in the portrait of Cecilia and far superior to that implemented in the *Portrait of a Musician*. The iris is painted in very pale chestnut colour and, to give it a watery substance, Leonardo darkens the outer edge and lightens the part in contact with the black pupil; he then uses an almost white brushstroke to mark the light, at which the woman is staring and which can be seen reflected in her eyes. As always, Leonardo transposed onto his painting the results of his scientific research, which in these years concentrated on the study of optics and of the mechanisms of sight. The imperceptible luminous dot in the upper part of the pupil condenses the light and reflects the main light source that illuminates the face. This leap forward in the realism of the image – which is not present in the portrait of Cecilia – gives the *Belle Ferronière* an almost disturbing quality, entirely due to the assurance and emotional calm of her gaze, which seems ready to challenge any confrontation. The painting is very important because it offers evidence of the advanced level of Leonardo's scientific research shortly after 1490; and it also helps us to gain a much better understanding of what would soon become the style of his greatest masterpiece, *The Last Supper*, which has unfortunately survived in such a disastrous state of conservation as to be partly illegible.

18

THEATRE AND SCIENCE

Within a very short period, the multiple talents of which Leonardo gave ample proof soon after his arrival in Milan won him recognition as the main protagonist on the artistic, intellectual and social scene at court. Leonardo's growing public acclaim was a reflection of Ludovico il Moro's consolidated political position, since the latter, intent on being accepted as the true duke of Milan, implemented a very shrewd strategy of self-legitimization by strengthening the historic alliances with Florence and Naples and by stimulating Milan's transformation into a capital of European culture – moves that often left the hard-working Milanese astounded at exhibitions of pomp and splendour to which they were not accustomed. The model of propaganda chosen by Ludovico closely resembled the one that had been successfully used by the Medici for the previous three decades, and no one could help him more in this imitation than the great Florentine painter whose complex personality summed up the best qualities of Medicean culture.

A vivid sketch of this strategy and of the splendour attained by the Milanese court by 1490, after the first turbulent years, when Ludovico consolidated his power, is made by Bernardino Corio, an official at the Sforza court and author of a memorable chronicle of Milanese events that is still a key reference for our understanding of that period.

The court of our princes was most illustrious, filled with new fashions, customs, and delights. Nonetheless, at that time the virtues were held in all respect . . . without any concern, many partook of the amorous dance, reputed a wonderful thing by those who knew of it. . . . Ludovico Sforza, our glorious and most illustrious prince, had employed the most skilled men [in all the sciences and liberal arts], summoned from the remotest parts of Europe. . . . And in this vain happiness the most illustrious Sforza princes strolled through the cities and pleasant places of their realm, entertained by diverse pleasures. Thus in Pavia, after the spring of this year, which was 1492, they celebrated the most beautiful jousts, tournaments and mock battles. . . . As has been demonstrated, this illustrious state was established in such glory, pomp and wealth that it seemed possible to attain yet greater power, therefore, I believe, making its violent downfall even greater.[15]

Leonardo played a role in nearly all of these activities; and he did so with such success that they masked the difficulties – all too apparent to Ludovico – that he had encountered in completing the equestrian monument to the duke's father, Francesco. An example of his role as a protagonist in the most magnificent celebrations at the Milanese court is his 'production' of the feast held by Il Moro at the castle on 13 January 1490 to honour the arrival in Milan of Isabella of Aragon, bride of the legitimate heir to the duchy, Gian Galeazzo, by then deliberately distanced from the levers of power. A plague that had lasted for four years had just petered out, having taken numerous lives and threatened the foundations of the rich state:

In the year 1485 Lombardy was afflicted by a great pestilence that lasted almost four years, so that it took the lives of one hundred thousand inhabitants of Milan, and many families were lost to living memory; whereby Lodovico il Moro, as governor and as duke of Milan, ordered that three most solemn processions should take place in succession, in the presence of the young duke, accompanied by all the orders of the City.[16]

The chronicler is certainly exaggerating because the entire population of Milan is estimated at around 150,000 in 1490, second only to

Paris and London, but these were undoubtedly not easy years. This feast was a great success for Ludovico, as it placated – for a while – the king of Naples's dissatisfaction with the treatment that his granddaughter and her young husband were receiving. This success was largely due to Leonardo's brilliant staging, which made the festivities so striking and memorable that their fame soon spread to all the courts of Europe, as Ludovico had requested and desired.

Isabella of Aragon was the second daughter of the heir to the throne of Naples, Alfonso II, but also the daughter of Ludovico's own sister, Ippolita Maria Sforza; yet not even such close family connections diminished Ludovico's desire to remove her and her husband from power. In this dramatic intrigue of kinship and politics, as always in Renaissance Italy, politics and power took precedence over blood ties. The two cousins had been betrothed at very young ages and, once the marriage was officially celebrated, both Alfonso of Aragon and many other rulers at Italian courts would have expected the no longer young Gian Galeazzo to be invested as duke; but no investiture followed. Instead Il Moro arranged what amounted to a segregation of the ducal couple, in complete disregard of the disapproval of the court of Naples and criticisms from half of Italy. In order to silence his critics, at least temporarily, Ludovico wanted to show the world, in grandiose style but with no political substance, his good intentions towards the young duchess by ordering the festivities organized by Leonardo.

The artist, who had a natural propensity for elegance and refinement, dedicated all his skill to the occasion and the evening passed into legend, as can be seen from the fact that a report on it has been preserved for us in a letter from the Mantuan ambassador to Isabella d'Este, who was always eager for society news and gossip. The detailed chronicle dwells on the ceremonial of the dances, but above all on the value of the clothes and jewels – which, as the Medici had already shown, were a visible indication of the power of a ruling house. The letter describes the masques, which were almost certainly invented by Leonardo, since that was one of his passions, judging from the sketches of costumed masqueraders present in the codices; and this interest endured until his last days in France, when he still amused himself by inventing exotic and astonishing costumes. But, as recorded in the

opening pages of this book, at the heart of the festivities was the novelty of the stage machine that Leonardo had designed and built:

Once the dances were finished the musicians remained, by which time it was about half past seven in the evening [twenty-three hours and a half], and the performance commenced. 'El Paradiso' was made to resemble half an egg, the inside of which was gilded all over, with countless lights in the form of stars, with certain slits through which all seven planets could be seen, in order of size, high and low. Around the edge of the aforesaid semi-sphere were the twelve signs [of the zodiac], with lights inside that made a pleasurable and beautiful sight: inside the Paradise were many songs and sweet and gentle sounds.

A number of shots were fired and all of a sudden the satin cloth in front of the Paradise fell to the ground, and a screen [sarzo] was left in front of it until a puttino, dressed like an angel, announced the performance. Once he had finished saying the words, the said screen fell to the ground, and such was the ornament and splendour that could be seen to begin with that it seemed a natural paradise, and the same was true also for the hearing, owing to the pleasant sounds and songs inside it. In the midst was Jupiter with the other planets surrounding it, in order of size.[17]

Stage machines, which had been used in medieval times in passion plays, were relatively common in Italy but, as far as we know, no one had given them such thought and genius ever before, turning this device into a little masterpiece of architecture and mechanics. The guests were impressed, and this general sense of satisfaction was not lost on either Leonardo or Ludovico. Many other accounts have survived of festivities organized by Leonardo with great commitment and, it can be assumed, with great panache. One of the most elaborate was for a performance of Orfeo by Angelo Poliziano for which Leonardo designed a mechanism that made an enormous globe rise up from the floor; and on it sat Pluto, king of the underworld, addressing the poet in grim and terrible language. Never before had science entered the halls of the Italian courts with such wonders.

19

THE NEW SCIENCE

The central importance that Leonardo acquired at the Milanese court, where he lived alongside the other intellectuals summoned by Ludovico in order to bolster his own reputation and that of the city, stimulated the artist's intention to continue his pursuit of knowledge. Perhaps the most interesting figure he encountered there was Francesco di Giorgio Martini (1439–1501), a Siennese architect and treatise writer whose interests coincided with those of Leonardo. Francesco di Giorgio, with whom Leonardo spent many days during a joint inspection of Pavia, where they discussed (together with Bramante) matters of civil and military engineering, was profoundly aware of the intellectual value of art and architecture. Like Leonardo, he was gifted with the skill of illustrating his inventions through detailed drawings and his *Opusculum de Architectura* (British Museum, London), a codex composed by Francesco prior to his arrival in Milan and of which various fragments survive, is the creation that comes closest to Leonardo's own work, not only in its field of application (the invention of various labour-saving machines for use in hydraulics and engineering) but also on account of the author's drawing skills, which few of his contemporaries could match.

It seems therefore very probable that the elderly architect rekindled the interests that Leonardo had cultivated for years, albeit less systematically, and gave him the idea of 'treatises' – because, prior to this

date (1489–90), there is no trace of any such intention in Leonardo's codices. Whatever the case, Francesco di Giorgio, who was a very practical man, knew how to focus his energies on a narrow field – that of engineering, with its broad links to mechanics and hydraulics – whereas Leonardo was destined from that time on to become dispersive, lost in a nebulous research without boundaries and limits.

This thirst for intellectual development was also linked to Leonardo's need to make up for his illegitimate birth and for his father's refusal to introduce him into the liberal professions. It was in Milan, in what was an animated but at the same time very contained world, that the vicinity of so many intellectuals made Leonardo feel cheated of the education that would have made him a 'man of letters'; and this denial gave rise to regrets that would never be alleviated for the rest of his life. Even as he embarked on the theorization of painting, in order to demonstrate its conceptual rather than mechanical nature, foremost in his mind was the need to show how, through painting, he could attain the position that his illegitimate birth precluded. Francesco Guicciardini, like all the sons of wealthy Florentine merchants, had started to study Latin at the age of six, something that Leonardo had been denied; and yet, having achieved pre-eminence in Milan, he set out to bridge or attempt to bridge that gulf by learning Latin at the tender age of 40. His ambition to become familiar with the classical language was also linked to the possibility of accessing those sources of ancient knowledge, given that so far none, or very few, of the key texts handed down across the generations had been translated into Italian. It was no coincidence that Francesco di Giorgio, too, was working on a translation and new edition of Vitruvius.

The desire to give some order to that chaotic thirst for knowledge and to his jumble of observations and speculations prompted Leonardo in the 1490s to formulate a genuine programme of research. On the one hand, the artist tried to learn Latin; on the other, he avidly collected existing copies of ancient texts, be they newly printed editions or old manuscripts. The first lists of the books that Leonardo was looking for, and indeed actually owned, date from this period. Like in painting, he was determined not to follow his contemporaries but to experiment instead with new forms of representation, letting himself guided by the direct observation of nature; to do so he turned to experience (which

he recognized as the sole source of progress in all forms of knowledge), and, even when dealing with the natural sciences, he suggested that the cultural baggage handed down by academic theories should undergo direct verification through experiments and systematic observations.

In his desire for the empirical verification of knowledge, Leonardo revealed, albeit in a form that was still very confused, a scientific principle for approaching reality that anticipated the birth of modern science. He planned 'books' in which he would systematically report the results of his scientific discoveries: books on the human figure in the form of a manual on anatomy; books on painting, namely a treatise on optics; and a book on mechanics in which he intended to include a treatise on flight. In the years around 1490 Leonardo was obsessed with flight, perhaps because the fantasy of the impossible becoming reality might have been able to show everyone, at one fell swoop, the power of a rational mind capable of observing and understanding the world around it. Avian flight was the test bench for this coveted desire for omnipotence. Leonardo cherished Icarus' legendary dream and, just as he sought to solve the world's oldest mathematical challenge (squaring the circle), he also wished to find the solution to the world's oldest technical challenge: the flight of Icarus – who, not accidentally, was regarded in classical mythology as the creator of sculpture and art.

In these ambitions Leonardo also revealed a childish naivety, thinking that he could transform a human being into bird using mechanical means, or alter the human body through the addition of wings that would overcome the force of gravity. How much his creative fantasy influenced the cultivation of this dream is easy to imagine. Luckily, however, his practical character was not completely overwhelmed by such reveries. Isolated in his dreams, Leonardo confided to his diary, a sort of critical alter ego, his thoughts and fears about his experiments. It was in these experiments that his analytical mind proved to be rational. When he devised the wings to be bound to someone's back with leather thongs and waxed canvas, he took into account the dangers of an attempted flight. He reckoned that it would be better carry out the test flight over a lake, so that, in the event of a fall, the water would cushion the impact. Moreover, not knowing how to swim, he invented a lifebelt in the form of an inflated wineskin that could be tied around his waist and would keep him afloat: 'You will try out this instrument

over a lake and you will wear a long wineskin, so that in case you fall you will not be drowned' (Codex B, fol. 74v).

Yet he could not get rid of the suspicion of being ridiculed for carrying out these experiments; and he was careful to try out the wings at the far end of the old courtyard of Castello Sforzesco, in the same area where he had his workshop for the erection of the equestrian monument to Francesco Sforza. It was, he noted, a secluded spot where he could perform his jumps, safely screened from the stares, certainly ironic, of the workmen who were building the lantern tower [*tiburio*] of the cathedral: 'If you stand on the roof, to one side of the tower,' he wrote, 'the men at work on the *tiburio* will not see you' (Codex Atlanticus, fol. 1006v, ex 361vb). Leonardo was the first to admit that the sight of a man running down the pitched roof with long leather wings tied to his shoulders and then launching himself into empty space would be ridiculous.

Alongside these attempts to experiment in a specific way with a revolutionary machine that would undoubtedly have shown the world his great ability as a scientist, Leonardo planned books that would explain the workings of the world and of the human body. But it was precisely in this field that his intellectual dependence on medieval culture prevented him from overcoming the prejudices inherited from the classical past, which he shared with all his contemporaries. Aristotelian and Platonic systems, Galen's theories, and in general all those systems governed by theology and abstract speculation saw the world as reflecting a superior order; it was a world where everything was the mirror of something else, and thus the human body was the mirror of the body of the cosmos. All Leonardo's experiments that aimed at exploring the world around him were engulfed by this basic prejudice. It was an ideological filter that hindered his scientific examination of nature.

Kepler and Galileo were still far in the future, as was the awareness of a critical and scientific method of evaluating experimental results, and Leonardo could not free himself of the medieval culture that shackled the cognitive potential of the human mind. Despite his extraordinary intuitions and his ability to criticize the 'trumpets' that broadcast a reality certified only through academic authority and not through rational demonstration, Leonardo was not the new man but, if anything, the last of the old men, as Eugenio Garin – the scholar who perhaps got closest

to understanding Leonardo's mind – once remarked with consider-able perspicacity.[18] At all events, by designing a systematic theoretical reconstruction of the world and mankind, Leonardo reveals the limits of his underlying idea of mankind and nature: it was still a religious one, which assumed a creative mind that had devised a single law of development in nature, whereas science would later arise precisely from an understanding of the changing laws that govern natural processes and, above all, of the role that chance played and continues to play in the development of the universe.

The limits of Leonardo's intellectual theory become clear at the moment when he decided to embark on a systematic study of the world. The backwardness of his mental system is encapsulated in a passage in Codex H, a notebook he kept during his years in Milan:

The beginning of the treatise on water. By the ancients, man was called a lesser world, and certainly the use of this name is well chosen, given that, as man is made of earth, water, air and fire, his body is similar to that of the earth. Where man contains bone, which supports and provides a framework for the flesh, the world has rocks, which support the ground. Where man has within him a pool of blood and the lungs expand and contract as he breathes, so the body of the earth has its ocean sea, which also expands and contracts every six hours as the world breathes. As veins flow from the said pool of blood and branch throughout the human body, so the ocean sea likewise fills the body of the earth with infinite veins of water. The body of the earth has no nerves, which are missing because nerves are made for the purpose of movement . . . and since no movement occurs, nerves are not necessary. But in all other things these bodies are very similar. (Ms. A, fol. 55v)

This forced simile between the human body and the planet earth is again stressed in another note dating from this period:

The water that rises in the mountains is the blood that keeps the mountain alive. And if that vein is pierced or cut, Nature, which assists its living organisms through its generous desire to overcome the loss of that effused humour, offers abundant help. This is analogous to a con-

tusion in man, where one can see the help provided by the increased
afflux of blood under the skin, which creates a swelling in order to assist
the infected part. This is also analogous to the vine when it is cut at
the very top. Nature then sends from the deepest roots to the topmost
cut place its humorous fluid and, as this poured out, [Nature] does not
deprive it of vital humour until the end of its life. (Ms. H., fol. 77r)

Further on, he continues:

Nothing grows in a place where there is no sentient, vegetative, or
rational life. Feathers grow on birds and change every year. Fur grows
on animals and is moulted every year, except in some parts – for example
the fur on lions' manes, cats and other similar creatures. Grass grows
in the fields and leaves on trees, and every year these are renewed in
great part. Therefore we could say that the earth has a vegetative spirit,
that its flesh is the soil, its bones are the layers of rock that form the
mountains, its cartilage is the tufa rocks, its blood is the watercourses,
the pool of blood lying around its heart is the ocean. Its breath follows
the rise and fall of blood in its pulses, and so in the earth it is the ebb
and flow of the sea; the vital heat of the world is fire that pervades the
earth, and its vegetative spirit resides in the fires that emerge in vari-
ous parts in hot-water springs, sulphur mines and volcanoes, such as
in Mongibello [Mount Etna] in Sicily and many other places. (Ms. H.,
fol. 34r)

The poetic language of the passage is very moving, but it reveals the
mind of an artist, not that of a scientist. The passage is strongly auto-
biographical and recalls the artist's lengthy, painstaking observations of
leaves and grass and his wildlife studies; again, this is very modern but
not exactly new.

At the same time, even the most accurate intuitions and remarks
made in these passages, such as those concerning the rush of blood
to injured parts or the way fluids pour from a cut vine, are lost in the
underlying theory, which comes from outside science and rather sees
the earth as a living organism governed by laws similar to those that
govern mankind. While science today has drawn closer, at a meta-
phorical level, to the idea that our planet forms a single living organism,

Leonardo's evocative image of the ocean's breath refers to something different: to the earth as a living body created by God and ordained in accordance with precise laws that must remain unknown to us.

It is even more painful to see how Leonardo's extraordinary ability for analytical insight is embodied in drawings that are the forerunners of modern anatomical plates, miraculously detailed, yet always interpreted in the light of a 'natural philosophy' of ancient origin that barred access to the ultimate true reality of nature. This certainly applies to the anatomical drawings that Leonardo started to make in Milan around 1490, and that reveal an extraordinary, almost incredible connection with the drawings and anatomical dissections that an unknown youth had initiated in Florence during the same months. The latter was Michelangelo Buonarroti, a rival with whom Leonardo would compete in the years to come. Leonardo dissected a human skull at the beginning of April 1489 [Plate 33] and the extraordinary detail of the drawing continues to mesmerize viewers today. But, while the observation and drawing are such that they could not be bettered by a modern anatomist gifted by some astonishing coincidence with the same talent for drawing, the interpretation of the working of the skull is wholly inadequate because, here again, Leonardo was referring to anatomical theories derived from Aristotle; in this case his understanding was based on the tripartite scheme described by Aristotle in *De anima*, according to which human perceptive and intellectual activities take place inside three communicating ventricles of the brain.

Torn apart by a desire for experimental knowledge and by the need to absorb the store of knowledge handed down from antiquity, Leonardo's life in these years appears to have been a solitary struggle overshadowed by a sense of persecution. In order to overcome his illegitimacy and sense of inferiority as a scientist, his reaction was to make the most of his recognized talent at court. Leonardo used the reputation he had built up as an artist to gain autonomy and respect as a scientist. The only truly concrete result that would emerge from this inner struggle was that he developed his pictorial skills and his talent for drawing to a point where he could express and synthesize scientific concepts that only he could grasp, even if he was unable to decipher them completely. The artist in him was the one who gave form and clarity to the studies on fluids and motion undertaken by the aspiring scientist; and he did

so by using drawings whose graphic perfection made them immediately comprehensible [Plate 34]. The artist was also the one who brought clarity to the design of artificial machines through the linearity of his skilled drawings. The search for a law that bound geometry and the human body together is expressed in the drawing 'Vitruvian Man' made in around 1490, in this feverish intellectual climate of eagerness to discover the world [Plate 35].

In this drawing, which was inspired by the same theme explored by Francesco di Giorgio, Leonardo imagines that the human body can be assimilated to the laws of geometry: the strained interpretation is clear, because both legs and arms are extended in order to inscribe the 'ideal' man inside the circle and the square, yet once again the image, and thereby also the underlying concept, are made to look convincing thanks to their artistic perfection, a seductive substitute for scientific rigour. Graphic perfection dazzled not only Leonardo, but also his contemporaries, and even future generations. The same is true of the anatomical drawings, which from this moment onwards would be seen as Leonardo's most impressive output.

The extraordinary clarity of the images immediately does justice to the acuteness of his observation. The teachings of Verrocchio were applied not only to the task of artistic representation but to that of exploring mankind and the human body. Even Leonardo's ability to make rapid sketches for his drawings became part of this scientific research; but above all it unintentionally became a brand new and revolutionary form of expression. Leonardo learned to annotate, through drawing, the physiognomies of the people he saw in the street; and he followed them for hours, sketching each gesture and movement, each facial characteristic. As many have remarked, this was 'pictorial shorthand' and the artist used it as a summary record of the rapid observations made in the street, but it also had cognitive value because it was already fully expressive. Leonardo's pictorial shorthand could describe with impressive veracity an action that took place before him. While he believed that he was putting art at the service of science, using his manual talent to sustain his intellectual observations, he was unaware that the real science he was creating was that of expression, a unique skill that reached heights unattainable by all others.

Mechanics, physics and physiology, these are all fields in which

Leonardo's contribution is not truly innovative: he remained a dilettante, albeit a brilliant one, because he started with too great a handicap and perhaps the times were not yet ripe for the birth of an experimental 'method'. On the contrary, his drawings became scientific diagrams and succeeded in representing what the artist could not otherwise have shown, because no mathematics for complete diagrams had yet been invented and no physics that could be applied to motion and mechanics. Fortunately Leonardo himself needed to make use of his art as a backing for his scientific ambitions. The latter were destined to disappear into nothingness, while the former continued to justify his presence in the eyes of Ludovico and the Milanese court. While his studies left him exhausted and alone, and also significantly hampered his productivity and therefore his earnings, Leonardo was, fortunately, overtaken by events, bolstered by a natural tendency to enjoy life in all its beauty, from a penchant for elegant clothing to emotional generosity. It was at this moment, at the start of a collision course with the world as he single-mindedly pursued intellectual redemption, that Fortune produced a surprise and a consolation for Leonardo: a very young boy who would go to live with him and would remain close to him for the rest of his life.

20

SALAI

In 1490 – to be more precise, on 22 July – Leonardo was joined at home by a youth who would change his life. His name was Giacomo Caprotti, he was ten years old, and he was beautiful and high-spirited in a way in which only scamps who seduce older homosexuals can be. It is an old tale that has been relived time and again throughout history and would be repeated, with less drama, in the life of Leonardo's rival, namely between Michelangelo and his beloved assistant, Urbino.

The mature intellectual, drained of his creative energy, was captivated by his own reflection in the vitality of this uncultured, coarse and ignorant assistant, who for precisely these reasons was direct and determined, like the whirlpools in the rivers that Leonardo used to stare at in silence for hours on end. Leonardo fell in love with the youth, deluding himself that this love would rejuvenate him or might simply infuse in him some of that vital spirit that he so appreciated in his observations of nature. Giacomo was a champion of unruliness and slyness and his hunger was not only metaphorical, for experience, but also for food, which he devoured at a rate that stunned Leonardo in the first few days. Leonardo ironically commented on the boy's prowess in his diary (Codex C, in this case), in a continuous dialogue with his alter ego: 'Iacomo came to live with me on Saint Mary Magdalene's day in 1490, aged 10' (Ms. C, fol. 15v).

The boy's age should not surprise us, both because the process of growing up, both physically and psychologically, was faster in those days than it is today and because then a youth who was on the cusp of adolescence was regarded as being ready for work and more besides. Parents from modest backgrounds were all too willing to send their sons to a master, even if they were well aware of the sort of requests, not always entirely legitimate, that might be made of their boys. We know this from a letter addressed to Michelangelo in which a loving father, writing to offer his son's services to the artist, stressed that, if Michelangelo caught sight of this handsome youth only once, he would not only want to engage him to work in his house but he would also certainly want him in his bed.

Leonardo's refined elegance and the life he led at court left little doubt about his sexual inclinations, and the old charge of sodomy was certainly bandied as far as Milan by jealous rivals. In a period whose behavioural – and above all sexual – codes are difficult for us to decipher, we can only follow Leonardo's own comments on the events that followed the beginning of that cohabitation. For all his angelic looks and blond curls that fell onto his shoulders, the boy soon proved to be a little devil, and indeed the name, Salaino or Salai, is taken from one of the protagonist devils in *Morgante* (an epic poem by Luigi Pulci that was enormously successful in Florence and in northern Italy from the 1480s on). Leonardo immediately ordered new clothes for the boy, and in repayment the boy stole money from his purse:

> On the second day I had two shirts cut out for him, a pair of hose and a doublet, and when I put money aside to pay for these things he stole the money from the wallet, and it was never possible to make him confess, although I was absolutely convinced. 4 *lire*. Thievish, obstinate, greedy. (Ms. C, fol 15v)

These comments contain all of Leonardo's fascination with the boy's unscrupulous conduct. It never occurred to him, as it did to Michelangelo on more than one occasion, to send him back; instead he took him to dinner with his friend, the architect Giacomo Andrea da Ferrara. Here the little rascal's behaviour became even more insolent: he broke three glass cups and spilled wine on the floor. But Leonardo's

comment, with all its good-humoured irony, reveals an affection that had already overwhelmed him: 'had supper for two and did mischief for four'.

Such remarks continued in the next months, when it becomes all too apparent that the master is by now very taken by his pupil and a note of satisfaction creeps into the reports of his misdeeds. The frequency of entries that refer to Salai is itself a sign of the boy's centrality in Leonardo's life right from the outset, because Leonardo had never written about anyone so extensively and so often as he did about Salai. Almost all the other individuals in Leonardo's life are vague shadows; only Salai, from the moment of his first appearance, is a real-life person in full colour – in flesh and blood and with emotions. On 7 September Salai stole a silver stylus (a nib used for drawing) worth 22 *soldi* from another of Leonardo's collaborators, Marco d'Oggiono, who, unlike Leonardo, had no wish to be gulled by the boy and immediately searched in his box, where he found it hidden.

As time passed the boy's behaviour remained unchanged, indeed his thefts became even more daring. On 26 January Leonardo took his collaborators to the house of Galeazzo Sanseverino, captain at arms and a relative of Ludovico il Moro, who had organized a tournament to celebrate the wedding of Ludovico and Beatrice d'Este in Pavia on 17 January. A pageant had also been held at the tournament with a masqued party for which Leonardo designed fanciful costumes of 'savages', enacting a popular theme in the Renaissance: the contrast between primitive ages and the refinement of contemporary civilization. Leonardo came to Sanseverino's house together with the other players, and there they tried on the costumes under the supervision of their master, who acted like a modern art director at a fashion show. The grooms who were to appear in the pageant undressed in a room and, without a thought, left their garments and their purses on the bed. Salai promptly emptied their pockets: 'certain of the grooms had taken off their clothes in order to try on some of the costumes of the savages who were to appear in this pageant, Giacomo went to the wallet of one of them as it lay on the bed with the other personal clothing, and took some money that he found there' (Ms. C, fol. 15v).

Salai also learned to put his robbery to good use. In February he stole 'a Turkish hide' that had been given to Leonardo by Sanseverino him-

self, and he sold it to a cobbler for 20 *soldi* and with the money bought aniseed comfits. The thefts continued in April; this time the victim was another pupil, Antonio Boltraffio, who carelessly left a silver stylus on a drawing he was finishing. In a nutshell, Salai was not exactly the ideal sort of boy who could be relied upon in the intimate setting of a household, but Leonardo would never be apart from him for the rest of his life and lavished money on him, leaving him all his gold after he died, together with his clothes and the gems he had collected.

The boy was also very vain, or perhaps it was Leonardo who exalted his beauty, celebrating it with the fine garments that he continued to buy for him. To mark the first anniversary of his arrival, Salai received a completely new wardrobe and, as always, Leonardo kept a detailed record: 'The first year: a cloak, 2 *lire*; 6 shirts, 4 *lire*; 3 doublets, 6 *lire*; 4 pairs of hose, 7 *lire* 8 *soldi*; a suit of clothes, lined, 5 *lire*; 24 pairs of shoes, 6 *lire* 5 *soldi*; a cap, 1 *lira*; laces for belt, 1 *lira*.' But a note dated 4 April 1497 – seven years later, when Salai was 18 and must have been a young man in the flower of age and beauty – reveals that the pupil's elegance had become a point of honour for his master, who gave him clothing fit for a prince and certainly very different from the clothes worn by other artisan apprentices: 'The cloak of Salai the fourth day of April 1497, 4 *braccia* of silver cloth, 15 *lire* 4 *soldi*. Green velvet for the trimming, 9 *lire*. Ribbons, 9 *soldi*. Loops, 12 *soldi*. For the making, 1 *lire* 5 *soldi*. Ribbon for the front, 5 *soldi*. Given him 13 *grossoni* 26 *lire* 5 *soldi*. Salai stole 4 *soldi*' (Ms. I, fol. 94r).

We can imagine how passers-by in the street looked in admiration at the elegant master and his handsome pupil dressed in costly velvet with frivolous ribbons fluttering on the front of his cloak. But, to many, the ostentatious sophistication of master and pupil alike seemed out of place, since no employee could have afforded such elegant attire. From the figures recorded in the notebook we learn that Salai's cloak alone cost more than two months' salary of a good employee, hence a sum that was completely out of reach for Leonardo's apprentice. We can also imagine the cockiness with which Salai displayed his looks and elegance in Milan, where men and women spent their lives in the silk- and linen-spinning workshops that spread throughout the city and in the neighbouring countryside. His delinquent tendencies, noted by Leonardo from the first day they met, never changed and in the end led

to his death in a brawl in 1525 – fortunately well after Leonardo had died and thus sparing him that sorrow. But during Leonardo's moment of triumph in Milan, the eccentricity of the master and his pupil fuelled much malicious criticism of their living together – which irritated more on account of their ostentatious elegance than on account of the unusual nature of their relationship.

Idle gossip will always find those eager to listen to it, and a surviving example of the many criticisms levied against Leonardo, although untouchable while under Il Moro's protection, is an obscene sonnet dedicated to him and to all Florentines, who were renowned for their preference for homosexual love affairs. The author of the sonnet, more accurately a biting satire, was a poet from Bergamo, Guidotto Prestinari, self-appointed censor of corrupt Tuscan habits. The fact that these criticisms of the master's lifestyle were to a certain extent public, and even took the form of obscene poetry, testifies to how little he cared for such moralistic judgements, even if in other respects he was obsessed by any possible criticism of his science and his theories. His notebooks are pervaded by the fear that his reputation as a scientist would suffer because he lacked the typical qualifications of university scholars, and above all because he did not know Latin: 'I know well that, since I am not a man of letters, some presumptuous persons will think they may with reason censure me by alleging that I am totally unlettered. Fools!' (Codex Atlanticus, fol. 372v).

Yet at a private level Leonardo does not seem to have cared much about criticism. He continued his social and playful activities, and always found the time to organize festivities and masques, to scrutinize the world around him and in particular other people, their appearance, their strange gestures and anything else that drew the attention of this handsome man of exuberant vitality who, at the age of 40, was an arbiter of fashion at one of Europe's most powerful courts – one that pulsed with feverish development, eager to appear as the sole centre of Italian elegance and modernity. The vacuum of talent, intelligence, and indeed culture that Ludovico il Moro had noted in his prosperous city seems to have been filled by Leonardo alone, so numerous were the projects and initiatives he undertook. Leonardo arranged his workshop so that, together with his collaborators, he could deal with the tasks requested by Ludovico while at the same time, in the midst of

these festive commitments and of a rather complicated domestic life, he started to embark on experimental projects that had nothing to do with the commissions given to him by the duke – as we shall see. In the last decade of the century Leonardo reached the peak of social success, and this raised his ambition to its highest point. But both would be undermined by the failure of the project that was closest to his heart: the equestrian monument to Francesco Sforza.

21

THE PHANTOM HORSE

Shortly after arriving in Milan, Leonardo started to work on the equestrian monument to Francesco Sforza, but the project ground to a halt in 1489, when Pietro Alamanni wrote to Lorenzo the Magnificent on behalf of the duke of Milan to ask for the names of other metal casters. In Milan they had learned to appreciate Leonardo's great talent but also his equally great inconclusiveness, and they had serious doubts about his ability to finish the enterprise.

The first project for the horse was extremely daring. Leonardo, as I have already said, planned to make the animal rear up with the rider in the saddle; this created the challenge of placing all the weight on the back thighs, not to mention the difficulty of making the molten metal flow from the top of the animal's head down to its hooves, a full seven metres below. After the crisis that gave rise to Alamanni's letter, and perhaps thanks to the advice of Florentine metal casters (possibly including Lorenzo di Credi?), Leonardo changed his initial idea and developed a more reasonable design for the equestrian monument – one in which the horse was shown trotting, a pose often seen on coins decorated with ancient monuments; but its dimensions were still colossal.

For this second design Leonardo proceeded to make a clay model that was already being admired by the Milanese in 1493, in the old

court of the Sforza Castle. From this moment on, the work became the talk of all Italy. Poets and writers, trusting too much in Leonardo's skill, started to describe the monument as one of the seven marvels of the world, celebrating it alongside Ludovico's court and politics. Indeed, Ludovico il Moro had finally succeeded in making the other Italian courts pay attention to his duchy, no longer – or not only – for his hard-working subjects and the quality of their industrial products, but for the refinement of his courtiers. Leonardo's fame had spread throughout the peninsula and by 1487 he was included in Giovanni Santi's chronicle as one of the greatest artists. Leonardo was firmly convinced that the equestrian monument would become part of his legacy, and these expectations are amply borne out by his notes, where he appears to convince himself and his patron to complete the most difficult enterprise ever attempted since antiquity:

> If you do not want to make it of bronze, lest it be removed, remember that all the fine objects in Rome were plundered from cities and lands vanquished by the Romans. And it made no difference if they were exceptionally heavy, like the needle [obelisk] and the two horses [Dioscuri]. And if you make it so awkward that it cannot be carried away, it will be made into walls and rubble. Do as you please, because every object will meet its end eventually. And if you say that you have no wish to make something that gives more honour to the maker than to the person who pays, remember that most things honour the name of their maker and not the payer. (Ms. Madrid I, fol. 1r)

In many ways the passage is prophetic. Leonardo understood early on that art could bring eternal fame to the artist rather than to the patron, and today we are well aware that artists have legacies that last much longer than the individuals who commissioned their works. But the passage also helps us to understand the far-reaching motivations and ambitions with which Leonardo approached this work, aiming to make his mark on history and to establish his primacy among Italian artists. It is no surprise that this ambition was not expressed in relation to painting, a field in which he had accumulated greater renown, but rather in relation to sculpting in bronze. Casting was primarily a technical skill, and in this respect Leonardo felt he could draw on

the enormous pool of knowledge he had accumulated over the years through his observations of materials and machines.

In painting there were too many other players, whereas Leonardo had in mind a test that only he could pass. Casting combined all the known sciences and therefore encapsulated that ambition to exert control over the laws of nature, mechanics, pyrotechnics, not to mention every aspect of optics and mathematics, both of which were at this moment united as one in his mind, where they served the quest to create the perfect work of art. Having taken a merciless glance at his contemporaries, Leonardo was convinced not only that their attainments could be surpassed, but that this could only be achieved with the help of science and research, experimentation, and an understanding of the natural world. Leonardo's conviction was that good art could not exist without the study of optics and mathematics, statics and mechanics, let alone the knowledge of almost all the properties of natural materials. This approach explains the important change that occurred in his mind in the early 1490s, at the very time when he met Francesco di Giorgio and resumed the project for the bronze colossus: it was then that he persuaded himself of the need to study and verify virtually the whole span of human knowledge. This was the project that – as we have already seen – prompted him to learn Latin in order to be able to read the classical sources first-hand.

After his fruitful meeting with Francesco di Giorgio, Leonardo followed his example and started to translate and interpret the classical texts directly – Vitruvius above all. During his stay in Pavia with a man who not only shared his interests but also had been able to use them successfully, becoming the mechanical, engineering and pyrotechnical expert most sought after by Italian princes, Leonardo felt compelled to draw up an encyclopaedic programme of study and work.

Get the master of abacus to show you how to square a triangle. Get Messer Fazio to show you [the book] on proportion [Fazio Cardano, a professor at Pavia and printer of John Peckham's *Perspectiva Communis* in 1482]. Ask the friar at Brera to show you *De ponderibus* . . . Ask Maestro Antonio how bombards are placed on bastions by day or at night. Ask Benedetto Portinari how to run on the ice in Flanders. Regarding the proportions of Al-kindi, with notes by Marliano, Messer

Fazio has a copy. The measurement of the sun, promised me by
Maestro Giovanni, the Frenchman. . . . Groups by Bramante, *Metaura*
by Aristotle, in Italian. Try to get Vitolone [Witelo, the thirteenth-
century Polish optical theorist], which is in the library at Pavia and
treats of mathematics. (Codex Atlanticus, fol. 611a)

Seeking out men and books, experimenting with flight and the
laws of fluids, rationalizing the layout of canals in the countryside of
Lombardy, designing the *tiburio* for the cathedral in Milan and the
cathedral in Pavia, casting the bronze horse and planning festivities, dis-
secting corpses to discover the laws of human motion in order to draw
it more accurately: the artist was overwhelmed by a mania for omnipo-
tence in the febrile pursuit of everything that constituted knowledge.
At long last, helped by the advice of Francesco di Giorgio – who had
worked in Siena with Paolo Biringuccio, the greatest European expert
in metallurgy (his son, benefiting from his teaching, would write a
famous treatise *Della pirotecnica*) – Leonardo made arrangements for the
moment of casting.

Leonardo drew the casework in painstaking detail. He decided to
cast the parts of the horse on the horizontal and then to weld them
together, and he asked a number of friends who were knowledgeable
in metallurgy and chemistry to join him; these were old acquaintances
from Florence who would help him in the task. Between 1492 and 1493
he hosted in his house two expert foundrymen, a certain Mastro Giulio,
who was German, and a certain Tommaso (Zoroastro): 'February 1492,
On Thursday 27 September Maestro Tommaso came back and he
worked for himself until the last day of February. On 18 March 1493
Iulio the German came to live with me until 6 October' (Codex Forster
III, fol. 88v). Five collaborators lived with Leonardo in his house in
around 1492, and in 1494 they were joined by a Spaniard: a certain
Ferrando, a painter. Running a household of artists is not simple, above
all when one of them was a light-fingered youth like Salai and another
was a blacksmith who dabbled in astronomy and magic like Tommaso
Masini, who went by the name of Zoroastro and is remembered for
his pranks rather than for his works of art. The household was looked
after by just one servant, poor Caterina, whom some have identified as
Leonardo's mother, who joined him in Milan in her old age so that she

could spend her last days with him (but this hypothesis is completely unfounded).

Even if the project for the horse and its casting served as a focus of activity for Leonardo and his workshop, the artist seems not to have turned down other commissions proposed by Ludovico il Moro. Between 1487 and 1490 he was busy designing a model for the lantern [*tiburio*] of the Duomo of Milan, but his design was rejected in favour of one proposed by the more concrete and practical Francesco di Giorgio Martini. Once again, despite Leonardo's spark of genius and his wide-ranging expertise, when it came to giving tangible form to an architectural project of public significance, his plans were disregarded. The same happened with the commission to cast the bronze doors for the cathedral of Piacenza, a project that Leonardo tried to obtain using a stratagem that was, by all accounts, unusual. The Codex Atlanticus contains the draft of a letter that Leonardo planned to ask a trusted friend to write; the letter was designed to advise the committee responsible for the cathedral [the *fabbricieri*] to give him the job. Leaving aside any pretence at modesty, this imaginary friend, who was none other than Leonardo himself, in his habitual split personality, recommended the artist as the best possible candidate:

> There is no man capable, believe me, except Leonardo the Florentine, who is making Duke Francesco's horse in bronze, although this need not be taken into account because it is work that will last all his life; and being so great a work, I doubt whether he will ever finish it. (Codex Atlanticus, fol. 887r–v)

The passage is certainly unusual and indeed it could perhaps be read as simple fantasy, given concrete form on paper by a mind that was overly engaged in swift repartee with its alter ego. Whereas on the one hand this draft autograph letter reveals Leonardo's praise for himself as the best foundryman in the world, on the other his own mind tells him that perhaps he will not be able to complete the task.

As if the treatises started during this period did not give him enough to do, Leonardo still had to resolve the question of *The Virgin of the Rocks* with the Franciscan friars. His demand for a higher price reveals how profoundly his attitude to the production of paintings had changed.

In the contract of 1483 the monks intended to commission a classic fifteenth-century *ancona*, an altarpiece structure with a monumental frame, carved and gilded, and in the centre the actual painting that, according to medieval custom, was valued more for its gold and lapis lazuli than for its pictorial quality, which for the patrons had no intrinsic value at all. But Leonardo knew that, precisely in the painting of the Madonna, he had produced an artistic miracle, which had nothing whatsoever to do with contemporary artisanal production: there was virtually no gold or lapis lazuli (just a small amount on Mary's cloak), but here was something that contemporaries were not yet able to evaluate, namely artistic talent, which, Leonardo realized, could be turned into economic value.

Private collectors were also aware of that value, and in turn they had started to use works of art as political currency. In particular, an anonymous art collector – whom Leonardo refers to in his complaint – was offering a much higher price for the painting. This explains why Leonardo approached Il Moro with a complaint that stressed how the original price, agreed at 200 ducats, had barely covered the cost of the wooden *ancona* decorated by De Predis and that the painting alone was worth the additional price of 100 ducats that had already been requested.

Notwithstanding that the said two works are worth ccc [300] ducats, as recorded on an inventory by the said suppliants [Leonardo and De Predis] given to the said *scolari* [members of the confraternity of the Immaculate Conception, in the church of San Francesco Grande], and the said suppliants have asked the said commissioners to make the said valuation with its sacrament, but yet they do not wish to make one *nisi de equitate* [unless fairly], wishing to value the said Madonna painted in oil by the said Florentine only at XXV ducats, instead of valuing it at 100 ducats, as stated on an inventory held by the said suppliants, and they have been offered the sum of 100 ducats by persons wishing to buy the said Madonna; hence they are obliged to appeal to Your Lordship . . . *quod cechus non iudicat de colore* [because the blind cannnot judge colour]. . . . Given that the relief work on the said *ancona* alone amounts to the said 800 imperial *lire* that the suppliants have been paid, this sum has been spent on costs.[19]

This financial tussle marks the emergence, for the first time, of an understanding of the value of art. In the end the painters pulled it off because the friars of San Francesco had to settle for another painting that, as was said earlier, would only be finished ten years later. Meanwhile, this plea can perhaps claim the status of being the first modern valuation of a work of art, a valuation that did not use as benchmark the amount of gold and lapis lazuli the painting contained, but rather the artist's talent.

From then on the development of the art market in Italy was open to all possibilities, and Leonardo was paid 100 ducats by the new and anonymous admirer; this sum allowed him to continue working on the project of casting the colossal horse (three times larger than life) that all had admired in the old courtyard. The entire Milan was waiting to see the completion of the miraculous casting, for which, as Leonardo himself would write to Ludovico, he had paid six workers for three years, receiving only 50 ducats in exchange. In 1494 the casting was ready to start: Leonardo's plans have survived and some seventy tons of bronze had been collected. These would have to be poured through the vents and turned into the smoothly rounded features that the artist had compiled from the best horses in the ducal stables, in drawings listed one by one, as if they were human models.

But on this occasion Leonardo's ambition came into conflict with the even greater and more reckless ambition of his great protector, Ludovico, who had isolated his nephew Gian Galeazzo, the legitimate heir to the duchy, in a sort of childish limbo in Pavia Castle. But the duke had misjudged the determination of his niece, Isabella of Aragon, who may have inherited even from him her decisive and wilful temperament. Isabella had no desire to give in to her uncle's arrogant demands; and she urged her grandfather, King Ferdinand of Naples, to entrust the government of the duchy to her husband, Gian Galezzo. In order to counter the threat posed by Ferdinand of Aragon, Ludovico allied himself with the French and supported Charles VIII when the latter invaded Italy with the aim of conquering the kingdom of Naples. This was the first in a series of errors made by an overly cynical and overly ambitious Italian prince, which were to cause atrocities after atrocities in the peninsula, culminating with the Sack of Rome of 1527. But in the early months of this alliance Ludovico appeared to have resolved

his problem. Indeed, Charles VIII's arrival at Asti on 11 September 1494 bolstered Ludovico's confidence sufficiently to convince him to stage the accidental and providential death of poor Gian Galeazzo – who, with admirable timing, died in inexplicable circumstances on 22 October.

Ludovico finally became the legitimate duke of Milan; and, in order to extend his alliances, he offered the young Habsburg emperor, Maximilian of Austria, a huge sum of money together with his own niece, Bianca Maria Sforza, sister of the unfortunate Gian Galeazzo. Everything went according to plan, at least in appearance, until Charles VIII's triumphant conquest of Naples, which prompted fears that Milan might now be subject to the threat of French annexation. At this point Ludovico reversed two major alliances, first by entering a pact with Venice, Milan's historical rival in northern Italy, and, second, by supporting the revolt of Pisa against Florence, the city that had been one of the closest allies of the dukes of Milan for the past half-century. Since he had not hesitated before spilling the blood of his own relatives, Duke Ludovico certainly did not think twice before betraying the friendship of the Florentines. Relying on his warlike past, he prepared to resist the French, whom he defeated at Fornovo near Parma with the help of Sanseverino, his companion in the festivities prepared by Leonardo.

Within the space of a few months the sparkling masques of the 'savages' in paradise and the splendid jousts were transformed into the more sinister gleam of battle armour, and the importance of the equestrian monument to the father of the fatherland [*Padre della Patria*] was superseded by the drumbeat of war. The metal amassed for its casting was used for the cannons that would fire at Fornovo. This change of mind is documented with customary sobriety by a diplomatic dispatch:

On 17 November 1494 the Duke of Ferrara, having been 17 days in Milan . . . received the gift of 100 *miera* [158,700 pounds] of metal from the duke, who had bought it to make the horse in memory of Duke Francesco; the said copper was transported to Pavia, then along the Po to Ferrara, and also Maestro Zanin went with him, to manufacture artillery.[20]

Ludovico il Moro's first political act as the legitimate duke of Milan was to turn the metal destined for Leonardo's horse into weapons. The artist's dreams of glory, which poets had been too hasty to praise, faded as the rounds of artillery echoed over the battlefield. In 1495 the clay model was still there, in the old courtyard, as a testament to the artist's creativity, but even that would not survive the fury of a new war. Defeated at Fornovo, the French withdrew north of the Alps, but after Charles VIII's death Louis XII became king of France and, as nephew of Valentina Visconti, he had legitimate grounds to aspire to the duchy of Milan. Ludovico was in despair. He abandoned Pisa and the alliance with the Venetians, who as a result drew closer to Louis XII, in a move to undermine the unreliable duke. Ludovico's fate was sealed. The French laid siege to the duchy and occupied its capital, Milan, in September 1499.

The city was deprived of its political autonomy for ever, and Leonardo lost his great protector. It was the end of an epoch and once again his ambitions had been thwarted. It would be a work in which he never believed that would bring him eternal glory in Milan and the rest of Italy, a painting he had undervalued to the extent that, in a letter to Il Moro in 1497, he said he was obliged to paint it in order to earn a living and repay the costs incurred for the failed project of the bronze horse, almost as if to equate painting to forced labour.

22

THE LAST SUPPER

While I sincerely regret the need for writing, I regret more that this is the cause for interrupting my desire to obey your Excellency as always . . . And if your Lordship were to believe that I had money, you would be mistaken, because I have kept 6 'mouths' in my household for 36 months, for which I have had 50 ducats . . . I will say nothing about the horse because I know what these times are . . . and likewise I am still owed my salary for two years since.[21]

Complaints about money, its absence or its inadequacy, are common to many artists. With Leonardo such complaints become the underlying characteristic of a constant groping towards grandiose dreams forever interrupted by the very nature of their unrestrained ambition. Searching through Leonardo's chaotic notebooks and letters, it is possible to guess the artist's agitated state of mind in the closing years of the century, when he was burdened by regrets at having been forced to abandon the work in which he had placed all his aspirations for greatness and had resigned himself to focusing his efforts on painting *The Last Supper* in the refectory of Santa Maria delle Grazie [Plates 36, 37, 38]. He was certainly given the commission by a member of the Sforza court, but it is not clear whether it came from Ludovico or from Gian Galeazzo prior to his death, and above all it is not clear when

he received it. He was already working on the painting in 1497, given that Ludovico, in a letter of 29 June to Marchesino Stanga, prompted the latter to urge the artist to complete it: '*Item* to urge Leonardo the Florentine to finish the work that he has started in the Refectory of the Grazie, so that he can then attend to the other work.'[22] The work is not that large and another Renaissance artist would have completed it in a matter of months, but in Leonardo's case we know that the conception and realization of the work could and did occupy the artist for years.

Many scholars are convinced that Leonardo started to study the painting of *The Last Supper* as early as 1492–3, but this hypothesis seems unlikely given that in those years he was very taken with the casting project and would not have had time to dedicate to *The Last Supper*. It seems more likely that the artist's interest turned to this painting after 1494, when the metal destined for his horse was carried off to be turned into bombards. Nonetheless, even in the absence of a firm chronology we can follow the painting's genesis in the very unusual method of its conception. Until then, there is no record of other artists who imagined a scene in the sense of rehearsing it prior to working out the figurative details of the painting. This reversal of the mental approach to a painting stems from his experience of preparing theatrical sets for the Milanese court over the previous ten years. In some folios of the Codex Forster, which can be roughly dated to the period 1495–6, we find the first traces of Leonardo's project, and here it is imagined as a genuine 'stage set':

One who was drinking and left the glass in its place and turned his head towards the speaker. . . . Another speaks into his neighbour's ear, and the man who's listening turns towards him to lend an ear while holding a knife in one hand and half a loaf which he has just cut in the other. Another as he turns with a knife in his hand upsets a glass on the table. Another sets his hands on the table and looks on. Another whistles through his mouthful. Another leans forward to see the speaker shading his eyes with his hand. Another draws back, behind the one leaning forward, and sees the speaker between the wall and the person bending down. (Codex Forster II, fols. 62v, 63r)

Christ Giovan Conte [a condottiere from Tuscany], who works for the Cardinal of Mortaro. Giovannina has a fantastic face and lives at

Santa Caterina, at the hospital. (Codex Forster II, fol. 2r)
 Alessandro Carissimo of Parma for the hand of Christ. (Codex
Forster II, fol. 6r)

The artist wanted to tackle the well-explored topic of *The Last
Supper* from a psychological angle; and he imagines how the scene
might appear if a sensational announcement was made unexpectedly
during a meal, and how it would provoke astonishment among the
guests. He may perhaps have studied moments like this at court festivi-
ties, and he undoubtedly prefigures a language of gestures that can tell
the story, transforming this episode of the gospels, which is generally
summarized by a convivial image, into a genuine narrative. It is true
that another Tuscan artist, Ghirlandaio, whom Vasari describes as also
being part of Verrocchio's workshop, had tried to animate the scene
of *The Last Supper* by grouping the figures in unusual ways around the
table and trying to make the gestures appear natural. But Leonardo
goes much further: the naturalness he sought was not one of physical
congruity, but rather one where the psychology worked. This was a
step forward even from the studies made for the *Adoration of the Magi*,
where he had attempted to represent the wonder, joy and amazement
of a crowd of people from different social backgrounds when they were
faced with the revelation of the divine. The tenderness of the Madonna,
the regal composure of the Magi, the excited amazement of the young
men and the unseemly sense of marvel of the old are all present. In
The Last Supper Leonardo wanted the images to talk to the viewer and
to confide their thoughts simply through facial expressions and hands.
'Another twisting the fingers of his hands, turns with stern brows to his
companion. Another with his hands spread open, shows his palms and
shrugs his shoulders up to his ears, opening his mouth in astonishment'
(Codex Forster II, fols. 62v–63r).
 After placing his characters, just as a director would do with the
actors and as he himself had done at the court festivities, Leonardo
went through all the people he actually knew in real life, in an attempt
to associate them to particularly significant faces – or even hands, espe-
cially because the latter acquired special importance in the play of hand
gestures used to define a temperament or, more precisely, a character.
We imagine, for example, that the beautiful Giovannina, whom he had

seen at Santa Caterina and whose face he admired, might have been the ideal model for Saint John on the right hand of Christ – who, according to an ancient tradition that continued to be used even in later paintings, looked like a young adolescent, a fact that later gave rise to popular fantasies regarding the presence of a woman beside Christ.

Leonardo's note, whose laconic nature gives it a ring of truth, allows us to look deep into his creative process at this time. It seems to be apparent that, alongside radically innovative elements, others still persisted from the fifteenth-century tradition. On the one hand, the idea of a painting that expresses psychological emotion is very modern: it grew out of the studies on physiognomy that Leonardo had undertaken a decade earlier and, more generally, it projects artistic creation towards new goals. On the other hand, the use of real figures as models for the painting highlights a form of naturalism that still held Leonardo in thrall, while other artists were already questioning it at around the same time.

The idea that nature alone could be the mistress of art is constantly underlined in the treatise on painting on which the artist was working at this time. Nature was the only mistress of art and imitation of nature was a safe guarantee of successful representation. Singling out the subjects to be copied – the condottiere Giovan Conte for the figure of Christ, but with the hands of Alessandro Carissimo of Parma – was a collation process that reflects a very old, certainly fifteenth-century idea. Michelangelo, Raphael and the artists of the following generation would reject this procedure and turn to a creativity that focused entirely on the artist's imagination, taking its cue from nature but superseding it through artistic talent. When Raphael was asked how he could have imagined his Galatea twenty years after Leonardo's *Last Supper*, he would say that, not having found a woman who satisfied him, he had blended together the beauty of several, in order to reach what would later be termed an 'ideal beauty' that exceeded natural beauty. Michelangelo, on the other hand, who was also interested in ideal beauty and psychological expression, would never have used a precise model for inspiration and his anatomy studies, as detailed as Leonardo's if not even more, sought to attain a perfect knowledge of the human body that he would never imitate but rather transform and modify, in sculpture and painting, in order to make it more expressive and beautiful.

In its own way *The Last Supper* represents a high point of fifteenth-century art, but it is still constrained by that figurative culture weighted down by the need to imitate nature. Only later, when he came into contact with the new generations, did Leonardo become convinced that the path to perfect artistic representation was not through nature but through a more complex transformative process. For the time being, we see him walking, notebook in hand, through a city on edge because of the presence of the French troops at its gates and spying on faces, poses, expressions and details that he could isolate and reuse in his theatre – because this is how he saw it: the table of *The Last Supper* is not a table with the figures seated around it but rather a stage on which the Apostles are lined up on one side, giving the spectator a better view. Leonardo's search for models on the streets of Milan raised eyebrows because such an eccentric figure certainly did not pass unobserved, and even 50 years later a Milanese writer, Giovambattista Giraldi Cintio, was able to describe the event in such vivid detail that it gives even more emphasis and truth to the words hastily scribbled by Leonardo in the Codex Forster:

When he [Leonardo] wished to paint some figure, he would first consider its quality and nature: that is, whether noble or plebeian, joyful or severe, troubled or serene, old or young, angry or peaceful, good or evil; and then, having understood the figure's nature, he would go to those places where he knew persons of that kind congregated and he carefully observed their faces, manners, clothing and bodily movements; and when he found what fitted his purpose, he noted it using a stylus [*stile*] in a little book that he always carried in his belt. After repeating this procedure again and again and being satisfied with the material he collected for the image that he wished to paint, he would proceed to give it shape, and he would succeed marvellously. And, given that he did this in all of his works, he did it with his customary diligence in that panel he was painting in Milan, in the monastery of the preaching friars, in which he painted our Redeemer with his disciples at table.[23]

The process described by Giraldi is also echoed in several passages from Leonardo's treatise on painting, the *Libro della pittura*, where we

also find other ways of getting the best results from this kind of study, for example by sketching people when the light is not too strong at sunset. But Giraldi's lapsus when he refers to *The Last Supper* by calling it a 'panel' brings us to what was the real problem for Leonardo. Although he showed off in every possible way when it came to his imitation of nature, we now know for certain that, for him, the real creative process took place during the compositional phase of the painting when, while working on the chiaroscuro and before any colour was even applied, those effects that gave expression to the pictorial narrative slowly started to emerge. In this respect the panel of the *Adoration of the Magi* is a veritable manifesto of Leonardo's creative technique, and we can imagine his difficulties in approaching instead a mural painting of considerable size.

The wall to be painted measures 460 × 880 cm, approximately 40 m^2, and it was impossible to think that a panel could cover this size. The only possible wall-painting technique was fresco, but for Leonardo fresco imposed an insoluble constraint: the speed of its execution. In fresco painting the colour has to be applied on fresh plaster before it starts the necessary drying process, which generally lasts for a day. This is why the sections of the painting are known as *giornate* [days]. For the same reason, once the plaster has been applied, it has to be painted swiftly, or else the size of the *giornata* section must be reduced; but this presents the risk that, when these sections get dry, the chromatic tones will be different.

Nothing could be more alien to Leonardo than this procedure. For him, the most creative phase of painting started when the scene was reproduced life-size and he would start working on the chiaroscuro, watching it develop, as if it were a real model in which things happened: for instance, over time, the minute gradations of light and shade slowly changed the expression on a face or the melancholic mood of a landscape. Leonardo took ages, working at a very slow rate: where another artist would have taken at most two months, Leonardo needed at least two years. Moreover, his *sfumato* effects were created using layer on layer of transparent glazes [*velature*], something that in fresco painting was impossible. When the pigment dissolved in water is applied, it is absorbed into the uppermost porous layer of the plaster and prevents any subsequent layers from entering the saturated plaster. When

painting a fresco, one has to create the impression of transparency with heavily diluted colours; but, since repeated layers of colours are impossible, Leonardo used pigment dissolved in oil.

Leonardo's very slow technique for *The Last Supper* has also been described by a contemporary witness: the writer Matteo Bandello, who saw him at work throughout the period when the monks (and even Ludovico) despaired of his slowness. But behind this lengthy procedure was hidden Leonardo's search for a perfect imitation of nature.

He used to go early in the morning, as I have seen and watched him do on many occasions, and climb up onto the scaffold, because the *Last Supper* is quite high off the ground; as I said, he used to spend the whole day, from dawn until dusk, with his brush in his hand, forgetting to eat or drink while he painted without a break. Then two, three or four days would arrive when he never lifted a hand, just standing there, one or two hours a day, contemplating, considering and examining, as he judged his figures. I have also seen him (depending on whim or inspiration) setting off when the sun was at its strongest, at midday, from the old court where he was working on that stupendous clay horse, and coming straight to the Grazie; and climbing onto the scaffold, he would take up the brush, give one or two brushstrokes to one of the figures, and then immediately go off somewhere else.[24]

Bandello's testimony, which perfectly captures Leonardo's timing and way of working, defies even Leonardo himself and his theory of natural imitation, which he flaunted everywhere. Far from being a process of imitation, Leonardo's was a creative process that stemmed entirely from the workings of his own mind. Painting was a living work that the artist would imagine changing even when he was away from it (in the old courtyard), and even from afar it continued to work within him, suggesting alterations that he would hurry to fix with rapid brushstrokes. Nothing could be more modern than this creative process, or more distant from the imitation of nature. Leonardo could collect all the real-life sketches he wanted, but what he then fixed in the painting was exclusively his mental sensations; in this he did not differ from a contemporary abstract painter.

Being well aware that he needed such lengthy preparation times,

Leonardo could have used dry fresco techniques, which had already been successfully tested, above all in Florence; but, once again, he wanted to experiment with new technologies. He prepared the wall using a gesso prepared with wax and pitch, which he thought would allow him to use the oil-based pigments, just as he did in panel painting. At first the effect was marvellous, and the conquering French king, Louis XII, was so struck that he asked whether he could detach the painting from the wall and take it back to France! Reluctantly he was obliged to leave it in the refectory at Santa Maria delle Grazie, where it then rapidly started to deteriorate, revealing the tragic limitations of Leonardo's experimental technique. Once again, like Icarus, his mind had soared too far, too fast, over-reliant on his speculative techniques. In 1515, barely 20 years after it was finished, the painting was admired by Antonio de Beatis, secretary to Cardinal Luigi d'Aragona, who disconsolately recorded its rapid deterioration. Today, after the challenging restoration undertaken by Pinin Brambilla between 1990 and 2005, we can again get an idea of what the painting must have looked like, but considerable reserve needs to be exercised because the effects of the restoration, while highlighting important sections of the original painting, undoubtedly interfere with the overall legibility of the work, leaving us to guess at its greatness rather than see it in full.

Leonardo did not imagine the scene very differently from earlier artists like Ghirlandaio: making skilful use of fake architectural features, Leonardo inserted the table scene into the real architecture, extending it by means of perspective with a rectangular hall that opens at the end into windows through which the countryside can be glimpsed. The table is brought right to the front, to the edge of the wall, and the disciples are seated on the inner side of the table, so that no one creates an awkward effect by not facing the room. They all sit in groups of three, which breaks the uniformity of the row, and by talking together they express their individual reactions to Christ's words: 'Truly, I say to you, one of you will betray me' (Matthew 26.21).

The Lord's words trigger a different reaction from each disciple. Bartholomew, on the far left of the table, stands up and leans towards Christ – who is seated in the centre – almost as if he cannot believe his own ears and wants to draw closer to the master who has just uttered them. Beside him, James the younger and Andrew throw up their

hands in surprise and also look towards Christ. Peter's reaction is even more extreme: he leans over to whisper in the ear of the beautiful but wretched-looking young disciple, John, as if he wanted to hear confirmation of those words. As he leans towards John, Peter grasps his knife, ready to do battle against anyone who would commit the offence that Christ has just announced; and in doing so he thrusts forward Judas, whose right hand clasps to his chest the pouch containing the money he has just received in exchange for his betrayal. Judas' face is the least visible, owing to the strong foreshortening, almost as if Leonardo felt that the sentiments of the man who betrayed Christ could never be gauged. This foreshortening, now made even more dramatic by the loss of colour, is the same as appears in the preparatory cartoon in Windsor [Plate 39], an indication that this was a choice that Leonardo made immediately. Moreover, in the beautiful drawing, the choice to leave the traitor's expression undefined is highlighted by the artist's deliberate concentration on the anatomical details of the neck muscles rather than on the actual physiognomy.

In the centre of the scene, Christ, isolated by the light of the window behind him, appears in full frontal pose, spreading his arms in a gesture of resignation and looking down at the table in order not to give the impression of denouncing the traitor, whom he already knows. Christ knows that his destiny must be accomplished and does not want to hinder it in any way. The figure is imposing in its own way, with the blue cloak draped across half of his upper body and his head slightly bowed, although not enough to hide the lips, which remain slightly apart as they pronounce the words. Christ's self-possessed face is perhaps the most successful outcome of Leonardo's scientific study of physiognomy, because it shows the restrained, placid expression of a man announcing his capture and subsequent crucifixion without indignation or dramatic emphasis. Jesus' composure reveals his divine nature, in stark contrast with the emotions that surge like a breaking wave among all the other companions.

While Christ remains immobile, like a rock that withstands breakers in a rough sea, the scene is even more chaotic on his left. Thomas, James the Elder and Philip are entwined in a single impetuous wave of astonishment. James pulls back, open-armed, while Philip stands up and in his haste shoves his right elbow into James's shoulder. Behind

them Thomas can be seen pointing upwards, as if perhaps to put him-
self forward to punish the traitor. Separated from this group by the
outstretched arm of Matthew, who points towards Jesus with both
hands, Taddeo tries to explain what is going on to Simon, who is seated
at the end of the table holding his hands in a questioning gesture.

The long table, covered in a white linen tablecloth embroidered in
a blue pattern typical of Flemish linen, represents a hiatus, a luminous
underpinning for the scene, constantly referring the viewer to what is
happening beyond it. Plates, glasses, cutlery and food – all now barely
visible – are set out on the white linen and, in turn, represent a paint-
ing within a painting, attaining a perfection of detail that heralds the
Flemish still-life compositions of the following century. Thanks to the
stronger composition of the white pigment used for the tablecloth,
the restoration here has achieved miraculous results and has recov-
ered virtuoso naturalistic details never seen before. A case in point is
the transparency of the half-empty glass of wine in front of Philip,
which allows the tablecloth to be glimpsed through the glass as well as
Thomas' left hand and the lights glimmering on the edges. Below the
table the painting is now virtually unreadable, but it is possible to make
out the feet of the apostles that form an intricate and interwoven pat-
tern, as shown in sixteenth-century copies of the painting.

The scene is harmoniously resolved, even if it lacks that natural-
ness that Leonardo himself praised so fulsomely in theory. The space
beyond the table is too narrow for all the figures to sit down and eat
together, and the setting only makes sense in view of these complex and
interwoven groups of figures. Here spatial coherence is brilliantly over-
come by pictorial artifice, and Leonardo demonstrates once again that
art cannot be limited to mimesis but rather aspires to a more complex
depiction of individual psychological reactions by forcing naturalism
and realism.

Even the simplified geometric layout used to divide the scene fails to
diminish the expressive force of the painting. Faithful to the principles
of geometry, which he clings to like a man drowning in the com-
plexities of the universe, Leonardo singles out of this group of thirteen
men the figure of Christ, whom he places in the centre, dividing the
other twelve by four in order to obtain rigorously observed groups of
three. Also, in this composition the artist oscillates between stringent

mathematical control and visionary creative intuition. In stylistic terms, and regardless of the deteriorated surface, the painting still allows us to appreciate the delicate passages of light over faces and clothing. The colours of the garments, all of which conform to a simplified style that Leonardo himself would describe as 'a classical fashion' [*una foggia all'antica*], do not vary much, the mantles being predominantly blue. This helps to concentrate attention on the sequence of gestures.

23

ADDIO MILAN

The door that Ludovico il Moro had thrown open to Charles VIII in the hope that the latter would defend him against the aggression of other Italian states, especially Venice and Naples, remained wide open, unfortunately, and in 1499 it let in the French troops once again. Louis XII's army arrived at the gateway to Italy and made a straight line for Lombardy. They met with no resistance at all. The web of alliances that Ludovico had so carefully constructed fell apart with a speed that left even foreign political observers dumbfounded. Not only Maximilian of Austria abandoned Ludovico because he was unwilling to engage in war against France, but Ludovico's own commanders ducked out, the castellans whom he had entrusted with the defence of the state. Last of all, even the people of Milan, worn out and overtaxed, abandoned him. The summer of 1499 marked the end of the Sforza court; and that society, which had seemed to be so compact around its ruler, now crumbled and distanced itself, in preparation for the arrival of new masters. Ludovico watched the unstoppable collapse of his system of government and, in a desperate attempt to defend the duchy, appealed to the Milanese in a speech that Francesco Guicciardini summarized a few decades later in his *History of Italy*:

and having convoked the people, to whom he was becoming odious on account of the heavy taxes, and in their presence he abolished several of those duties that were most oppressive, adding with warm words, that if the good people of Milan found themselves overcharged with taxes, he trusted that they would not ascribe it to his natural disposition, or to a covetous desire of accumulating riches, but to the condition of the times, and the dangers that surrounded Italy. . . . for so long a term of years under his government, they had enjoyed peace and quietness, which had enabled them to grow rich, and augment the splendour and magnificence of their city beyond all others; witness the stately structures, the public spectacles, the great increase of artificers and other inhabitants, not only in Milan, but over the whole duchy, to the no small envy and amazement of all the other states of Italy.[25]

We might imagine that, in speaking these words, Ludovico would have been thinking above all of Leonardo, who was the recognized symbol of that magnificence throughout Italy, and that, if Leonardo was present at this speech, Ludovico would have sought him out among the crowd, seeking comfort that the artist was unable to offer him. Consumed by his intellectual obsessions, Leonardo was bored of politics, tired of the antics of its players, and he could not interest himself in anything except his own research. While Ludovico was forced to watch as the affection gained during those of years of splendour melted away like snow in the sunshine, everyone's thoughts turned to their future life under the new victors. Leonardo was one of these: he wasted no time in forging bonds of friendship with the new master of Milan, Louis of Luxembourg, count of Ligny, who arrived with the first storms of autumn.

Art was a first-class visiting card, and one that a cultured, refined man like the new governor could not resist. For his part, Leonardo thought he had found a new and even more powerful patron. But the atmosphere in Milan was not propitious and, in the meantime, while waiting to see which way fortune would turn, Leonardo took his money to Florence and deposited it at the hospital of Santa Maria Nuova in December that year. It was a modest amount, 600 florins, a quarter of the sum that Michelangelo would be paid that very same month in Rome for a single sculpture. Perhaps Il Moro had not paid

him well for his service (and this might explain the speed with which Leonardo hastened to abandon him to his fate), or perhaps the Sforza payments had financed his expensive scientific research, the dissections, the experiments on flight, the books, and, last but not least, the elegant clothes for Salai and the comfortable lifestyle of the small group that Leonardo had gathered around him, his household or 'family'. At any rate, Leonardo needed to earn enough to pay for his studies and for his way of life. The contacts he had made in Milan provided an immediate lifeline, which took him first to Mantua, in January 1500, and then, in March, to Venice.

In Mantua Leonardo could rely on the admiration of Isabella d'Este, who had followed his career as a painter with an enthusiasm bordering on fanaticism. As was seen earlier, Isabella had even asked Cecilia Gallerani to send her the portrait that Leonardo had painted; and now she could not resist the idea of having her own portrait painted, a move she hoped would win the admiration of all other Italian courts. As soon as Leonardo arrived, she posed for him in profile, wearing a most elegant dress, which revealed her beautiful shoulders in a bare décolleté [Plate 40]. Having neither Cecilia's youth nor her extraordinary beauty, Isabella would make the most of the elegance that had already made her famous throughout Italy. Her hair, gathered in a fine net, perhaps of silver, falls exuberantly but tidily down her back. Her straight profile, revealing the hint of a smile that barely lifts the thin-lipped mouth, is lit by a proud look that stares into the distance. Leonardo does not appear to have been very inspired by Isabella and reduces the portrait almost to an illustration of fifteenth-century style, barely softened by the beautiful shading that contours her face.

Isabella's ambitions were not enough to keep him in Mantua: Leonardo needed a powerful state, one to which he could sell his extensive knowledge, since he was beginning to regard painting as a secondary activity, and a rather boring one at that. He left Mantua to travel to Venice, where his close friend, Luca Pacioli, had already arrived and was waiting for him. Pacioli, who had taught mathematics in Venice before going to Milan, had now returned to take up an important post. He was one of the few influential figures and persons of recognized authority who believed in Leonardo's scientific talent, and this attracted Leonardo far more than any artistic commission. By

March Leonardo was busy carrying out an inspection to assess the need
to reinforce Venetian mainland defences against the possible invasion
of the Turks. Whether this inspection had been requested by the 'most
serene republic' or he had decided to offer his military expertise with-
out a direct commission, the inspection paid off and Leonardo drew up
a report on the defence of the Isonzo, which was regarded as the weak
point in Venetian defence to the east:

> My most illustrious Lords, As I have perceived that the Turks cannot
> invade Italy [. . .] without crossing the river Isonzo, and although I
> know it is not possible to devise any means of protection which shall
> endure for any length of time [. . .] I have formed the opinion that it is
> not possible to make a defence in any other position which would be of
> such universal efficacy as that made over this river.[26]

Leonardo's suggestion was to amplify the natural defences by con-
structing locks to regulate the speed of the river's flow. His studies
of flow dynamics were starting to bear fruit and, as far as we can tell,
Leonardo's advice was taken quite seriously by the Venetian govern-
ment, although not to the point of securing him a permanent position
in the city. Venice offered at the time the greatest book market in
Europe and Leonardo leapt enthusiastically into that torrent of knowl-
edge, which was flowing into the lagoon from all over the continent,
without censure and impediments. He realized the importance of this
new instrument of printing and the possibilities it offered, as it was
growing faster and more sophisticated day by day, in the workshops
of Aldo Manuzio and other typographers in Venice. The artistic cli-
mate, however, was very different from that of Milan, where for two
decades he had dominated the scene without any real competition:
here instead the great workshops of the city vied against one another in
fierce competition, producing works of art of the highest quality, and
the decisions were never taken by a single prince, as in Milan, but by
the patrician elite, which had firm ties with artists like the Giorgione
and the Bellini as well as with youngsters like Titian and Sebastiano
del Piombo, whose precocious talent was making an impression on the
market.

Meanwhile unsettling news for Leonardo arrived from Milan: in

January the Milanese, led by Sforza partisans, rose up against the French, demanding the return of Ludovico – who, in tears, had left Italy for Germany four months earlier. Leonardo's old acquaintances, such as General Galeazzo Sanseverino, for whom he had prepared jousts and masquerades with costumed 'savages', had returned to the city, and it was likely that they had been informed of the eagerness with which Leonardo had fraternized with Ligny and the French. In April the duke made an attempted comeback close to Novara but was comprehensively defeated and taken prisoner while trying to flee dressed as a Swiss soldier. Venice had the most efficient spy network of its day and news arrived practically in real time – especially the worst news, like the public hanging and quartering of one of Leonardo's friends who had remained loyal to Il Moro, Giacomo Andrea of Ferrara. In such precarious and turbulent circumstances, the best option for Leonardo was to go back to Florence, where he could rely on important contacts.

The summer saw him heading back to his native city, where much had changed: the Medici had been ousted since 1494 and the city's republican government was now led by Piero Soderini, with some assistance from Niccolò Machiavelli. One constant remained, however, throughout all the changes: Leonardo's father, Ser Piero, was of the same status and disposition, and his hostility towards his illegitimate son had not faded. By now his third wife had finally given him legitimate sons – mediocre men who would leave no trace of their existence, yet they represented the continuation of the family inheritance and as such needed to be protected against the peasant girl's son, conceived in the shade of scented cypresses.

Leonardo was therefore not welcomed into his father's house but took lodgings at a monastery, from where he then moved to various noble Florentine families. He arrived in the city with his small retinue, including Zoroastro, who was well known but not well regarded in Florence. He must certainly have been also accompanied by Salai, now in his mid-twenties, handsome and elegant – if a little overly so for the strict tastes of the city's merchant class, which had only recently been under the spell of Girolamo Savonarola's moralistic regime (until the ashes of a pyre in the Piazza della Signoria put an end to his repressive rantings on 28 May 1498). Leonardo had no intention of changing his way of life and presented himself on the Florentine scene with a refined

elegance that immediately struck his fellow citizens. The description offered in the so-called 'Anonimo Gaddiano' refers to this moment, and it is no coincidence that the chronicle draws attention not only to his handsome looks but also to the flamboyance of his clothing:

> He was a handsome person, well proportioned, graceful and with a beautiful countenance. He wore a rose-coloured cloak that came only to his knees at a time when it was the custom to dress in long robes. He had a magnificent head of hair, which fell in carefully arranged curls halfway down his breast.[27]

Determined to reconquer his native city, Leonardo took rooms at the monastery of Santissima Annunziata, where his old friend Filippino Lippi – the painter who 20 years earlier had carried out the commission given to Leonardo by the Signoria but never touched by him – generously handed him the work that the monastery had commissioned of him: a panel painting of the Annunziata. Once more, almost against his will, Leonardo found himself back in a world from which he was desperately trying to escape.

He regarded himself as a military engineer, a mathematician, a savant with expertise in anatomy, mechanics, geology and botany, and his horizons were those of the universities, not of artists' workshops. But in Florence, at least at the moment when he arrived, there were no other openings except those offered by painting.

At the same time, for the first time in his life, Leonardo was forced to take into account the existence, in his own native city, of a very advanced community of artists, capable of offering perfectly valid alternatives to the research that he had worked on alone during his Milanese years. Leonardo had scorned the mediocre representation of nature achieved by contemporaries when he left Florence two decades earlier. He believed that a more effective representation of the natural world could only come from the experimental study of nature and the study of optics, physiognomy and anatomy. These were all concepts that he had been explaining for the past ten years, at least in his *Libro della pittura*, a work that was now almost complete.

A tour of the city's churches and of the *saloni* of the best families informed him that his fellow citizens had taken different approaches,

and their achievements were certainly not to be overlooked. The frescoes and altarpieces by Ghirlandaio, Perugino, Pinturicchio and Filippino Lippi himself revealed a reality that was no less credible than his own, convincing in its realism but at the same time conjuring up an ideal world in which humanity seemed to purify itself of all vulgarity and to draw closer to that representation of an ideal universe that everybody imagined by means of abstruse philosophical constructs and that the Florentine painters had finally succeeded in fixing on murals and in painted panels.

Even more astonishing progress was evident in architecture; echoes of it may have reached Leonardo's ears in Milan thanks to the visits of Francesco di Giorgio Martini, in the form of the designs by Giuliano da Sangallo and the studies of Bramante, with whom Leonardo had collaborated. On his return to Florence he saw how architecture had been freed from the prison of schematic geometry in which he, too, had felt entrapped and that, seen as such by his contemporaries, had presented an insurmountable barrier, which had not permitted him to achieve much in his Milanese years except for fantastic designs, sometimes highly practical but remote from what was requested by the new humanist awareness. Now, dressed in his knee-length pink cloak, hair flowing over his shoulders in curls that were still brown rather than grey, he visited the buildings of Giuliano da Sangallo, which revealed the birth of a world about which, in his own isolation, he had not even heard. The sacristy of Santo Spirito, the Palazzo Gondi, the Villa Medicea at Poggio a Caiano and, lastly, the church of Santa Maria delle Carceri in Prato: all these were extraordinary works, built with a discipline that combined functional and spatial research with the harmonious laws rediscovered through the study Vitruvius' canons.

While Leonardo had shut himself away in his notebooks and studies, in the presumptuous conviction that only intellect would suffice to penetrate the laws of nature and limited by the idea that the human microcosm was a mirror of a macrocosm whose governing laws could be understood, Giuliano, the true pioneer of Florentine experimentalism, had criss-crossed Italy in search of the laws of composition that had guided the classical architects when they constructed their astonishing monuments. He had measured and drawn almost all the classical buildings, had gone as far as Benevento and Naples, had measured

the Roman forum and anything that shed light on the classical laws of architecture, on that ability to imprison space and bring it alive, which could be felt in Roman monuments still practically intact. Giuliano had also spoken to other architects and had been helped by younger and not so young members of his own family (one of the leading dynasties of Renaissance architects), who were now ready to continue his work. Giuliano had pushed the boundaries of architecture forward, much further than Leonardo could possibly have imagined.

Nor could Leonardo – accustomed as he was to being celebrated in printed works and in sonnets and even heralded as a new Apelles in the *Antiquarie prospettiche romane*, a major book published the previous year[28] – have imagined that he would be publicly insulted by a young artist who had only just started in a *bottega* at the time of Leonardo's departure, the son of a well-to-do family of Florentine merchants who had fallen on hard times. That youth was Michelangelo Buonarroti; and he was rapidly creating a stir in Italy's artistic circles. Like Leonardo, he came from an affluent family and was determined to show that art was an intellectual activity worthy of his status and on a par with the other liberal arts.

Only just 25, the youth had already given signs of such greatness that everyone spoke of him as the true genius of Italian art. Sought after by cardinals and, before long, by popes, when Leonardo arrived back in Florence Michelangelo had just been commissioned to carve a marble colossus from a block that no one had managed to use in the previous 20 years. The statue had been commissioned by the Opera del Duomo [the Works Committee for the Cathedral], but people already talked about the statues he had carved in Rome, in particular the one in the basilica of Saint Peter's, the *Pietà*, for the French cardinal Jean de Bilhères-Lagraulas. Imagine the surprise with which Leonardo discovered that, independently and at an even earlier age, Michelangelo had begun to study anatomy by dissecting corpses in the hospital of Santa Maria Nuova between 1490 and 1493!

Michelangelo's anatomy dissections, which were recorded in drawings no less refined than those that Leonardo himself had made, were not tied down by being intended for a study of human physiology like the one in which Leonardo had become a little lost, as his progress was hampered by the many biases inherited from the classical physiol-

ogy that he continued to study. Instead Michelangelo had dissected corpses to understand not why but how the human body moves, and he had transposed his discoveries into his sculpture (and his paintings), attaining a representation that was so convincing as to overshadow the research of every other living artist in Italy.

While no one could deny the extraordinary quality of Leonardo's shadows and the precision of his psychological insights, Michelangelo had realized in colour and in stone real men animated by that heroic spirit that made Florentine art much more fascinating than the purely mimetic art of the Flemish. Michelangelo had skinned corpses, lifted muscles and isolated bones, recording human morphology in his drawings with a graphic quality that was in no sense inferior to that used by Leonardo in his sketches. Moreover, unlike Leonardo, he did not lose his way among countless minor pathways of research but instead had an obsessive determination to realize tangible works, capable of challenging the limits of the material – as he had done when carving his *Pietà* out of a single block, or as he was doing right then, moulding his *David* to a height of over four metres, almost as tall as the equestrian monument that Leonardo had had to abandon in Milan.

Leonardo's inability to bring about his own ambitions was regarded with disapproval in a city that owed its freedom, its greatness and its very reason for existing to the concrete actuality of its inventions. Michelangelo could not wait to challenge and humiliate the old master whom everyone was talking about – and of whom he was jealous for other reasons as well. Michelangelo, too, was a homosexual but had nothing of Leonardo's elegance and beauty; he showed instead in his behaviour an ostentatious sobriety, exaggerated to the point of brutality. Young Buonarroti might have seemed like a bear compared to the mature, elegant brilliance of the man who had reappeared in Florence with his young lover in train. Their public clash became legendary in the city. They had come across each other by chance, at one of those small gatherings in which citizens used to discuss passages of Dante Alighieri while sitting on the benches outside Palazzo Spini. Leonardo was obviously well aware of Michelangelo's love of the Florentine poet and had the idea of inviting the young sculptor to contribute to the discussion. Registering the ironic dig at his 'mechanical' status, Michelangelo had a brutal reaction to the invitation:

'Explain it yourself! You who designed a horse to be cast in bronze, which you could not cast, and shamefully gave up.' And with these words he turned his back on them and went on his way, while Leonardo reddened at these words . . . On another occasion, Michelangelo, wanting to sneer at Leonardo, said to him: 'Those Milanese blockheads actually believed in you!'[29]

Openly, publicly, Michelangelo challenged a man of mythical status and accused him of lack of resolution and incapacity. We can imagine how much pain this reproach must have caused Leonardo, highlighting as it did his pretensions of omniscient scientist and the fact that he had not succeeded in casting the great Sforza horse. It rubbed salt into fresh wounds and presaged the battle that he would shortly enter into against this presumptuous and arrogant young man. Leonardo also took revenge on the arrogance of the young sculptor in his *Libro della pittura* where, in order to show the superiority of painting over sculpture, he presented the sculptor as a savage, a brute who wrestled with his material; and the portrait of this savage was so close to what everyone knew of Michelangelo's own ways of working that one could not fail to realize that Buonarroti himself was the one humiliated in these lines, which are in fact some of the most beautiful ever written by Leonardo:

The sculptor undertakes his work with greater bodily exertion than the painter, and the painter undertakes his work with greater mental exertion. The truth of this is evident in that the sculptor when making his work uses the strength of his arm in hammering, to remove the superfluous marble or other stone which surrounds the figure embedded within the stone. This is an extremely mechanical operation, generally accompanied by great sweat which mingles with dust and becomes converted into mud. His face becomes plastered and powdered all over with marble dust, which makes him look like a baker, and he becomes covered in minute chips of marble, which makes him look as if he is covered in snow. His house is a mess and covered in chips and dust from the stone. The painter's position is quite contrary to this (speaking of painters and sculptors of the highest ability), because the painter sits before his work at the greatest of ease, well dressed and apply-

ing delicate colours with his light brush, and he may dress himself in whatever clothes he pleases. His residence is clean and adorned with delightful pictures, and he often enjoys the accompaniment of music or the company of authors of various fine works that can be heard with great pleasure without the crashing of hammers and other confused noises.[30]

The passage was a mortal blow to Michelangelo, another social misfit – an aristocrat who had slipped down into the mechanical arts, from which he wanted to redeem himself; yet with a cruel dig Leonardo pushed him back towards the status of a manual worker. A more perfidious revenge could not have been imaginable for the young Buonarroti, who boasted that his illustrious ancestors were involved in the government of Florence.

But had Michelangelo's ill will been provoked by something more? A clue may perhaps be hidden in Leonardo's notebooks: a small sketch of a youth, who points upwards with a clearly visible erect penis, and underneath the name of 'Granaccio' – a young artist who had spent his apprenticeship in Ghirlandaio's *bottega* with Michelangelo and was among the great artist's few lifelong friends. Leonardo had evidently appreciated his more hidden skills and had kept the memory alive on paper. Whatever the circumstances that Leonardo recorded in that drawing, Michelangelo was not pleased and his aggression was tainted by a bitter judgement of the perhaps excessively open manner in which Leonardo expressed his preference for young men.

These are mere conjectures, but they are useful in clarifying how Leonardo's position in Florence was far from easy, particularly in the light of much more serious reasons. Leonardo's old friendship with the Medici did not help to create a welcoming climate around the returning artist. What was needed was something that could rekindle people's admiration for a master who had been absent for so long: a work that the artist could complete within a short time, and maybe a large cartoon that would show the extraordinary expertise he had achieved through his knowledge of shadows and his science (because science indeed it was) of the emotions.

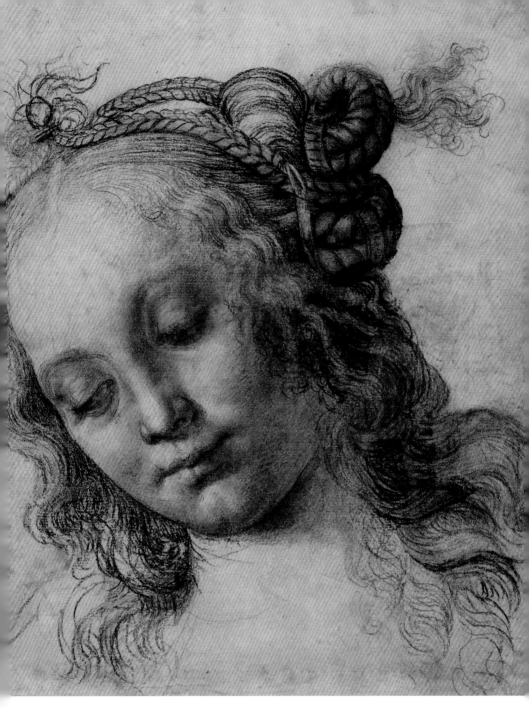

Andrea del Verrocchio, *Head of a Woman*.

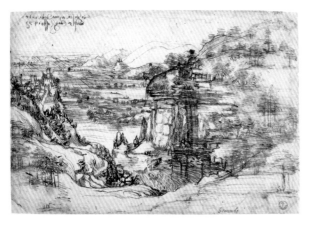

2　Leonardo, *Landscape*, 1473.

4　Francesco Melzi (?), *Port.*
　of Leonardo.

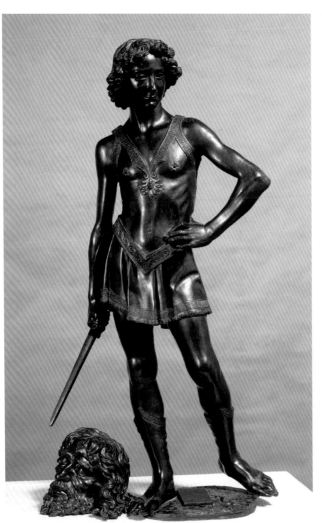

3　Andrea del Verrocchio,
　David, 1473–5.

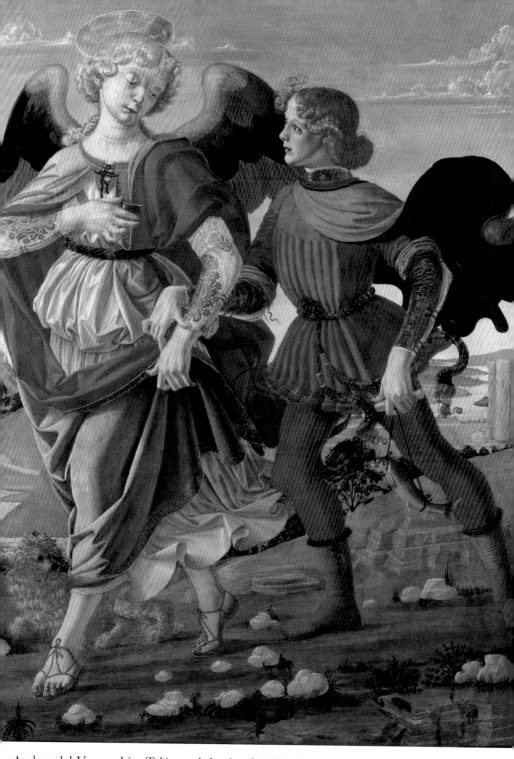

Andrea del Verrocchio, *Tobias and the Angel*, 1470–5.

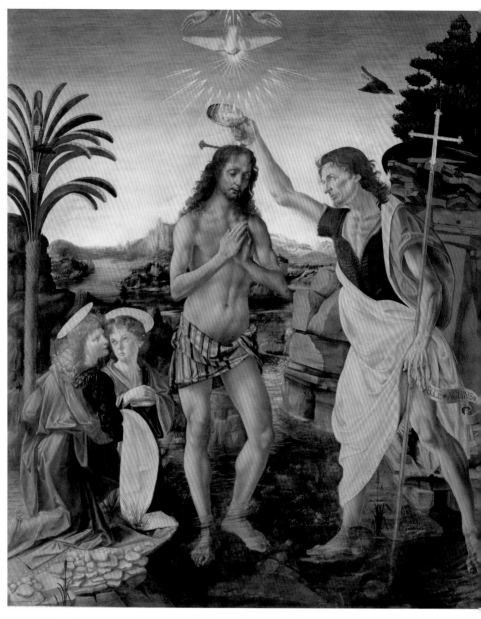

6 Andrea del Verrocchio and Leonardo, *The Baptism of Christ*, 1472–3.

(Opposite) 7 Andrea del Verrocchio, *Tobias and the Angel*, detail, 1470–5.

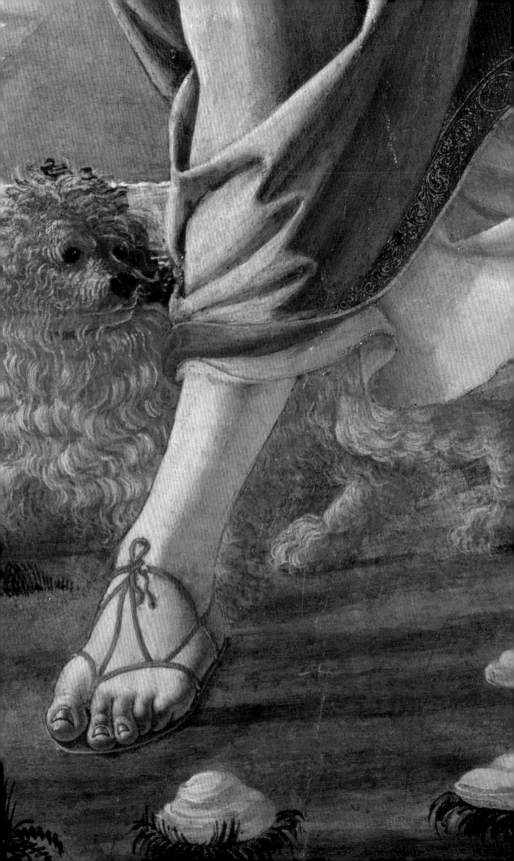

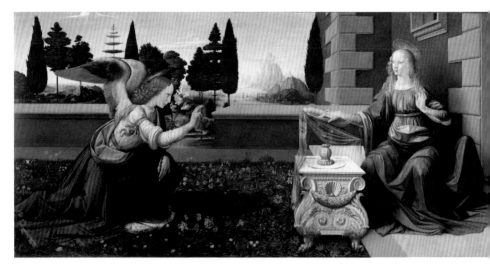

8 Leonardo, *Annunciation*, 1472–5 (?).

9 Leonardo, *Study of Drapery for the Right Arm of the Angel of the Annunciation*, 1472–5.

10 Leonardo, *Study of Drapery for a Seated Figure*, c. 1475.

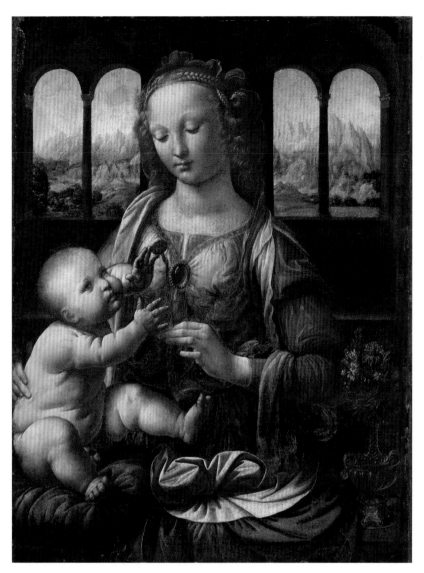

11 Leonardo, *Madonna of the Carnation*, 1472–4.

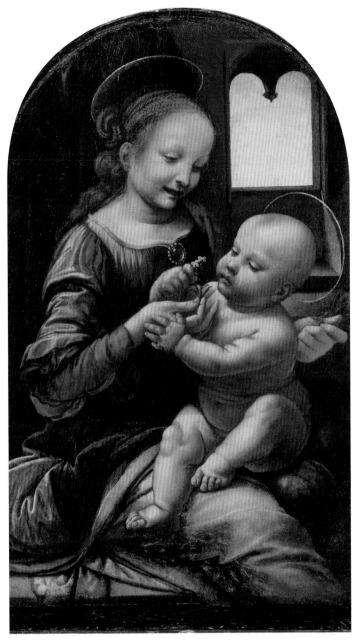

13 Leonardo, *Benois Madonna*, 1472–5.

(Opposite) 12 Beato Angelico, San Domenico Altarpiece, detail, 1424–5.

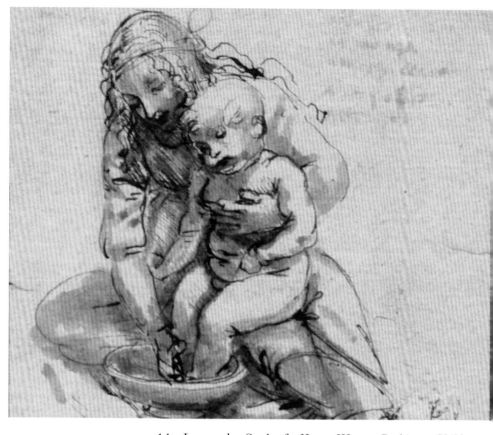

14 Leonardo, *Study of a Young Woman Bathing a Child*, c. 1472–5.

(Opposite) 16 Leonardo, *Saint Jerome in the Wilderness*, 1475–80.

15 Leonardo, *Sketch of Bernardo di Bandino Baroncelli*, hanged December 1479.

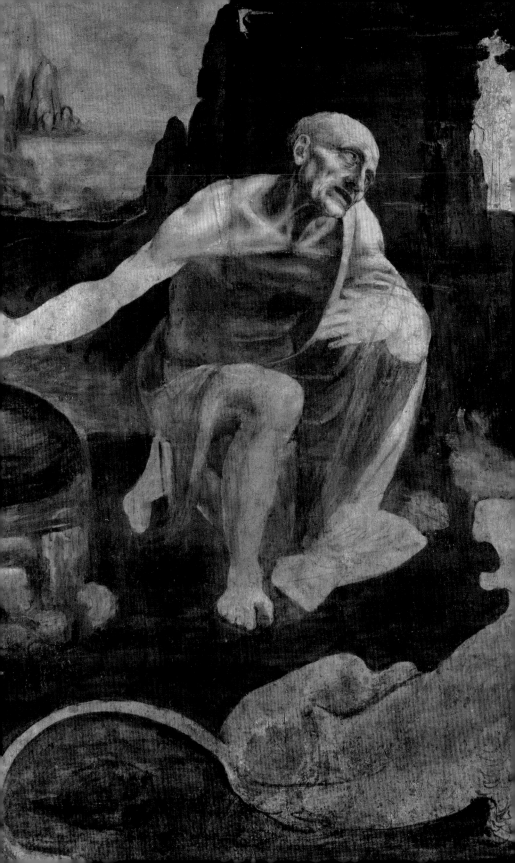

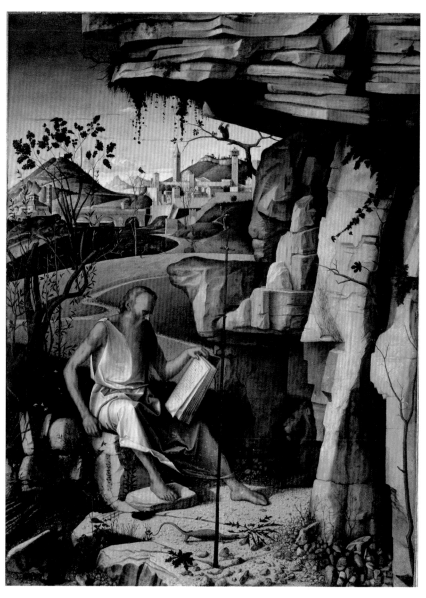

17 Giovanni Bellini, *Saint Jerome in the Desert*, 1479.

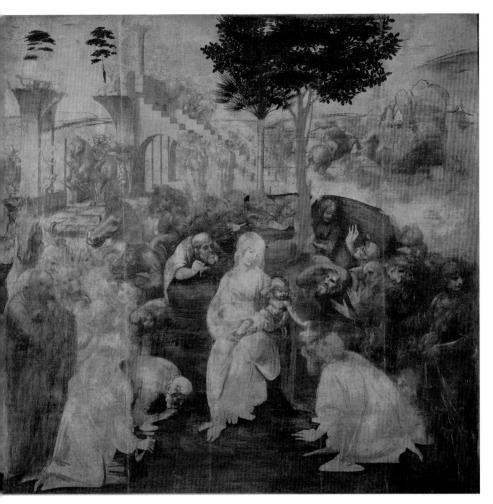

8 Leonardo, *Adoration of the Magi*, 1481–2.

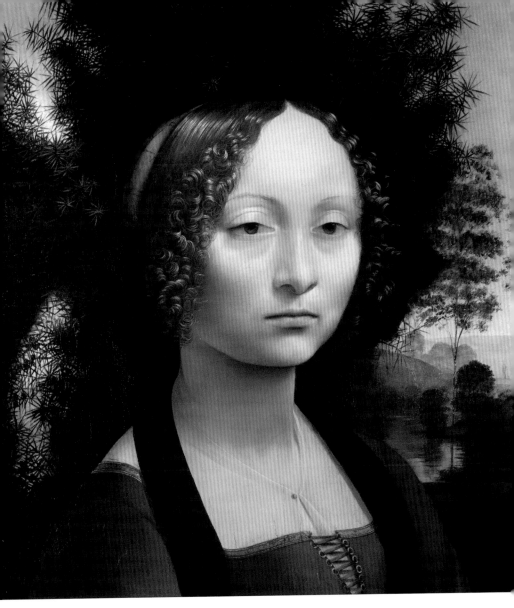

19 Leonardo, *Portrait of Ginevra Benci*, 1478–80.

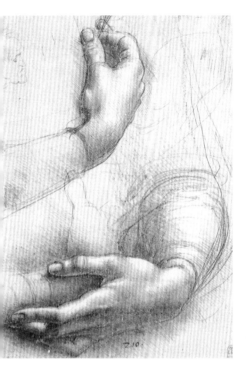

20 Leonardo, *Study of a Woman's Hands*, 1478–80.

21 Leonardo, *Study for the Background of the Adoration of the Magi* with perspectival projection, 1481.

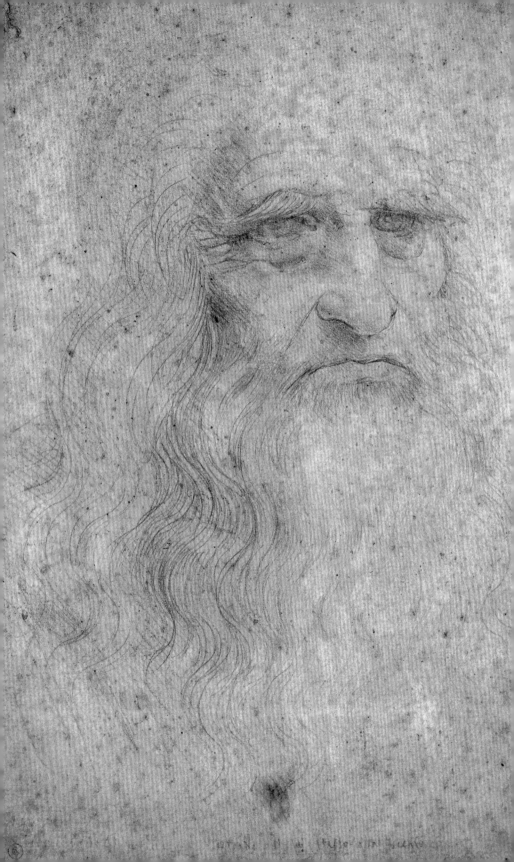

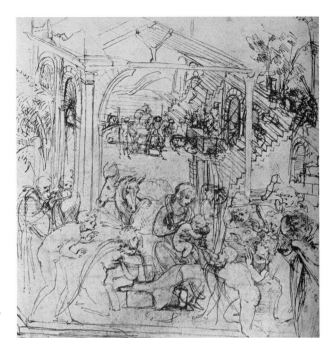

23 Leonardo,
Preparatory sketch
for the *Adoration of the
Magi*, 1480–1.

24 Leonardo,
Adoration of the Magi,
1481–2, detail.

25 Leonardo, Drawing of the
casting mould in metal
armature for the equestrian
monument to Francesco
Sforza, 1491–3.

(Opposite) 22 Leonardo, *Head of a Bearded
Man, Possible Self-Portrait*,
c. 1510.

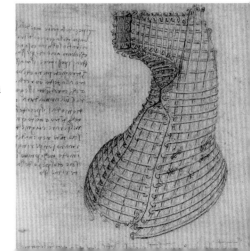

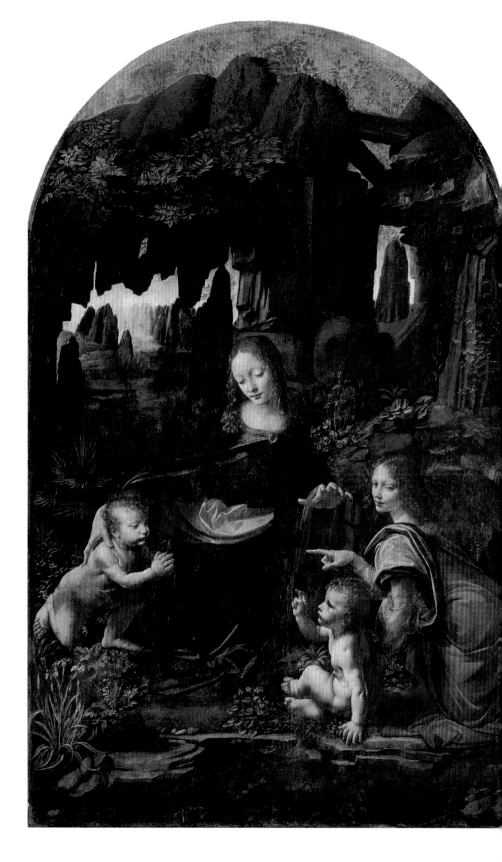

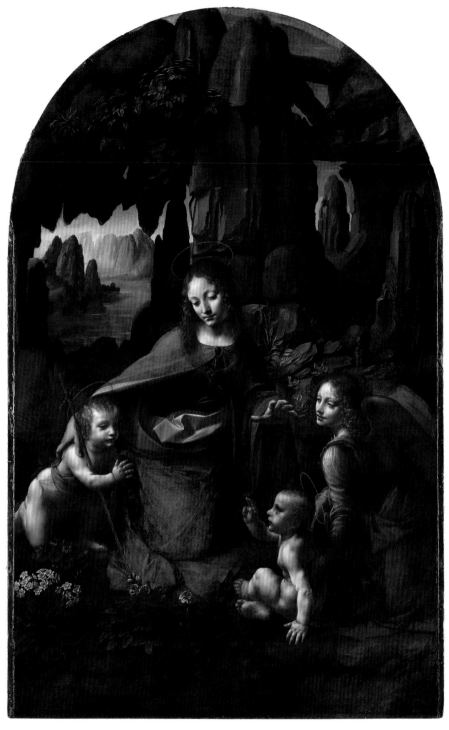

27 Leonardo and assistants, *The Virgin of the Rocks*, 1495–1508.

pposite) 26 Leonardo,
e Virgin of the Rocks, 1483–5.

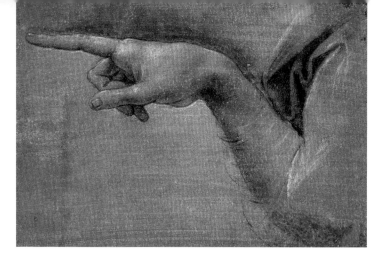

28 Leonardo, Preparatory drawing for the pointing hand of the angel in *The Virgin of the Rocks*, c. 1483.

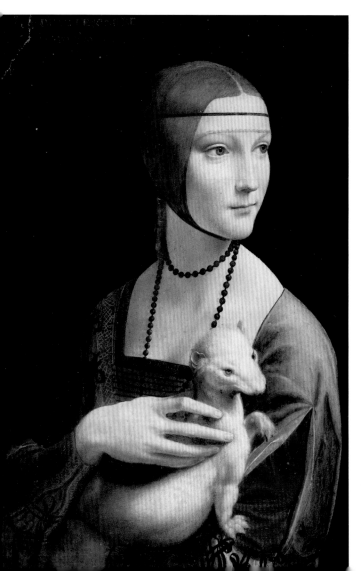

29 Leonardo, *Portrait of Cecilia Gallerani* (*Lady with an Ermine*), c. 1489–90.

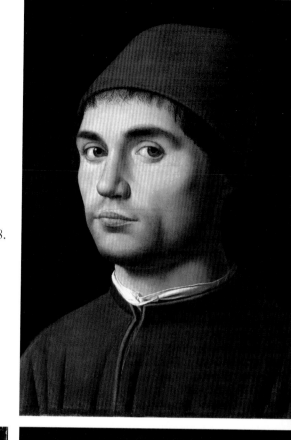

30 Antonello da Messina,
Portrait of a Man, 1475–8.

(Below right) 32 Leonardo,
Portrait of a Woman (*La Belle Ferronière*), 1490–5.

31 Leonardo and assistants,
Portrait of a Musician,
c. 1485.

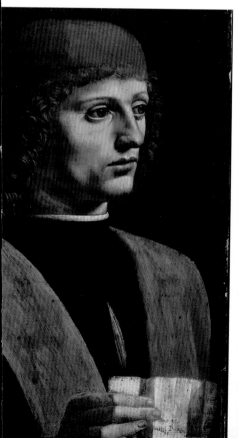

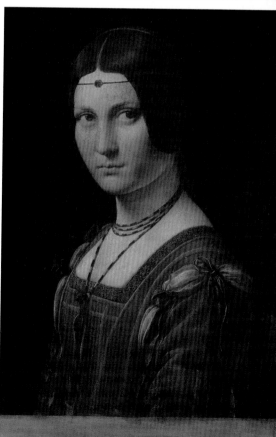

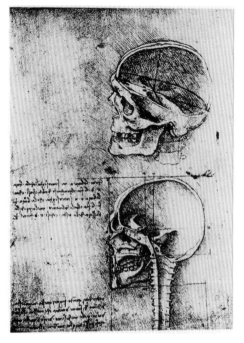

33 Leonardo, *The Skull Sectioned*, 1489.

(Opposite) 35 Leonardo,
Proportions of the Human Figure
(from Vitruvius), c. 1490.

34 Leonardo, *Anatomical Drawings of the
Heart and Coronary Vessels*, c. 1513.

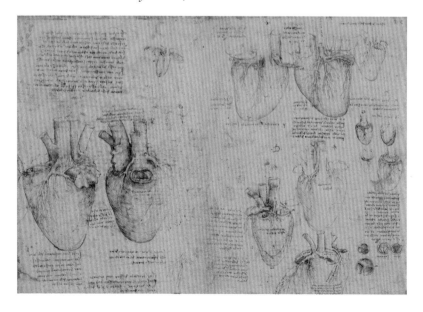

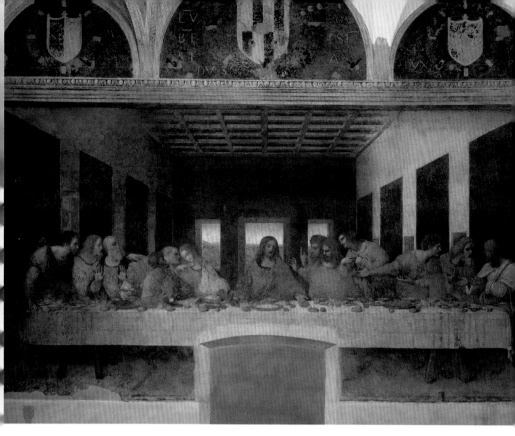

36 Leonardo, *The Last Supper*, 1495–8.

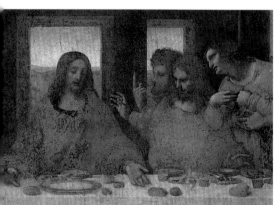

37 Leonardo, *The Last Supper*,
 detail, 1495–8.

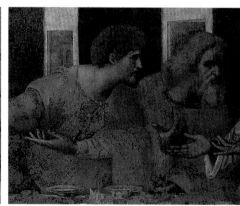

38 Leonardo, *The Last Supper*,
 detail, 1495–8.

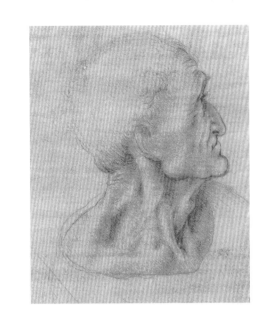

39 Leonardo, Study for *The Last Supper*
 (*Head of Judas*), c. 1495.

40 Leonardo, *Portrait of Isabella* 41 Leonardo, *Virgin and Child with*
 d'Este, 1500. *Saint Anne and the Infant Saint John.*

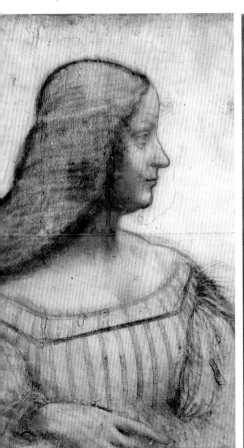 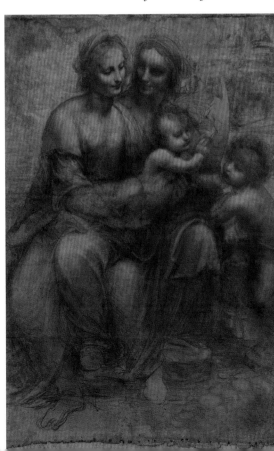

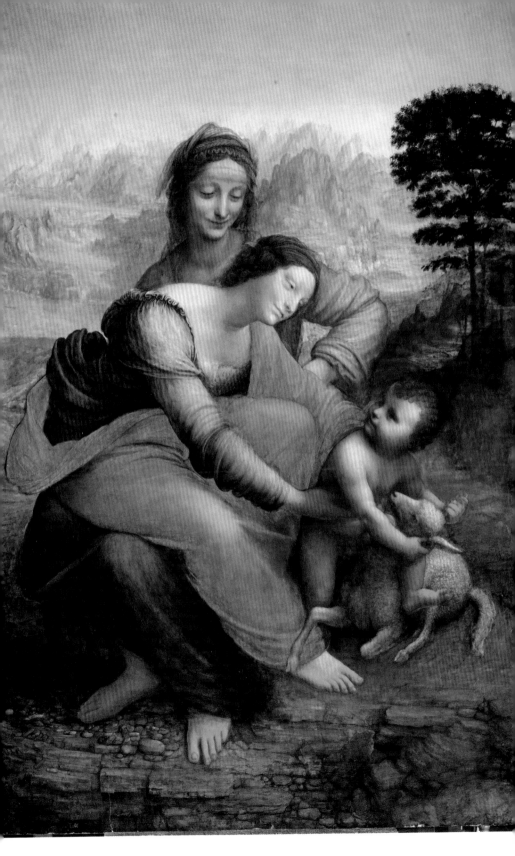

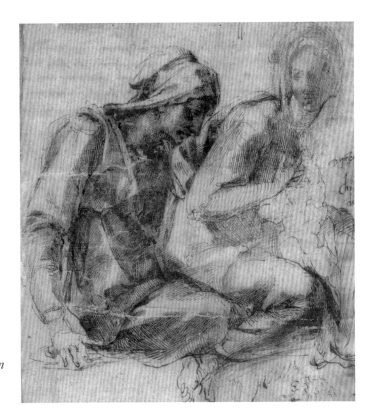

(Opposite)
42 Leonardo, *Virgin and Child with Saint Anne.*

43 Michelangelo Buonarroti, *Virgin and Child with Saint Anne.*

44 Leonardo and assistants, *Madonna and Child* or *Madonna of the Yarnwinder* (*Lansdowne Madonna*).

45 Leonardo and assistants, *Madonna and Child* or *Madonna of the Yarnwinder* (*Buccleuch Madonna*).

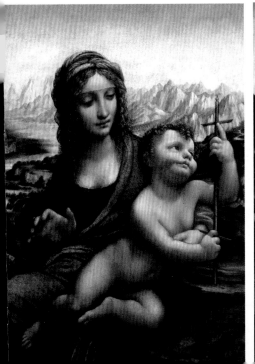

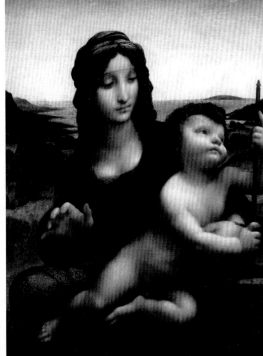

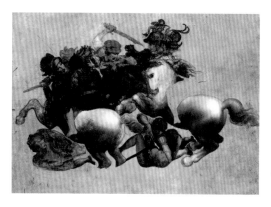

46 Copy after Leonardo, *Battle of Anghiari* (*Tavola Doria*).

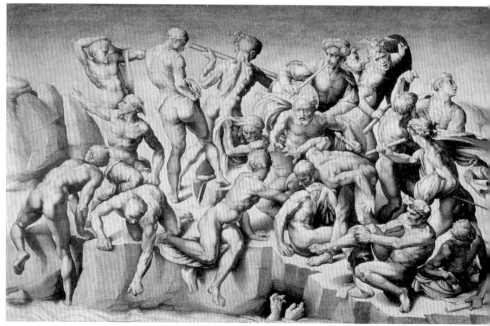

47 Bastiano da Sangallo, Copy of Michelangelo's cartoon for the *Battle of Cascina*.

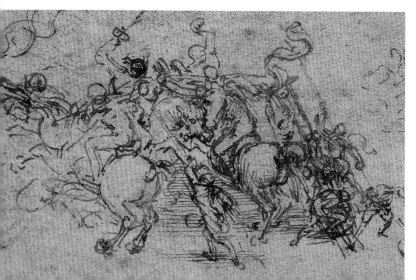

48 Leonardo, Preparatory study for the *Battle of Anghiari*, c. 1503.

49 Leonardo, Sagittal *Section of a Human Skull*, c. 1493.

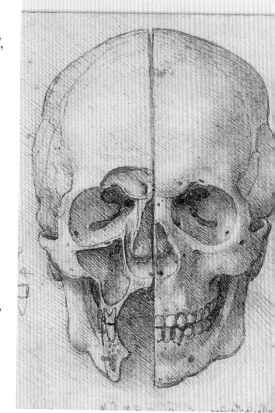

(Below right) 51 Leonardo, *The Vertebral Column*, 1510.

50 Leonardo, *Studies of the Sexual Apparatus*, c. 1493.

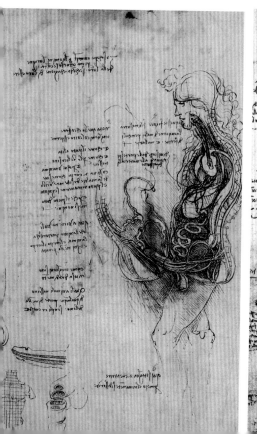

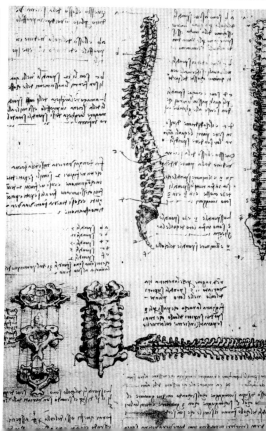

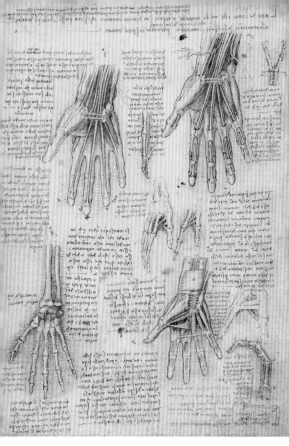

52 Leonardo, *The Bones, Muscles and Tendons of the Hand*, c. 1510.

53 Workshop of Leonardo, *The Angel Incarnate*, c. 1503–8.

54 Workshop of Leonardo, *Saint John the Baptist*, c. 1503–8.

55 Raphael, *The Expulsion of Heliodorus from the Temple*, 1514.

56 Leonardo, *Map of the Pontine Marshes*, c. 1514.

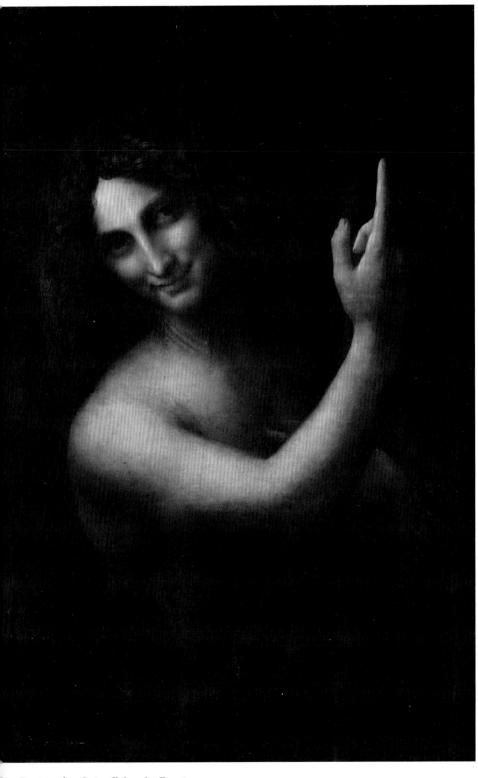

7 Leonardo, *Saint John the Baptist*.

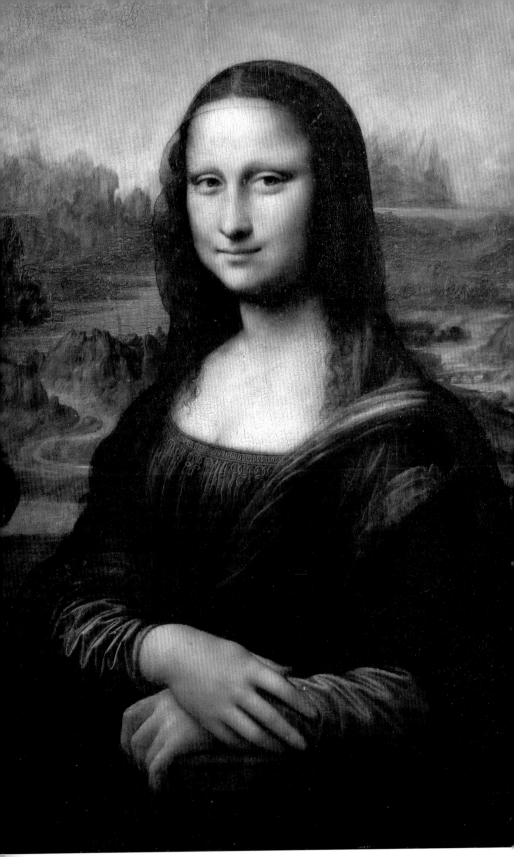

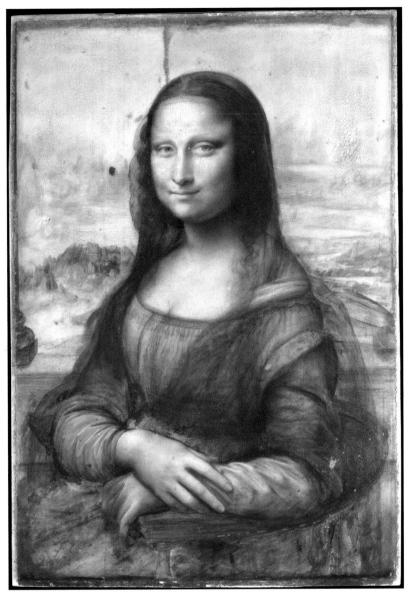

59 Leonardo, *La Gioconda*, infrared reflectogram.

(Opposite) 58 Leonardo, *La Gioconda*, c. 1503–16.

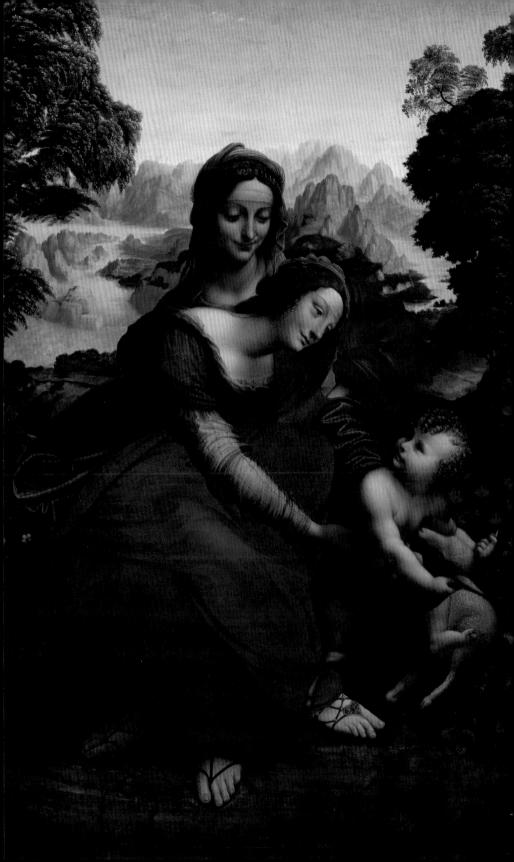

61 Leonardo, *The Drapery at the Virgin's Hip*, after 1513.

(Opposite) 60 Workshop of Leonardo, *Saint Anne, the Virgin and the Child*, c. 1508–13.

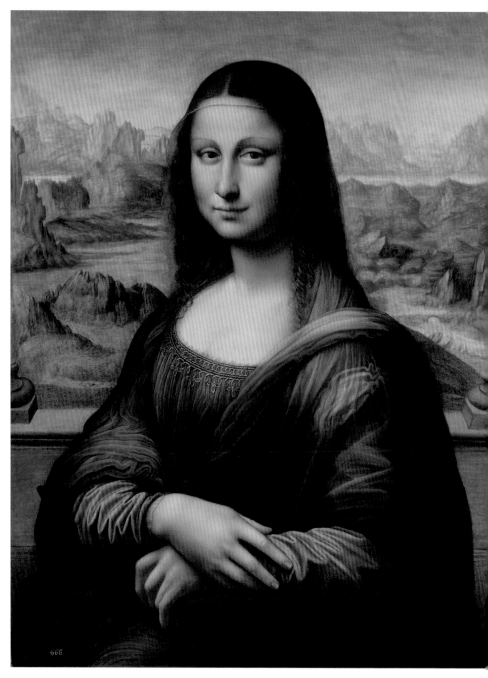

62 Workshop of Leonardo, *La Gioconda*, c. 1503–16.

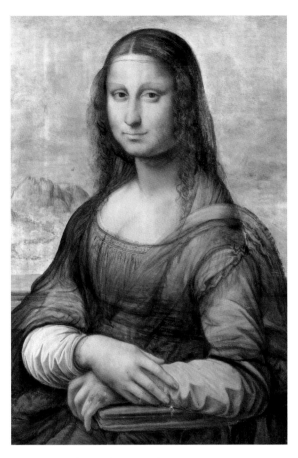

63 Workshop of Leonardo, *La Gioconda*,
c. 1503–16, infrared reflectogram.

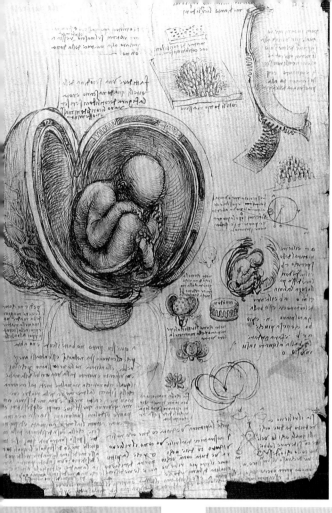

64 Leonardo,
Embryological Studies,
c. 1510–14.

(Bottom left) 65 Leonardo,
A Standing Masquerader,
c. 1517–19.

66 Leonardo, *Cats, Lions
and a Dragon*, c. 1516.

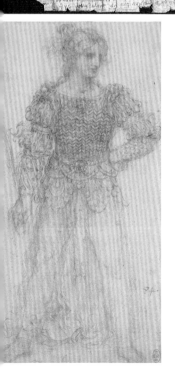

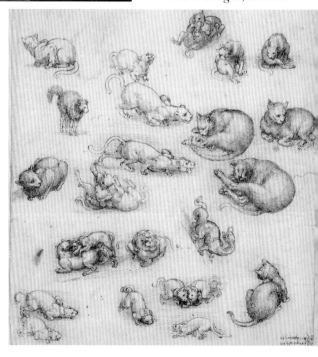

Part III

BACK TO FLORENCE

24

A FATHERLESS FAMILY

Giorgio Vasari tells the story of how Leonardo set about seducing the Florentines anew and, writing nearly fifty years later, he still felt the echoes of the excitement aroused by a cartoon of Saint Anne and the Virgin, 'delighted to witness the beauty of her child, who holds him tenderly in her lap, while with a modest glance downwards she notices Saint John as a little boy who is playing with a lamb'.[1] The composition was so successful that, when the cartoon was finished, for two days artists and ordinary citizens flocked to Leonardo's room to admire it in amazement: the intended effect was achieved at the first attempt.

Vasari's account is not exactly precise in the details by which the cartoon should be identified, since a cartoon on this subject, drawn in charcoal with white chalk highlights, exists at the National Gallery, London (the Burlington House cartoon) [Plate 41]; but, although a young Saint John can be seen in it, there is no sign of any 'lamb', as in Vasari's description. Instead a much more detailed description of an almost identical composition appears in a letter written by one of Isabella d'Este's correspondents, who, at the duchess's request, pursued the artist in an attempt to persuade him to paint a small picture for her, or at least to colour the portrait he had made one year earlier during his brief stay in Mantua. Pietro da Novellara, a learned theologian and vicar general of the Carmelites in Mantua, visited Leonardo in the

lodgings that Leonardo had taken at the Annunziata with Salai and
another collaborator, and he describes the scene he found there. The
letter offered the duchess and later readers a lively, carefully observed
and precise portrait of the conditions in which the artist was living in
the spring of 1501 and of the subjects on which he was working:

> Leonardo's way of life is very changeable and uncertain, so he seems
> to live for each day as it comes. Since he has been in Florence, he has
> only made one sketch; it is a cartoon of a Christ child, about a year old,
> almost jumping out of his mother's arms to seize hold of a lamb. The
> mother is in the act of rising from Saint Anne's lap and holds the child
> back from the lamb, an innocent creature, which is a symbol of the
> Passion. Saint Anne, who is also partly rising from her seat, seems anx-
> ious to restrain her daughter from holding her son back from the lamb,
> which may symbolize the church, which would not hinder the Passion
> of Christ. These figures are as large as life, but are drawn on a small
> cartoon, because they are represented either seated or bending down,
> and one stands a little in front of the other, towards the left. And this
> sketch is not yet finished. He has done nothing else, except that two
> of his apprentices are painting portraits to which he sometimes adds a
> few touches. He is working hard at geometry and has lost all patience
> with his brush.[2]

The document is much more accurate than Vasari's memory and
allows us to identify the work as the preparatory cartoon for the paint-
ing of the *Virgin with Child and Saint Anne*, now in the Louvre, Paris
[Plate 42]. The cartoon seen by Novellara has not survived, but the
painting has; and the accurate description confirms that by this date
Leonardo was working on a painting that, without major variations, he
continued to re-elaborate until the end of his life. Some scholars believe
that the cartoon described by Vasari was probably completed after the
one that Novellara saw, while others believe that it was finished earlier.
The hypothesis that the London cartoon was completed before the car-
toon for the painting in the Louvre is frustrated by the chronology of
events: if, in March 1501, soon after his arrival in Florence, Leonardo
visited Tivoli and by April he had already finished the cartoon seen
by Novellara, it is not clear when he would have had time to draw the

cartoon now in London. It is easier to imagine that the London cartoon was made after the one seen by Novellara, and in this case it represents a variation that was subsequently abandoned. However, the issue is not easy to solve, and indeed even a third version of the composition might have existed – unless Vasari was confusing various sources of information, as he often did, by reporting the presence of a 'lamb' in the London cartoon while in fact the lamb had been seen not in a cartoon but in the painting that Leonardo completed later, several copies of which were in circulation during Vasari's lifetime.

Saint Anne is a painting that, in spite of its exceptional quality, was for centuries ignored and attributed to Leonardo's pupils by scholars who were too quick to follow the inaccurate and often unfounded information provided by Vasari, who affirmed that the master made only the cartoon now in London. There may be quite different explanations for the presence of several cartoons from the same period, all finished to such a high level. Leonardo was seeking a major commission in Florence, one that would re-establish his status as the city's leading painter. Saint Anne was a subject very dear to the Florentines, especially during those years of the republic. The despotic *podestà* Gautier de Brienne, [known as] the duke of Athens, had been chased from the city on the feast day of Saint Anne on 26 July 1343, and from that date the citizens had dedicated a special cult to the saint who had protected their liberty.

Thus the widespread interest in the composition accounts for this choice of theme. It is no coincidence that Michelangelo made at least two important drawings on a similar topic during the same period [Plate 43]. It is impossible to date these drawings precisely, but, on the basis of an unjustifiably strained approach that assigns every iconographical innovation to Leonardo (even if the only work that we know for sure was copied by one artist from the other is *David*, which Michelangelo carved and Leonardo copied in a drawing before reusing it later as *Hercules*), Michelangelo's drawings of *Saint Anne* have been arbitrarily dated to the months after Leonardo had completed the cartoon (or cartoons), in order to confirm the older artist's influence over the younger one. Leonardo's influence over Michelangelo was first imagined by the critics and then 'proved' through the arbitrary dating of sketches, although this alleged influence does not fit with Michelangelo's desire

to challenge Leonardo right from the moment of the latter's return to the city.

The disdainful originality that emanates from Michelangelo's every gesture is confirmed precisely by these drawings, which are completely different in tone from those of the older master. Where Leonardo essentially resolves the intertwined pose of the figures using a deep shadow that allows the overlap to be imagined but conceals the incongruous nature of Mary's and Saint Anne's positions, Michelangelo aims to resolve the anatomical poses of their bodies. This incongruity would not have been lost on Michelangelo, given that the Virgin could never have sat on her mother's lap in that manner, particularly because there was not enough room for her legs. At all events, what is certain is that Michelangelo and Leonardo worked in the early years of the sixteenth century on a composition with an identical subject matter, but Leonardo, well aware of how slow he was and how difficult he found it to finish a painting rapidly, went to enormous efforts to complete the cartoon so thoroughly that it could be seen as a finished work and therefore could arouse his fellow citizens' admiration. The operation was successful in every respect, and the life-size cartoon was so extraordinary that, if there had been even the hint of a challenge between the two artists at this stage, Leonardo would certainly have been the winner of this first round.

The subject of the cartoon on which Leonardo was working in April 1501 is expertly interpreted by Pietro da Novellara, who provides a concise and exemplary testimony of how a religious work of art might be perceived by contemporaries and of the subtlety with which the artist attuned his compositions to the degree of understanding they were likely to elicit. At the same time, in an attempt to stem the excessively liberal interpretation that had been in vogue in Renaissance art for some years, Novellara's letter confirms that artistic compositions were still expected to be understood with simplicity and immediacy by those who looked at a work of art. In the Burlington House cartoon the Christ child makes a gesture of blessing towards the young Saint John that had already appeared in *The Virgin of the Rocks*, but here the composition seems suspended in a delicate counterpoise of balances and weights, reminiscent of a complex industrial machine.

Mary, seated on Saint Anne's lap (although her upper body is further

away than it would have been in reality), lifts her left leg to balance the effort of lifting the child as he leans forward towards his cousin. Straining to accompany that gesture, Mary leans forward imperceptibly and moves her right shoulder in the opposite direction, to her left knee. The light that picks out Mary's shoulder and knee helps to create the impression of a balanced, effortless movement. The Christ child who caresses his cousin's face with his left hand and turns it towards the blessing is an innovation that moves the viewer through the naturalness of that affectionate gesture. Saint Anne, satisfied by the accomplishment of his destiny as martyr and redeemer of the church, which she represents, turns to Mary with a reassuring smile, pointing with her left hand to the heavens, where all their destinies have been decided.

The composition is treated in almost obsessive detail. Its success relies on the delicate definition of the facial expressions, which marks yet another step forward in the language of an entirely psychological narration, acquired through the experience of *The Last Supper* in Milan. Yet, by comparison to that earlier work, an important novelty appears in the cartoon of *Saint Anne* – one that signals a turning point in Leonardo's art: here, for the first time, we see both the standardization of physiognomies and their idealization. It is no coincidence that this further stage occurred in Florence, and in Michelangelo's presence, since this was the artist who moved human physiognomy, in both sculpture and painting (as would be soon be seen in the *Tondo Doni*), decisively towards an ideal synthesis, which complemented the spirituality and universality of his work.

When working on *The Last Supper* in Milan, Leonardo sought out particular faces that could best express his ideas about the sentiments to be represented. He carefully selected real people for their physiognomy, and even for their hands. The streets of Milan became an open book, a huge catalogue from which he could select the physical appearances that would most closely convey the idea he had in mind. On reaching Florence, after a short stay in Tivoli, where he came face to face with the universality of classical sculpture, Leonardo embarked on a new path, quite different from naturalism, that would lead him towards an ideal representation capable of touching the spectator more intimately.[3]

Michelangelo must have been aware of this change, since he had

arrived at this conclusion years earlier (both the *Bacchus* and the *Pietà* are significant examples of this idealistic rendering of the face). In his sculptures (and in the *Tondo Doni*, which can be dated to 1505), Michelangelo had developed a new form of idealism, which censured excessive physiognomic characterization, the search for imitative effects of nature, and preferred a universal idea of the human body that allowed him to narrate higher sentiments through the human being precisely because he distanced himself from the natural world. Nor could Leonardo readily disregard this research, owing to Michelangelo's scientific studies, in particular his anatomical studies – because young Michelangelo had been a step ahead of Leonardo in this respect too: the younger artist could boast a perfect knowledge of the human body, and certainly a capacity to represent it that had never been achieved before, not even by Leonardo.

If the older artist was in Rome, as he seems to have been, he must have seen Michelangelo's *Pietà* at Saint Peter's, where he would have been astounded at the naturalistic and at the same time ideal perfection of the face of the Virgin and that of Christ. Also, if Leonardo had been impressed by the classical statues of Tivoli, he could not ignore the fact that Michelangelo had reached and surpassed those models in his *Bacchus*; moreover, Michelangelo was now working with a form of representation that was wonderfully in harmony yet also idealized, above all in its psychological expressions – which, rejecting the old medieval and fifteenth-century symbols, made sculpture approachable precisely because of its ideal energy, as in the case of *David*, whose pride was stamped on every inch of his face.

The radical change in the physiognomies painted by Leonardo occurred in Florence and, more precisely, in the cartoons for Saint Anne; therefore it is right to hypothesize that Leonardo was goaded by the confrontation with the younger, aggressive artist, with whom he had to compete for market and for primacy in the city. The stylistic change visible in the Burlington House cartoon built on the improved drawing technique achieved by Leonardo, who, already by the mid-1490s, in Milan, had abandoned drawing in silverpoint in favour of a soft pencil [*matita grassa*], and this enabled him to produce softer shading, more in harmony with the elusiveness of light that was central to his optical studies. Many of the preparatory drawings for *The Last*

Supper were made using a soft and shaded pencil. This then led to a breathless crescendo in the cartoon for *Saint Anne*, where Leonardo used shaded pencil in a wholly new and fully expressive manner.

The darkest tones and the blurred edges of the drawing are ideal for disguising the inconsistencies of unusual poses. The most awkward part of the composition, Mary's left hip resting on Saint Anne's legs, is cast into the deepest shadow, which hides the imprecise details of the pose but allows the successfully portrayed parts to merge in dreamlike softness: the arms, the child's body with his raised hand, the faces of Mary and Saint Anne. There is no trace of dryness in the cartoon, thanks to the shaded pencil, and the figures are enveloped in a penumbra that softens the details while the highlights, by creating sudden shifts of tone, pick out the key elements of the narrative. Mary's face is almost identical to that of Saint Anne, and her youth only emerges in the more vivid facial contours revealed by a stronger light. In order to produce that graceful gesture, the child's body is unnaturally elongated as he sits on Mary's lap, but this inconsistency is well hidden by the shadow in which Leonardo envelops his legs and hips, which are as sinuous as those of a siren.

25

THE *MADONNAS* OF THE *YARNWINDER*

The child reaching over his mother's arm as he tries to grasp the Cross, the symbol of his Passion, became a topic very dear to Leonardo in this period. On Novellara's subsequent visit (14 April 1501), when he tried to persuade the artist to add colour to the portrait of Isabella d'Este, he found Leonardo increasingly bored with painting but at work on a small panel that the friar described with his usual connoisseur eye:

> The little picture he is doing is of a Madonna seated as if she were about to spin yarns [*inaspare fusi*]. The child has placed his foot on the basket of yarns, has grasped the yarnwinder, and gazes attentively at the four spokes, which are in the form of a cross. As if desirous of the cross, he smiles and holds it firm, and is unwilling to yield it to his mother, who seems to want to take it away from him.[4]

There are now two versions of this painting, which was commissioned by Florimond Robertet, the French minister posted to Milan: the *Lansdowne Madonnna* [Plate 44] and the *Buccleuch Madonna* [Plate 45]. In certain respects both can be *ascribed* to Leonardo, but neither is wholly convincing. The former is of higher quality with regard to the landscape in the background and the chiaroscuro of the Virgin's face, while the latter, which has a simplified and very flattened landscape,

gives signs of a talent not up to Leonardo's standard in the definition of the chiaroscuro, too. Both paintings have been taken from the same cartoon, and recent studies of the preparatory drawings underlying the paint show significant changes between the initial idea and its subsequent development.

This further mystery involving Leonardo's works can be explained in the light of Novellara's first letter: Leonardo, who had 'lost all patience with his brush', got pupils to execute the paintings he had been commissioned to produce and intervened only occasionally, to correct and improve their work. This practice accounts for the difficulties that arise when assessing these two paintings, and also for the somewhat simplified technique. But the important thing here is that in these two paintings, too – and they are the last ones attributable to Leonardo in this decade – one finds the classicizing physiognomy of the Virgin that we have already seen in the Burlington House cartoon and a rigorous reiteration of her typical physiognomy. By now, for Leonardo, women have high cheekbones, prominent eyelids and a straight nose extending above a small, thin mouth. The lowered eyelids contribute to the elusive, meek nature of their gaze, which is also gentle and detached. The model of this ideal woman is repeated again and again, both in drawings and in paintings, but is also apparent in the male figures (which become extremely rare from this point on) – as in the Saint John that he would paint in the following decade.

Novellara's letters and the information that the friar managed to extract from Leonardo's pupils also announce the changes that were happening in the artist's life: he had lost patience with painting, was lost in a delirium of mathematical studies, and above all was now again attracted by military projects, a field where he clearly felt that his numerous and wide-ranging talents could bear fruit. In the composition of the *Madonna of the Yarnwinder* one figure is absent again, and deliberately so: that of Saint Joseph, a father who reminded Leonardo too much of his own absent father, whom he avoided even in paint.

26

THE HUMAN BEAST

Leonardo could never resign himself to being pushed back into the narrow confines of a workshop painter, especially in a city that was so rich in talent that it showed no sign of being easily impressed by Leonardo's genius.

The chance of making an active return to his military and scientific interests was offered him in 1502 by Cesare Borgia, known as Il Valentino, son of Pope Alexander VI. For ten years, both father and son had tormented Italy with their unbounded ambitions, accompanied by such unseemly behaviour that it has become legendary and a source of piquant material for authors down the centuries. Before his election as pope in 1492, while he was still a cardinal, Rodrigo Borgia had already fathered four children when he fell passionately in love with a young girl from a minor noble family in Lazio, Giulia Farnese. Such was his lack of restraint that he instigated what almost amounted to a cult to her beauty, instructing painters to depict her as a Madonna in frescoes with which he embellished the Vatican apartments after his election, and even taking her with him on processions through the city, amid the contemptuous looks of the Roman populace, which never missed an opportunity to jeer. In an attempt to retain her affections Alexander VI wrote her letters that would make even the most ardent of secret lovers blush today; and he rewarded her by elevating her brother, Alessandro

Farnese, to the cardinalate. In 1534 he, too, would become pope, under the name Paul III.

The licentious behaviour of the pope and his family caused astonishment even among those who had the greatest reason to be tolerant, so much so that some festivities – or it would be more truthful to call them orgies with multiple couplings on the floor of the Vatican apartments – were faithfully recorded and circulated in the letters of visiting ambassadors. Such dissolute behaviour within the family was compounded by the abuse that Alexander VI and his son Cesare inflicted on young Lucrezia, daughter to one and sister to the other. While in the historical record Lucrezia became a symbol of every form of wickedness, she was in actual fact a modest and responsible wife who went on to live an irreprehensible life during which she devoted herself to her sons, to her husband, Alfonso I d'Este, duke of Ferrara, and to the duchy.

However, the ambition of Alexander VI and his son Cesare did not stop at a good marriage for Lucrezia or at the acquisition of a small Italian state. The pope had set his sights on creating a state with European influence for his own family; and he entrusted his son with the task of conquering and annexing the territories of various central Italian lordships, hoping to expand his rule later on through the annexation of one of the major states, such as the duchy of Milan or the republic of Florence.

As the new century dawned, Cesare Borgia embarked on a campaign of rapid and violent conquests, which left its victims no time to mount a resistance. Within a few years, Cesare's courage, fortune and, above all, political cynicism turned him into a prince who was in some respects exemplary – at least for a political writer like Niccolò Machiavelli, who saw in him a new type of leader, of a decisive and volatile character and capable of seizing control over his own destiny without waiting for royal approval, let alone divine providence.

Never had there been a more affectionate father and a more affectionate son than Pope Alexander VI and Cesare, his second-born child, united as they were by their ambition and by sexual appetites that far exceeded the limits of decency. The two worked in total agreement with each other and the timing of their actions still surprises today for its perfect synchronicity. In the most sensational assassination carried out by Cesare Borgia, at Christmas 1502, it is extraordinary how, on

the very day when Cesare imprisoned Vitellozzo Vitelli, Paolo Orsini, Liverotto da Fermo and Francesco Orsini in Senigallia before killing them, 331 kilometres away, in Rome, the pope ordered the imprisonment of all the other Orsini brothers; the plan was to wipe out the entire family and avoid any possible reaction from that dynasty – which, thanks to the number of generals it boasted and their military valour, seemed destined to conquer Italy:

> [Cesare]. . . strangled Vitellozzo and Liverotto in a wretched manner, using a new and cruel method, and a few days later Lord Paolo and the duke of Gravina; and that same day the pope ordered the arrest in the palace of Cardinal Orsini and messer Rinaldo Orsini, archbishop of Florence, and messer Jacopo da Santa Croce, a Roman gentleman among the leaders of the Orsini faction; of these the cardinal was immediately put to death; the other two, having been imprisoned for some time, were released.[5]

In 1502, after Cesare Borgia's conquest of Urbino, the whole of Italy lived in terror of his next move, and none more so than Florence, which could rely on promises of French defence but not on any effective army. Arezzo and Pisa seized the opportunity of the disorder created by Il Valentino to rebel, and the whole of Florence trembled with fear of what might happen in the event of an attack by the pope's son and his fearsome army – everyone except the painter of gentle Madonnas, Leonardo da Vinci, who, without a moment's hesitation, offered his services to Cesare Borgia as a military expert who could improve the defences of the fortresses the duke had recently conquered. In the same way in which he had offered his services to the French in Milan two years earlier, Leonardo now approached Cesare Borgia, showing no compunction about playing a part in what might have become an attack on his home city of Florence. Perhaps Leonardo answered only to the calls of science, not to those of politics or affections; and he may have seen that voracious assassin as the perfect prince to whom he could offer his expertise, thus escaping from the insufferable position of workshop artist. On 21 June Cesare conquered Urbino and on 30 July, just over a month later, Leonardo was employed in his service in the conquered territories and had a mandate from the duke who appointed him:

Our most excellent and most beloved familiar Architect and General
Engineer, Leonardo Vinci, bearer of the same, has our commission to
survey the holds and fortresses of our States, in order that according to
their necessities and his judgement we may equip them.[6]

His role was to inspect the newly conquered fortresses and, where pos-
sible, improve their defences.

The long tour of inspection in Romagna did nothing to slake
Leonardo's thirst for knowledge, and in addition to visiting fortresses
he also visited libraries, noting – along with with the special charac-
teristics of some of the fortresses and ports in Romagna – the rare
codices that he would like to read. Leonardo became a fully fledged
collaborator of Duke Valentino in his campaign to conquer central
Italy, acquiring the title he had sought for decades: 'our most excellent
and most beloved familiar Architect and General Engineer'. But, luck-
ily for Italians, this nightmare was destined to vanish as rapidly as it had
appeared, and Leonardo would once again be without a protector: all
within the space of one short autumn.

After the savage murders at Christmas, in Senigallia and in Rome,
the papal family's cruelty and thirst for power became real concerns
for the monarchs of France and Spain, and Valentino's campaign in
central Italy experienced a setback while the circles of European and
Italian diplomacy tried to assess the consequences of this new terri-
torial power. No sooner did Cesare Borgia realize that concerns about
his too rash conquests were growing around him and his father, upset-
ting the delicate balances of power in Italy, than there was nothing he
could do to stop the network of protection and collaboration that had
supported his enterprises from crumbling. Even the throne of Saint
Peter's seemed incapable of protecting him against the growing hostil-
ity around him. Once again, before matters came to a crunch, the web
of alliances and complicity collapsed in a confused but rapid process,
leaving Valentino alone.

In the spring of 1503, relations between the prince and his architect
also evaporated in the general confusion and Leonardo, not believing
his own eyes, was unable even to discover where his new protector
had gone. An entry in his diary would be incomprehensible if histo-
rians had not seen that rapid collapse as a unique form of implosion:

'Where is Valentino?' asks Leonardo.[7] It was a rhetorical question that highlights the instability of the relationship through which Leonardo had mistakenly thought he would rediscover the protection he had enjoyed under Ludovico il Moro, which had been so beneficial to his art. Unfortunately that relationship would never be reproduced, at least not in Italy, where no power was truly stable.

On his return to Florence in April 1503, Leonardo was treated with suspicion by many, owing to his closeness to Cesare Borgia, to whom he might have passed important information regarding the republic's military organization. That spring Florence embarked on a new war against Pisa, and the city was once again in serious crisis because Pier Soderini's government faced domestic opposition and critics that could not easily be silenced.

With Valentino's fall, any possibility of remuneration vanished too, and the artist's coffers began to feel the effects. In the notebooks that once contained artistic visions of unparalleled beauty and brilliant scientific insights, shopping lists appeared instead – humiliating records of income and expenditure that reveal how difficult life was at that time for an artist until recently accustomed to the luxury of the great Milanese courtiers:

Memorandum how on the eighth day of April 1503 I Lionardo da Vinci lent Vante [Attavante] the miniaturist four gold ducats in gold. Salai took them to him and gave them into his own hand. He undertook to repay me within forty days. Memorandum how on the above-mentioned day I gave Salai three gold ducats which he said he needed in order to get a pair of rose-coloured stockings with their adornments. And I have still to give him nine ducats, against which he owes me twenty ducats, that is seventeen lent at Milan and three at Venice.[8]

Salai's rose-coloured stockings, notwithstanding – or perhaps precisely because of – these difficult times, seem to have been the artist's only consolation.

On 5 March Leonardo withdrew 50 ducats from his account with Santa Maria Nuova, leaving barely 450 ducats in all. The jobs that the Florentine government offered him after an initial period of hesitation were insubstantial: the only ones that translated into actual work were

an inspection of the fortress of Verruca on the road to Pisa and another at the mouth of the Arno, on a project to deviate the river in the event of siege: both minor jobs for which the only payment recorded was expenses. From Milan there was little news: on 23 June Leonardo and de Predis, his partner in the painting of *The Virgin of the Rocks*, wrote to the French king, asking him to settle the dispute with the monks of San Francesco so that the pair may obtain a larger compensation for the painting.

The climate surrounding Leonardo was one of hostility and impatience on account of his slowness and inability to complete a project; and, although these were the years when his name was starting to circulate in printed works such as the *De illustriorum urbis Florentiae* by Ugolino Verino, those who knew him best and admired him had no trust in his ability to finish anything. Evidence of this lack of confidence appears in an extremely private note that Agostino Vespucci, an assistant to the Chancery of Florence and nephew of the more famous Amerigo, made in the margins of an incunabulum [early printed book] by Cicero, who was mentioning an unfinished painting by Apelles. Inspired by this reference, Vespucci noted that Leonardo da Vinci did the same with all his paintings: 'This is what he [Leonardo] did with the head of Lisa del Giocondo and that of Anne, the mother of the Virgin. We will see', he added, in a sarcastic comment that proved to be prophetic, 'what he is going to do with the hall of the Great Council, about which he has just agreed with the Gonfaloniere.'[9]

So during these three years in Florence Leonardo had concluded nothing, not even the project for Saint Anne, which had prompted the admiration of so many fellow citizens back in 1501. No one believed in him, even though this same note announced the last of the great failures of his life, the decoration of the Great Council Hall in Florence, which was commissioned in an atmosphere of general scepticism. It comes as no surprise to learn that in the summer of 1503, perhaps the most bitter of his entire life, Leonardo took a step that would have been completely incomprehensible if it had not occurred in the climate of failure and mistrust that enveloped him at the time. The escape from Milan, the time spent wandering around Mantua and Venice, then the return to Florence, immediately abandoned again in the attempt to serve Cesare Borgia, the hated prince whose downfall happened under Leonardo's

own eyes: everything had gone badly for him in the past three years, and in July 1503 the artist took an extreme step, the product of pure despair.

He wrote a letter to the sultan of Istanbul, Bajazet II, offering him his services as engineer and intending to abandon Florence and Italy forever. Simply in order to escape his status as a painter and the mistrust that surrounded him in Florence, Leonardo was ready to run off to the East and enter the service of the sultan. One of the many merchants who travelled between Istanbul and Italy must have told him that the powerful sultan was toying with the idea of building a bridge over the Bosphorus, and this gave Leonardo hope: just as he had done 20 years earlier, when he offered his expertise to Ludovico il Moro, tempting him with the promise of a bronze horse, now, in the despair of July, when war was imminent in Florence, Leonardo offered the sultan his project for a bridge:

> I, your servant, have heard about your intention to build a bridge from Istanbul to Galata, and that you have not done it because no man can be found who would be able to plan it. I, your servant, know how. I would raise it to the height of a building, so that, on account of its height, no one will be allowed to go through it. But I have thought of making an obstruction so as to make it possible to drive piles after having removed the water. I would make it possible that a ship may pass underneath it even with its sails up. I would have a drawbridge so that, when one wishes, one can pass on to the Anatolian coast. However, since water moves through continuously, the banks may be consumed. Therefore, I will find a system of guiding the flow of the water, and to keep it at the bottom so as not to affect the banks.[10]

The letter was written in Arabic and sent to the sultan, who ordered it to be filed in the Topkapi Palace, where it has been conserved ever since. The grand viziers of the sultan read it carefully, since they were well aware of the talent and daring engineering skills of the Italians: many of the buildings that the Ottomans had recently conquered in the eastern Mediterranean along the coast and on the islands were evidence for these skills. Giovanni Bellini had recently visited Bajazet's court, where he had painted the sultan; hence they had no reason to doubt the

talent of this Tuscan painter and engineer, who seemed so confident of his skills. But the simplicity with which Leonardo proposed to carry out a project that appeared completely unworkable to many must have alarmed them. Leonardo's reputation for being someone who never completed his work must also have given them cause for concern: a Turkish ambassador had been present in Milan at the spectacular feast of Paradise more than ten years earlier, and it was not difficult to find information about so prominent a figure. Perhaps they thought he was slightly mad; and they left the letter in the archives and Leonardo in Florence, where everyone wanted him to do what he was best at: paint!

27

REAL WARS AND MOCK BATTLES

Commenting on his Cicero, the sardonic Agostino Vespucci, nephew of the explorer who had just opened the doors to the New World from a continent suddenly turned old, referred sceptically to the commission that Leonardo had just received in October 1503: to decorate the Great Council Hall in the Palazzo della Signoria (now Palazzo Vecchio), the city's political hub. Leonardo's talent was so prodigious that it defied even the proverbial practicality of the republican government – which, once again, staked its reputation and money on this eccentric citizen; for three years had he been seen strolling around the city with his small but elegant court of assistants and lovers, all of whom were handsome, unconventional, and in search of a way to make ends meet.

This time the project was extremely ambitious and formed part of an idea devised by Pier Soderini's government: to ask artists to portray the glory of the republic. The first sensational step taken to further this idea was the public installation of *David*, the marble giant whose recent completion had sparked a complex debate regarding its final resting place – a matter of state in the most literal sense of the word. In an act that was unprecedented in the history of the Old World, the republican government of Florence summoned all the major artists present in the city, even those who were not born there, to decide where to place the marble giant. The colossal statue – the first since Roman times to see

the light of day, being carved *ex novo* from a single block – had become a symbol of republican pride in Florence, and Gonfaloniere Soderini had convened the artists in order to ensure that it was valued in the highest possible way, thereby recognizing for the first time their specific competence in adding value to political strategies.

The meeting was attended by all the artists whom later generations would identify with the Renaissance itself; and the decision was eventually taken to place the *David* at the entrance of the Palazzo della Signoria. Leonardo, with a touch of rancour, opposed the decision and instead agreed with others that the statue should stand apart, against the wall of the loggia beside the Palazzo: 'I agree that it should be in the Loggia, where Giuliano [da Sangallo] said, but on the parapet where they hang the tapestries on the side of the wall, and with decency and decorum, and so displayed that it does not spoil the ceremonies of the officials.'[11] The mention of decency may have referred to the addition of a gilded leaf that for a while covered the youth's genitals – which on this occasion must have appeared to Leonardo too 'indecent' to be displayed.

The next step taken by Pier Soderini's Signoria was to commission the two artists widely regarded as the greatest, Leonardo da Vinci and Michelangelo Buonarroti, to undertake a new work, which would be even more openly political and celebratory of the republic. In what would become an open contest between two equally innovative and extraordinary ways of conceiving art, the work consisted of two huge mural paintings on the walls of the Great Council Hall in the Palazzo della Signoria. Their subject matter was two battles through which the young republic could vaunt its military virtues. This programme was a proclamation of intent by the government – which, prompted by Niccolò Machiavelli, secretary to the Signoria, was engaged in the hard work of reinstating a citizen militia, a local army that would in part replace the mercenary troops used by the republic for years. One of the protagonists of the time, Francesco Guicciardini, praised the importance of this political project:

> At the same time [in autumn 1505], work on the militia ordinance began to be enforced; in the past this had been practised in our countryside and wars were fought not with mercenaries and foreign soldiers, but with citizens and our own subjects.[12]

Nothing could arouse the military pride of the Florentines better than the evocation of the two battles that the citizen militia had successfully fought in defence of its own liberty: the first a victory against the Pisans in July 1364 at Cascina on the banks of the Arno, not far from Pisa, and the second a victory against the Milanese in 1440, close to the town of Anghiari. It is easy to imagine how much the republican government staked on the realization of this decorative cycle, all the more as it had been trying for years to quash the rebellion of the Pisans in a long siege. Michelangelo was assigned the *Battle of Cascina* and Leonardo the *Battle of Anghiari*. The task of agreeing on the detailed portrayal of the battles was delegated to the historians who worked for the republic, above all Niccolò Machiavelli, who knew how to gather exact information regarding these events. Leonardo was asked to depict a particular moment in the battle of Anghiari, namely the fight for the standard and the exact moment when the Florentine commander, Micheletto Attendolo, grabbed it from the commander of the Milanese troops, Niccolò Piccinino. Michelangelo was asked to depict another crucial moment of the battle of Cascina, when the Florentine troops were surprised by the enemy as they bathed on the banks of the river.

Both episodes are described in detail in the Florentine chronicles, but we do not know whether the two artists were offered the chance to choose exactly which moment of the battle to paint from a number of options. Undoubtedly, the moments that were finally chosen allowed both Leonardo and Michelangelo to display their own innovations and studies to great effect, and therefore it seems very likely that the choice of topic was made in collaboration with the artists. In displaying the battle between armed horsemen, Leonardo could put to good use his passion for horses; most of all, he could draw on the long and complex studies carried out in Milan during the previous decade, while working on the equestrian monument for Francesco Sforza. At the same time, his studies on physiognomy would reach a new frontier in this kind of representation. After the surprise and dismay shown on the faces of the Apostles in *The Last Supper*, he would now have an opportunity to experiment with the expressions of extreme ferocity, violence and hatred as well as with the physical impetus that all animate a battle scene [Plate 46].

For his part, Michelangelo, who had neither the desire nor the oppor-

tunity to tackle anything but the male figure and the expressive potential of the human body, would have to portray a scene in which nude males were surprised by the Pisans while refreshing themselves in the Arno and were able to foil the attack only thanks to their commander Manno Donati, who had not joined the bathers and immediately gave the alarm [Plate 47]. Michelangelo's soldiers, naked like classical athletes, are seen struggling to recompose themselves rapidly in order to confront the enemy. Michelangelo's perfect control of male anatomy – visible in the cartoon, which has survived through a copy made by Bastiano da Sangallo – allowed him to represent an orderly scrummage in which the spaces between the bodies and the movements of individual men are perfectly organized; and the realistic effect could not have been more astounding.

It was Michelangelo who was the more daring one in this challenge, since he had practically never painted anything on a wall, except during his apprenticeship in Ghirlandaio's workshop. After that he had painted on easel panels, such as the small *Temptations of Saint Anthony* and a larger one of *Saint Francis*, both now lost. However, in recent months he had finished the *Tondo Doni*, which portrayed a sacred family, and its beauty and innovation was the cause of widespread marvel. For the *Tondo* he chose the rapid medium of tempera, in which the colour is mixed with egg white and a small amount of glue; this method allows it to dry very fast, even though it does not permit much tonal variation. Thanks to the use of dashed brushstrokes of extraordinary precision, Michelangelo obtained such softness in shading that he surpassed the quality and refinement of oil paintings, which were all the vogue in those years.

Unlike Leonardo, Michelangelo did not like dawdling over his work; once the image had reached a good level of definition through his tense way of drawing, which was full of energy, he moved quickly to colour, moulding the surface through chiaroscuro contrasts in order to give plastic force to his figures – because he only drew human figures. Yet in those painted figures he revealed such excellence that, in spite of his small number of pictorial works, the Florentines were convinced that he would certainly be capable of completing a pictorial enterprise of huge proportions. He, too, was rash in his own fashion; but, unlike Leonardo, he knew exactly how to recognize his own limits and would

never embark, throughout his life, on a project that he was unable to finish.

In 1504, in a Florence that worried about political events in Italy and the instability of its own government, everybody's attention was focused on this unprecedented challenge between the old master aged 52, who was renowned for his extraordinary talent in painting, even if not manifested in particularly large works, and the young artist, still under 30, who was known mostly for his sculpture – magnificent and imposing works, but sculpture nonetheless. Already by this time Michelangelo thought that the problem of art was not the technique used but the force of invention and the accuracy of representation, two areas in which he did not brook comparison. Leonardo, in turn, also regarded this commission as an extension of his sophisticated studies of light and of the gradations between light and shadow.

The first sketches for the *Battle of Anghiari*, like the one preserved at the Accademia of Venice [Plate 48], immediately reveal the level at which he intended to develop the narrative. The subject matter is condensed in the clash between the horses; and the horsemen almost seem to be a natural extension, a fusion of flesh and fury. Once again, Leonardo tends to identify and express human feelings through those of the animal, as he had done in the portrait of Cecilia Gallerani. To reinforce this identification of the enemy with the beast, he painted a fabulous ram's head on the armour of the enemy captain, Niccolò Piccinino, a symbol of bellicose *furor* but also of the animal regression to which the enemy had stooped. To complete the metamorphosis, there are horns on his helmet that seem to sprout straight from his skull. His face transformed by fury gives additional expression and emphasis to the metamorphosis.

The copies of Leonardo's cartoon (the *Tavola Doria* and the canvas by Peter Paul Rubens) are detailed enough to allow us to interpret the painting that Leonardo never finished. The horses' profiles are reduced to diagrams of clashing forces, giving unnatural emphasis to the arched backs, lifted high by hooves compressed like springs ready to explode. A powerful mechanical device seems to be concealed under the animals' muscles and the men's armour. The battle is a condensation of forces transformed into flesh, steel cuirasses and angry shouts, but the upward thrust of the group prepares and highlights the winner as he pulls the

standard pole from the enemy's hands: the Florentine captain, whose
unaltered face is almost a manifesto of rational control over bestiality
and who epitomizes, in his symbolic gesture, the significance of vic-
tory. On the helmet of the victorious commander, rising above the
throng, is a winged dragon that symbolizes wisdom and prudence. The
symbolic reading goes along with and strengthens the dynamics of the
battle, which are revealed with the immediacy of a chronicle; the clash
is between good and evil, reason and bestiality, men and animals – and
the attack itself is so violent that even the atmosphere is set in move-
ment, making the flags whirl as if in a storm. The tangle of bodies had
to appear credible and the painting ambitiously aimed to show how
even the air was filled with dust.

In the successive phase of the study Leonardo focused on the physi-
ognomies of the men and animals, trying to give that narrative and
psychological value to their features that he had experimented so well in
The Last Supper. The force and violence of the combat can be read in
the men's faces as it twists their features, but the greatest novelty is
in the humanized expressions of the horses, which appear to participate
in the fight with as much intelligence and skill as their riders. Never had
horses been painted with such terrified and moving eyes as those that
Leonardo prepared in the Palazzo della Signoria, and the entangled
front legs of the two horses in the centre of the scene reach such heights
of pathos that the two animals seem to embrace each other in despair
rather than clash with hatred. In the classical fights between centaurs a
human torso had to be shown on the horse's body in order to narrate
the fusion of man and beast, yet Leonardo gave human faces to the
horses simply through the art of drawing and chiaroscuro. The clash
between animals was transformed in the final preparatory phase of the
painting into an insoluble cluster of limbs and bodies in which there is
no difference between human and animal.

That war that Leonardo had never managed to contribute to with
his machines and exploding projectiles, with war chariots whose wheels
were fitted with scythes and whose metal warheads were intended to
destroy enemy chariots designed almost like future tanks – that war
was now represented in its bestial violence, which burst onto the artis-
tic scene, overriding the dignified representations of battles so widely
admired in Florence in the solemn geometrical forms of Andrea del

Castagno and Paolo Uccello. Leonardo's imagined battle reveals the human creature's pure regression to primordial sentiments, its becoming one with the primitive natural forces represented by the horses and by the fury of the wind whipping the standards and the banners. The tangle is so dense that only colour would have been able to introduce order, and from the surviving copies we know that the artist made use of the clear contrast of the horses' colour to make it easier to understand the clashing forces. Leonardo imagines the horses as being palest in colour in the parts closest to the viewer in order to separate their impact visibly from that of the horsemen, whose individual bodies and armour can only be discerned with difficulty. The horses in the inner part of the scene are brown, a colour that complements the shadow into which the tangle of bodies dissolves. Here his technique is somewhat reminiscent of the way in which the bodies of the Virgin and Saint Anne merge in the Burlington House cartoon.

But, once the image had reached a good level of definition through these preparatory studies, the artist was forced to confront the age-old problem of its practical realization. The Florentine Signoria, well aware of Leonardo's shortcomings in this respect, had done everything possible to encourage the successful execution of the project, starting with wildly generous advance payments that, in this particular instance, were nothing more than a gamble. The contract, perhaps the most intricate of the entire Renaissance, tried to foresee and prevent every possible defection on the part of the artist. Leonardo was paid monthly, both for the work on the cartoon and for the painting, and deadlines were set for delivering the preparatory cartoon, after which, in the event that Leonardo failed to meet this deadline, the patrons had the option of appointing other artists to complete the wall painting using his cartoon. At the same time, however, the artist was given the guarantee that, if he wished to alternate between the preparation of the cartoon and painting the battle scene, even in part, he would be free to do so. By hedging their bets in this way, the sceptical councillors of the Gonfaloniere thought they had found a way to protect themselves against their notoriously unreliable but exceptionally talented fellow citizen.

Florence's survival had for centuries been linked to the political astuteness and pragmatism of its administrators, and this contract, which was drafted in the chancery overseen by Machiavelli between

late 1503 and early 1504, is a perfect example of this. Alongside this elaborate notarial document, a complex artisanal structure was also put in place in order to help the artist overcome all the practical problems linked to his way of working. By now it was widely known that Leonardo not only drew the scene to be painted in his cartoons, but prepared the actual painting itself. His cartoon not only showed the outlines of the figures and the main shadows, applied with two or three shades of charcoal (Raphael would do the same shortly afterwards in his marvellous cartoon for the *School of Athens* in the Vatican): Leonardo completed what was to all effects a painting on the cartoon, albeit in monochrome with infinite shades of grey and highlights in lead white, so as to experiment to the full with the brightest light and the darkest shadow.

His intentions were already clear from the first supplies of materials, a list of which is preserved in the archives of the punctilious Florentine administration. On 28 February 1504, having prepared a large wooden scaffold in the Salone dei Papi at Santa Maria Novella, where there was enough space to reproduce a scaled version of the immense walls of the Great Council Hall at the Palazzo della Signoria, the apothecaries Francesco and Pulinari del Garbo and the stationer Giovan Domenico di Filippo delivered

> a ream of paper and 18 notebooks with sheets at 12 *soldi* and . . . 11 a notebook for Lionardo da Vincio to make the cartoon for the Hall and for squaring and flattening the said sheets . . . 39 *libbre* and 4 *oncie* of white wax to mask the windows of the Palazzo del Podestà and the Council Hall and for the window at the Friars and the Sala de' Signori, and between the rooms and the Ten and elsewhere, and turpentine, *biacca*, sponge and other things given to Lionardo da Vinci.[13]

Together with the sheets of paper to be glued together to form a single, large square of paper of the same dimensions as the painting, Leonardo had *biacca* delivered to him: a white pigment made by corroding lead sheets with ammonium that was widely used in all paintings except in murals – where, as Cennino Cennini warned and Cimabue's great *Crucifixions* at Assisi testified, it darkened and turned violet over time. *Biacca* was also widely used to highlight watercoloured drawings,

and Leonardo had used it for years to finish his pencil drawings. So, with the help of *biacca* and his assistants, he now prepared to complete a real monochrome painting in the Salone dei Papi before it would be transferred in colour onto the walls of the Palazzo della Signoria.

At this time, given that this was an enormous cartoon, Leonardo must already have finished the general layout as well as the drawing itself; therefore it is plausible to imagine that the life-size cartoon of the painting would have been ready in two or three weeks. But nothing of the sort happened, confirming that any predicted timing was destined to fail with Leonardo. For more than a year he did nothing but work on the shading of the cartoon, trying to create those misty effects that he was pursuing through his studies on optics. Under the gaze of the Florentine councillors, first satisfied but then growing increasingly concerned, and as Agostino Vespucci looked on, as one might imagine, with a mocking smile, given that he had predicted renewed failure also on this occasion, Leonardo worked on the cartoon by hanging it from a huge frame and gluing its edges to a thin linen cloth, which also appears in the expenses recorded by the Signoria: 'and for a sheet and 3 canvas cloths given to the said Lionardo to bind the cartoon'. The frame on which the cartoon hung was so large that it needed supports, and the scaffold had steps to make it easier to climb up and down. Since the records also contain references to 'wheels for the platform for Leonardo', it seems likely that the artist ordered a movable platform to be built that could be rolled back from the vertical cartoon: in this way he would get an overall view of the composition and would avoid seeing it only in parts, as would have been the case with a fixed scaffold.

He therefore spent a whole year making this huge painting on paper, bringing it to a level of perfection seen in the copy made by Rubens, also in monochrome. But while the Signoria urged Leonardo to finish off the work rapidly and even modified the contract in May 1504 to hasten the work, Leonardo was distracted by other projects. He did not abandon the treatise on the flight of birds, and above all he did not stop working on a mathematical problem that was pointless as well as laborious, that of squaring the circle, for which he thought he found a solution, as he recorded in his notebooks on 30 November 1504: 'On the night of Saint Andrew's day I came to the end with the squaring of the circle: and it was the end of the light and of the night, and of the

paper on which I was writing.'[14] Exhausted but pleased to announce both the end of that day and the last of the sheets of paper on which he had solved the problem, Leonardo felt fully satisfied at having reached, or rather at believing that he had reached, this important intellectual goal. No painting ever gave him as much satisfaction, even if he had achieved excellent and real goals in painting alone. All the while he remained indifferent to the Florentine government's growing concern about the unending gestation of the painting for the Palazzo della Signoria, which now had to be postponed to the following spring.

In the meantime Michelangelo was also working on his cartoon, having rapidly completed the preparatory drawings, and he too was committed to dozens of other works: the *Tondo Pitti*, the *Tondo Taddei*, and the *Tondo Doni*, the statues for the Piccolomini Altar, the *Madonna of Bruges*, the *Saint Matthew* for the Opera del Duomo and yet more; but that November while Leonardo was toiling over squaring the circle, Michelangelo finished the preparatory studies for his *Battle of Cascina*, and a month later, on 31 December, ignoring the end-of-year celebrations, the tenacious young artist ordered another supply of paper for the huge final cartoon:

1504 xxxi *decembris*. To Francesco and Pulinari di Salamone del Garbo apothecaries for X *libre* of white wax and sponges and turpentine to wax the windows and for the cartoon of Michelagnolo and to Lionardo da Vinci, up to the 3rd of this month, 10 *lire* 6 *soldi* for several tacks and tapes to cover the window where Lionardo da Vinci is working.[15]

The moment of direct confrontation in the Great Council Hall was drawing ever closer. However, while Michelangelo had completed all his private orders within just one year after finishing the *David*, Leonardo kept the duchess of Mantua waiting on tenterhooks, while she regularly pestered him with reminders sent through her ambassadors, requesting a small figure painting, a youthful Christ. Isabella, with a flash of that seductive insight for which she was already famous throughout Italy, invited Leonardo to work on her small painting in order to distract himself from the battle scene, as she knew for certain through her informers that he was already bored with it: 'when you are tired of the Florentine painting, we ask you to paint this little figure

by way of recreation, by which you will do us a very gracious service and benefit yourself.'[16] However, the duchess could never have imagined that Leonardo found it much more restful to dedicate himself to mathematics than to her 'salon painting'. Apart from mathematics, Leonardo was also distracted by grief and deeply bitter feelings, from which he may have sought solace by retreating into that marvellous world of abstract numbers and circles that become squares with the help of a square and a ruler.

Ser Piero, his father, died in the summer of 1504 without having legitimized him; he relegated him forever to the position of the reject, the bastard, from which no amount of fame spreading throughout Italy in printed books could ever redeem him. The pain over the loss – or over the fact that, with that loss, the possibility of healing the wound of his illegitimate birth vanished forever – must have made him suffer in a way that he could not even acknowledge to himself. The death of his father appears to have been recorded in a scant couple of lines (but written with his right hand) between the note about stockings bought for Salai and the pay owed to his assistants: 'On the 9th day of July 1504, on Wednesday at seven o'clock, died Ser Piero da Vinci, notary at the Palace of the Podestà, my father. He was 80 years old, and left ten sons and two daughters' (Codex Arundel, fol. 79r, f. 272r). The note is found again in the Codex Atlanticus (fol. 196v), in an even more synthetic form: 'On Wednesday at seven o'clock died Ser Piero da Vinci on the 9th day of July 1504. On Wednesday at around seven o'clock.' But 9 July 1504 was a Tuesday: Leonardo was undoubtedly very shaken by the news.

As he notes, that father, so sensual and so avid for sex and power, left ten sons and two daughters; and, if he had had children with his first two wives, he might have left 30 children, if not more. These ten males, five from the third wife, Margherita, and five from the fourth wife, Lucrezia, left no room for him, Leonardo, the son of a young peasant girl, Caterina, sired because there was nothing better on offer in the countryside around Vinci. There was no space in that army of sons for Leonardo's legitimacy; and, even worse, Leonardo discovered that his father had not even wanted to leave him a single florin and had rejected the idea of including him as part of the family to the last. The wound that had never stopped smarting was renewed with the opening

of the will and the realization that Leonardo was nothing for the Vinci family.

The artist's pain moved his elderly uncle, Francesco, his true childhood friend, the uncle who never felt the urge to work and who stayed in the countryside, idling his days away, as Nonno Antonio said, but who guided Leonardo in his earliest explorations of nature. Francesco had no heirs and his brother Piero, together with his last wife, had exercised their rightful authority by making him draw up a will in which all his possessions went to his legitimate nephews. But in this Florentine world, which was so brutal and enslaved to business interests and to the laws of inheritance, Francesco had a weak spot for Leonardo and challenged the memory of his brother and of all the other nephews, with whom he had nothing in common: the eldest of them, Antonio, had been born when Francesco was already forty, whereas Leonardo had been the joy of his youthful years. Hence Francesco decided in secret to bequeath a considerable part of his inheritance to Leonardo – a share that was larger than anything he would leave to his legitimate nephews. This was a tribute to the love and affection that was beginning to break the rigid rules of the medieval world, as well as an homage to the years when young Leonardo had won the heart of his young uncle and his grandparents, Antonio and Lucia, in the house in Vinci, while in Florence Ser Piero was going through wives and reams of paper, in an attempt to obtain a legitimate son from the former and social prestige through the latter. But during those hot days of mourning Francesco's will was still a secret, while Ser Piero's rejection was clear-cut – and now fixed for eternity by his death.

Leonardo was under increasing pressure from the Signoria to finish the cartoon that had been started more than a year earlier, and Michelangelo was breathing down his neck with unstoppable energy as well as insolence. The city of Florence, which could be crossed from one side to another in less than one hour, was far too small for two geniuses of this magnitude. Michelangelo had started his cartoon in December, finishing it just over a month later, an incomparable achievement as far as Leonardo was concerned. Finally, Leonardo's horses champed at the bit on the immense sheet of card that was pasted with flour and raised up in the Salone dei Papi. The moment had come to transfer it onto the wall. The transport alone was a challenge: there were only a

few hundred metres between the Salone at Santa Maria Novella and the Palazzo della Signoria, but the whole cartoon and its frame measured several metres in length, perhaps ten, and was at least six metres high; it could be cut, but it would still have been difficult to transport. In February 1505 a payment was made 'for 4 wheels to make a cart for Lionardo da Vincio, or a platform, as stated in the ledger'.[17] From this we can infer that a large cart was prepared on which Leonardo's cartoon would be transported, and at the same time a new scaffold was put up in the Great Council Hall of the Palazzo della Signoria, where from now on Leonardo had to start work on transferring his battle scene onto the wall.

Michelangelo was also ready to climb onto a scaffold next to Leonardo's, and the whole city quivered in anticipation of the most exciting competition in living memory and tried to predict the outcome of the challenge. To win the challenge, Leonardo needed to paint in his slow and reflective technique, to superimpose thin washes [*velature*] in transparent hues, and to coax the image out of the mist in which he enveloped it, so as to make it seem both realistic and at the same time ideally superior to nature. He was not content with the technique he had used in Milan, since early reports had reached him of the deterioration of the painting in the refectory at Santa Maria delle Grazie. He knew he had to change materials and the way of preparing the wall for painting. He could have used the technique that other Florentine artists had used for mural painting, the dry fresco technique that would have freed him from the slavery of working with *giornate* [daily sections]. There were good examples in Florence of *a secco* [dry] wall paintings that had lasted for decades, if not centuries; but, as always, Leonardo had too little confidence in others and too much in himself, and he decided to experiment with a new form of preparation for the mural.

In the plaster for *The Last Supper* he had simply created a waterproof layer using a light plaster made of slaked lime and marble dust, coupled with layers of lead white pigment [*biacca*] and oil, perhaps also with the addition of an animal glue. Here, in the Great Council Hall of the Palazzo della Signoria, he ordered considerable quantities of 'Greek pitch', which arrived on 30 April 1505: this was a resin taken from the pines that grew along the Mediterranean coast and was used to seal ships' timbers and to prepare paints. It had never been used to

waterproof walls, but Leonardo thought that it would solve his main problem by turning the wall into a perfectly smooth, impermeable surface. The Greek pitch had to be dissolved over heat, and this explains the presence of those braziers mentioned in a list of Milanese equipment that was recalled by some Florentines years after these events. At the end of April, the workers responsible for applying the plaster and preparing small parts of the painting were at work and were paid by the Signoria, together with Leonardo's new assistant, Ferrando, a Spaniard who started to help him with the painting itself:

> To Lorenzo di Marcho labourer for three works and fi. [sic] in the Great Council Hall on the painting by Lionardo da Vinci. ... To Raffaello d'Antonio di Biagio painter for 14 works working on the painting by Lionardo da Vinci in the Council Hall at 2 soldi a day, lire 14. To Lucha di Simone ropemaker for one hundred tegolini and for one pail and a half of earth for use by Lionardo da Vinci on his scaffold for the painting. To the painting in the Great Hall for more colours and jars bought for Lionardo and 5 gold florins paid to Ferrando the Spaniard painter and to Tommaso di Giovanni who grinds the said colours given by Giovanni piffero.[18]

He spent the month of May preparing the sealed plaster and grinding pigments in the porphyry mortars in order to make them as fine as possible. Everything was ready: the bowls containing colours, the brushes of all different sizes, the palettes for mixing paints, the well-filtered and clear drying oils. The pail of earth provided by Luca di Simone is particularly interesting, because this must have been coloured earth (terra di Siena?) with which Leonardo coloured the preparatory wash to produce a ground that was not white, but warm and golden, as is confirmed by some copies of the portion of the painting that was completed. The coloured earth was mixed in large quantities with the plaster used by the artist to seal the wall and to prepare it for the addition of colour.

The large scaffold in the Hall must have looked like an apothecary's shop. In early June – an ideal month, owing to the warm temperature and the long hours of daylight – the much awaited moment finally arrived and Leonardo started to paint. Disaster struck immediately. According to old wives' superstitions, Friday was not a good day on

which to start a project, but Leonardo did not heed superstitions – at least not until that day, when he annotated the event in his notebook as nothing short of divine punishment for his boldness:

On the 6th day of June, 1505, Friday, at the stroke of the 13th hour, I began to paint in the palace. At that moment when [I] applied the brush the weather became bad, and the bell tolled calling the men to assemble. The cartoon ripped. The water spilled and the vessel containing it broke. And suddenly the weather became bad, and it rained so much that the waters were great. And the weather was dark as night. (Ms. Madrid II, f. 2r)

What else could happen, after such anticipation? If the start was ill-fated, the end would be tragic. With the help of Ferrando and of his old friend Zoroastro, busy grinding colours, Leonardo continued to paint all summer. The first figures to be traced were the horses, and they immediately became an object of wonder in the Florentines' eyes. For a short while, the long wait appeared to have paid off. Nothing could have been more pleasing to the Signoria than the fake battle Leonardo was painting, since the real war was not providing the same satisfaction. In August that year Pisa had finally been besieged and initially the campaign seemed to move towards Florence's advantage, but in September, when the final attack should have been made, there were cowardly defections among the Florentine troops that seriously embarrassed Pier Soderini's government. The events are told in inexorable detail by Guicciardini:

The day arrived on [17th] of August when, after a long skirmish, the enemy was overwhelmed and quite a few were captured. All the gun carriages and flags were taken, and these were put up in the Council Hall, given that the Gonfaloniere was very proud of this victory and attributed it to his own renown. ... and then having breached several lengths of wall with the artillery, and wanted to press home our advantage, there was so much cowardice and so little order among our troops, that being brutally rebutted they made no effect whatsoever, and then, given that some Spanish troops sent by Consalvi [Gonsalvo] arrived in Pisa, it was necessary to withdraw, having lost all hope, with

great burden on the captain, the commission and the Gonfaloniere [battle of 8 and 12 September] . . . At the same time the militia ordinance was set in motion, following the ancient practice in our contado, that wars were fought not with mercenaries and foreigners but with citizens and our own subjects [Autumn 1505].[19]

In front of this harsh reality it was all the more necessary to take refuge in the consolations of art, and Leonardo's cartoons could assuage the anxieties of the entire city. But not his own anxieties, which continued to drive him toward imaginary intellectual goals. In July, with total disregard for the pressures of work and for the fact that a large team of artisans, painters and joiners were reliant on him, he started to write a new book, and proudly announced its conception in his notebook: 'Book entitled "Of Transformation" that is of one body into another without diminution or increase of substance, begun by me, Leonardo da Vinci on the 12th day of July 1505' (Codex Forster I, fol. 3r).

Bored by the battle of Anghiari, Leonardo immediately commenced another battle, with mathematics. The autumn brought reassuring news: his rival, whose progress had been worrying him, had left the Council Hall and abandoned the city back in March, and for the time being the contest appeared to have been won by the old master. Michelangelo had been summoned to Rome by the new pope, Julius II, to design and then work on a monumental tomb to stand in the Vatican basilica. The commission was richly rewarded and brought him fame beyond all expectation. While Leonardo continued to receive a monthly stipend of 15 ducats for his painting, in March the pope had advanced 50 ducats to Michelangelo just for his travel expenses. In the following months Michelangelo had been paid 1,000 ducats, an exorbitant sum, to purchase marble from the quarry of Carrara. What was more, Michelangelo promptly bought his first property outside Florence, a piece of news that must have disturbed Leonardo. Suddenly the commission on which Leonardo was working must have appeared trifling by comparison to the fame and money received by his rival.

The voice of the siren from Milan had been audible already for a few months, and now it grew more persuasive every day. The French governor of the city, the *maréchal* de Chaumont, Charles d'Amboise, invited Leonardo to Milan in the name of King Louis XII, and in the

early months of 1506 the artist accepted, leaving the Gonfaloniere Pier Soderini and the entire Signoria disconcerted. Florence appeared to have been afflicted by the curse of emigration. Its greatest sons were unable to produce their best work in their native city – they could do it only abroad. Both Leonardo and Michelangelo would grow famous in the coming years, above all for works commissioned in other Italian capitals, in Milan and in Rome.

Pier Soderini could oppose neither the pope nor the French king, both of whom were too important in the political scenario in which Italy now found itself. Julius II had embarked on his campaign to reconquer the territories that belonged to the church. He was an energetic pope: as a cardinal he had held the Borgias to account, and now, as pope and at the head of a real army, he wielded a sword more often than he held a cross. His irascible temperament meant that he did not hesitate to brandish a stick when he wanted to get his own way with others. Louis XII was a similar sort of character. He was preparing to invade Italy with a large army in order to reconquer Genoa. The manoeuvre was a cause of concern for some Florentines and of rejoicing for others. Genoa was allied to Pisa and its defeat would also bring down Florence's worst enemy. At the same time, the French king's invasion of Italy would destabilize the fragile political balance and bring back the Habsburg emperor, Maximilian of Austria. Venice, the kingdom of Naples, the papacy, and smaller states like Mantua and Florence had to decide on which side to stand, well aware that the wrong alliance might cost them their future. Above all, the future of Pier Soderini was at stake, since he was regarded as being too closely linked to the French faction. As a result, he had to guard himself not only from enemies among the republicans but also from the Medici, who had never stopped plotting to return to Florence with the support of Cardinal Giovanni (the future Pope Leo X), who was now fostering closer relations with the new pope.

In such a complex and unstable scenario, it was not easy to oppose Leonardo's latest betrayal. On the other hand, the artist did not like the city's political climate. His mind yearned after grand projects, and grand projects needed grand patrons. Michelangelo had thrown himself into the pope's arms, and it was therefore right for Leonardo to throw himself into the arms of the French, all the more as their embrace

was open beyond any reasonable expectation. From Milan Leonardo received a request for a funerary monument for the condottiere Gian Giacomo Trivulzi: this was not the pope, but the project was still worth a considerable amount, which the artist himself estimated at around 3,046 ducats in a detailed quotation recorded in the Codex Atlanticus between 1506 and 1508. But what attracted him to Milan more than anything was the request of the French governor, Charles d'Amboise, to paint a number of paintings directly for him and for the king of France, and to assist him again in repairing Milan's defensive fortifications. Leonardo decided to leave Florence for Milan in early 1506, leaving behind him the riderless horses on the wall of the Palazzo della Signoria. The governor of Milan guaranteed to protect Leonardo from the Florentine Signoria's demands that he return to Florence, and on 18 August 1506 d'Amboise wrote in person to Soderini:

Because we still need Master Leonardo to provide certain works that, at our request, he has begun, let it please your Excellencies, as we now request them, to extend the time they have given to Master Leonardo by two months.[20]

Pier Soderini's response is polite and respectful, as it ought to be when writing to the representative of a king on whom the security of the Florentine state depended. He agreed to let Leonardo return to Florence the following September, but of course Leonardo had no wish to return and a new request for a further extension arrived from the governor in due course. On 9 October Soderini wrote to d'Amboise again, and on this occasion his irritation at Leonardo's offensive behaviour is all too apparent. Leaving aside any pretence at diplomacy, Soderini accused him of having cheated the Signoria by accepting a conspicuous sum of money in exchange for very little work:

We beg Your Lordship's pardon for writing again about Leonardo da Vinci, who has not behaved as he should have done towards this republic, because he has taken a good sum of money and only made a small beginning on the great work he was commissioned to carry out, and in our devotion to Your Lordship two extensions have already been granted. We do not wish any further requests to be made on this

matter, for this great work is for the benefit of all our citizens, and for us to release him from his obligations would be a dereliction of our office.[21]

The reply verged on insolence and d'Amboise waited until December to reply in harsh terms, praising Leonardo's almost supernatural talent and feigning surprise that his own fellow citizens were not ready to grant him in return a freedom and an honour of similar greatness. Soderini was left champing at the bit until, almost incredible though it seems, in January 1507 King Louis XII himself became involved and informed Soderini in the clearest of terms that Leonardo was his, and that he would use him and protect him for however long was needed. Leonardo's talent, irrespective of his eccentricities, had conquered a kingdom. In order to put an end to the petulant complaints of the small state that Louis regarded as completely irrelevant on the European political chessboard, and whose sole merit in his eyes was that it produced a stream of artistic and literary talent of outstanding ability, the king summoned the Florentine ambassador in Paris, Francesco Pandolfini, and the latter immediately informed Florence of the king's wishes:

> Write to them that I wish to employ their painter, Master Leonardo, who is now in Milan, and that I want him to make several things for me. Act in such a way that their lordships will order him to enter my service at once, and not to leave Milan before my arrival. He is an excellent master, and I desire to have several things from his hand. . . . I replied that if Leonardo were at Milan your lordships would order him to obey his Majesty.[22]

This is how matters stood; and there would be no more discussion. In Milan Leonardo was given back all his goods, and in April 1507 he also received his properties. The spring of 1507 marked the start of a glorious new Milanese season, but it would not give any fruits.

28

WAITING FOR GLORY

The powerful admirers and protectors who welcomed Leonardo to Milan with open arms could shield him from the annoying requests of Pier Soderini but not from the consequences of his own dreams of glory. Waiting for him in the city, which was now under French rule, was the unresolved question of *The Virgin of the Rocks*, which the Franciscans still demanded. New legal proceedings were underway, although on this occasion the French governor leant more heavily on the Franciscans, with the result that they, too, became more lenient in their requests. Leonardo had to agree to paint a new altarpiece for them. We know from the test carried out on the preparatory drawing that the master, assisted only by one of the de Predis brothers, initially tried to vary the painting by using a new drawing of the Virgin in adoration; but they must have given up very soon, and therefore, for convenience, they made a replica of the altarpiece that had played such a role in establishing Leonardo's reputation. There was one important alteration, however: the angel who supported the little Christ child with its left hand no longer pointed at the young Saint John with its right, because to the Franciscans that gesture seemed unseemly and inappropriate in a painting intended to celebrate the Immaculate Virgin.[23] The simplification of this gesture led to a general simplification of the whole composition, in which Leonardo's

intervention was undoubtedly much more limited than in the first version.

On the other hand, at this time Leonardo had lost all interest in painting, which he regarded as an annoying obstacle to his own scientific projects. His one wish was to finish that painting as quickly and with as little effort as possible; he looked upon it as a tiresome legal duty. For a start, it was a painting from which he had nothing more to expect. The shadows are no longer painted with that delicacy that aroused wonder in the first copy, and even the rocks behind the figures are markedly simplified – so much so that a modern expert on geology observed that, while in the first version of *The Virgin* the rock formations have the consistency of real life really observed, in the second version the rocks give no sense of reality; they simply look like an abstract catalogue of geological types, a juxtaposition of landscape motifs with no real logic, like those that often appeared in contemporary paintings from central Italy. The flora, too, is simplified: one need only look at the incongruous palm that appears to the right of the Virgin and compare it with the beautiful, sophisticated representation in the first version, modulated by glints of light. The glimpse of the landscape overlooking the Alpine lake has lost the hazy denseness of the spring-like atmosphere and its contrasting lines and colours are delineated with too much candour.

Leonardo's hand and his underdrawing contribute significantly to making this a masterpiece of Renaissance painting, but its pictorial details do not bear comparison with the first version because the drawing alone is not enough to re-create the miraculous atmosphere rendered in that version through chromatic harmonies and gradients [*sfumature*] of shadows. The perfect and natural spatial organization of the first painting is modified in the second by the rather incongruous position of the angel, who is no longer between the Virgin and the Christ child, but seems to stay behind her left arm. Although the drawing is the same in both, it is worth noting how much lack of care about shadows can alter the spatiality of the painting. It is the perfect calibration of light that gives credibility to the space in Leonardo's paintings.

The entire painting seems to have been done, if not in a hurry, then certainly in a simplified manner. The transitions between light and shade are not as gradual as in the first version, and their contrasts are so marked that the parts left in shadow almost disappear. No secondary

lights can be seen – those reflected lights that brought to life the parts left in shadow and defined them in a golden half-light. These remarks also serve to show that, although Leonardo certainly played a role in refining the final surfaces of the painting, the preponderant contribution by de Predis gives it a different feel, stylistically backdating it to the century that had just closed. Not only are the borders of the shadows sharp and stiff, as Leonardo feared, but the features are described using calligraphic lines that had completely vanished from his painting.

Leonardo was tired, and the painting is proof of his tiredness. His enthusiasm had turned elsewhere. One autumn evening in 1503 he had triumphantly noted that he had finally solved the problem of squaring the circle, a problem about which the world was no more concerned then than later. As has already been said, the problem had no real solution and never would have, but Leonardo could not resist the attraction of this logical puzzle, and his desire to redeem himself in the eyes of the world, of academics in particular, was such that he devoted himself to the question for months and years. In this way he was deluding himself that, by solving the problem, he had attained, if not surpassed, the greatest mathematical minds he had discovered through his books.

There seemed to be no bounds to his intellectual recklessness. Shortly after that announcement, it must have been Luca Pacioli – who moved to Florence in 1503 – who convinced him that he had been wrong, and Leonardo resigned himself (perhaps) to abandoning mathematical problems. Now, having returned to Milan, he embraced another extravagant dream: a *Treatise on Anatomy*, which would have at least 120 chapters and thousands of drawings. It was a project on which he had been working for years, on and off. With the guarantee of royal protection and with the support of the governor of Milan, the artist thought that he had found the necessary conditions in which to publish at least a part of his projects. He himself was beginning to realize that the accumulated material was becoming unmanageable: with hundreds of codices, thousands of notes, and tens of thousands of drawings, he could no longer make sense of it himself. The chaos to which he aimed to bring order was swallowing him, like sinking sands, and as the years passed his energy waned. As he approached sixty, he had not managed to finish anything he had started.

His willingness to serve the king through painting remained purely

theoretical, because from the moment he arrived in Milan his sole objective was to publish his treatises, at long last. The favourable attitude and willingness of the government were encouraging. Once again, the old artist was granted an exclusive treatment that was unparalleled among his contemporaries. As we have seen, in a letter dated 20 April 1507, the governor returned to him the possessions he had received from Ludovico il Moro, which had subsequently been expropriated. Most importantly, these included the vineyard and the house located just outside Milan. It was Salai who benefited most from this restitution, because he now had full control over Leonardo's property and life. Salai's family moved into the house and his relatives administered the vineyard on his behalf rather than for the legitimate owner. D'Amboise was content to commission sketches from Leonardo for his planned pleasure villa just outside Milan. This was an opportunity for the artist to return to the old classical models, to which he referred by designing an island of Venus with a series of clever devices for water games from which water gushed out from below, as well as a fabulous water-powered mill devised as a giant fan for refreshing the air during the torrid Lombard summers.

So long as he limited himself to thinking up highly original equipment and devices, Leonardo was second to none, but when it came to building and putting these projects into practice his drive petered out and ground to a halt – especially now that his energy was beginning to fail. Fortune was on his side during those months (or he convinced himself that it was), because the king himself arrived in Milan at the end of April and the city was decked with triumphal displays and theatrical sets for which Leonardo could still produce stupendous ideas without too much effort. The city seemed to be reliving the era of Ludovico's festivities, and the wind was blowing strongly in Leonardo's favour. Thanks to the king's arrival and to this possibility of making ephemeral structures [apparati] to which his genius was perfectly suited, Leonardo the old master was once more the brightest star in Milan; and he soon won back the favour of its most powerful citizens, including Girolamo Melzi, captain of the Milanese militia and the most influential protector of the city's security. Moreover, there was something else about Melzi in which Leonardo was particularly interested: he had a handsome and intelligent son, Francesco, who had studied at the best universities of

Lombardy and knew Greek and Latin, as well as having a sound knowl-
edge of humanist disciplines.

Leonardo's meeting with the young Francesco in the summer of
1507 persuaded him that he had found the key to resolving his prob-
lems. His intuition was indeed partly borne out by events. He found
that the assistance of this well-educated and energetic youth was essen-
tial to the task of reorganizing his codices and of finally embarking on
the publication of his ambitious treatise on anatomy, together with
the one on painting. The reorganization of his manuscripts had to be
postponed, though: yet again, events conspired against Leonardo pre-
cisely at the moment when he could have healed, once and forever, the
wound opened by his father's failure to recognize him. Yet the wound
remained open through Leonardo's own lack of children, because he
regarded himself as living an eternal boyhood, and his irregular, illegiti-
mate status imposed new prices for him to pay.

In July 1507 – as mentioned earlier – Francesco, the uncle who
had loved and protected Leonardo in his childhood, died in Florence.
When the testament was opened Ser Piero's widow discovered that her
brother-in-law had disobeyed the hateful orders given by Ser Piero,
that Francesco's possessions be left to Piero's legitimate sons and
that Leonardo be cut out of the inheritance. Leonardo's half-brother,
Giuliano, a notary like his father, not content with having inherited all
of his father's property, now impugned his uncle's will too, wishing to
expropriate the artist from the only inheritance he had received from
the da Vinci family. After Ser Piero's death, his legitimate sons seem to
have taken over not only the family patrimony but also the tenacious
desire to exclude their half-brother from the family line. This was, in
every respect, moral and emotional persecution – of a man who had
been a true descendant of the da Vinci family – for having lived not only
with his uncle Francesco but also with his grandparents, Antonio and
Lucia, people whom Ser Piero's sons had never known.

Leonardo's explosion of grief after the news of the litigation was
uncontainable, and it blinded him. This exaggerated reaction can only
be explained by the enormous pain caused by his father's obstinate rejec-
tion, which had accompanied him throughout his life. At the very time
when, without batting an eyelid, Leonardo let his cunning Salai take
advantage of him and remove a property that was much more valuable

than his uncle's bequest, he decided that he could not and would not renounce Francesco's inheritance. In both cases, the symbolic value of the assets was love: his love for Salai and the love he claimed from his paternal family. As before, his anger was expressed in a few incoherent notes in the Codex Atlanticus, which are difficult to interpret: 'You disliked Francesco so heartily and let him enjoy yours in life. You wish me so much ill, and . . . Whom did you love more, Francesco or me?' (fol. 571av). The only thing that emerges for certain is an indignation that hampers all reason and prevents us from understanding both the recipients of the letter and the intentions of its author.[24]

This scorn prompted him to turn to Louis XII, who proved to be very well disposed towards the artist. The king of France lowered himself to write a letter to the Signoria of Florence, on this occasion to solicit the rapid settlement of the dispute that had offended a man whom he held in high esteem, describing him in the letter as *nostre paintre et ingenieur ordinaire*. Still not satisfied after having bothered the king of France, Leonardo went to Florence in September 1507 and then turned to Cardinal Ippolito d'Este for help. In Florence everyone knew that he was under the protection of the French king and, as this was the period of the latter's highest power in Italy, Soderini was obliged to treat Leonardo as a prince; he did not even dare to mention the painting that had been left unfinished on the walls of the Palazzo della Signoria.

The talent of his fellow citizens was proving to be one of Soderini's greatest political problems. At around the same time the other fugitive, Michelangelo, had also returned to Florence, but not before having insulted Julius II; and his flight had become a full-blown diplomatic incident. Having quarried a large amount of marble at Carrara, Michelangelo had returned to Rome in spring 1506 only to find the pope rather unwilling to continue work on the tomb. Incensed at this treatment, Michelangelo left Rome without permission; the pope first tried unsuccessfully to send his horsemen after him, then on 8 July 1506 wrote an official letter to Pier Soderini, asking for Michelangelo's return. Michelangelo, however, refused to move because he was frightened of the consequences, and Soderini spent the whole of July on tenterhooks. We can only imagine Soderini's state of mind when he received a letter from the king of France, followed by one from the pope. Not only had these two artistic titans pocketed money from the

government without finishing their work, but both were now laying siege to the Signoria through their protectors and appeared unwilling to let their prodigious talent blossom on the banks of the Arno.

This paradoxical situation would play into the hands of a young artist from Urbino who had only recently arrived in Florence: his name was Raffaello Sanzio, and he was the son of a painter and letterato much loved at the Montefeltro court. Indeed he introduced himself to Pier Soderini with a letter of recommendation from the duchess of Urbino. Raffaello was 24, was handsome, and had received such an impeccable artistic education that he was welcomed by all. No one could be more different in character either from the ineffectual master or from the untamed sculptor, who suffered from persecution mania and made himself disagreeable to everyone. Raphael had very clear ideas about his career and arrived in Florence with the intention of absorbing the most advanced research of the Florentine world and perhaps of looking specifically at the work of Leonardo, who was celebrated in all the printed books of the time as the greatest Italian master, alongside Perugino. Young Raphael had already burnt his boats with the latter by painting a *Marriage of the Virgin* that re-elaborated, almost obsequiously but in a much more contemporary style, a painting on an identical theme by the older artist from Umbria.

A feature of the youth's work was his ability to assimilate and improve upon the research of better artists. He had arrived in Florence just before the two titans had hastened to leave it and, perhaps precisely because of their rapid exit, he had established himself in what was certainly not an easy market by offering an extremely valid alternative to the refined Florentine patrons. Before moving to Florence he had started by working on the Piccolomini Library in Siena in 1503–4 and had immediately been offered major commissions, the most important ones being the portraits of Angelo and Maddalena Doni, a family of rich bankers for whom Michelangelo himself had painted his *Sacra famiglia*. Whether (or not) he had seen the initial portrait of Lisa del Giocondo, about which Agostino Vespucci wrote in 1503, and whether (or not) he had been working autonomously on his research for female and male portraits, in these paintings Raphael forged a path that Florentine painters would find it difficult to follow. Blessed with a sweet style that transposed his models into an ideal and dreamlike world, the boy from

Umbria was gifted with extraordinary manual skills and had mastered perfectly the new oil technique, blending colours with such softness that even Leonardo could not have done better.

Commissions continued to pour in for Raphael over the coming months, while he was working on two paintings that were destined to influence the future evolution of Italian painting: the *Deposizione Baglioni*, for a noble family from Perugia, and the *Madonna del baldacchino*, for the Dei family, intended for the church of Santo Spirito. Before this, Raphael had also painted the *Madonna del cardellino* for the Nasi family, wealthy cloth merchants, in which the features of the Virgin, the Christ child and the infant Saint John had a sweetness that some said was inspired by Leonardo's paintings. Only that none of the works that Leonardo had started in Florence was anywhere near completion, whereas in three years Raphael had finished at least four paintings, all masterpieces.

Such sweetness of expression was a natural attainment for Raphael's art and indeed it cannot be excluded that even Leonardo was influenced by it during these months. Moving beyond the anatomical studies undertaken by Michelangelo and Leonardo and beyond the latter's optical studies, Raphael had achieved such a natural harmony of the human body in space – which was based on perfect foreshortening, on careful blending of colours, and especially on gradual alterations of the light – as to give the impression that his figures really were enveloped by moving air. Moreover, the painter had an extraordinary talent for capturing the psychology of his characters, which he combined with such balance in the representation of gestures that, from then on, critics and collectors would find it hard to decide which of these three artists deserved the highest consideration. Isabella d'Este realized this immediately and, although still pestering Leonardo for a painting, she soon turned to Raphael; but with him she was successful.

There are no documents that record a direct meeting in Florence between Leonardo, Raphael and Michelangelo in the spring of 1506, when all three were in the city, but if by chance such a meeting did occur, it would not have given Leonardo much cause for concern, because his mind was elsewhere, as always. When he came back in the spring of 1508 as a guest of the affluent Maecenas, Baccio Martelli, in order to resolve the disputed inheritance with his half-brothers,

Leonardo was still absorbed by anatomy and by the project for his monumental treatise ('1508, 22 March. Started in Florence in the house of Baccio Martelli'), and whenever he had a free moment he rushed to the hospital of Santa Maria Nuova, where he was present at the near-miraculous death of a 100-year-old man whose corpse he immediately dissected. In early 1508 Michelangelo left Florence; and Leonardo, too, relieved at having settled the dispute, got ready to return to Milan. There is no doubt about his expectations. Shortly before his departure, at Easter, he wrote to Francesco Melzi, announcing their future project with childlike enthusiasm:

Good day to you, Messer Francesco. God knows why, of all the letters I have written to you, you have never answered one? Now wait till I come, by God, and I shall make you write so much that perhaps you will regret it.[25]

29

BODY AND SOUL

The enthusiasm that surrounded Leonardo's anatomical studies and would continue, even after his death, to influence progress in this field of scientific activities can be explained by the fact that the results he had achieved were so extraordinary as to bring knowledge of the human body and its representation to a wholly new level. Interest in anatomy was not, in itself, new for artists – certainly not for Florentine artists; and in this they had much in common with doctors. On his return to Florence, Leonardo had realized that young Buonarroti had independently performed numerous dissections, and had then succeeded in drawing them with a level of detail that was on a par with that of Leonardo himself. Following the tradition of Italian artists, Michelangelo had pursued in his anatomical studies the truth about the visible body, namely the outermost parts of muscle, bone and nerves shown in representation. On the contrary, Leonardo was interested in a far deeper level, one that was closer to dissections carried out by practising doctors, as he sought to understand the function of the internal organs, those responsible for the causes of diseases. The different aims of artists and doctors have been clearly identified by modern scholars:

> In the case of Renaissance art, the aims and methods of artists and doctors were too diverse to be able to interact. Indeed, their horizons

and approaches were completely different, and would remain so for centuries to come; while the artist explored the form and structure of the human body, as well as its range of movements, the doctor was interested above all in the more complex internal organs, which are the principal origin of disease.[26]

The work that Leonardo had accomplished in this field as early as the 1480s had moved clearly in the direction of medical rather than artistic research, and at the same time had been curtailed by the prejudices and limits imposed in this area of study by the authority of medieval tradition. While Michelangelo (and perhaps Verrocchio before him), unimpeded by theoretical prejudice, drew and 'saw' exactly what he was dissecting on the marble table of the hospital of Santo Spirito, Leonardo, like many doctors, used these dissections to check medieval theories of how the human body worked. Some of his extraordinary drawings, complete with notes, illustrate the prevalence of this approach to anatomy, which was still medieval, and the fact that Leonardo, although subsequently mythologized as the forerunner of modern science, did not depart significantly from his contemporaries. Only Vesalius, in his treatise of 1543, would lay the basis for a new knowledge of anatomy that was to mark the dividing line between the old and the new, between medieval and modern, not unlike Copernicus with the theory of the Earth's rotation. Yet it is also true that, when tracing Leonardo's studies over the course of two decades, there is evidence not only of his gradual detachment from medieval theories and of the onset of a critical spirit that tended to free dissection from the theoretical prejudices of earlier treatises, Mondino's in particular; it can also be seen how far Leonardo perfected the framework of knowledge throughout this process and drew closer to the synthesis that Vesalius would undertake 30 years later.

In his method of dissecting bodies and organs, Leonardo introduced a painter's sensitivity that aided his comprehension of the dissected object and gave the graphic representation of the organ under investigation an unprecedented clarity. The capacity to control the representation of space allowed Leonardo's anatomical drawings to make a qualitative leap that amply justifies the enthusiasm shown for these plates by both the artist and his contemporaries. Even before Vesalius, Leonardo

seems to have understood that the progress of anatomic knowledge called for a highly sophisticated drawing technique, in which artistic sensitivity played an essential part. Once again, and without his realizing it, it was his artistic nature that allowed him to make progress in his work as an anatomist. After the overblown nineteenth-century exaggerations about the genius of Leonardo, who seemed to have invented and understood everything, we have now reached a more balanced conclusion about the real substance of Leonardo's anatomical studies: without exaggeration, it is now believed that Leonardo did indeed renovate a number of dissection methods, and 'the anatomical structures that he was the first to describe can be clearly identified, as well as some techniques that he introduced, such as mid-sagittal sections of the skull, the spine, the thorax, the pelvis, and transverse sections of the limbs'.[27]

Alongside this stimulating innovation, which was prompted by his method of artistic enquiry, learned in all probability during the years spent in Verrocchio's workshop, and by his own interests, Leonardo brought to medical illustration a talent and a technical ability that had never been seen before in medicine. Carlo Pedretti drew attention to this, in straightforward terms, in his comments on the anatomical drawings from the late 1480s, writing with reference to the sections of the skull [Plate 49]:

There is no doubt that these drawings owe their incomparable artistic quality not only to the outstanding technical mastery of their execution and to an innate pictorial sense of form in space, but specifically to the scientific precision with which what is seen is absorbed and reproduced with absolute objectivity and attention to detail. It is therefore correct to talk of a miracle of precision and clarity in the most minute particulars, such as the dots used to indicate the spongiform matter of the dissected bone and the way in which sutures are represented with foreshortening (see the drawing on the verso). Therefore, when observing the start of the cut on the crown of the skull, where the two edges seem slightly parted, one immediately realizes that the teeth of the saw had to find the right angle before continuing with a decisive and steady cut right to the end.[28]

The detail noted by Pedretti is important for understanding the spirit in which Leonardo approached the study of anatomy in the late

1480s: on the one hand, there was a psychological filter in the form of the medieval and late classical theories through which he interpreted what he was actually dissecting; on the other, his artistic training as a superb copyist of nature (we need only think of the plaster-soaked fabrics drawn in Verrocchio's *bottega* and the plants and flowers illustrated in his paintings) obliged him to record the minutiae of the body in painstaking detail and to resist the urge to show an idealized image, as an engraver or a draughtsman would have done when working for an anatomist. The lack of a precise join in the skull due to the teeth of the saw and to that first, uncertain act of dissection would have been eliminated by a professional anatomist's draughtsman, but in Leonardo's drawing it is preserved because his ingrained habit of recording the natural world cannot ignore any detail.

The duality of his recordings, at once ideal and naturalistic, becomes the principal reason for the fascination exercised by his drawings: they are as accurate as anatomical plates, but at the same time they lack that abstraction that the anatomist requires from his assistant draughtsman or engraver (as Vesalius would do, 30 years later). Of course, this visual excellence was coupled with a special technical talent for representation, the decision of the graphic line in the skull's curves, the perfect identification of the light sources and the softly blended shadows in the chiaroscuro that allows him to re-create completely the 'internal' spatiality of the object – in this case the skull, which becomes an object of great beauty in itself, with its lights and shadows and forms as regular as a wicker basket filled with acanthus leaves. Never until Leonardo had there been an artist with such medical expertise or a doctor with such artistic ability.

It is precisely in this rather simple combination that we find the hypnotic fascination of his anatomical drawings. Those by Michelangelo, although the product of the same talent for seeing and representation, fall short by comparison because their sole purpose is artistic representation: Michelangelo showed no interest in medicine that went beyond the prescriptions for his kidney stones and the rhubarb he took for his digestive problems. From this we can understand why it was that Leonardo's drawings are astonishing even when they betray a distinct lack of knowledge of anatomical function, as in the case of the famous drawing of the genito-urinary tract [Plate 50].

During this first phase of his anatomical studies Leonardo was not yet able to throw off the burden of authority and showed respect, indeed often reverence, in his adaptations, to the point of always using Mondino's *Anothomia* as a guide during his own dissections. It was Mondino who, in keeping with Galenic teaching, described the two ducts in the penis (one for the passage of the vital spirit or soul, the other for sense-perception and for urine) and the seven cells of the womb, as they can be seen in this drawing. But the way of illustrating the curve of the vertebral spine is original to Leonardo, and he would return to it in a drawing of 1510 in the series of the so-called Ms. A of Anatomy [Plate 51].[29] Contrary to everything that has been said over the past two centuries regarding Leonardo's ability to anticipate the evolution of science, this drawing, with its paradoxical section of the penis and its dual imaginary canals, shows how Leonardo's desire to verify the reality of the human body through experience was not sufficient, since he continued to see with his own eyes, in part, what classical authorities had taught him to see.

The influence of medieval prejudices on Leonardo's mind is also apparent from the comments he made on testicles in the same drawing, which a completely unfounded popular tradition regarded as being the source of strength and virility: 'How testicles are the cause of passion'. Likewise his repulsion for the other sex transpires from the remaining comments. The beauty of the young man and the almost non-existence of a physiognomy of the woman remind Pedretti of a comment noted on a sheet from 1510, which shows sketches of various hands: 'The act of coitus and the parts used for this purpose are so ugly that if it were not for the beauty of the faces and ornaments of those engaged in the act [addendum above the line: and their unrestrained attitude] Nature would lose the human species' [Plate 52].[30] It is clear that, when Leonardo refers to the ugliness of the genital organs, he is thinking of the female genitalia rather than the male ones, to which he dedicated delightful witticisms, like that of the monk and the washerwoman. A note in the upper right-hand corner underlines Leonardo's disgust for the physical union between man and woman: 'these drawings will demonstrate the reason for many risks of injuries and illnesses' – perhaps an allusion to the infections that some have associated with syphilis – a recent arrival

in Europe – but that seem more generally to connect the dangers of intercourse to sexual pleasure.

Later on, during his years in Rome – in which he did not give up his anatomical studies – Leonardo showed a dangerous tendency to forge ahead with his critical judgement: when studying the relationship of the fetus with the mother he even came to cast doubt on the Aristotelian theory of the generation of the soul, which had been adopted by the church and reiterated by Pope Leo X. For his contemporaries, this brush with theological positions would be a mark of the artist's heretical leanings in old age, which would be documented both in the first edition of Vasari's *Lives of the Artists* (although they would disappear from the second) and in Lomazzo's writings, giving rise to a crescendo of imaginary reports in the next centuries and fuelling outlandish legends about the artist's studies of magic, the occult sciences and much else besides. Nothing could be further from the truth. Paola Salvi gives a balanced summary of Leonardo's final achievements in his anatomical studies when she compares his work (which was unfortunately never known to contemporaries) to that of Vesalius. The treatise on anatomy published by the latter in 1543 is generally regarded as a turning point, one that closed an era and opened another, like the work of Copernicus; and she summarizes its key traits as follows:

The simultaneous presence of vast erudition and a critical relationship with the classical sources; the safe option offered by direct research on the human body as a source of knowledge; the integration of such precise – and artistically esteemed – illustrations into the text to stimulate research; the collaboration between the scientist and a typographical art at the highest technical level.[31]

But all these unique qualities – as scholars have noted – are already present in the work of Leonardo da Vinci. Unfortunately he was unable to bring his work to the attention of his contemporaries owing to the dispersion of his notebooks and the volume of disordered sheets and notes he left at his death.

The exile undergone by Leonardo's brilliant anatomical studies affected both his artistic anatomy and the anatomy conventionally described as

human, while his thought had circulated mainly through the *Libro di pittura* in the abridged edition of 1651 (judging by what we know now). Therefore it was Vesalius and Michelangelo who acquired renown as the pillars on which anatomical treatises for artists were based – the first by providing the analytical model for the description of the parts, the second by offering an interpretation of the greatness of the edifice of the human body through sculptural models, which could be easily integrated and compared with examples taken from classical statuary. Thus, through the plates engraved by Carlo Cesio and through the treatise of Bernardino Genga, not to mention the 'real-life' anatomical studies made during training, artists got engaged in a kind of anatomical research in which the cognitive component was weaker than the normative [*precettistica*], but the strongest results were nonetheless reminiscent of Leonardo's penetrating method.[32]

There is no doubt that Leonardo was aware of how much he had achieved in the field of anatomy, and this explains his anxiety and happiness when, at Easter 1508, he announced to Francesco Melzi their shared project. Unfortunately, however, the artist once again made the kind of mistake that dogged his entire life: he relied too much on the protection of powerful patrons. On this occasion he turned to a king, Louis XII of France, who at the time seemed to hold the key to Europe's destiny but who, within the space of a few short months, thanks to the intelligence of a pope who had no armies but excellent advisors, would become a marginal figure on the chessboard of Italian politics – to the point of not being able as much as to guarantee Leonardo's position in Milan.

This time the illusion lasted for just over a year. The artist was paid a regular stipend, about 30 *scudi* a month, by the French government until April 1509, and the one who benefited from this in the first place was Salai. In July 1509 Louis XII returned to Milan after the triumph at the battle of Agnadello, and Leonardo was again able to stage one of those festivities that had made him famous. It took the form of a combat, in a public square, between the lion and the dragon, in which the former symbolized the republic of Venice and the latter the French state. But the lion was also a fox and was already planning an alliance that would corner the dragon. Leonardo himself derided the arrogance

of Venice when he jotted down a remark that seemed, to him and many others, the boastful claim of braggarts: the Serenissima had announced that its coffers were deep enough to afford a war that could last for ten years and cost up to 36 million in gold [ducats]. But the news was taken extremely seriously by Pope Julius II, who had turned precisely to Venetian bankers to finance his wars by pledging the papal tiara. Julius had never pardoned Louis XII for calling a schismatic council at Pisa; and he engineered a complete reversal of Italy's political alliances by forming the Holy League of October 1511, which brought together the papacy and Venice, along with the Swiss cantons, the king of Naples, Ferdinand of Aragon, and, after some hesitation, Maximilian of Austria, who was still holding Ludovico il Moro's sons at Innsbruck. The destiny of the French was cast, and with it that of the state of Milan – and Leonardo's.

These were difficult months. D'Amboise died on 10 March 1511 and the new governor was not on such familiar terms with Leonardo. Francesco Melzi's father stepped in to protect him by hosting him at Vaprio d'Adda, in the family villa on the river, in the middle of lush woods and far from the disorders of the city. But even this solution was not an easy one. Salai was unpopular with everyone: traces of annoyance and of the arguments caused in the small household by the all too obvious relationship between the rapacious young assistant and the old master, who no longer had the strength to turn down the young man's increasingly invasive demands, can be found in Leonardo's accounts as well as in some mocking drawings made by pupils in Leonardo's codices. An offensive sketch in the Codex Atlanticus dates from precisely these months: in it, alongside Salai's name, someone has added a roughly sketched orifice penetrated by a male member. One of the most controversial drawings also dates from the same period, revealing more clearly than anything the tensions created by Salai's presence in the house, and above all his relationship with the master [Plate 53]. It shows the figure of a youth, standing in a three-quarters pose and holding his hand up to his chest while he points upwards with his right hand, in a gesture that would later be copied in the *Saint John* now in the Louvre. The sketch represents Salai and was made by one of Leonardo's pupils, who returned to studies done by the master for the project of a youthful Saint John that he had already imagined during his

Florentine years: the saint had his left hand on his chest while the right held a bowl, symbol of the future baptism. Leonardo almost certainly never made a painting of this figure, but at least a copy of the design has survived and is now in the Galleria Borghese in Rome [Plate 54].

The pose, the gentle inclination of the face and the studies for the left hand can be found in sketches made by the master and his pupils, all datable to the Florentine period between 1503 and 1506. The features of the face leave little doubt that the model for the study (and the painting) was, once again, Salai, the Satyr who had enchanted Leonardo. The negative reaction to this enchantment is evident in the large phallus that an anonymous pupil has drawn, quite clearly, between the young man's legs. This member and its forceful erection emphatically draw attention to the real nature of the attraction that the angelic Salai exerted over Leonardo, offering the observer a visible and unmistakeable contrast between the sweetness of the face and the brutality of the instrument of pleasure. The nature of the drawing would appear to exclude the presence of Leonardo's hand even in the upper part. In all likelihood, one of his pupils copied a drawing that Leonardo had made of *Saint John* holding the bowl, but 'completed' it with a male member in the lower part, adding an ironic reflection on the qualities of the handsome Salai. Considering the burlesque nature of the drawing, and its timing, it is possible to suggest that the drawing was made by Tommaso Masini, also known as Zoroastro, who lived with Leonardo for many years, both in Milan and in Florence, and collaborated in 1506 with the first attempts to transport the *Battle of Anghiari* onto the wall of the Palazzo della Signoria.[33]

No one had any illusions about the nature of the relationship between Leonardo and Salai and about the price that Leonardo paid for it. The house and vineyard that Ludovico il Moro had given Leonardo, located close to his *Last Supper*, were now lived in by Salai's father, and the other pupils struggled to put up with his arrogance. The gossip that had given rise to those cruel sonnets about Leonardo's preferences ten years earlier started to circulate again. *Vox populi*, carefully ignored by the sixteenth-century exegetes, would explode in an ironic dialogue between Phidias and Leonardo written by Giampaolo Lomazzo, who, as an artist and a Lombard, was able to discover details of events earlier in the century through the Melzi family and other witnesses. In blunt

terms, Lomazzo described the carnal passion that bound Leonardo to the young Salai, although even Vasari was careful to comment only on his exceptional beauty:

Leonardo Salai was the one I loved most in my life, and there were many.
Phidias And did you ever play the game from behind that Florentines love so much?
Leonardo And how many times! Just think how beautiful he was, especially when he was about fifteen.
Phidias Are you not ashamed to say these things?
Leonardo Ashamed? Why? There is nothing that is more praised than this among the virtuous; and I will demonstrate that this is true using very good reasons.[34]

Girolamo Melzi, Francesco's father, knew how to tolerate and shield from scandal Leonardo's sexual inclinations, which were not particularly original for the time, and he protected him even when the Swiss began to set fire to the countryside around Milan. In those days the French army was like a bear attacked by a pack of hounds. Leonardo watched the fires lit by the Swiss in disbelief, realizing that his own future was also going up in smoke, together with any hope of concluding his studies. His host, Girolamo Melzi, began talks with the representatives of the new regime as the armies continued their relentless advance. In a rearguard action and a stroke of good luck, the French won the bloody battle of Ravenna on 11 April 1512, and for a few days Leonardo deceived himself that he could return to live in what he regarded as his city, the only one where he had friends and a house.

Cardinal Giovanni de' Medici, Lorenzo's son, was brought to Milan as an illustrious prisoner. He had been sent to the battlefield by Julius II, as the cardinal legate, but had fallen into the hands of the French. At Milan, the cardinal was treated with great respect and he, too, made every effort to win the goodwill of the king and his dignitaries, all of whom had come under Julius II's interdict, by granting whatever forms of spiritual immunity lay within his power. Giovanni was little more than a boy (he was born in 1475) when Leonardo had left Florence; but he was after all a Medici. From Milan the cardinal was transferred to

France, but as he was travelling into exile he was freed by a small army of peasants and returned to the armies of the League, by then closer to victory. Even his liberation was seen as a good augury, a sign that Fortune was by then determined to punish the French.

Conditions in Milan rapidly deteriorated, as they also did in Tuscany, which was accused in no uncertain terms of abetting the French, as Leonardo knew too well. Giovanni de' Medici, soon to become Pope Leo X, and his brother Giuliano, the only one in the family to possess political acumen, rapidly took advantage of this political earthquake and opened negotiations with the League officials in Mantua for the restoration of the Medici rule in Florence. To give his city and its surrounding territory a clear sign of the ire that awaited those who rebelled against the Medici, the cardinal led the Spanish troops in person as they besieged Prato in August 1512. The resistance of the local militia was overcome on 29 August. The sack of the town, which came after a siege rendered even more brutal by the summer heat and by the fields scorched by peasants, was one of the most horrific episodes of Italian history. The future pope deliberately turned his head while soldiers engaged in outrageous acts of cruelty. Reports of citizens being skinned alive and boiled and of the mass rape of boys and girls were soon doing the rounds of Italy. The atrocities were toned down in the diplomatic prose in which Giuliano brought the news of the town's capture to Isabella d'Este, who had given hospitality first to Leonardo and then to the Medici brothers.

Leonardo read both versions of the revolution: the accounts told by the terrorized escapees and those that filled the diplomatic correspondence. Like other figures of the time, Leonardo seems hardly to have reacted to the first: the atrocities of war were a recurrent and perhaps necessary evil, on which he might have reflected in technical rather than humanitarian terms. In the autumn of 1512 a new possibility opened up, perhaps a new illusion, but nonetheless an unhoped for opportunity for him to find powerful new protectors. The Medici returned to Florence immediately after the sack of Prato, while the air was still thick with smoke from the fires that burnt in the not too distant town. Soderini had been promptly dismissed and the city celebrated the entry of Giuliano and Giovanni as if for years it had been waiting for nothing else. In the name of his old friendship with Lorenzo, Leonardo

could rely on the support of Lorenzo's sons. Once Soderini's support-
ers, with whom Leonardo had not been on his best behaviour, were
removed, the new government could welcome Leonardo back to his
native city.

The atmosphere in Milan had become distinctly chilly with the onset
of winter, and the change of regime meant that everyone had to realign
with the victors, who in this instance were the old masters. On 29
December 1512 the legitimate son of Ludovico il Moro, Massimiliano
Sforza, made his triumphal entry into the city, accompanied by his half-
brother Cesare, son of the same Cecilia Gallerani whom Leonardo had
painted years earlier, just before she became pregnant. Girolamo Melzi
– Francesco's father and Leonardo's protector – successfully swapped
allegiances and once again entered the services of the Sforza, whom
he had previously abandoned. But things were much more difficult for
Leonardo. In the early winter of 1513 the artist weighed up the possibil-
ity of leaving Milan for Florence. It would not be an easy move, because
there were all the notebooks to take, dozens upon dozens of volumes
that he was trying to reorganize with the help of young Francesco;
there were unfinished paintings, including the wonderful *Saint Anne*,
which had already been copied and recopied by his pupils and sold to
Milanese collectors. But fate tempted him with an extraordinary event.

The aged Julius II, the warrior pope, died in early February and
on 9 March Giovanni de' Medici was elected as his successor. Before
that election Leonardo had never felt so close to the summit of power,
even when he had been welcomed and defended by the king of France.
The Medici had been his patrons since his youth, and later on he
would write in a couplet: 'The Medici created me and destroyed me.'
But, right then, his only thought was for the greatness and friendship
of the family. The festivities given by Leo X on the occasion of his
election and coronation immediately became an object of amazement
and admiration, and all the more so for Leonardo, who regarded him-
self as the leading expert and producer of courtly celebrations. The
city was bedecked with tapestries and garlands and embellished with
painted triumphal arches, and fistfuls of gold coins were thrown by
boys turned for the occasion into winged genii and suspended from
ephemeral structures, rapidly erected in Rome: all this was reminis-
cent of a splendour that Leonardo had known since infancy, with the

jousts organized by Lorenzo in Florence, the mounted processions of the Magi, the gold and jewels displayed by the retinues of dignitaries. No one in Europe could surpass the Medici in organizing celebrations and in the promotion of art; and, despite his age, his disappointments, and the cumbersome presence of his unfinished works, the 60-year-old artist was certainly not lacking in either curiosity or enthusiasm.

The invitation to move to Rome came from the pope's brother, Giuliano, and it could not have been otherwise. Over the decades Leo X had built up a reputation for his munificence and for the elegance of his feasts, but it was Giuliano who paid the bills, as his biographers were keen to point out. If Leo X embodied the spendthrift side of the family, Giuliano had inherited the refined taste for art and culture for which his father and grandfather had been renowned. There was very little time to organize his journey south, and Leonardo arrived in Rome before the gold dust had even settled after dancing in the air during the festivities held in September for the pope's coronation and for his brother Giuliano. Leonardo and his small household had set off on another adventure: 'Left Milan for Rome on the 24th day of September 1513, with Giovanni, Francesco de Melzi, Salai, Lorenzo and il Fanfoia.'[35] This time they were leaving to conquer the city of cities: Rome.

Part IV

IN EXILE

30

ROME

The Great Illusion

The autumn that welcomed Leonardo to the southernmost city he had ever visited was hotter than a Milanese summer. The soaring sky, occasionally crossed by clouds from the sea, was very different in colour from the ultramarine blue he had mixed so many times for the skies above the hills in the backgrounds of his Madonnas; at midday it even had tinges of the colour of violas, while at sunset it shifted from gold to deep pink [*lacca*]. These colours showed to even better advantage the great marble and travertine monuments scattered between the Tiber and the hills, like ruins of a civilization of giants, while across the city immense pines stood out against the sharp outlines of temples and baths. They grew to heights found only in Rome, their crowns suddenly dark in the evening against the turquoise sky.

Leonardo must have been struck by the intensity of the light, the subject of his most penetrating observations as a scientist and painter and the inspiration for his best work: the pale blue light, which filtered at dawn through the mists rising from the Po valley; and the golden light of the sunset, which changed the world into a fabled vision. Leonardo had observed everything, but never light that arrived straight from a sun closer to the equator, a notion that was still unknown to the artist. This magnificent light enhanced especially the stone carvings, making them look very different from how draughtsmen had portrayed

them in sketches of the Eternal City that had circulated in Europe for decades. Under the midday sun the travertine stone and the pale marble were animated by geometric forms that now seemed the stuff of fantasies, an obstinately unreal world that had survived the fury of barbarians and of autumn storms for over a millennium. On immense columns, on the side pillars of arches and in their curved undersides, armies of stone carvers – themselves become no more than dust – had captured men, animals and plants, giving eternal life to the imaginings of artists and poets, inventions that Leonardo now saw for the first time and was able to observe at his leisure.

There were monuments that seemed newly built, such was their solidity and strength: the Pantheon with its granite columns, fashioned with tools that no one knew how to make any longer, except perhaps in Florence, and capitals whose airy acanthus leaf designs stood taller than a man; the Colosseum, under whose lower arches passing herdsmen would shelter their flocks, but whose uppermost levels stood proudly intact, crowned by a cornice carved with the same rigour throughout its hundreds of metres of length. Between the white stones, vineyards and gardens filled with luxuriant plants grew year-round, on ground that not only yielded grapes and bitter oranges but where statues of all sizes had been unearthed, with arms, legs and muscles so perfectly fashioned in marble that no anatomist could rival them. Had these ancient sculptors also got queasy stomachs from dissecting corpses in hospitals? Woods and wasteland had spread into the spaces between abandoned buildings with the unstoppable vitality of the Mediterranean. Leonardo had only heard talk of it before, but now he saw with his own eyes how palm trees could rival the height of columns and bell towers.

When he arrived in Rome with all his luggage and personal effects, Leonardo saw how the groves of ilex stretched from the banks of the river to the hilltops, their shiny dark green leaves forming a dense canopy that light could not penetrate. Only the chestnut trees and the vines, already stripped of fruit, had started to turn colour and lose their leaves; for the rest, the gardens were still lush and created space for themselves everywhere, between stones, inside the great courtyards of the affluent families, inside the convents on the Aventine, and even on top of the Roman towers recently abandoned by the families who used them to protect their palaces.

But visitors from the north were not only impressed by the city's historical grandeur. Rome was in the grip of a new building fever, which was changing its appearance for good. The huge Palazzo della Cancelleria, built by Cardinal Riario with money won at the gaming table, had already been finished. It looked as imposing and strong as an ancient royal palace, and its colonnaded courtyard was as large as a piazza. The vast blocks of ashlar masonry that Leonardo had seen used in his home city were smoother here, under the influence of the classical orders, and were used in all shapes and sizes. On the bank of the Tiber stood the newly completed palace of Europe's richest banker, Agostino Chigi, designed by Baldassarre Peruzzi, an architect from Siena. Clearly influenced by Vitruvius, the villa was embellished with stone architraves and pilasters (or so it seemed to Leonardo) and in between with graffiti-style paintings, in an endless celebration of Ovid's tales.

As one approached St Peter's, one would suddenly get an idea of the colossal work of renovation the city had embarked on, thanks to the greatest concentration of talent ever seen. Julius II, the pope about whom Leonardo had heard so much, had started a process of urban transformation on an enormous scale, and the results were there for all to see. A wide road, clear on its course, ran parallel to the last stretch of the river before St Peter's. The pope had intended that Via Giulia should house the offices for the administration of justice; and one of Leonardo's old acquaintances, Donato Bramante, with whom the artist had collaborated in Milan on plans for the cathedral lantern, had designed a huge palace to this end. The foundations were already visible, marked with travertine blocks so large that one alone could have formed the base for Leonardo's unrealized equestrian monument. New palaces for dignitaries were being built along the road facing St Peter's, in a classical style reinvented by Bramante and a series of young architects whose names would soon become familiar to Leonardo.

Yet it was the basilica of St Peter's, the heart of the city and of western Christianity, that revealed the scope of this renewal. The choir of the old Constantinian building had only just been demolished and a new basilica was being built to Bramante's design, with a central plan and a dome supported by columns, each one as large as a church. Beside St Peter's the great Belvedere courtyard was also under construction, like

a Colosseum unrolled in a straight line. Three superimposed rows of arches ran from the side walls of the basilica to the Belvedere building, erected by Innocent VIII 50 years earlier as a country residence. The works impressed visiting European ambassadors, as the pope intended: not being able to show them armies, he showed them instead grandiose plans and intelligence. In order to overcome a natural rise in the hilly terrain, the large 'corridor' enclosed a courtyard that was so vast that naval battles could be staged there, along with bull races and spectacles of all kinds. While the project had been started by Julius II, the Medici pope on whom Leonardo relied proved to be no less enterprising in the first few months of his reign. Leo X had openly declared that it was the pope's duty *almam urbem pulchris edificiis exornari* ['to embellish the beloved city with beautiful buildings'].[1]

The city that welcomed Leonardo was the paradise dreamed of by artists of all kinds. Blessed with a wonderful climate and light, and filled – from spring to autumn – with scents that enraptured its inhabitants and the visiting pilgrims, this was a place guaranteed to seduce a man in love with every aspect of nature. To Leonardo, Rome must have brought home the power of the vast machine of the universe. But, even for him, the greatest wonder lay in the immense and well-preserved display of classical architecture – a perfect backdrop for the new challenges facing any ambitious artist. Moreover, here there was money, so much of it that a steady stream was conveyed through the ambassadors of European states and through the dignitaries of the papal court, and – an essential facilitator to the magnificence of both – in some measure to the artists who were reinventing a new world. It was all he could have wished for, even as a scientist. Rome not only boasted La Sapienza, one of the oldest universities, renowned for the calibre of those who taught there, but also benefited from the first discoveries brought back by the courageous monks sent to evangelize the New World. Unheard of plant species appeared in Rome's monasteries and were immediately added to the rich collections of the Vatican's physic gardens. News of rare animals and precious woods and minerals arrived in Rome before they reached Spain, where the colonization of the Americas was beset by complications.

In Rome, Leonardo found a city that seemed a paradise and a pope ready to act as his protector. It certainly seemed to be the start of a new

chapter, one that heralded his arrival at the top of the world, although he immediately had the impression that he had got there too late: he was 60 and his age was beginning to have an effect, together with the accumulated frustration of the unfinished projects, of the discoveries that had failed to bring him the fame he deserved or thought he deserved. His mood darkened and he began to have regrets fuelled by ambitions that had ruled his entire life but remained unrealized. The comment that he wrote in the Arundel Codex at the very start of his Roman period throws a revealing light on the burden of his frustration and on what had been his entire life's ambitions. He had wanted to compensate for his social status through his prowess in science, and had tried, again and again, to make the great discovery that would have changed the course of humanity, or at least of part of it, while bringing him eternal fame as the inventor:

> Had anyone discovered the range of the power of the cannon in all its varieties and imparted his secret to the Romans, with what speed would they have conquered every country and subdued every army? And what reward would have been deemed sufficient for such a service? (Codex Arundel, p. 145r, f.279v)

Here, perhaps for the first time with refreshing honesty, he returned to the fantasy that had always inspired him: the dream of making a discovery that would have rendered him immortal, earning him the gratitude of those in power – not in his capacity as a painter but as a savant, like Archimedes, who, as Leonardo goes on to note, was honoured by the Romans as a semi-god despite the fact that he had 'wrought great mischief' to them. But now that Leonardo's life was drawing to an end, this fantasy appeared for what it was, a childish dream – and, what was more, a dream embittered by recent events. His relations had not been with the great Romans but rather with miserly and minor tyrants constantly struggling for their own precarious survival. He had served Ludovico Sforza, who had ousted his own nephew using a series of shrewd and cunning tricks before failing him, Leonardo, in the most wretched way. He had then attempted to offer his services to the Venetian Signoria and to the quarrelsome republic of Florence before walking into the arms of that villain, Cesare Borgia,

a beast hated by everyone, who finally dissolved like poisonous fumes, consumed by his own excessive ambitions. In desperation, Leonardo had even gone as far as to approach the Turks, who turned him down. Where were the Romans? Those men of vision who had built the palaces and temples that made made such an impression on him today, even if the passing centuries reduced them ruins? He could still turn to the pope's brother, Giuliano de' Medici, who nibbled on scraps of power among Rome's insidious corridors; but what could Leonardo find that was extraordinary enough to offer a patron of his calibre? Would he still have time to discover something that would change the course of history?

It was autumn, and with these thoughts his mood turned gloomy, shaded by the ruined buildings from a past that no one could ever revive. Archimedes was destined to shine as a solitary star in the firmament of the great scientists and inventors whom Leonardo da Vinci aspired to join.

31

A MODEST APARTMENT

The estimate for the works on Leonardo's apartment in the Belvedere has survived, and it is not encouraging. The quarter where Leonardo's rooms were being prepared was at the northern end of the great courtyard, now a building site right beside the Belvedere palace where Julius II had set out the statues from his sculpture collection. The area was reserved for artisans serving the papal court, and the quarters were cramped and not very dignified. Workshops supplying mirrors and leather goods lined the four sides of a courtyard overlooked by two-storey buildings, which were guarded by a small tower in the corner.

The rooms reserved for Leonardo were hardly spacious, as is evident from the estimated bill of works submitted on 1 December by Giuliano Leno and Francesco Magalotti, two Roman contractors who would have been familiar figures on the building sites of early sixteenth-century Rome. By that date Leonardo had therefore certainly settled in Rome. The dimensions given by the estimate and the relatively modest cost of the works (some 67 ducats) confirm that Leonardo did not exactly receive the red-carpet treatment. Judging from the size of the brick floor, the largest room measured 7.70 × 4.40 m. In order to make room for Leonardo and his household, a section of the two-storey building overlooking the shared courtyard was renovated, but without any corridors or privacy, as Leonardo would later complain. Among the

furnishings we find 'a bench for grinding colours', a sign that Leonardo intended to continue painting, or at least to work on the paintings he had started years earlier.

Accustomed to the hospitality of Il Moro, and then of Amboise, who had wanted him close to his own quarters, Leonardo immediately felt sidelined, relegated to the outskirts, among the artisans. Giuliano de' Medici, his protector, lived in the centre of Rome, in an immense palace that had belonged to the Orsini and was as large as a small town, with several courtyards and a menagerie of rare animals that was also used to train Giuliano's personal guards, made up of warriors of different nationalities who were more suited to bearing proof of the lord's magnificence than to defending him. The new pope's brother lived in ostentatious luxury and soon became a target for the criticism of foreign ambassadors. In particular, the Venetian ambassador relentlessly passed judgement on the conduct of the pope's closest relative: 'He holds court with more pomp in Rome than Duke Valentino at the time of Pope Alexander.'[2] The comparison of the Medici with the Borgia was deliberately venomous: it did not bode well for the papacy.

There had been no room for Leonardo in this luxury: apart from the old family connections and the fact that his talent was held in regard, the Medici's expectations from the artist must have been very different from his expectations from them. He was not paid a particularly generous salary, as can be seen from an entry in Giuliano de' Medici's accounts dated 28 April 1515, when the artist had already been in Rome for two years: 'To Lionardo da Vinci for his pension, d[ucats] XXXIII and d[ucats] VII to the same for payment to Giorgio the German, in all d[ucats] 40.'[3] Housed in the artisans' quarter, Leonardo started to unpack his luggage, opening up the painted panels he had carried around for over ten years and the notebooks that Francesco Melzi had tried to organize at least five years earlier.

The winter passed as he settled in and got to know the city. The cold grew more intense after Christmas, but it was not severe enough to slow down the frenetic activity that had overtaken the city. The first commission given to Leonardo was shamefully modest. He was asked to produce the mirrors, and perhaps armour, for Giuliano de' Medici's *guardaroba*, and he was even given an assistant for the purpose,

a German called Giorgio who would cause nothing but trouble. The old artist started to look around, trying to penetrate the buzz that surrounded St Peter's. But his discoveries were far from reassuring. The first piece of bad news was that his old rival Michelangelo was already in Rome. Everything pointed to a repeat of the muddled three-way relationship that had ended so abruptly eight years earlier in Florence, only that this time there would be the sons of Leonardo's first patron, Lorenzo de' Medici, instead of Soderini and the republican government. But, apart from Michelangelo, there was a new figure and a new problem: this was none other than Raffaello Sanzio, the artist whom Leonardo had already met in 1507 in Florence, where he had monopolized the richest patrons. Leonardo may hardly have remembered the boy from Urbino who had arrived in Florence in 1504, while he was trying to concentrate on the cartoon for the *Battle of Anghiari*. That boy had now grown in age and also in fame, at a pace that would have been unimaginable for an artist of Leonardo's generation. Moreover, the world was quite different: instead of courting princes, the artists themselves were elevated to the rank of prince.

The city that welcomed Leonardo in 1513 was one where artistic competition bubbled with tension and conflicts and where art itself had soared to heights unachieved in the previous ten centuries. The scene was dominated by Michelangelo and Raphael, while, all around them, top-ranking artists like Baldassarre Peruzzi and Sebastiano del Piombo jostled for attention. Fifteen years earlier, in the short treatise by Prospettivo Milanese, Leonardo had been celebrated as one of the greatest living artists: 'The ancients never made such a large statue nor imagined such a model / that devoured the sky, without fear / of the dark countryside as a theme / believing that Vinci has an immortal soul / because he holds Jupiter's unvanquished palm.'[4] These overblown words were intended to extol the model of the great equestrian monument to Francesco Sforza. We do not know to what extent these apologetic tones were shared by others in Italian artistic circles, but what is certain is that the failure of the bronze casting and of the project as a whole represented a painful setback for Leonardo, as Michelangelo did not hesitate to point out. The project's failure damaged Leonardo; worse still, it had been joined by the attempt to compete against Michelangelo in the Palazzo della Signoria, Florence,

so that he now arrived in Rome as a great artist more famous for his unfinished work than for his talent.

The noise of the stonemasons around St Peter's, the queues of mules unloading heavy loads of lime from Tivoli into the basins along the Belvedere corridor, directly under Leonardo's windows, soon convinced him that he had come to the wrong place, because Rome was in the clutches of an unprecedented fever of architectural renewal. From the moment Pope Julius II had chosen to redefine the temporal limits of the papacy through artistic propaganda, the city had become a teeming workshop: if Julius II could barely wait to see his great projects fully realized, the same was true of his successor, Leo X, the grand banker Agostino Chigi, and other members of the Roman curia, all of whom had commissioned innovative works that they wanted to see completed rapidly.

Raphael, who had come to Rome only in 1508, was decorating the Vatican apartments with a team of perfectly trained collaborators, and by the time of Leonardo's arrival he had already finished the frescoes of the *Disputation over the Sacrament* and the *School of Athens*, the *Parnassus*, the *Miracle of the Mass at Bolsena*, the *Liberation of St Peter*, and *The Expulsion of Heliodorus from the Temple* [Plate 55], where he had even introduced into the temple, at the furthest edge of the painting, a powerful white horse in movement that was as good as any that Leonardo had sketched on the walls of the Palazzo della Signoria in Florence. Even if it was inspired by the cartoon, or by fragments of Leonardo's painting, as Leonardo scholars have argued, the Vatican fresco reveals, without a shadow of doubt, Raphael's skill in elaborating and rapidly improving on ideas left by other artists, even if they were unfinished. This was a new world that was opening before the Italian public, a renewal of the pictorial style that generated excitement on account of the realism of its poses, the fluidity of the narrative, and the perfect spatial congruity that Raphael produced through his expert use of chiaroscuro and perfect mastery of perspective foreshortening.

The young artist from Urbino was so confident of his primacy that he relied almost entirely on pupils to decorate the other rooms. With unprecedented energy and entrepreneurial spirit, Raphael did not abandon his private patrons and, in 1513, he personally painted the portrait of Federico Gonzaga for Isabella d'Este, the *Madonna di*

Foligno, and the *Sistine Madonna* [also known as the *Sacred Conversation*, now in Dresden]. Nor did he fail to respond to other requests from his extraordinarily wealthy patron, Agostino Chigi, for whom he painted the wonderful *Galatea* in 1511 and the *Sybils and Angels* in Santa Maria della Pace immediately after, then began the projects for the Chigi Chapel in Santa Maria del Popolo. Other extraordinarily beautiful paintings of the Virgin, such as the *Madonna della Seggiola* and the *Madonna della Tenda*, for minor but no less generous patrons, were also painted during these same years. The catalogue of this prodigious artist, characterized by beauty and speed, would expand exponentially in the next two years – those during which Leonardo passed across the brightly lit stage of Rome like an imperceptible shadow.

This was not all. The other prodigy of beauty and speed, Michelangelo Buonarroti, had just completed an endeavour that would astonish the world through its novelty no less than through its technical daring. On All Saints' Day in 1512 (one year before Leonardo arrived at Rome), accompanied by a procession worthy of a royal coronation, the Sistine Chapel had been opened to the public: it had been painted in just three years, between 1509 and 1512, almost entirely by Michelangelo alone. The work was impressive both in its size and in its quality; and, while it prompted all the visiting connoisseurs to describe it as a miracle, it would undoubtedly have devastated Leonardo. The painted ceiling measured 750 square metres and the lunettes a further 200 square metres, the whole surface making a total of nearly 1,000 square metres.[5] This was a genuine one-man revolution in technique and style. For over a decade Michelangelo had been Leonardo's main artistic and intellectual rival and the two men reflected each other because they had too much in common – above all, the painful burden of their social background. Both were born to well-to-do families, but both, for different reasons, had chosen to become artisans and now sought to better themselves in the eyes of the world.

Michelangelo was gifted with the same love for technical challenges but, unlike Leonardo, he always completed them. There was no competition between the two; yet, given the shifting politics of the time, Leonardo's arrival at Rome was not good news to Michelangelo. Leonardo's intimacy with the Medici, who had summoned him to Rome at their own expense, was a threat because Michelangelo had

been an antagonist of the Medici for more than twenty years, since he had fled in 1494, abandoning Piero and his small court although Lorenzo the Magnificent had almost adopted him. For the rest of his life, Michelangelo would pay the price of his political autonomy from a family he would be obliged to serve but that he regarded as a disaster for the freedom of Florence; and this was a city with which, unlike Leonardo, he identified in full. For years, he had found a magnificent patron in Julius II, but the election of Giovanni de' Medici as Pope Leo X had again marginalized him on the two most important artistic stages in Italy: Rome and Florence. Within days of Leonardo's arrival, Michelangelo was in limbo, shut up in his house on the margins of Rome's bustling centre, waiting to see how and how much the Medici family's bad temper would harm him.

Michelangelo's real rival was Raphael, whose outstanding talent and natural social charms had already attracted favours, loves and commissions, leaving Michelangelo with the work on Julius II's tomb. After the Medici had settled at the papal court, Michelangelo had activated every diplomatic lever in order to reacquire their favour, and the arrival of his old rival must have been a setback. The violent battle now underway with Raphael was also fought through the mobilization of the two artists' respective 'contacts'. The letters exchanged between Michelangelo and Sebastiano del Piombo during these months are testimony to a bitter clash with Raphael's supporters for control of the largest artistic commissions in the city; and when, in 1516, Cardinal Giulio de' Medici (the future Pope Clement VII) entrusted Raphael and Sebastiano del Piombo with the realization of two large painted panels to be sent to France (once again, this was an open contest), Michelangelo intervened by providing Sebastiano with sketches and drawings for his composition.

Relations between the artists in Rome were never simple, but here they were complicated by great ambition, great talent and, above all, huge sums of money. The only artist who might have supported Leonardo in the blistering climate of the Eternal City was Donato Bramante, whose designs for the central plan of the basilica of St Peter's are believed by some to have been influenced by the proposals put forward by Leonardo when they had collaborated on a project to build the lantern [*tiburio*] of Milan's cathedral. But the two men never met in Rome, or at least there is no trace of their meeting. It was said

that Bramante had bad memories of working with Leonardo and deliberately excluded him from the many activities he controlled on behalf of the pope, except perhaps for a study of the port of Civitavecchia in which Bramante was also involved. A few months after his former colleague arrived at Rome, Bramante died on 14 April 1514, leaving Raphael as his spiritual heir and the man who would continue with his architectural projects. As if this was not enough, Fra Giocondo da Verona, a man who was well over eighty, was called to Rome to work alongside Raphael on St Peter's. He was much older than Leonardo, yet was seen as being more reliable. For Leonardo, this was the first burning disappointment that the Eternal City had in store.

32

LEONARDO AND ROME

The lack of documents concerning Leonardo's time in Rome is inexplicable if one considers the volume of communications at the time. To get an idea of this 'vacuum' around Leonardo, one should reflect that John Shearman, in his monumental work on sources for Raphael, collected at least 74 documents concerning the latter for these three years, 1513–1516. A similar volume has not yet been produced for Michelangelo, but the known sources already allow his activity to be followed almost month by month.

The absence of documents on Leonardo for the same period and in the same context is in itself indicative of his isolation, and perhaps also of his lack of interest in the Roman artistic scene. The only trace he left in Rome records his involvement in a project for the construction of parabolic mirrors and in anatomical studies on the subject of reproduction. Proof of his lack of interest in the city's artistic goings-on can be found in his registration in the Florentine community of Rome. Leonardo was introduced not by another artist but by a doctor; and other clues from his manuscripts include the Roman addresses of doctors, not artists.[6] Vasari is of no help here, since he was told about Leonardo's stay in Rome by Paolo Giovio, one of the few who left a written account of the artist from that period; in it Giovio acknowledges Leonardo's greatness but appears not to have appreciated either his way of life or his charac-

ter, given that it is to him that we almost certainly owe Vasari's rather grotesque description of the master.

Paolo Giovio is one of the most important witnesses of Leonardo's stay in Rome. In his 'fragments' he clearly emphasizes Leonardo's interest and activities as an anatomist, confirming that, while he was in Rome, these occupied most of his time. Moreover, Giovio, who was born in Como in 1486, had studied medicine in Padua with the young anatomist Marcantonio della Torre, who had been very close to Leonardo at the end of the century. It was this common ground that allowed Giovio a full understanding of the artist's work on the anatomy tables. Giovio himself had also arrived in Rome in 1513, in the household of Cardinal Bandinello Sauli, and his testimony is very important and agrees with the other traces left by the artist. The episode he recounts in his brief biography offers the most authentic interpretation of Leonardo's Roman period, during which the artist was able to convey the meaning of his research for the very first time, and precisely to Giovio. Vasari's translation (even if made on the basis of Giovio's account) is a misleading trivialization of that experience. For this reason it is worth referring directly to Giovio in order to understand the judgement that the Roman court made of Leonardo:

Leonardo, born at Vinci, an insignificant hamlet in Tuscany, has added great lustre to the art of painting. He laid down that all proper practice of this art should be preceded by a training in the sciences and the liberal arts which he regarded as indispensable and subservient to painting. He placed modelling as a means of rendering figures in relief on a flat surface before other processes done with the brush. The science of optics was to him of paramount importance and on it he founded the principles of the distribution of light and shade down to the most minute details. In order that he might be able to paint the various joints and muscles as they bend and stretch according to the laws of nature he dissected the corpses of criminals in the medical schools, indifferent to this inhuman and disgusting work. He then tabulated all the different parts down to the smallest veins and the composition of the bones with extreme accuracy in order that this work on which he had spent many years should be published from copper engravings for the benefit of art. But while he was thus spending his time in the

close research of subordinate branches of his art he only carried very
few works to completion; for owing to his masterly facility and the fas-
tidiousness of his nature he discarded works he had already begun. . . .
There is also the picture of the infant Christ playing with His mother,
the Virgin, and His grandmother Anne which King Francis of France
bought and placed in his chapel.[7]

The passage is extraordinarily important because Giovio wrote it around
1540, well before Vasari embarked on his *Lives*, and it demonstrates that
Leonardo and Giovio spent time together in Rome. Who else, at that
date, could have known, and in such detail, about Leonardo's anatomi-
cal studies? Unlike Vasari, who only mentions a 'cartoon' of *Saint Anne*,
Giovio had seen the panel painting, which was at an advanced stage of
completion and had been brought to Rome from Milan by Leonardo.
Giovio makes no mention, however, of the other two paintings that
many scholars believe Leonardo brought with him: *La Gioconda* and
San Giovannino. During Giovio's visits to Leonardo's apartment in the
Belvedere, the artist was only willing to show the panel of *Saint Anne*,
which was probably the most complete.

Rounding off the people whom Leonardo knew in Rome, it is impor-
tant to mention another member of the papal court and household:
Cardinal Bernardo Dovizi of Bibbiena. It seems extremely likely that
Dovizi played a role in the artist's final decision to leave for France,
given that he, too, was sent to France as apostolic *nunzio* in June 1517,
on the very same day when Leonardo left (perhaps in the cardinal's reti-
nue). Bernardo Dovizi had been secretary to Lorenzo the Magnificent
in 1488, when Leonardo was in the Medici palace, where he held an
important position, and their acquaintance dates back to that time.
Bibbiena was an exuberant homosexual and must have looked with a
sympathetic eye at Leonardo, a shining example of elegance. Moving
almost in parallel with Leonardo, Bibbiena was at the court of Ludovico
il Moro at Milan between 1498 and 1499 and, while Leonardo was in
Rome, Bibbiena was also a resident in the Vatican. It was there that he
commissioned Raphael to decorate his licentious bathroom [*stufetta*]
with amorous images from mythology; and he enjoyed particular favour
with Leo X and his court. We can therefore suppose that Bibbiena and
Giovio were the two main reference points for the bewildered artist,

catapulted as he was into that new world where there was no time for scientific speculation and new palaces and churches came to life from dawn to dusk. Leonardo's unease in such a competitive climate is summed up in an important document: the letter of complaint that the artist sent to his protector, Giuliano de' Medici, in July–August 1515.

We know of the letter through the drafts that Leonardo wrote on some pages of the Codex Atlanticus, drafts that reveal his difficulty in communicating with his patron and in general the difficulties he faced in dealing with the outside world, especially at this stage and in this context. When Leonardo arrived in Rome, Giuliano had recently been appointed Gonfaloniere of the church by his brother, Leo X, and had his portrait painted by Raphael for that occasion. The painting was immediately celebrated as a masterpiece of royal dignity and psychological acuity. Shortly before, Giuliano had married Filiberta of Savoia, a union that the Medici family hoped would open the way to a fruitful alliance with the French royal family, and in the meantime he was already living in princely fashion in the majestic Palazzo Orsini at Monte Giordano (rather than a palace, this was a fortified neighbour-hood). Giuliano's public prominence intimidated Leonardo because, although accustomed to dealing with kings, here in Rome he felt out of place. He wrote and rewrote the letter several times, trying to find appropriate words to express his complaints:

Most illustrious Lord, I greatly rejoice most illustrious Lord at your . . . I was so greatly rejoiced my Lord by the desired restoration of your health, that it almost had the effect that [my own health recovered] – [I have got through my illness] – my own illness almost left me. But I am extremely vexed that I have not been able to completely satisfy the wishes of your Excellency, by reason of the wickedness of that deceiver, for whom I left nothing undone that could be done for him by me and by which I might be of use to him. (Codex Atlanticus, f. 252r)[8]

The desperate attempt to justify his own delays and failings reappears in Leonardo's notebook like a recurrent nightmare, made more dra-matic in Rome by the presence of artists who, month after month, astounded the world with the daring, the concreteness and the novelty of their endeavours. The substance was always the same. Leonardo

had to justify himself for not having completed a commission, even if in this case the commission had nothing to do with painting. He had been given an assistant and collaborator for the task, a German referred to as 'Giorgio Tedesco', who also appears in payments of Leonardo's stipend. It was precisely this assistant who was the target of Leonardo's complaints and whose behaviour made his life impossible. The relation between the two allows us to glimpse a lack of authority and structure in the minor commission that Leonardo had been given. We are very far from the sort of work that was being commissioned from Raphael and Michelangelo at the time. But Leonardo's main regret was that he had had to abandon his anatomy studies, the activity in which he was most interested. The dynamic of these events is not very interesting, at least not in comparison to what they reveal of the artist's conditions: on the one hand, he was being used as an artisan; on the other, he was frustrated at not being able to pursue his studies of anatomy. In the letter, on the one hand we see the artisan annoyed at the rudeness of his assistant:

> The next thing was that he made himself another workshop and pincers and tools in the room where he slept, and there he worked for others. Afterwards he would go and eat with the Swiss guards, where there are plenty of idle fellows, but none more than him; and he would go out on most evenings with two or three others, taking firearms to shoot birds among the ruins, and this went on till evening. (Codex Atlanticus, f. 671r)

On the other hand, we see the keen experimenter who has been banned from the study of anatomy: 'This other hindered me in anatomy, disapproving of it before the Pope and likewise at the hospital.' It is difficult to believe that an artisan paid seven ducats a month would have had an audience with the pope, yet alone convince him to stop Leonardo's anatomy sessions, and also influence those in charge at the Ospedale della Consolazione (or other institutions) where the artist carried out his dissections.

 If we follow instead a well-founded hypothesis put forward by Domenico Laurenza, the censorship of Leonardo's scientific activities formed part of a more general attempt by Leo X to block certain philo-

sophical speculations that questioned one of the fundamental dogmas of Catholic theology, namely the assertion that the soul was infused by God into the neonate at the moment of birth. Many natural philosophers questioned this assumption through theoretical arguments, but Leonardo, who was scarcely interested in religion for its own sake, did so using empirical methods that involved his meticulous observations of the structure of the placenta and fetus – never mind that he used bovine placentas in his studies of reproduction, under the mistaken view that they were the same as human ones. Without Leonardo's even realizing it, his studies had landed him in the controversial field of theological philosophy, and he found himself in the middle of a bitter debate. Moreover, Leonardo regarded the debate with sarcasm, and his notes on reproduction and on the nutrition of the fetus end with a comment that sums up his position regarding the indisputable truths of the church: 'The rest of the definition of the soul I leave to the imaginations of friars, those fathers of the people who by inspired action know all secrets.'[9]

His scepticism towards theological truths must have been well known to Giovio who, 30 years later, while helping Vasari to draft the first edition of the *Lives*, would summarize Leonardo's conflict with the papal court by suggesting to the biographer that ambiguous passage that, in centuries to come, would be used to fuel all kinds of speculation regarding the artist: 'because he held such a heretical view of the soul that he did not conform to any religion, believing himself to be more philosopher than Christian.'[10]

Leonardo's unease in the intellectual climate of Rome can only partly account for his exclusion from the important commissions given by the Medici to other artists during these years. By far the most important one was the construction of the new St Peter's, a task entrusted to Raphael in August 1514, after Bramante's death a few months earlier. With well-deserved satisfaction, Raphael stressed the economic and professional value of the commission in several documents. But how can we explain Leonardo's exclusion, precisely at a time when he was in the Vatican, manufacturing mirrors and being paid by the pope's brother? Why did no one think of a role for Leonardo, particularly since he had worked for many years on the central plan and on architecture? It did not cross Bibbiena's mind because during these months he appeared to

be Raphael's most powerful 'patron' at the curia, to the point of wishing to marry the young artist to his niece. Nor would matters go any better with the other great project that the Medici were preparing at the time, namely the construction of the façade of the church of San Lorenzo in Florence, which would be given to Michelangelo in spring 1516, while Leonardo was still in Rome. Despite the tension between Michelangelo and the family that was now firmly in power again in Florence, such was the trust and admiration in which the Medici held him that the past was forgiven and the sculptor and painter was entrusted with the first major architectural commission of his career, without any hesitation or need for some earlier proof of expertise in this field.

Leonardo's complete marginalization from the Roman artistic scene was due to his proven inability to complete the projects with which he was entrusted. The pope wanted to see St Peter's (and the façade of San Lorenzo) completed as quickly as possible; he wanted this so much that this condition was even specified in the brief that appointed Raphael as the master of the building project on 1 August 1514: *Nos, quibus nihil est prope antiquius quam ut fanum id quam magnificentissime quamque celerrime construatur* ['We, who hold nothing more desirable than that this sanctuary be erected as magnificently and as rapidly as possible'].[11] Nothing could be clearer.

There was, however, also a purely artistic reason that excluded Leonardo from these commissions: his approach to architectural design differed from that of the new generation of architects now in vogue in Rome. In his study of architecture, Leonardo focused on functionality and on the laws of geometry when creating forms, two characteristics that were now seen as outdated and belonging to the past century. As in anatomy, where he sought the laws governing the macro- and the micro-cosm, in architecture, too, he looked for geometric and mathematical rationality, which did not always coincide with Renaissance beauty and modernity. This autonomy of design in relation to the stylistic codes inherited from the past explains why Leonardo was not particularly interested in classical architecture and in surveying the ancient monu-ments. While it cannot be ruled out that Leonardo surveyed and made notes on classical fragments, we do know for certain that he did not base his architectural research on his observations of these ruins. On the contrary, with Bramante, Raphael and Michelangelo the study of

classical architecture became the backbone of a design 'system', and every project they conceived of drew inspiration from its model: classical architecture, whose fragments [*testimonanze*] they analysed and surveyed at every opportunity, even developing special instruments for the purpose, as Raphael mentioned in his letter to Pope Leo X.

Leonardo's marginalization became even more dramatic when Cardinal Giulio de' Medici decided to send two paintings to the French court as a sign of the excellence that had been attained by Italian painters, in hopes that this excellence would lead to a greater consideration of the Italian court, and of the Medici in particular. However, the cardinal did not turn to Leonardo, who at least in painting could boast undeniable fame, but rather to Raphael and Sebastiano del Piombo, both of whom received commissions in early 1516 – to paint respectively a *Transfiguration* and a *Resurrection of Lazarus*. This was an explicit sign of the Medici's lack of faith in Leonardo, now regarded as the relic of a glorious past who was unable to keep abreast of new developments. In the light of these events, Vasari's passing reflections on Leonardo's Roman years are coloured with bitterness: Leonardo's indecisiveness provoked Leo X's open criticism, and he became a figure that attracted more curiosity for his eccentricities than admiration for his art:

Leonardo went to Rome with Duke Giuliano de' Medici upon the election of Pope Leo X, who was a great student of philosophy and most especially of alchemy. In Rome, he developed a paste out of certain type of wax and, while he walked, he made inflatable animals that he blew air into, making them fly through the air; but when the air ran out, they fell to the ground. To a particularly large lizard, found by the gardener of the Belvedere, he fastened some wings with a mixture of quicksilver made from scales scraped from other lizards, which quivered as it moved by crawling about. After he had fashioned eyes, a horn, and a beard for it, he tamed the lizard and kept it in a box, and all the friends to whom he showed it fled in terror. . . . He created an infinite number of these mad inventions and also experimented with mirrors, and he tried out the strangest methods of discovering oils for painting and varnishes for preserving the finished works.[12]

33

THE THREE PAINTINGS SHOWN TO
CARDINAL LUIGI D'ARAGONA

The last document to mention an easel painting by Leonardo is the sarcastic note by Agostino Vespucci, who in 1503 expressed profound reservations regarding the artist's ability to complete the portrait of Monna Lisa. The last significant work that we know about is the second version of *The Virgin of the Rocks* painted in Milan, for the most part by his collaborators and de Predis, between 1507 and 1508. For the remaining 11 years of Leonardo's life, the sources reveal a man who was interested solely in his anatomical and mathematical studies, was overwhelmed by the chaos of his own writings, and tried to sort out and publish his research with the help of Francesco Melzi, even though the latter only managed to produce the *Libro della pittura*.[13] As early as 1508 Leonardo had been assailed by fears of being unable to classify and order his notes, and after that matters only got worse.

Begun at Florence, in the house of Piero di Braccio Martelli, on 22 March 1508. This will be a collection without order, made up of the many sheets which I have copied here, hoping to arrange them later each in its place, according to the subjects of which they treat. But I believe that before I am at the end of this [task] I shall have to repeat the same things several times; for which, reader, do not blame me, for the subjects are many and memory cannot retain them [all] and say: 'I

will not write this because I wrote it before.' (Arundel Codex, p. 115, f. 1r)[14]

From 1506 onwards, painting seemed to be the last thing on Leonardo's mind; but we know that during his time in Rome he did not abandon his brushes and colours; the presence of that 'bench for grinding colours' listed in the estimate of works on the Belvedere apartment provided by Giuliano Leno hinted that much. Moreover, he could not abandon painting because he had to continue to employ his loyal disciples, who had followed him each time: Salai and Melzi, as well as the one called Fanfoia, who had come from Milan (this individual has not yet been identified with certainty). We know that during his time in Rome Leonardo travelled to Parma with Giuliano de' Medici in September 1514, drew a memorable drawing of the Pontine marshes, (perhaps) in preparation for a reclamation project [Plate 56], prepared studies for the reorganization of the harbour at Civitavecchia, performed dissections, tried to finish Giuliano's commission to manufacture mirrors, and argued with the 'German deceiver'; but undoubtedly he also painted, finishing his three most modern – and perhaps most beautiful – paintings:

> One of a certain Florentine woman, drawn from life, at the instance of the late Magnificent Giuliano de' Medici. The other of Saint John the Baptist when young, and one of the Virgin and the Christ Child who are seated on Saint Anne's lap, all completely perfect.[15]

The three paintings on which he worked in Rome were later taken to France, after he abandoned the Eternal City and accepted Francis I's invitation to stay at the small châteaux of Cloux near Amboise. In the elegant châteaux on the banks of the Loire Leonardo would receive a visit on 10 October 1517 from a guest of honour, Cardinal Luigi d'Aragona, a friend of the pope and of the Medici. The cardinal's secretary, Antonio de Beatis, recorded the highlights of the visit in his diary, leaving one of the most truthful documents concerning the artist's condition in the last months of his life. The paintings, shown to the visitors for the perfection of their execution and for the originality of their composition, would alone be sufficient to make Leonardo one of the

greatest Italian Renaissance painters, but all three are particularly difficult to interpret. Of these paintings, the *Saint Anne* is the one whose story is best known, because when he left Milan in 1513 at least one copy remained in the city, revealing the extent of its completion at that date. The story of the other two paintings is much more complicated, namely *Saint John the Baptist* [Plate 57] and the portrait of 'a certain Florentine lady' [Plate 58], now known as *La Gioconda*. This last one was perhaps the same painting that was mentioned in 1503 by Agostino Vespucci, but on that morning in 1517 it was presented by Leonardo as the portrait of a favourite of Giuliano de' Medici, and therefore there is no reason to doubt that it was indeed made for the pope's brother.

Of all three, the painting of *Saint John* is the most problematic, because there is no evidence of this composition before 1517 and the design is completely new, even if the saint's gesture is a reworking of *Angel of the Annunciation*, a lost work that was painted by Leonardo during his time in Florence and perhaps never even finished.[16] The painting has been interpreted almost unanimously by scholars as evidence of the influence that Leonardo's presence in Rome exerted on Raphael, since the gesture with which the adolescent saint points to the heavens whence Christ would descend was to be copied by Raphael in some of his contemporary drawings. Today this relationship, part of a critical tradition that was heavily biased towards Leonardo, is being reconsidered by many, in view of the fact that the context described by the sources reveals a dominant Raphael, at the height of his creativity, in confrontation with a Leonardo whose presence in Rome appears to be entirely irrelevant, both socially and artistically. One need only consider their respective residences: the former lived in the throbbing heart of Rome, where he would shortly build a palace worthy of a prince, while the latter was relegated to the apartments designed for artisans at the Belvedere. If there were influences between the two men during these three years, it is natural to think of one that was at the very least reciprocal. There are in Raphael's work several earlier versions of Saint John's gesture, the index finger of his left hand pointing heavenwards. Raphael's compositions allow us to follow the slow development of this gesture, from its inception in the frescoes of the *Disputa* in 1509 to its fullest expression in the Foligno Altarpiece (1512–13), before Leonardo's arrival at Rome.

The painting of *Saint John* presents other elements that prompt the suggestion of an influence exercised by Raphael and, more generally, by the Roman environment on Leonardo, an artist arrived from Milan: Milan was a city whose taste was still predominantly anchored in the Quattrocento, whereas Leo X's Rome was dominated by a classicizing fashion. The evidently pagan character of the painting and the sensual beauty of the youth, who announces the advent of Christ with a beckoning smile, erotic more than devout, are typical of the liberal climate that spread through the city in those years, after the ostentatious triumphs set up for the cavalcade of the new pope on 11 April 1513, in which triumphal arches embellished wonderfully, in the grand style of ancient Rome, lined the streets. The painting represents the point at which Leonardo draws closest to classical culture, and it would be difficult for it to find a patron in any context other than Rome. Although at the current state of research this patron has not yet been identified, it might have been the cardinal of Santa Maria in Portico, Bernardo Dovizi of Bibbiena, who could have intended to use the painting to celebrate Pope Leo X and the city of Florence, whose patron saint was Saint John. The identification of Bibbiena as the possible patron of the work is further supported by the fact that the cardinal was sent as apostolic nuncio to France, at exactly the time when Leonardo moved there too. The fact that Leonardo took with him to France a small panel measuring just 69 × 57 cm points to the fact that he might have intended to deliver the painting to his patron in France, once it was finished.

Such an erotic version of the announcement of Christ's coming might have been appreciated by the same man who had his bathroom in the Vatican decorated with one of the most licentious scenes of the time: in it the gods were consumed with love, in an iconographic context that echoed in detail the mural decorations of the Domus Aurea. Bibbiena had known Leonardo long enough to be acquainted with his 'specializations' and the reality of his working patterns, and he was a very devout follower of Saint John, to whom he paid tribute in Florence on 24 June 1516, on the eve of his departure for France. He was therefore an ideal patron – one who, precisely in view of his forthcoming journey, may have wished to take with him the patron saint's protection even if, in keeping with the times, his devotion was depicted in the contemporary language of a classical and transgressive beauty.

It is difficult to imagine another context in which such a beautiful and disturbing *Saint John–Apollo*, so focused on the essential qualities of his own body as to render any devout attributes invisible, could have been conceived. More than announcing a new era of the spirit, the youth exhibits his adolescent body as an invitation to a world of carnal delights, as testified by his own beauty. Would it have been possible for Leonardo to paint *Saint John* without having seen the nudes in the Sistine Chapel? The erotic ambiguity of these images did not escape Leonardo, because in a lucid note intended for the *Libro della pittura* he commented on the erotic charge that emanated from devout images:

> It once happened that I made a painting representing a divine subject, and it was bought by a man who fell in love with her. He wished to remove any emblems of divinity in order to kiss the painting without scruples, but finally conscience overcame his sighs and lust, and he was obliged to remove the painting from his house.[17]

The passage may have been inspired by this painting, even if we find it hard to believe that Cardinal Bibbiena resorted to returning the painting in order to ensure a chaste night's sleep.

The style of the painting is very late, the paint almost dissolves into the half-darkness, and the contours fade as in a vision, because the consistency of the material is completely subjugated by the transparency of the shadow. The saint's pose represents a further variation on the pose that Leonardo had developed for the youthful *Saint John the Baptist* with the bowl, or for *The Angel Incarnate* that was mentioned earlier. The choice of portraying the saint against a dark background highlighted by the light from above has a symbolic value because it associates the light with Christ's descent; but, once again, it is also a dramatic device to stage and give the greatest emphasis to the saint's pearly nudity and to the smile that forms the true centre of the painting.

Parallels with studies carried out by other artists present in Rome at the time, such as Sebastiano del Piombo and Raphael, are clear; Raphael, too, created dark backgrounds for his portraits in order to heighten the psychological impact of their expressions, and it cannot be ruled out that he copied this feature from Leonardo, given that he generally preserved the denseness of the natural material without let-

ting it disintegrate into the half-darkness, as Leonardo did. Studies of shade were at the heart of the work of Sebastiano del Piombo, who does not appear to have been much concerned by Leonardo's presence and was already exploring the nocturnal effects of painting in his *Pietà* (now in Viterbo). This particular research was seen by the artist as a personal achievement, and he even accused Raphael of not knowing how to blend the shadows: 'They contain figures that look as if they had been smoked – figures that seem to be made of shining iron – all bright and dark, and drawn after the fashion of Leonardo.'[18] The letter proves that in Rome the study of light and the study of blending shadows did not wait for Leonardo's arrival before flourishing among the great artists. Although the effects achieved by Leonardo through the use of *sfumato* in this painting reach an unattainable level of beauty, it cannot be said that there were not artists in Rome who were already moving in the same direction and might have contributed to his research.

Lastly, there are some aspects of the technique of execution that back the hypothesis of a very late date for the painting. The paint film in the shaded areas presents very visible craquelure, typical of a medium with a low pigment content. These cracks are a characteristic of Leonardo's late painting and also appear on the illuminated skin of the *Gioconda*, on the breast and forehead in particular, but in the painting of *Saint John* they are exaggeratedly wide, to the extent of breaking the unity of that imponderable darkness in which, by contrast, the flesh becomes luminescent. Such extensive craquelure cannot be explained simply by the transparent and very oily layers [*velature*] in which Leonardo painted, which are evident both in the *Gioconda* and in *Saint Anne*. This characteristic of *Saint John* is more likely to be the result of a new experimental insight acquired by the artist – a mix of oil and varnishes, or indeed a mix of pigment and varnish used in the darker parts. A clue to this daring new experiment might come from the artist's time spent in the Vatican, when according to Vasari [*Lives of Artists*, p. 297] he started to test new varnishes in the Belvedere workshops: 'he tried out the strangest methods of discovering oils for painting and varnishes for preserving the finished works.'

Traces of this experiment can be found in all three paintings, which were elaborated, continued or started at Rome. In *Saint Anne* the exaggerated craquelure appears on the knot in Mary's robe and on the

landscape to the right of the group, which we know with certainty was worked on after Leonardo's departure from Milan. This use of varnishes over the layered glazes of the shadows is undoubtedly functional to the attempt to reproduce on the panel the evanescence and impalpability itself of natural shade, as he had succeeded in doing since 1501, using a pencil smudged with the finger or with hard brushes. But in *Saint John* Leonardo goes a little too far, because the expert perfection of the flesh in full light contrasts with the poor depiction of the shaded parts and of the browns in general, so much so that the consistency of the paint is barely distinguishable in the youth's soft curls and in the leopard skin that envelops his body.

Reflectography also appears to confirm Leonardo's overriding interest in painting shadows during the closing years of his life, when shadows become more important than the tangibility of bodies. There are very few traces of the drawing, which was barely studied before being transferred to the panel. The mouth was noticeably changed in the painting by comparison to the drawing, where the upper lip had been much higher on the right-hand side of the face. Likewise, the lower contour of the saint's right arm, at the joint with the scapula, is repeatedly traced using various summary lines, evidence that this detail had been little studied. The painting was conceived almost as if without a drawing, as a thickening of light, an apparition studied directly on the panel. Furthermore, for Leonardo the discovery of the psychological expression could only be accomplished in the light that contoured and softened the face, allowing a bodiless expression to emerge.

34

A WORLD OF WOMEN

The other two paintings seen by Cardinal d'Aragona and his secretary, Antonio de Beatis, are difficult to date. One, the painting of *Saint Anne with the Virgin and Christ Child*, had been discussed by Isabella d'Este's agent, Pietro da Novellara, in 1501, and Vasari would also mention it, although without having seen the painting: he only described the cartoon, thereby misleading generations of Leonardo scholars, who would regard the marvellous painting in the Louvre as the work of Leonardo's pupils.[19] Novellara also added his views on the meaning of the painting and there is little to add to his interpretation in theological terms – although this was the main and most communicable interpretation: behind it lie many other meanings, allusions and desires that prompted Leonardo to return to the painting almost twenty years later.

Although it was started in Florence at the turn of the new century, the painting followed Leonardo to Milan after 1506. Here it was again worked on, but not finished. Leonardo treated it, as usual, as a living being on which the transformations of light and colour were observed and discovered over time. The development of the painting up unil 1513, just before Leonardo's departure for Rome, is witnessed by a number of copies, which then remained in Milan, made by pupils (they certainly used Leonardo's cartoon). The most interesting copy from this point of view is the one that is now at the Hammer Museum of Los

Angeles [Plate 60], and until 1810 had been in the church of San Celso, Milan, where it was copied continuously by many artists. This practice has given rise to a strange phenomenon of copying the copy, since it was located in a church open to the public while the original was inaccessible in the collections of the French monarchy.

As a result there are many more copies of the painting at its 1513 stage than there are of the painting that was finished by Leonardo between 1513 and 1519. A comparison of the two allows us to highlight the differences in pictorial quality between the work undertaken by pupils under his guidance and the final painting and to understand how Leonardo, in spite of having attained a perfect definition of the composition in 1513, insisted for another five years on a few small details (the differences) that, at first glance, seem unessential but that proved decisive to making the master's painting a perfect masterpiece, while the painting by his pupils remains a most beautiful painting. The variations made by Leonardo during his Roman years concern the landscape – the tree on the left of the group disappeared – changes to the rear part of Mary's robe and the removal of both her and Saint Anne's sandals. Moreover, the colours of the robes are radically muted in order to give greater luminosity and depth to the scene.

In the 1513 version, the tree on the left encroaches on the two seated women, squeezing them into a narrow visual corridor that creates a sense of claustrophobia. In the following years Leonardo not only removed this tree to give more light to the scene and to lead the viewer's eye to the magnificent backdrop of the landscape, but also opened the tree on the right by adding glimpses of the sky between the leaves and by making it as transparent as a stage wing made of lace. In the later version the landscape is divided cleanly between the upper part, all blue, where the mountains fade and merge in the distance with the water and the sky, and the lower part, which is misty, rocky and almost arid in its golden reflections. One of the most successful landscapes in Italian art, it has such immediacy that it seems to anticipate impressionist painting. With the lightest of tonal variations, Leonardo paints the snow-capped mountains, adding small touches of white on the tops and transparent layers [velature] of shade on the rocky flanks. The landscape that replaces the tree on the left has slightly different colours, and its later execution is evident. The blue of the mountains on the right,

whose tectonic structure is defined almost with Quattrocento-like pre-
cision, makes away for inconsistent browns that look like seething froth
rather than like eroding rock. Water runs through and penetrates the
whole landscape, like a flood from which the two women and the child
are saved, seated on a hill beyond which the world of nature is being
changed before our very eyes. The plateau on which the scene is set is
coloured, in marked contrast with the background – which consists of
brown and golden ground deprived of any plants on the left, while on
the right the landscape is less archaic and even shows signs of human
presence: a small bridge, built over a river that runs between the rocks
(but whose waters are white, not blue as in the distance). The spatial
divide between the plateau where the women sit and the rest of the
world could not be wider – were it not for the fact that, as in the first
version of *The Virgin of the Rocks*, water flows also across the foreground,
beside the naked feet of Saint Anne, in a clear stream that reveals the
pebbles on its bed.

The other major transformation can be seen on the Virgin's left-
hand side, for which a study drawing has survived and is now in the
Windsor collection [Plate 61]. This, too, might seem a trivial detail
prompted by Leonardo's maniacal obsession with minutiae, but this
is not so: he realized that in the first version of the painting Mary's
body was tipped too far forwards and her movement to grasp the child
lacked harmony and communicated a sense of precariousness to the
viewer. By painting that large knot that holds up the folds of the rose-
lake dress, the the artist rebalanced the whole figure – as if he added a
counterweight to a scale that was off balance in order to bring the two
pans into line.

This variation, on which the artist reflected for years, proves critical
to giving the composition that sense of perfect mechanical equilibrium
that makes it so fascinating. But the general rebalancing of the com-
position is also linked to the particularly pale colours used for the final
version. The main colours are ultramarine blue for Mary's mantle and
laquer colour [*color lacca*] for her overdress. All that can be seen of Saint
Anne is her arm covered in grey fabric, the same colour that is barely
visible on her lap, on which the Virgin is sitting. The tones of these
colours, and even of the lapis lazuli, which is generally so deep, are very
pallid, consumed by light and reduced to little more than a vibration, in

order not to overpower the delicate hues of the complexions caressed by shadows. While in *Saint John* Leonardo plunges the image into shadow, in *Saint Anne* he attempts to consume it in light, lightening the drama of the shadows so much that on both women's necks they are reduced to a faint golden hue that in no way conceals the physiognomy.

Here again the drawing is invisible and the definition of the image is linked to a subtle variation in colour. Moreover, colour defines the age difference between the two women, who otherwise share the same abstract physiognomy that had by now become Leonardo's norm. The viewer can tell that Saint Anne is older only by her darker skin, as if she had spent longer in the sun, but otherwise nothing detracts from the regularity of her features, which are completely identical to her daughter's. In this delicate play of chiaroscuro vibrations, the garments are reduced to transparent veils, as if they, too, were made of shadow, albeit a coloured shadow. Mary's overdress, painted using delicate pink lake pigment [*lacca rosa*], shades into white over her bosom, creating a revolutionary effect of insubstantiality. No painter at this time had reduced matter to its luminous essence, and here Leonardo reaches a high point of astounding novelty. Centuries would pass before painting would abandon itself to the effects of pure colour and light without the mediation of drawing. Even the transparent veil that covers the Virgin's arm was unimaginable before its use here.

The success of these effects, contrary to what might be expected, is linked to the rapidity of Leonardo's brushstrokes. The fact that he waited for years to define a detail did not mean that he worked by mixing colours on the palette and continuously changing the colour, even at a distance of months. Leonardo observed and waited until he could capture the right light, but when that moment came he was quick to mix the colour and dab the painting, leaving a small shadow of pigment that miraculously achieved the desired effect. In the mountains on the left-hand side of the painting that were finished during his Roman period, the manner of execution is very clear, as is that of the Virgin's arm. The mountain arises out of a quick dab of brown, alongside an equally quick and confident touch of blue or white, and the transparency of the thin layers produces that luminous, atmospheric effect, at the sight of which we are prompted to squint as if we were in a real landscape, in order to bring the distant outlines into focus. Had the

artist wasted time by adding further touches of colour, this miraculous freshness that turns matter into light would have been lost.

Lastly, another alteration that, again, might seem insignificant is the removal of the women's footwear. The sandals that appear in the Milanese version (and in all five of the known versions copied from this painting)[20] have the crossed laces typical of late fifteenth-century and early sixteenth-century Madonnas. This type of footwear was copied from Roman bas-reliefs and statues and provided an embellishment suited to a religious image. But Raphael had already removed these sandals from his Florentine Madonnas (*Madonna of the Meadow, Canigiani Madonna*, and *Holy Family with the Lamb*): leaving the Virgin with bare feet gave the image a certain timelessness while revealing the influence of classical sculpture, which was increasingly used as a reference in sacred art. Raphael gave bare feet to his *Sistine Madonna*, too, which was painted before 1513 and seen by Leonardo on his arrival in Rome.

This classicizing choice influenced Leonardo who, while continuing to work on his Saint Anne, decided to remove (or leave out) the sandals worn by both women. Moreover, the appropriateness of the image in a devotional sense might have been a consideration in the early version, which was almost certainly intended for a religious institution; but, once the painting no longer had a particular recipient and became instead a mobile laboratory on which Leonardo continued to study the effects of light and colour, its religious significance was less important. The artist emphasized the character of the painting as a naturalistic metaphor, the symbiosis between human generations in movement and natural transformation (of the rocks and the water). And the bare feet brought Saint Anne and Mary closer to the pagan images that populated the walls of Rome's palaces and churches. Even this simple act of removal likened the painting to an ideal vision that recalled the beauty and harmony of the universe. The infant Christ, whom Pietro da Novellara had described as ready to sacrifice himself to fulfil the destiny of humanity, seems to ask his mother's permission to climb onto the lamb, a creature whose docility is transferred, through empathy – as in the case of Cecilia Gallerani's ermine, or in that of the horses at Anghiari – to the child; and its gentle submission heightens the tender emotion of the scene.

Although unfinished in some areas, or perhaps precisely because of

this, the painting arouses a deeply emotional and aesthetic response, as the numerous copies that were made of it demonstrate. In purely pictorial terms, this is Leonardo da Vinci's most successful attempt to exalt the material substance of nature and human bodies through colour and to conjure a vision of pure light that is mobile and difficult to grasp, yet goes straight to the viewer's heart.

35

THE MYSTERIOUS WOMAN

The third painting shown by Leonardo to Cardinal Luigi d'Aragona is introduced by the artist as a female portrait, painted on behalf of Giuliano de' Medici. It is therefore the portrait of a *favorita* that, like the painting of *Saint Anne*, was left without a patron because Giuliano died in 1516, shortly after having married Filiberta of Savoia, and it would have been wholly inappropriate for her to have kept the portrait of her late husband's mistress. Therefore this painting, too, remained in Leonardo's possession, and he worked on it for years, projecting onto it his concerns and using it for his last experimental ventures. But the change of identity did not stop in Leonardo's workshop, because immediately after the artist's death that smiling face acquired its own life and over the centuries it has remained a genuine enigma. After it was seen in 1517, the painting was mentioned in the diary of the Anonimo Gaddiano, which was completed around 1550. This is an important testimony for the life of Leonardo because the author was a Florentine who had direct experience of the master's activity in that city. But, to our great surprise, this most truthful source for Leonardo's life mentions a portrait, not of Lisa del Giocondo but rather of her husband, Piero.

Matters are complicated by Vasari, who, although he had never seen it in person, goes out of his way to praise the portrait of Lisa del

Giocondo and weaves an elegant fable around the painting that helped
to establish the myth, both of the painting and of its sitter, while con-
fusing the clue left by Agostino Vespucci, who referred (as we have
already seen) to a Monna Lisa. The words used by Vasari to describe
the painting only increase the perplexity of historians, because he refers
to anatomical details (the eyebrows, the facial hair, even the pores of
the skin, etc.) that are completely absent from the portrait of Monna
Lisa as we know it today:

> The eyes have the lustre and moisture always seen in living people,
> while around them are the lashes and all the reddish tones that cannot
> be produced without the greatest care. The eyebrows could not be
> more natural, for they represent the way the hair grows in the skin –
> thicker in some places and thinner in others, following the pores of the
> skin. The nose seems lifelike with its beautiful pink and tender nostrils.
> The mouth, with its opening joining the red of the lips to the flesh of
> the face, seemed to be real flesh rather than paint. Anyone who looked
> very attentively at the hollow of her throat would see her pulse beating
> ... there is a smile so pleasing that it seems more divine than human,
> and it was considered a wondrous thing that it was as lively as the smile
> of the living original.[21]

Of course, none of this can be seen in the portrait that is now in the
Louvre, which raises the question: what was it that Vasari saw?

In 1625 Cassiano dal Pozzo saw the painting in France and identified
it as the portrait of Monna Lisa, and this is how it entered European
legend. Such a complex story of identity is not easily disentangled from
the primary sources just through stylistic analysis, because while the
executive technique, the idealized face, the chromatic spectrum and the
dematerialization of the image unquestionably bring it close to *Saint
Anne* in chronological terms, and therefore to Leonardo's late produc-
tion, the fact that he kept both paintings in his workshop for such a long
time and continued to work on them argues for a possible time frame
for the execution of the painting that ranges from the early 1500s to
1518 – 18 years during which the woman he had painted changed no
less than a living person would have done.

Nor has the recent discovery, at the Prado Museum in Madrid, of a

copy of the *Gioconda* made during the same period and using the same preparatory cartoons as for the painting in the Louvre, been any help [Plate 62]. Reflectography tests have highlighted how, beneath the film of paint in both works, there was originally a very different landscape from the one eventually used by Leonardo for the Louvre painting and by his collaborator for the work in Madrid [Plate 63]. To the left of the woman, where we now see a lake scene, Leonardo had originally drawn a rocky mountain with a path that wound down, making two curves before it vanished into the plain. A similar view appears in a copy of the *Madonna of the Yarnwinder* (also at the Louvre), a composition on which Leonardo certainly worked after 1501, according to the testimony of Pietro da Novellara,[22] and which was finished in 1507. The presence of this common landscape detail in the preparatory drawing for the *Gioconda* and in a workshop painting datable to the early years of the century proves with some certainty that the *Gioconda* was begun in those years and, over time, underwent the transformations described above. It seems likely that its unfinished state in 1514 made it possible for Leonardo to turn it into the portrait of Giuliano's favourite, and again, after the duke's death, into a symbolic portrait unrelated to any real-life woman. This long gestation would also explain the rather archaic character of the three-quarters pose, which is reminiscent of Flemish portraits of the late Quattrocento and was to be adopted by Raphael in his 1507 portrait of *Maddalena Doni*, whether he was inspired by Leonardo or not. But the real driver of the painting's fascination and ambiguity is the difficulty of positioning it within a precise iconographic tradition – of course, besides the highly particular story of how it came about.

When looking at the *Gioconda*, the first impression is of looking at a smiling Madonna, although there is no justification for this in the western iconographic tradition, since Madonnas do not smile, or at least they do not look straight at the viewer and smile. On the other hand, the clothes worn by the woman do not help to identify her as a woman of her time, and Leonardo knew this well, since he had theorized rather vague, unspecific styles for the clothes worn by his Madonnas and saints. The portrait of a living woman 'drawn from life', as Leonardo himself clarified in his presentation to Cardinal d'Aragona, would have required a fashionable attire, a tailored item that would arouse envy

and admiration (as had the dress that Ludovico il Moro gave to both his women, Beatrice d'Este and Cecilia Gallerani), not to mention the presence of jewels to indicate the sitter's social status. The definition of the clothing is an essential part of the characterization of the model and, in his earlier portraits, Leonardo had shown a clear understanding of this iconographic rule. Instead, the Louvre portrait presents a style of clothing that is completely undefined; and this confuses us because we cannot place the woman in a precise historical context, but only in that atemporal sphere typical of sacred images.

The Madonna hypothesis is immediately contradicted by the fact that she is smiling, and in a manner that I will avoid describing because too many adjectives have already been lavished on the nature of the *Gioconda*'s smile. All that could be said about a smile has been said, so it would be superfluous to say more, except for what is important to my purpose, namely that the smile is completely inappropriate for a Madonna or for a saint. Thus her dress comes into open conflict with the psychological expression that would be appropriate for a real person. A saint does not look at us in that way. Her gaze carries to the farthest consequences the gaze that we have already seen in *Saint John*; but in that case, given the many identities of the saint – shepherd and prophet – it was provocative, not alienating. Leonardo must have worked on this smile, or rather thought about it, for years, given that none of his earlier female portraits smile, and neither do any of his marvellous Madonnas; on the contrary, they are afflicted by a vein of melancholy that diminishes at last only in the *Virgin* seated on Saint Anne's knees, a work contemporary with the *Gioconda*.

It would be legitimate to suppose that such a particular sort of expression came to Leonardo during his Roman sojourn, where, despite the marginal condition in which he found himself and the suffering it caused him, he would have been unable to avoid noting the smile that Raphael had brought to the lips of his saints, models, Madonnas and courtesans. If, with Vasari's complicity, much has been taken from Raphael and given to Leonardo in terms of artistic inventions, there can no doubt that the female smile, in its fullness as a 'genre', was the creation of the painter from Urbino: he was the first to portray – also thanks to his love of women – a new psychological figure, who made a dramatic appearance in Rome and at the Italian courts of the late Quattrocento.

The life of the Eternal City had been marked for a number of decades by the presence of extraordinary women, seductive, cultured and intelligent, who imposed new roles in the modern world. The duchesses who animated the salon-like atmosphere of the court at Urbino began to inflame Roman circles with their witty observations from as early as 1508, when a manuscript of *The Courtier* by Baldassarre Castiglione began to circulate. A woman, Giulia Farnese, had influenced a pope's choices through her beauty and intelligence, manipulating and exploiting the irrepressible and rather bestial passion of her elderly lover, Pope Alexander VI. A very young woman was at the centre of another revolution in the second decade of the century: Francesca Ordeaschi, lover of the banker Agostino Chigi, who had been kidnapped in Venice and brought to Rome for his pleasure at the age of just 11. With her intelligence, Francesca affirmed her status in society and at the papal court, made Chigi renege on his plans for a socially strategic marriage to an illegitimate daughter of Francesco Gonzaga, and then married Europe's richest man herself, in the presence of Pope Leo X, causing a minor revolution that would bring to the fore the reality of love and the victory of the spirit over social conventions.

In this climate, where women finally took the initiative of asserting their intelligence and psychological complexity, Raphael is the artist who captures and embodies their new presence, which forcefully made its appearance on the social, religious and political scene. Raphael made these women visible through mythical evocations like *Galatea*, painted around 1511 for Chigi himself, but he did so above all through portraits of women whose smile conquered the minds of men, just as the courtesan Imperia had done: worthy men had fallen in love with her in the second decade of the sixteenth century. The smile that Raphael had introduced in his female portraits, such as *La Fornarina* and *La Velata*, must have stimulated Leonardo to explore this new psychological world in his *Gioconda*, but by using his own stylistic forms, which exalted the dimension of light over the consistency of matter. Leonardo developed this female psychological profundity with less realism through the ambiguity of the clothes, thereby bringing the sitter closer to a sacred or mythical figure outside time.

A third contributing factor in this creation of a powerful universal image is the landscape that occupies almost all the background of

the painting beyond the sketchily visible balustrade. This landscape, which has something in common with the ones already encountered in the versions of the *Madonna of the Yarnwinder* and *Saint Anne*, is studied in minute detail, vying for attention with the protagonist. It is not an abstract landscape but the reconstruction of Leonardo's native countryside as it must have looked before the transformations wrought by the passing millennia; the artist had first interpreted it in his studies and then, subjecting art to science, explained it through brushes and colours. Leonardo hints at this particular landscape, unmistakeably characterized by two lakes at different altitudes:

> in the great valley of the Arno above Gonfolina, a rock formerly united to Monte Albano, in the form of a very high bank which kept the river pent up, so that before it could flow into the sea, which was then at its foot, it formed two large lakes; of which the first was where we now see the flourishing city of Florence together with Prato and Pistoia. ... From the Val d'Arno upwards, as far as Arezzo, another lake was formed, which discharged its waters into the former lake.[23]

This evocation of a native landscape reveals, like a slip of the tongue, the presence of an autobiographical theme in the painting and tells us that Leonardo is talking about himself as he painted that smiling woman. We are faced with the magical evocation of a prehistoric landscape that was immensely significant to the artist because it was his native countryside, remembered in an imaginary journey back to its origins. At the end of his life Leonardo returned to his roots, celebrating his own life as a fragment of the infinite and changing life of nature. The mountains and waters blend into the sky, dissolving into a pale blue mist with slight touches of colour, as if they were evaporating, but they acquire more tangible form closer to the sitter, changing colour, becoming brown, taking the form of roads, faintly sketched towns, and that bridge to the right of the woman, which is identical to how Leonardo had conceived of it, though not painted it, in the *Lansdowne Madonna*.

There are three degrees of landscape and three degrees of natural development: the historicized landscape in which the woman sits, on this side of the fifteenth-century balustrade; the urbanized landscape with brown colours immediately beyond the balustrade, where the

humans have built roads and bridges; and then there is the ancestral landscape stirred by primeval forces, made up of moving water, crumbling rocks and the sky that fades towards the horizon. Everything proceeds in a circular manner, from one to the next, but at the centre of this movement is her, the unfathomable woman who symbolizes a new divinity, a natural power that sums up the strength of the spirit and of nature, and who appears determined to keep the secret of that perennial transformation. In this way the portrait becomes a narrative, supported by a pictorial technique developed here to the greatest perfection, without which the narrative would be ineffectual. The woman, her clothing and the landscape she dominates are made of the same incorporeal substance, light, whose vibrations alone conjure up the consistency or appearance of fabrics, flesh, rocks and air.

The degree to which this gradual and alchemical process of transformation from matter into light was sought after as a deliberate effect can be seen from a comparison with the Madrid copy, finished before the other and probably sold before Leonardo moved to Clos-Lucé, the small château he was offered by Francis I after arriving in Amboise in 1517. In this copy the colours are still real hues, the fabrics and trees have the consistency of real objects, and even the woman's mouth is red, as it should be; the sleeves of her dress are also a brilliant, vivid red, and the skin tones are more sensuous, closer to other contemporary portraits – indeed, in this version of the portrait, the resemblance to Raphael's *La Fornarina* is strikingly clear. In the next phase, Leonardo tones down the colours, subduing them to a spectrum that oscillates between brown and bluish grey. The red sleeve of the woman in Madrid converts into a much less garish golden brown, so as not to break the unity of tones – which seems the result of a coloured filter placed over the viewer's eyes. The woman's face loses all consistency, the natural details vanish (with all due respect to Vasari and his surprising description), making way for a continuous vibration of light. The lips have neither colour nor form; they are simply curled by her smile, while a slightly darker shadow defines the eyebrow and gradually fades down the profile of the nose, which is essentially shaped by the shadow of the nostrils. The veils and hair become a single brown mass, with faint highlights here and there to suggest the softness of gentle curls. The drawing has completely vanished and the woman is as unreal as the rocks and the countryside

behind her: one need only compare the final version with the slightly earlier one in the Prado, Madrid, to judge how much the loss of colour and matter adds to the fascination of the elusive image.

At the end of his life, now completely free from the tyranny of science and patronage and untrammelled by his own ambition, Leonardo created a new divinity, in which he merged elements of the Christian tradition with the power of the natural forces that he alone, among his contemporaries, had understood. While it is wholly superfluous to continue questioning the historical identity of this image, it is important to stress that it brought together so many associations for Leonardo himself (first and foremost, the memory of a mother whom he loved more as a dream figure than in real life) that in the future it became a genuine spiritual icon rather than a religious one, given that her power no longer resides in the child in her womb but in her oneness with the universe behind her.

Like a true icon, *La Gioconda* offers herself to the veneration of successive generations who would seek and find a catalyst for their own psychological energy, as Walter Pater described in words that remain unsurpassed by other scholars or by specialist critics for their beauty and acumen.

All the thoughts and the experience of the world have etched and moulded there, insofar as they have that power to refine and make expressive the outward form: the animalism of Greece, the lust of Rome, the mysticism of the medieval era with its spiritual ambition and ideal loves, the return of the pagan world, the sins of the Borgias. She is older than the rocks among which she sits; like the vampire, she has been dead many times and learned the secrets of the grave; and she has been a diver in deep seas, and retains their crepuscular light about her; she has trafficked strange fabrics with Eastern merchants; and, as Leda, she was the mother of Helen of Troy, and, as Saint Anne, the mother of Mary; and all this has been to her but as the sound of lyres and flutes, and she lives only in the delicacy with which it has moulded the changing lineaments, and tinged the eyelids and the hands. The fantasy of a perpetual life, sweeping together ten thousand experiences, is an old one; and modern philosophy has conceived the idea of humanity as wrought upon by, and summing up in itself, all modes of thought

and life. Certainly Monna Lisa might stand as the embodiment of this ancient fantasy, the symbol of the modern idea.[24]

As he had done all his life, Leonardo used painting to communicate what his science had been unable to convey; and his sensibility and artistic talent did justice to his scientific labours.

36

THE END

The renewed illusion of a powerful and generous patron was blown away in 1516 by the Scirocco and the bitter disappointments of Rome: the Medici family had its own painter, Raphael, and when special gifts were required to pay homage to the new French king, Francis I, it was again to him that its members turned. By contrast, Leonardo's freedom to carry out his studies was curtailed for the first time and he was banned from continuing to perform his dissections and studies on reproduction. The observations of fetuses [Plate 64] convinced him that the fetus was so closely bound to the mother that it lived and breathed through her, and this simple consideration came into conflict with the dogma laid down by Leo X, namely that the soul was infused by God into the neonate at the moment of birth, giving it life. It was better not to take this line of enquiry any further and avoid an accusation of heresy that would have been particularly embarrassing for a guest maintained at the expense of the papal household. The artist faded from view, and that obscurity became even deeper after the death of his protector Giuliano on 17 March 1516 in Florence. Leonardo and his small household were now just a burden on the payroll of the Medici administration and life in the workshops at the Belvedere continued to be unbearable.

The climate in Rome became poisonous when a conspiracy against

the pope was discovered around 1517; it was masterminded by a group of cardinals who had bribed his doctor to infect the anal fistula, from which the pope had suffered for years. It had been this affliction that had won him the papacy. During the conclave of 1513 the wound got inflamed and spread through the wooden cubicles crammed into the Sistine Chapel, where the cardinals were locked, a smell so abominable that it fuelled rumours of Giovanni de' Medici's grave illness. His most cunning friends quickly seized the opportunity to convince the more vacillating cardinals that Giovanni would not last long and therefore his papacy would be simply a way to extend the uncertainty that had paralysed the conclave. Three years after that election, the attention of those cardinals who wished to eliminate the pope focused on that fistula, but on this occasion Leo's reaction was violent in the extreme: he imprisoned one of his electors, Cardinal Alfonso Petrucci, in Castel Sant'Angelo and gave orders that he be strangled in his cell on 4 July 1517. The arrest and death of a cardinal were events of unprecedented seriousness at the papal curia and terror spread through the entire court. We can imagine the frame of mind in which Leonardo passed those months in a foreign city where he had no friends or protectors, and where the pope on whom he depended was absorbed in a savage power struggle for his own survival.

It was, once again, a French king who rescued him from this captivity. Francis I of Valois, who had become king of France in 1515, at the age of barely 21, travelled to Bologna that year to meet the pope. His appearance seems to have been a product of the extraordinary imagination of that century: handsome, young and courageous, he had all the characteristics of a fairy-tale king, as the Italian ambassadors were quick to comment in their dispatches when they saw his elegant entrance into the Emilian city. Moreover, his arrival coincided with a miraculous reflowering of roses. Among the nobles who thronged into Bologna to attend the meeting between the pope and the king was Filiberta of Savoia, all dressed in gold, as a relative of the king and wife of Leonardo's patron, Giuliano de' Medici. Leonardo was present too, and wasted no time in cautiously approaching the king through the latter's master of the chamber, Artur Boissif, for whom he drew a portrait on paper with the promise of developing it in paint. Francesco Melzi diligently recorded the identity of the man in the margin of the sheet

of paper, as well as the circumstances in which the drawing was made. At that stage Melzi never left the maestro alone for a moment, in an attempt to remedy his untidy habits.

Francis I had already come across Leonardo's work, not only through paintings that had arrived in France over the previous two decades (*Madonna of the Yarnwinder* painted for General Robertet, the high-ranking court dignitary, and *The Virgin of the Rocks*), but also through one of the artist's most fabulous inventions, a mechanical automaton that had astounded the guests at the celebrations hosted by the rich colony of Florentine merchants in Lyon on the occasion of the king's arrival there four months earlier. At the festivities a mechanical lion had taken a few steps into the room and then, at the touch of a baton, it had opened before the young king's eyes to reveal a cascade of fleurs-de-lis and an interior painted in royal azure. Both the colours and the flowers rendered homage to French monarchy. The lion had been invented by Leonardo and was probably sent by his protector, Giuliano de' Medici, to the merchants in Lyon, so that they give the French king a token of Florentine magnificence. It was therefore not difficult for Leonardo to approach the king through his closest courtiers, and we can imagine that the master of the chamber was charged by Leonardo to give Francis drawings or other projects. On the other hand, while the king had already been able to appreciate the artist through his works, the ceremonies at Bologna allowed the latter to become enamoured of the king, seeing as he possessed all those traits – elegance, generosity and beauty – that Leonardo loved in a patron. The chronicles are lavish in their descriptions:

His Majesty was seated under a canopy of azure velvet embroidered with golden lilies, on a throne that was fashioned in like manner. His Majesty was sumptuously clothed; he had a tunic of gold *soprarizzo* velvet with a cape of silver *soprarizzo* velvet overlaid with gold velvet and lined with gold lamé; on his head he wore a velvet cap, and he had white stockings and shoes and a coat of heavy gold and silver silk. His Majesty is so handsome, with a beautiful but not very delicate face, his nose a little on the large side, black hair against a white complexion, broad shoulders, and he is a good hand's breadth taller than me, aged 22, with the hint of a downy beard.[25]

With a physique tempered through jousting, which he engaged in right up to the time of his coronation, he was muscled and athletic in build. Francis appears to have been quite aware of his magnificent physical appearance and he took punctilious care to present himself on ceremonial occasions as finely dressed as in a painting. But what mattered more to Leonardo was that Francis was passionate about Italian painting and had made up his mind to take the best of Italy's artists back to France. Just like Ludovico il Moro before, Francis I had a kingdom that was powerful but not exactly abreast of fashion in terms of art, and he intended to enrich it by bringing Italian artists and works of art back to France. At that time Leonardo was desperate and more than willing; he was 63 and still nurtured some ambition. The details of Francis's proposal have not survived, but the timing makes it seem likely that it was Cardinal Bibbiena who acted as an intermediary in Leonardo's transfer, also because Francis I showed particular regard for the cardinal's critical opinions. Both men, Bibbiena and Leonardo, travelled to France in the late spring of 1517, the former as apostolic nuncio, the latter as painter and engineer. They would both be treated with great respect.

Leonardo and his small entourage were lodged in a residence in the small village of Clos Lucé, on a hill overlooking the Château of Amboise on the banks of the Loire, where the king often gathered his court. With its abundant marshes and woods, this was one of the most beautiful settings in France, and its variety of plants and birds, especially during the migratory season, made it a perfect place for Leonardo to spend the last years of his life. The leaves on the lime trees around the château turned yellow in the autumn, revealing glimpses of the grey river and slate roofs of the same colour. Leonardo arrived at the most beautiful time of year, when the reed beds were in flower and their flowery spikes floated downstream like snow. After spending three years in the Belvedere apartment, which was open to the inquisitive stares of friend and foe alike, Leonardo at last had a spacious residence all to himself, where no one could spy on his work. The Château du Clos Lucé had two floors, a simple structure with parallel wings that backed onto an octagonal corner tower with a steeply sloping roof not unattractive to look at. The pink brick façades stood out against the white snow during the long winter. The wide windows were framed in white stone jambs and divided by stone tracery that held the leaded

glass in place and captured as much light as possible from the miserly northern skies. Twenty years earlier, King Charles VIII of France had bought this building from one of his predecessor's favourite courtiers, Étienne le Loup, and had turned it into a comfortable house, adding a gothic oratory in tufa stone where his wife, Anne of Brittany, would retire to pray and mourn for her children, who had died in infancy. However, the queen's sorrow did not erase the joyous feel that Charles had brought to the house with the help of talented Italian artisans; and the young duke of Angoulême, the future Francis I, had organized festivities and jousts while he lived there with his sister, Marguerite of Navarre, and his mother, Louise of Savoia.

The loving relationship that bound the young king to this house reflects more than any number of words the regard he felt for his guest, whose melancholy must have touched him and made him want to lighten his mood at all costs. After the rough-and-ready apartment at the Belvedere, Leonardo now found himself in ample, well-lit rooms with decorated wooden ceilings and monumental fireplaces. This was luxury fit for a prince and a man who, through his own talent, had finally broken down the social barriers that had held him prisoner to his illegitimate birth. The revolution in art became a social revolution, and what Leonardo had been denied by Rome was now handsomely rewarded by France and its king. The Château at Clos Lucé, with its comfortable halls, seemed an ideal place for the artist to resume and systematize his studies; and he settled in immediately, being person- ally cossetted by the king, who often came to visit him – so often as to inspire the the completely unfounded legend of a secret tunnel joining the Royal Château of Amboise with that of Clos, which allowed the king to visit Leonardo away from prying eyes – and, after the artist's death, to visit his mistresses with even greater discretion.

Once again, this was a time for new and even more sumptuous festivities, for which Leonardo devised the most beautiful and highly original costumes [Plate 65], quite apart from overseeing their produc- tion in his own inimitable manner. The mechanical lion reappeared at a celebration given for Francis I at Romorantin, where the king had gone to visit his beloved sister, the cultured and highly refined Marguerite. The Mantuan ambassador noted the details of this event, during which a fake hermit led the king up to the mechanical lion; and this time it was

the king himself who struck the lion with a cane, 'and the Lion opened and inside it was all azure, which means love according to the customs here'.[26] New projects were spoken of: the royal Château at Romorantin, with gardens as large as a town, and a new road for Orléans. Meanwhile the small village of Clos Lucé reminded Leonardo of his childhood, at the end of his circular journey. A drawing of Amboise captures on paper the gentle country scene with its woods and its peaceful nature, far from the libraries that had been a lifelong attraction and from the illustrious figures with whom Leonardo sought to debate and challenge new frontiers.

Paper, too, remained a favourite and a much loved object; only now it was not the scraps from his grandfather's notarial deeds but entire reams of paper, marked with French watermarks. This was the paper that he used to make his last drawings, no longer of terrifying floods or horrifying sections of hearts and vertebrae, but rather a vision of domestic peace transfigured by his imagination: cats curled up around the hearth that, with a few strokes of the pen, become dragons, fantastic figures generated by an imagination that had remained unchanged since those long winters spent during his happy boyhood with his grandparents in the hamlet of Vinci – no larger than Clos Lucé but certainly less comfortable [Plate 66]. According to the secretary of Cardinal d'Aragona, at Clos Lucé Leonardo suffered from a paralysed arm and could draw and paint only with difficulty, helped by Melzi. This might have been a misunderstanding caused by the fact that the man would have seen Leonardo using his left hand; but it makes little substantial difference, because at this stage Leonardo was no longer interested in painting. His pride, his last efforts would be concentrated on the many volumes he showed to his guests: the notebooks on the anatomical dissections of dozens and dozens of corpses, so many that even he could not remember their exact number – 'he said that he had dissected more than XXX bodies, both of men and women, of all ages' – the book on the nature of water, sketches of various machines, and so much else. This blessed place on the banks of the Loire was the ideal gift for his closing years, as would have been the possibility of printing 'an infinite number of volumes all in the vulgar tongue', which he proudly showed to his visitors.[27]

Francis, the handsome king, was generous both with his money and

with his affection. The royal accounts record the payments assigned to Leonardo, and these include an extremely generous pension of 2,000 *livres* a year, worthy of a general and much larger than the one paid to Primaticcio 15 years later, which only amounted to 600 *livres* a year. To his main collaborator, Francesco Melzi, Francis awarded a pension of 400 *livres*, and to Salai an occasional reward of 100 *livres*. But the king's generosity emerged most clearly when in 1518 he purchased the three paintings Leonardo had brought from Italy for the astronomical sum of 2,604 *livre tournois*, equivalent to some 1,250 Italian *scudi*. This was much more than Sebastiano del Piombo was paid in the same year for his altarpiece, *The Raising of Lazarus*, which measured 381 × 289.6 cm (more than twice the size of all three of Leonardo's paintings put together). The money for the paintings did not go to Leonardo, however. He had no need, and everything he loved was already inside his mind. It was paid to Salai, at the bank of Milan in 1518: 'To Messire Salay de Pietredorain, painter, for some painted panels he has leased [*baillié*] to the King, II^M VI^CIIII l.t. III s. IIII d. (2,604 *livres* 3 *sols* 4 *deniers tournois*).'[28]

In Milan, Salai, who had already taken Leonardo's vineyard (where the artist had planted Malvasia vines from Crete, a wine that was reputed to be extremely fortifying, so much so that Pope Paul III doused his member and rinsed his eyes in it every morning), now deposited the money and, after the artist's death, he would also deposit the clothes and precious gems that his master had given him. For a boy who stole money from his companions' purses, as well as scraps of leather and styles for drawing, he had come a long way. Not content with having acquired money, land, the house and the precious gems, Salai also took the copies of his master's paintings that were lying in the workshop.[29] But the old man was pleased for him, because the boy, now in his forties, had been close throughout his life and, in his own way, a faithful disciple. The king did not lose time in demonstrating his affection for Leonardo and the entire French court became Italianized. Francis's increasing passion for Italian art knew no bounds, and in early January 1519 he asked Cardinal Bibbiena to procure the works of Michelangelo. There was no need to request works by the other star in the firmament of Italian art, since Pope Leo X had already commissioned two splendid paintings from Raphael, as gifts, and within a few months they would be

sent to France: a *Saint Michael Vanquishing Satan* and a *Holy Family with Saint Joseph and Saint Elizabeth*. The two rivals who had overshadowed Leonardo in Rome were about to reach France with their works, and even there, at Amboise; the world had suddenly become a very small place. But Leonardo was not particularly concerned, and with the help of Francesco Melzi he set to work on a clean copy, ready for publication, of his *Book on Painting*, while in his spare time he continued to study geometry and mathematics. Melzi had become his hands and eyes, and he was a gentleman whom Leonardo could trust completely. When Leonardo felt that his end was drawing close, he asked Melzi to accompany him to the church of Saint-Denis to draw up his will.

It was the morning of 23 April 1519. At that time of year, the French countryside is in full bloom; the pale, trembling leaves of poplars are reflected in the waters of the Loire; in the orchards apples and plums merge into a sweetly odorous cloud of blossom. This was the last spectacle that nature offered the man who had loved it to the point of turning it into his religion. Under the grey vaults of Saint-Denis, Leonardo dictated his last will and testament to the parish priest of the church, Flery, before four witnesses, including a Francesco from Milan, a monk from the order of Minimes at Amboise. Months earlier, with considerable forethought, Leonardo had asked the king to grant him a special dispensation to dispose of his inheritance; without that, since he was a foreigner, the crown might have seized his possessions after his death or, worse still, might have bequeathed a large share to his legitimate heirs, those half-brothers who had tried to rob him even of his uncle Francesco's bequest. This was the last act in a life that had always been lived outside the social norms of its time; and perhaps it was his way of balancing the books with the odious family that had always excluded him, causing him such suffering. The blood ties on which the society of the time based its rights and laws were replaced, in Leonardo's case, by the bonds of love and true friendship that joined him to his assistants, his real family.

Francesco Melzi was appointed executor of his master's will and one month after Leonardo's death he wrote to those half-brothers, his dry tone barely concealing his scorn: for them there would be only the 400 gold *scudi* deposited with the bank of Santa Maria Nuova at Florence, a sum that might have been difficult to remove without creating scandal

and objections. The rest of Leonardo's assets were left to his real family, the disciples who had followed and loved him for years. Salai inherited almost all the valuables, and he had already received and lodged safely in Milan the 1,250 gold *scudi*; in his will Leonardo now left him the house built in the vineyard given to him by Ludovico il Moro and half of the land, which Salai and his family had already benefited from for the past 20 years. The remaining half was left to Battista de Villani, another servant. To Francesco Melzi, who is referred to in the will as 'nobleman, of Milan', went 'each and all of the books' written and preserved by Leonardo, together with the drawings and the instruments used for painting. To Melzi he also left the remainder of his royal pension and all his clothes, a sign of intimacy and affection that recalls the similar gesture made by his old master Verrocchio towards his most faithful pupil, Lorenzo di Credi.

Having returned home, Leonardo retired to bed and, barely nine days later, he died after a relatively short illness. The king was not at his bedside, as he might have liked and as legend has certainly preferred to see him over the centuries, but Francesco Melzi, Battista de Villani and his serving girl Maturina were all there; the scent of roses from the garden filled the room and he could hear the gentle murmur of the little river as it flowed down to join the Loire. A sweeter death could not have been desired. His funeral was simple, with sixty torches carried by paupers from the parish and no further pomp. The tomb was in a small, light-filled collegiate church, Notre-Dame-en-Grèves, built right beside the river that circled the small island: the church would be devastated during an uprising in 1807, the tomb smashed and its contents scattered. It was Leonardo's fate not to have a homeland.

37

INHERITANCE

Giacomo Capriotti, known as Salai, was adroit at exploiting the wealth that Leonardo left him; but he did not enjoy it for as long as he might have wished, because on 19 January 1524, less than five years after the master's death, he was killed in a brawl in Milan. The inventory of his possessions shows that he inherited not only money and the vineyard from Leonardo, but also precious stones and valuable clothing. His wardrobe reveals the taste of a supremely elegant man, one who was vain and very commited to moving in socially fashionable circles whenever he had the opportunity to make a suitable display of elegance: three heavy coats made from the finest fabric, one of crimson damask, one of black arras and another of black *tabì* or tabby. Tabby was a silk fabric, similar to brocade, that took its name from the weavers' district in Baghdad where it was originally produced. It was woven to create wavy effects, like moiré taffeta, and embroidered with large embossed designs. Salai also owned three knee-length waistcoats made from the finest materials, one from damask and two in camlet – a very costly, heavy silk that was also used for elegant cloaks.

Salai lent money for usury, too, and one of his debtors was a Melzi, a relative of Francesco. He had tried to paint, but without much success because the paintings, the ones listed by the notary on behalf of his widow and of his sister, are all copies that can be traced back to

Leonardo, perhaps paintings he had left in Milan in the house where Salai's father had settled back in 1513. However, these paintings, whose value categorically rules out anything but a minimal intervention by the master, did prove to be an important conduit for the circulation of the few works that Leonardo had created. The subjects are, all, ones on which Leonardo had worked till 1513, and the paintings were subsequently completed by other artists and then purchased by collectors in Lombardy. In the list we find a *Gioconda*, with an estimated value of 80 *scudi*, a figure that would certainly have been out of reach for a painter of Salai's ability. It might have been the unfinished portrait mentioned by Agostino Vespucci in 1503, which was then elaborated by a pupil, if not by Salai himself, and then lost. This makes it even more certain that the identity of the [woman in the] portrait that Leonardo took to France was indeed that of Giuliano's mistress. The destiny of that painting has now been sealed by history. Instead of clarifying its story, every document that emerges from the archives now complicates it.

Francesco Melzi was unquestionably Leonardo's most gifted pupil and the one who loved him the most. In the letter written to Leonardo's half-brothers to announce his death, Francesco declares his affection in strong but simple language, which served to highlight their indifference still further:

> I understand that you have been informed of the death of Master Leonardo, your brother, who was like an excellent father to me. It is impossible to express the grief I feel at his death, and as long as my limbs sustain me I will feel perpetual unhappiness, which is justified by the consuming and passionate love he bore daily towards me. Everyone is grieved by the loss of such a man whose like Nature no longer has it in her power to produce.[30]

These were not mere empty words and, for as long as he lived, Francesco showed the sincerity of the love he so scornfully declared to Leonardo's brothers. Well aware of the value of the intellectual legacy layered like lava into that mountain of paper that had followed Leonardo for the past forty years, he preserved the papers jealously and tried to put them into some sort of order in order to print them and share Leonardo's gift with the entire world. He only succeeded in part, by transcribing

and ordering the *Book of Painting*; but after his death in 1570 his sons proved completely uninterested in the labours on which their father had spent his entire life, showing once again how blood relatives were in direct conflict with Leonardo's genius. His manuscripts began to be dispersed in the most banal fashion imaginable. The tutor who taught the Melzi children, Lelio Gavardo, almost certainly in agreement with Francesco's sons, stole at least 13 codices and tried in vain to sell them to the grand duke of Tuscany. An architect from the Barnabite order, Ambrogio Mazenta, endeavoured to have them returned but, when Gavardo gave them back, Francesco's sons decided to give them to him.

At that point the sculptor Pompeo Leoni grew interested in the manuscripts and managed to acquire ten of them, one of which was bought by the duke of Savoia, Vittorio Emanuele, while another was purchased by a certain Ambrogio Figino, who then passed it to Ercole Bianchi. Bianchi took it to Venice, where in 1775 it was purchased by the English consul Joseph Smith: by now the hunt for Leonardo's manuscripts and paintings was well underway throughout Europe. A third manuscript was acquired by Cardinal Federigo Borromeo, who donated it to the Biblioteca Ambrosiana in 1603. Pompeo Leoni traced other drawings and manuscripts belonging to Leonardo and took them to Spain, where he was working. After his death his sons tried to sell them to Cosimo II, grand duke of Tuscany, but to no avail: among the papers Cosimo II was offered was the cartoon that is now housed at the National Gallery, London. It was Leoni's son-in-law, Polidoro Calchi, who sold 12 manuscripts and three cartoons to Count Galeazzo Arconati, who donated them to the Biblioteca Ambrosiana, where in 1637 a further 12 manuscripts had miraculously reappeared, including the exceptionally important Codex Atlanticus and Codex Trivulziano. In 1796 the library was ransacked by Napoleon Bonaparte, assisted by French scholars who were convinced that Italian art was safe only in Paris, where even the revolutionaries had due regard for culture – while in Italy, a country that had fallen prey to barbarians, it was best to leave only sheep and musicians. At the Congress of Vienna in 1815 resolutions were passed stipulating that manuscripts and other works of art would be returned to Italy; but, once again, the erudite French representatives were reluctant to fight for the cause of enlightened culture and instead they tricked the person responsible for returning the manuscripts by

giving him forged codices. The only exception was Leonardo's Codex Atlanticus, which was brought back to the Ambrosiana, where it is still housed today. The remainder became the objects of a series of sales, acquisitions and occasional pilfering by collectors, above all English collectors, who had enough money and sufficient passion for all things Italian to stockpile the manuscripts.

After Melzi's death there was no longer any real awareness of the need to keep Leonardo's manuscript material together, since it was too fragmented to be checked with ease. There was also another codex that Leonardo had left in Milan, perhaps to his collaborator, the sculptor Cristoforo Solari, who left it to the uncle of the artist Guglielmo Della Porta, who then bequeathed it to his nephew, who preserved it jealously for the rest of his life. It was found in 1690 in a trunk that had belonged to him, and in 1713–17 it was bought by Thomas Coke, later the first earl of Leicester, in whose family library it remained until 12 December 1980 when it was purchased by the American billionaire Armand Hammer, before being acquired by Bill Gates in 1990. In the world's collective imagination, this acquisition reunited Leonardo with the most visionary of sciences, so that he came to symbolize the infinite possibilities of the intellect.

Notes

Unless otherwise stated, the English translations of quotations from Italian publications are by Lucinda Byatt.

Prologue
- Details regarding the Feast of Paradise are taken from E. Solmi, 'La festa del Paradiso di Leonardo da Vinci e Bernardo Bellincore: 13 gennaio 1490', in *Archivio Storico Lombardo*, IV Series, I, 31, 1904.
- *L'Historia di Milano volgarmente scritta dall'eccellentissimo oratore Bernardino Corio*, Stamparia di Paolo Frambotto, Padua 1646.

Notes to Part One
1. The document is in Archivio di Stato di Firenze, Notarile Antecosimiano, P38916192, f. 105v., and is published in Edoardo Villata, *Leonardo da Vinci: I documenti e le testimonianze contemporanee*, Raccolta Vinciana: Milan, 1999, p. 3.
2. The document is published in Gustavo Uzielli, *Ricerche intorno a Leonardo da Vinci*, series 1 (1st edn), Pellas: Florence, 1872: 'Ser Piero my son owes to Giovanni Parigi stationer lire 12' (p. 143). The same document is reported differently by Villata, *Leonardo da Vinci*, p. 5: 'Ser Piero my son owes to Giovanni Angelo stationer ff. 12 s.' Uzielli's book remains essential for a general overview of the historical context in which Leonardo was born and worked. Another important documentary

source is Beltrami, *Documenti e memorie riguardanti la vita e le opere di Leonardo da Vinci*, Treves: Milan, 1919.

3. G. Vasari, *Le vite de' più eccellenti pittori, scultori e architettori nelle redazioni del 1550 e 1568*, edited by R. Bettarini and P. Barocchi, 6 vols, Sansoni: Florence, 1967–1987; here vol. 4 (1976), pp. 17–18. English translations are from Giorgio Vasari, *The Lives of the Artists*, translated by Julia Conaway Bondanella and Peter Bondanella, Oxford University Press: Oxford 1991; here p. 285.

4. E. Garin, *Medioevo e Rinascimento*, Laterza: Rome/Bari, 1980, p. 92. Garin's unsurpassed work, with its exhaustive bibliography, is the ideal companion for a closer examination of Leonardo's scientific research and the artist's relations with the culture of the period.

5. Ibid., p. 301.

6. D. A. Covi, *Andrea del Verrocchio: Life and Work*, Olschki: Florence, 2005, p. 268.

7. Villata, *Leonardo da Vinci*, p. 7.

8. For commentary on this passage, see ibid., p. 8. On the drawing, see C. Pedretti and S. Taglialagamba, *Leonardo: L'arte del disegno*, Giunti: Florence, 2014, pp. 190–5, with ample bibliography.

9. Verrocchio's painting technique has been the subject of thorough diagnostic studies, which have helped to clarify the procedures used in the *bottega* thanks to tests carried out by Jill Dunkerton on a number of paintings in the National Gallery, London. See Jill Dunkerton, 'Leonardo in Verrocchio's workshop: Re-examining the technical evidence', *National Gallery Technical Bulletin*, 32 (2011): 4–31. On this subject see also Jill Dunkerton and Luke Syson, 'In search of Verrocchio the painter: The cleaning and examination of *The Virgin and Child with Two Angels*', *National Gallery Technical Bulletin*, 31 (2011): 4–41; and Luke Syson and Jill Dunkerton, 'Andrea del Verrocchio's first surviving panel painting and other early works', *Burlington Magazine*, 153 (June 2011), pp. 368–78. On the technical continuity of Leonardo's painting with that of Verrocchio's *bottega*, see Antonio Natali, 'Lo sguardo degli angeli', in A. Natali (ed.), *Verrocchio Leonardo ed il battesimo di Cristo*, Silvana Editoriale: Milan, 1998, pp. 61–94. Lastly, again for a comparison between Leonardo's techniques and those of Verrocchio, see Larry Keith, Ashok Roy, Rachel Morrison and Peter Schade, 'Leonardo da Vinci's *Virgin of the Rocks*: Treatment, technique and display', *National Gallery Technical Bulletin*, 32 (2011): 32–56. For a perceptive critical examination of Leonardo's position and role in Verrocchio's workshop, see David Allan Brown, 'Il giovane Leonardo nella

bottega del Verrocchio', in *Il bronzo e l'oro: Il David del Verrocchio restaurato* (Exhibition catalogue, Florence/Atlanta/Washington, DC, 2003–2004), edited by B. Paolozzi Strozzi and M. G. Vaccari, Giunti: Florence, 2003, p. 39. Also David Allan Brown, *Leonardo apprendista*, Giunti: Florence 2000. Two older but still very stimulating studies on the question of young Leonardo's presence in Verrocchio's workshop are Konrad Oberhuber, 'Le Problème des premières oeuvres de Verrocchio', *Revue de l'Art*, 42 (1978): 63–76 and Bernard Berenson, 'Verrocchio e Leonardo, Leonardo e Credi', *Bollettino d'Arte* (series 3), 27 (1933–4): 241–64.

10. Francesco Albertini, *Memorial of Many Statues and Paintings in the Famous City of Florence*, edited and translated by Waldemar H. de Boer and Michael W. Kwakkelstein, Centro Di: Florence, 2011, p. 101.

11. The annotation is in Codex Atlanticus. All references are to the Italian edition by Augusto Marinoni: Leonardo da Vinci, *Il Codice Atlantico della Biblioteca Ambrosiana di Milano*, critical transcription by Augusto Marinoni, Giunti: Florence, 1973–5 (12 vols, plates), 1975–80 (12 vols, text); here fol. 18v in vol. 1 (1975), p. 53. The English translations from Leonardo's notebooks are based on Edward MacCurdy, *The Notebooks of Leonardo da Vinci*, George Braziller: New York, 1955, here p. 1005.

12. Vasari, *Lives of the Artists*, p. 232 : 'Andrea Verrocchio, who was helped more by study . . . than by any natural gift, and thereby earned a place among the most prominent sculptors and understood the art perfectly, had a rather hard and crude style in his works'; see Vasari, *Le vite*, vol. 3 (1971), p. 533. Vasari's not very flattering judgement tends to undermine the value of the master in order to give greater prominence to his pupil, Leonardo.

13. Body fat was undoubtedly reassuring for people in the fifteenth century, and this explains the taste for chubby babies. This preference is borne out by evidence in *Il libro di buoni costumi di Paolo di messer Pace da Certaldo*, edited by S. Morpurgo, Le Monnier: Florence, 1921, which is also the source of the quotation here (p. xci).

14. L. Ricciardi, '*Col senno, col tesoro e colla Lancia': Riti e giochi cavallereschi nella Firenze del Magnifico Lorenzo*, Le Lettere: Florence, 1992, p. 179.

15. The letter from Piero Cennini is published in Rossella Bessi, 'Lo spettacolo e la scrittura', in *Le temps revient, 'l tempo si rinuova: Feste e spettacoli nella Firenze di Lorenzo il Magnifico*, edited by Paola Ventrone, Silvana Editoriale: Milan, 1992, pp. 103–17, at p. 105. On this subject see also P. Antonetti, *La vita quotidiana a Firenze ai tempi di Lorenzo il Magnifico*, Rizzoli: Milan 1994.

16. In Paola Ventrone (ed.), *Le temps revient, 'l tempo si rinuova: Feste e spetta-coli nella Firenze di Lorenzo il Magnifico*, Silvana Editoriale: Milan, 1992, p. 29.

17. In Villata, *Leonardo da Vinci*, p. 8. In the past this document provoked quite some embarrassment among Leonardo scholars and admirers of the artist. It was first published by N. Smiraglia, 'Nuovi documenti su Leonardo da Vinci', *Archivio Storico dell'Arte*, 2 (1896): 313–15. One of the first and most important commentaries of the document is in Gustavo Uzielli, *Ricerche intorno a Leonardo da Vinci*, series 2, Salviucci: Rome, 1884: 'An anonymous accusation is the preferred weapon of the weak and the sad, and overall the latter always outnumber the strong and the good everywhere' (p. 443). Further on, in order to dismiss the accusation, Uzielli cites Fazio degli Uberti, thus acting as the porte-parole of a society imprisoned by its own moralism, a society that, even faced with evidence of Leonardo's homosexuality, could not accept what, in its view, was a diminution of the integrity and stature of his national genius. A first disenchanted reading of the document can be found in Carlo Vecce, *Leonardo*, Salerno Editrice, Rome, 1998, pp. 55 ff.

18. The note is in Codex Atlanticus, fol. 186v, ex 66v–b, in Leonardo da Vinci, *Il Codice Atlantico*, vol. 2 (1976), p. 40. According to Vecce, *Leonardo*, p. 30, this note can be dated to around 1505. Freud's essay was published in 1919 and recently reprinted as Sigmund Freud, *Un ricordo d'infanzia di Leonardo da Vinci*, Skira: Milan, 2010.

19. The passage on the kite is taken from a book that was widely known at the time: *Fior di virtù*. This passage is printed in E. Solmi, *Le fonti dei manoscritti di Leonardo da Vinci e altri studi*, La Nuova Italia: Florence, 1976, p. 157.

20. Codex Arundel, fol. 205v, p. 106r in C. Pedretti and C. Vecce, *Il Codice Arundel 263 nella British Library*, Giunti: Florence, 1998. Further references to this codex will cite this edition.

21. Codex Atlanticus, fol. 327r, in Leonardo da Vinci, *Il Codice Atlantico*, vol. 4 (1976), p. 194.

22. Francesco Guicciardini, *Storie fiorentine dal 1378 al 1509*, Rizzoli: Milan, 1998, p. 124.

23. Ibid., p.126.

24. An extensive commentary on the iconography of this painting can be found in F. Zöllner, *Leonardo da Vinci, 1452–1519: The Complete Paintings and Drawings*, Taschen: Cologne, 2007, p. 49. For the English translation, see Jacobus de Voragine, *The Golden Legend: Readings on the*

Saints, translated by William Granger Ryan, with an introduction by Eamon Duffy, Princeton University Press: Princeton, NJ, 2012, p. 599.

25. On the portrait, see the description in Zöllner, *Complete Paintings and Drawings*, p. 37; Elizabeth Walmsley, 'Leonardo's portrait of *Ginevra de' Benci*: A reading of the X-radiographs and infrared reflectographs', in *Leonardo da Vinci's Technical Practice: Paintings, Drawings and Influence*, edited by Michel Menu, Hermann: Paris, 2014, pp. 56–71; C. Elam, 'Bernardo Bembo and Leonardo's *Ginevra de' Benci*: A further suggestion', in *Pietro Bembo e le arti*, edited by G. Beltramini, H. Burns and D. Gasparotto, Marsilio: Venice, 2013, pp. 407–20; Nicholas Penny, Review of exhibition 'Virtue and Beauty', National Gallery of Art, Washington, DC, 30 September 2001–6 January 2002, *Renaissance Studies*, 19.2 (2005): 243–9, doi: 10.1111/j.1477-4658.2005.0096c.x; F. Zöllner, 'Leonardo da Vinci's portraits: *Ginevra de' Benci, Cecilia Gallerani, La Belle Ferronière*, and *Mona Lisa*', in *Rafael i jego spadkobiercy: Portret klasyczny w sztuce nowożytnej Europy*, Wydawnictwo Uniwersytetu Mikolaja Kopernika [Scientific Publishing House of the Nicolaus Copernicus University]: Torun, 2003, pp. 157–83; D. A. Brown (ed.), *Virtue and Beauty: Leonardo's 'Ginevra de' Benci' and Renaissance Portraits of Women*. Princeton University Press: Princeton, NJ, 2001.

26. Villata, *Leonardo da Vinci*, p. 13; Pietro C. Marani, *Leonardo: Una carriera di pittore*, 24 Ore Cultura: Milan, 1999, p. 120. On the painting, which is currently undergoing restoration, see also Edoardo Villata, '*L'adorazione dei Magi* di Leonardo: Riflettografie e riflessioni', *Raccolta Vinciana*, 32 (2007): 5–42; Cecilia Frosinini, '*L'adorazione dei Magi* di Leonardo da Vinci e le prime indagini diagnostiche presso l'Opificio delle Pietre Dure, oltre il visibile', in *Leonardo da Vinci and Optics Theory and Pictorial Practice*, edited by F. Fiorani and A. Nova, Marsilio: Venice, 2013, pp. 333–51; Roberto Bellucci, 'Un nuovo avvicinamento sistematico al restauro dell'*Adorazione dei Magi* di Leonardo da Vinci', *OPD Restauro*, 24 (2012): 45–56. The argument put forward by Bellucci, who is currently working on the restoration of the *Adoration*, is the clearest and most compelling one on Leonardo's pictorial techniques with regard to his easel paintings.

27. Villata, *Leonardo da Vinci*, p. 14.

28. In Ricciardi, *Col senno, col tesoro e colla lancia*, p. 167.

Notes to Part Two

1. In Ricciardi, *Col senno, col tesoro e colla lancia*, p. 144.

2. Guicciardini, *Storie fiorentine*, p. 114.

3. Francesco Guicciardini, *Storia d'Italia*, 3 vols, Einaudi: Turin, 1971, vol. 1, p. 7. The English translation is a corrected version of the passage from Francesco Guicciardini, *The History of Italy*, translated by Austin Parke Goddard, 2 vols, London, 1763, vol. 1, pp. 5–6.

4. Roberto Bellosta, 'La vita economica a Milano e in Lombardia nei secoli XI–XV', in *Milano capitale: Volume celebrativo dell'80° anniversario del Rotary Club di Milano*, edited by G. Rumi, G. Sena Chiesa, G. Soldi Rondinini and L. Antonielli, Editrice Abitare Segesta: Milan, 2003, pp. 109–30; quotation here from p. 25 of the online version (downloadable from www.academia.edu).

5. Leonardo da Vinci, *Il Codice Atlantico*, vol. 12 (1980), pp. 182–4. In Villata, *Leonardo da Vinci*, p.16. This English translation is taken from Martin Kemp, *Leonardo on Painting: An Anthology of Writings by Leonardo da Vinci with a Selection of Documents Relating to His Career as an Artist*, selected and translated by Martin Kemp and Margaret Walker, Yale University Press: New Haven, CT, 2001, p. 251. The document is truly surprising and was extensively commented on by Jean Paul Richter in *The Literary Works of Leonardo da Vinci*, vol. 1: Compiled and edited from original manuscripts by Jean Paul Richter (3rd edn), Phaidon: London, 1970, pp. 325 ff. As Richter notes in footnote 1340, 'it is one of the very few MSS which are written from left to right . . . It is noteworthy too that here the orthography and abbreviations are also exceptional.' This passage has been more recently examined by Carlo Pedretti in *The Literary Works of Leonardo da Vinci*, vol. 2: Commentary by Carlo Pedretti, Phaidon/University of California Press: Oxford/Berkeley, CA, 1977, p. 279. Vecce, *Leonardo* has recently commented on the document too (pp. 77–9).

6. Villata, *Leonardo da Vinci*, p. 17. Kemp, *Leonardo on Painting*, pp. 252–3.

7. Ibid., p. 44.

8. *The Literary Works of Leonardo da Vinci*, vol. 1, p. 65, note 30; quoted with ample bibliography in Alessandro Ballarin, *Leonardo a Milano: Problemi di leonardismo milanese tra quattrocento e cinquecento: Giovanni A. Boltraffio prima della pala Casio*, 4 vols, Edizioni dell'Aurora: Verona, 2010, vol. 1: *Le due versioni della Vergine delle rocce*, p. 196. For a semantic reading of the painting, see Zöllner, *Complete Paintings and Drawings*, pp. 64 ff. The suspicion that the first version of *The Virgin of the Rocks* was purchased by Ludovico Sforza and given to Emperor Maximilian of Austria at Innsbruck in 1493, on the occasion of his wedding to Ludovico's niece, Bianca Maria Sforza, is fuelled by a passage in the Anonimo Fiorentino, who writes in the additions to the Codice Magliabecchiano: 'He painted

an altar panel for Lord Lodovico of Milan . . . which the said lord sent to Germany to the Emperor' (K. Frey, *Il Codice magliabechiano, cl. XVII. 17. contenente notizie sopra l'arte degli antichi e quella de' fiorentini da Cimabue a Michelangelo Buonarroti, scritte da Anonimo Fiorentino*, Grote: Berlin, 1892, p. 112). From Innsbruck, the painting went to France to another marriage, this time between Maximilian's niece, Eleonora, and Francis I. These suggestions are set out in Zöllner, *Complete Paintings and Drawings*, pp. 223–4.

9. In Fritjof Capra, *L'anima di Leonardo*, Rizzoli: Milan, 2012, p. 102.

10. Codex Urbinas Latinus, 1270, fol. 67v. The English translation is taken from Martin Kemp, *Leonardo da Vinci: The Marvellous Works of Nature and Man*, Oxford University Press: Oxford, 2007, p. 76.

11. All the technical and diagnostic information on *The Virgin of the Rocks* refers to the tests carried out on the London version, which are reported in Keith et al., 'Leonardo da Vinci's *Virgin of the Rocks*'. In this valuable report of the diagnostics performed on the painting at the National Gallery, the authors put forward the hypothesis that the second, more yellow priming [*imprimatura*] was given in order to hide the first underdrawing, which showed the Virgin in a pose of adoration; then, once this composition had been abandoned, in order to return to the first version, Leonardo applied the second priming to make the first underdrawing less visible. The sequence is also credible for the other paintings of Leonardo that followed a technique commonly used in Florence, namely underdrawing applied directly onto the gesso and glue ground, then priming, and then a second layer of underdrawing.

12. On the portrait, see Pietro C. Marani, 'La Dama con l'ermellino e il ritratto milanese tra quattro e Cinquecento', in B. Fabjan and P. C. Marani (eds), *La Dama con l'ermellino*, Silvana Editoriale: Milan, 1998, pp. 31–49, here p. 37. See also two other important contributions in the same volume: J. Shell, 'Cecilia Gallerani, una biografia', pp. 51–65 and G. Butazzi, 'Nota per un ritratto, vesti e acconciatura della Dama con l'ermellino', pp. 67–71. On the Renaissance portrait in general, see J. Pope Hennessy, *The Portrait in the Renaissance*, Bollingen Foundation: New York, 1966. A comprehensive description of the portrait is also contained in Zöllner, *Complete Paintings and Drawings*, p. 226. Lastly, for a general interpretation of the painting against the background of Leonardo's work, see Kemp, *Marvellous Works of Nature and Man*; and compare D. A. Brown, 'Leonardo and the idealized portrait in Milan', *Arte Lombarda*, 67 (1983): 102–16.

13. The sonnet is published in B. Fabjan and P. C. Marani (eds), *La Dama con l'ermellino*, Silvana Editoriale: Milan, 1998, p. 37.

14. In Beltrami, *Documenti e memorie*, p. 51, doc. 89. On the letter and the idealizing value of Cecilia's portrait, see Antonio Forcellino, *Gli ultimi giorni di Leonardo: L'invenzione della Gioconda*, Rizzoli: Milan, 2014.

15. *L'Historia di Milano volgarmente scritta dall'eccellentissimo oratore Bernardino Corio*, Stamparia di Paolo Frambotto: Padua, 1646, pp. 882–3. Bernardino's chronicle is very truthful and describes the period of maximum splendour at the Milanese court.

16. P. Morigia, *Historia dell'antichità di Milano*, Forni: Bologna, 1967 [1592], book I, ch. 27, p. 165 (anastatic reproduction). For the plague of 1485 and its influence on *The Virgin of the Rocks*, see also Ballarin, *Leonardo a Milano*, vol. 1, p. 196.

17. The account of the festivity on 13 January 1490 was written by the Este ambassador, Jacopo Trotto, and is printed in Villata, *Leonardo da Vinci*, p. 54. On the *apparati* for festivities and theatrical performances, see Carlo Pedretti, 'La macchina teatrale per l'*Orfeo* di Poliziano', in *Studi Vinciani, documenti, analisi e inediti leonardeschi*, Droz: Geneva, 1957, pp. 90–8, and Katw T. Steinitz, 'A reconstruction of Leonardo da Vinci's revolving stage', *Art Quarterly*, 12 (1949): 325–38.

18. Garin, *Medioevo e Rinascimento*, pp. 289 ff. On Leonardo's relations with academic culture and the perception of his failings due to his self-taught status, see Giuseppina Fumagalli, 'Leonardo "Omo sanza lettere"', *Raccolta Vinciana*, 17 (1954): 39–62. Throughout his life, Leonardo felt that he was looked at askance by the university professors who officially represented knowledge. He fought against this judgement, which may have been imaginary, or perhaps was openly expressed. Whether this discrimination against a man whose activities took place completely outside academic institutions was real or imagined, the perception of an intellectual discrimination embittered his life and forced him to make constant justifications and to affirm his legitimacy; it was only his great success as an artist that helped to curtail the doubts that had grown around his studies and his research.

19. Villata, *Leonardo da Vinci*, p. 72. The letter written by Leonardo and Ambrogio de Predis to Ludovico il Moro is undated, but it is thought to have been sent between 1491 and 1493.

20. Ibid., p. 85. The account given by Marin Sanudo is printed in *La Spedizione di Carlo VIII*, edited by R. Fulin, Visentini: Venice, 1873, pp. 118–19.

21. The passage from Codex Atlanticus, fol. 914a can be dated to around 1496–7 and documents Leonardo's state of mind after the failure of his

project for the equestrian monument, when he seems to have dedicated himself to *The Last Supper* simply as an expedient motivated almost solely by the need to earn a living. The note is important also from another point of view, because it reveals Leonardo's sudden shyness when he had to turn to his protectors. The start of the letter, on fol. 867r, changes at least four times, as Leonardo could not find the right words with which to address Ludovico. The same happens again many pages later, on fol. 867v, when he resumes his complaints. We will find this same shyness twenty years later, when Leonardo wrote a letter of complaint to Giuliano de' Medici, who housed and protected him during his stay in Rome (1513–16). Here too, uncertainty, shyness and overbearing respect made him change the incipit of the letter several times, so much so that it is plausible to suggest that the artist's awe for his patrons was directly proportional to his need for their goodwill. Another explanation for the problems Leonardo experienced in communicating with others is that general sense of inadequacy that he felt, an inadequacy that could go some way to explain his constant dialogue with himself throughout numerous diaries and notebooks, almost as if he preferred to be in dialogue with his alter ego rather than with the outside world. With regard to Leonardo's tortuous literary forms, it is worth recalling the words written by Giuseppe De Robertis in 'La difficile arte di Leonardo', *Studi*, Le Monnier: Florence, 1944, p. 79: 'Even verbal matter is generated in Leonardo after a long effort – always in an attempt to achieve the maximum traction with maximum brevity, and to stimulate inventiveness. Entire pages are filled with streams of words, interminable lists that in his mind must have been many living cells out of which he expected his metaphorical language to spring.'

22. This letter from Ludovico il Moro to his administrator Marchesino Stanga urged Leonardo to complete *The Last Supper*, and we learn that in June 1497 Leonardo was working on the fresco but the work was far from finished. See Villata, *Leonardo da Vinci*, p. 102.

23. Giovambattista Giraldi (1554), in Giuseppe Bossi, *Del cenacolo di Leonardo da Vinci: Libri quattro di Giusepppe Bossi pittore*, Skira: Milan, 2009, pp. 28–9 (anastatic reproduction). On Leonardo's attention to and accurate study of facial expressions in *The Last Supper*, and on his work in general, see the fundamental work by M. Kwakkelstein, *Leonardo da Vinci as a Physiognomist: Theory and Drawing Practice*, Primavera Press: Leiden, 1994.

24. The passage from Bandello is printed in Bossi, *Del cenacolo*, p. 22. It

is also extensively commented upon by Forcellino, *Gli ultimi giorni di Leonardo*, p. 48.

25. Guicciardini, *Storia d'Italia*, vol. 1, pp. 339–40 = Guicciardini, *History of Italy*, vol. 2, pp. 330–1.

26. Codex Atlanticus, fol. 638d–v. The English translation is taken from Pietro C. Marani, 'Leonardo in Venice', in *Leonardo's Projects, c. 1500–19*, edited with introductions by Claire Farago, Garland Publishing: New York, 1999, pp. 1–14, here p. 6.

27. The passage is in Frey, *Il Codice magliabechiano*, p. 115.

28. *Antiquarie prospettiche romane composte per Prospectivo Melanese depictore*, edited by Giovanni Agosti and Dante Isella, Guanda: Parma, 2005. Printed around 1500, the codex is important for many reasons. It celebrates Leonardo as an internationally renowned artist and at the same time appears to allude to the fact that he had never visited Rome or shown any particular interest in classical antiquity, and the anonymous Prospettivo Milanese now invites him to do so.

29. Frey, *Il Codice magliabechiano*, p. 115.

30. Leonardo da Vinci, *Libro di pittura: Codice urbinate lat. 1270 nella Biblioteca Apostolica Vaticana*, edited by Carlo Pedretti, critical transcription by Carlo Vecce, 2 vols, Giunti: Florence, 1995, vol. 1, p. 158. The English translation is taken from Martin Kemp (ed.), *Leonardo da Vinci on Painting: An Anthology of Writings by Leonardo da Vinci*, selected and translated by Martin Kemp and Margaret Walker, Yale University Press: New Haven, CT, 1989, pp. 38–9.

Notes to Part Three

1. Vasari, *Lives of the Artists*, p. 293 = *Le vite*, vol. 4 (1976), pp. 29–30.

2. Letter from Pietro da Novellara dated 3 April 1501, in Villata, *Leonardo da Vinci*, p. 134. For a fuller understanding of the context in which this letter is written, see V. Delieuvin, *La Sainte Anne, l'ultime chef-d'oeuvre de Léonard de Vinci*, Louvre Éditions: Paris, 2012, p. 77.

3. It is important to underline that Leonardo's stylistic change dates back to this moment and to his Florentine sojourn. Setting aside the imitation of nature still present in *The Last Supper*, which was completed just before 1500, the works that he started in the new century, just a few years later, already reveal, quite clearly, that abstract physiognomy, almost a canon of female beauty that would never leave the artist again. Beginning with the Burlington House cartoon, and then in the *Madonnas of the Yarnwinder*, *St Anne*, *St John with the Bowl*, and *St*

John the Baptist of the Louvre and *La Gioconda*, we always find the same person in Leonardo's paintings, or more correctly we find an identical physical type that interprets the various roles without any concern for resembling a particular figure, but preoccupied instead to represent in the best possible way an ideal beauty that should be at the same time an expression of ideal sentiments, contained within the limits of an appropriate pose. All this had been present in Michelangelo right from his earliest works, and at this date (the early sixteenth century) he was already fully focused on his research.

4. The letter from Pietro da Novellara dated 14 April 1501 is in Villata, *Leonardo da Vinci*, p. 136. For commentary and contextualization, see Delieuvin, *La Sainte Anne*, pp. 23–7.

5. Guicciardini, *Storie fiorentine*, p. 393.

6. In Villata, *Leonardo da Vinci*, p. 144.

7. The note appears in Codex Arundel, fol. 202v (p. 45 in Pedretti and Vecce's edition); it is published in Villata, *Leonardo da Vinci*, p. 148. This note raises the same problems as many of Leonardo's comments, because the question seems to be addressed almost absent-mindedly to himself, as a marginal comment in a note that mentions domestic issues, boots, the cape, and so on. Leonardo seems completely overwhelmed by the major events of history; he has been, or still is, deceptively seeing himself as a key pawn for Borgia, but discovers that he has simply been discarded with no explanation. But in this case the events leading to Valentino's fall from power are extraordinary: over a few months, after his father's death, the duke loses political support and old enemies gain the upper hand without even a hint of a real conflict.

8. Codex Arundel, fol. 229v (p. 62r in Pedretti and Vecce's edition). The English translation is taken from MacCurdy, *Notebooks*, pp. 1158–9.

9. The note is reported and amply commented upon by Delieuvin, *La Sainte Anne*, p. 126. Vespucci knew Leonardo very well and held him in high esteem as a painter, but perhaps even more as a mathematician, because in those years he offered him a valuable book of geometry, as is recorded in a note in Codex Arundel, fol. 132v: 'Il Vespucci wishes to give me a book of geometry' (MacCurdy, *Notebooks*, p. 1172).

10. The letter to the sultan is in Villata, *Leonardo da Vinci*, p. 158. The English translation is from *The Literary Works of Leonardo da Vinci*, vol. 2, p. 213.

11. Villata, *Leonardo da Vinci*, p. 164. The English translation is taken from John T. Paoletti, 'Report of the Committee to Advise on the Placement

of the *David*', in *Michelangelo's David: Florentine History and Civic Identity*, Cambridge University Press: Cambridge, 2015, pp. 313–22, here p. 321.

12. In Guicciardini, *Storie fiorentine*, p. 424.

13. Note of expenses on 28 February 1504, in Villata, *Leonardo da Vinci*, p. 165.

14. Codex Madrid II, fol. 112r, in Villata, *Leonardo da Vinci*, p. 176. The English translation is from *The Literary Works of Leonardo da Vinci*, vol. 2, p. 371. The sequence described by Leonardo is theatrical, dramatic, and shows a certain literary awareness, but completely lucidity is required to resolve mathematical problems and most of the solutions found in the middle of the night prove fallacious in the light of day. This was certainly the case on this occasion. The solution to the problem of squaring the circle, a theoretical challenge postulated but until then never resolved, would still occupy mathematicians for centuries, until finally, in the nineteenth century, an authoritative expert would declare the problem insoluble.

15. Expenditure note of 31 December 1504 in Villata, *Leonardo da Vinci*, p. 176. On the question of Michelangelo's cartoon, see Antonio Forcellino, *Michelangelo: A Tormented Life*, translated by Allan Cameron, Polity: Cambridge 2009, pp. 73–5.

16. In Beltrami, *Documenti e memorie*, p. 94, doc. 152.

17. Expenditure note of 28 February 1505, in Villata, *Leonardo da Vinci*, p. 179.

18. Expenditure note of 30 April 1505, in Villata, *Leonardo da Vinci*, p. 184. This is one of the most important expenditure notes for pinning down the chronology and material procedures of the *Battle of Anghiari*. Payments are recorded for all those who prepared the wall to receive the painting – the labourers who applied the plaster and then the special primer [*mestica*] studied by Leonardo so as to make the surface impermeable. Then there are the expenses for the pigments to be ground, and even for the jars for mixing them.

19. The story of the short-lived success that quickly turned into a cause for shame in the whole city on account of the villainy of the soldiers appears in Guicciardini, *Storie fiorentine*, pp. 419–24.

20. Letter of 18 August 1506 from Marshal Amboise to Pier Soderini, in Villata, *Leonardo da Vinci*, p. 200.

21. Letter from Pier Soderini to the Florentine ambassador in Milan, in Villata, *Leonardo da Vinci*, p. 203.

22. Ibid., p. 207.

23. The timings of *The Virgin of the Rocks* and the various hypotheses regarding the two existing versions are summarized by Ballarin, *Leonardo a Milano*. See also Vecce, *Leonardo*, pp. 80–3 and 285–7.

24. The draft of the letter, filled with scorn for the brothers, is contained in Codex Atlanticus, fol. 571r–v, formerly 214v–a, and is commented upon in Vecce, *Leonardo*, p. 271. Leonardo imagines himself speaking to the brothers and accuses them of hating him more than they hated his uncle, because they did not allow the latter to enjoy his own properties during his lifetime, while with Leonardo they are not even willing to wait for his death before appropriating what is his. The animosity that emerges from these lines confirms the pain that Leonardo felt as a result of his blood relatives' appalling behaviour.

25. The letter is in Codex Atlanticus, fols 872v (ex 317r–b) and 1037v (ex 372v–a), and is published in Vecce, *Leonardo*, p. 283. In confirmation of what was said earlier about Leonardo's difficulties when it came to turn to his protectors, the linearity of this letter, which is ironic and full of affection for the young pupil he has recently met, shows that it was only when Leonardo felt pressurized that he became shy and found it hard to express himself.

26. Paola Salvi, 'Leonardo da Vinci e la scienza anatomica del pittore', in *Il tempio dell'anima: L'anatomia di Leonardo da Vinci fra Mondino e Berengario*, edited by Carlo Pedretti, Cartei & Becagli Editori: Florence, 2005, pp. 13–28, here p. 19.

27. Ibid., p. 15, n.1. For the classification of the anatomy drawings in the Windsor Collection, see Kenneth Clark and Carlo Pedretti, *The Drawings of Leonardo da Vinci in the Collection of Her Majesty the Queen at Windsor Castle*, Phaidon: London, 1968–9.

28. Carlo Pedretti, 'Fogli di anatomia a Windsor', in *L'anatomia di Leonardo da Vinci fra Mondino e Berengario*, edited by Carlo Pedretti, Cartei & Becagli Editori: Florence, 2005, p. 14.

29. Ibid., p. 22.

30. Ibid., p. 23.

31. Paola Salvi, 'Leonardo e la scienza anatomica', p. xxii.

32. Ibid., p. xxxi.

33. There are two beautiful studies by Leonardo for the left hand of this invention and in both the hand is presented in a more advanced phase than the version that would appear in the painting in the Borghese Gallery, with the ring finger and little finger bent. The first drawing is at Milan, in the Biblioteca Ambrosiana, Codex Atlanticus, fol. 146r–b

(ex 395b–r), the second is at Venice, in the Gallerie dell'Accademia, inv. 138. There is also a drawing attributed with no documentary evidence to Baccio Bandinelli, whereabouts unknown, which shows the entire figure of the angel down to the waist, but in this version the fingers are folded, as in Leonardo's studies and as they are in the painting in the Borghese Gallery. A reconstruction of the history of this composition, which has not yet attracted sufficient reflection, can be attempted as follows. In around 1503–7 Leonardo was studying a three-quarter figure for an *Angel of the Annunciation* or a *Young Saint John*, using Salai as the model. During the intermediate phase, the fingers of the left hand stretch straight out and the right hand points up to the heavens. It is at this stage that a pupil copies the drawing and makes a caricature of Salai. Subsequently Leonardo continues to work on the studies, folding the fingers of the left hand and lowering the right arm in order to make it hold the bowl. This stage is documented by the painting of *Young Saint John* in the Borghese Gallery. During the third and last phase, probably during his Roman sojourn, Leonardo again altered the right arm, bringing it across the chest with the index finger pointing upwards, as it is in the painting of *Saint John*, now in the Louvre.

34. In Vecce, *Leonardo*, p. 294; on the other obscene sonnet by Guidotto Prestinari, who years earlier had alluded to Leonardo's homosexual habits, see again Vecce, *Leonardo*, p. 131 and Uzielli, who provided a very tortuous commentary in a second, much enlarged edition of his original *Ricerche*: Gustavo Uzielli, *Ricerche intorno a Leonardo da Vinci*, series 1 (2nd edn), vol. 1, Loescher: Turin 1896, pp. 519–36.

35. Codex E, fol. 1r, in Beltrami, *Documenti e memorie*, p. 137, doc. 217: 'I left Milan for Rome on 24 of September 1513 with Giovanfrancesco de Melzi, Salai, Lorenzo and il Fanfoja.' Also in Villata, *Leonardo da Vinci*, p. 244.

Notes to Part Four

1. On Leo X's strategies to rebuild Rome during the years when Leonardo was present, see Manfredo Tafuri, 'Roma instaurata: Strategie urbane e politche pontificie nella Roma del Primo Cinquecento', in *Raffaello architetto*, edited by C. L. Frommel, S. Ray and M. Tafuri, Electa: Milan, 1984, pp. 59–106, with extensive bibliography. A more detailed study of the works that were underway during Leonardo's Roman period is Forcellino, *Gli ultimi giorni di Leonardo*; see also Pietro C. Marani in P. C. Marani and P. Ragionieri (eds), *Leonardo e Michelangelo: Capolavori*

della grafica e studi romani, Musei Capitolini, Edizioni Silvana: Rome, 2011, pp. 54–65.

2. M. Sanuto, *I Diarii* (MCCCXCVI–MDXXXIII), Forni: Bologna, 1969–70, vol. 20, col. 110. The same volume contains the dispatches describing the triumphal entrance of Giuliano 'il Magnifico' and his wife Filiberta di Savoia to Rome on their return from Turin, where their marriage had taken place (April 1515): '[Giuliano] The Magnificent entered yesterday, on Holy Saturday, with his wife; he was greatly honoured, but no cardinals went to meet him . . . – only – with Santa Maria in Portico, who is [Cardinal] Bibbiena, Medici and Cybo, his first cousins, went to Ostia to visit him and there was a handsome spectacle to see 1,000 horses enter. He stayed the night in Casa Orsini at Monte Giordano, then went along to the pope's palace and in the evening returned to the house. With him there were well-dressed women in gold cloth and silk, cushions, hangings, tapestries for the family, long coats [*saioni*], breeches and all the galanteries of this world' (pp. 101 and 103).

3. The document is already known to Leonardo scholars, and a recent and accurate commentary appeared in Domenico Laurenza, *Leonardo nella Roma di Leone X* (XLIII Lettura Vinciana), Giunti Editore: Florence/Milan, 2004, p. 41.

4. *Antiquarie prospettiche romane*, p. 3.

5. For the febrile activity of Raphael in Rome during this period, see C. L. Frommel, S. Ray and M. Tafuri (eds), *Raffaello architetto*, Electa: Milan, 1984 and Antonio Forcellino, *Raphael: A Passionate Life*, translated by Lucinda Byatt, Polity: Cambridge, 2012; also Konrad Oberhuber, *Raffaello: L'opera pittorica*, Electa: Milan, 1999. For the documents concerning Raphael's activity, see John Shearman, *Raphael in Early Modern Sources*, 2 vols, Yale University Press: New Haven, CT, 2003. On Michelangelo, see Forcellino, *Michelangelo*; F. Zöllner, *Michelangelo: L'opera completa*, Taschen: Cologne 2008; Cristina Acidini Luchinat, *Michelangelo scultore*, 24 Ore Cultura: Milan, 2010 and Cristina Acidini Luchinat, *Michelangelo pittore*, 24 Ore Cultura: Milan, 2011.

6. On the persons whom Leonardo frequented in Rome, see Laurenza, *Leonardo nella Roma di Leone X*, and C. L. Frommel, 'Leonardo fratello della Confraternità della Pietà dei Fiorentini a Roma', in *Raccolta Vinciana*, 20 (1964): 369–73.

7. Paolo Giovio, 'Leonardi Vincii Vita', in *Paolo Giovio: Scritti d'arte: Lessico ed ecfrasi*, edited by S. Maffei, Scuola Normale Superiore di Pisa: Pisa, 1999, pp. 234–9, here p. 235. The English translation is from *The*

Literary Works of Leonardo da Vinci, vol. 1, p. 3. On the relations between Giovio and Vasari, see Barbara Agosti, *Paolo Giovio: Uno storico lombardo nella cultura artistica del Cinquecento*, Olschki: Florence, 2008 and Vecce, *Leonardo.*

8. In Laurenza, *Leonardo nella Roma di Leone X*, p. 44. The English translation is taken from *The Literary Works of Leonardo da Vinci*, vol. 2, p. 336. The letter is also commented on by C. Pedretti in the same volume, pp. 303 ff. On this topic, see also Vecce, *Leonardo*, p. 323: 'despite his defects Master Giorgio was a skilled glassworker and mirror maker . . . Leonardo had used him because he was working on the design of a large parabolic mirror similar to the principle of Newton's telescope.'

9. In Laurenza, *Leonardo nella Roma di Leone X*, p. 13, n. 39. With a skill that still astounds us today, thanks to the acuteness of observations he could make in the absence of any optical instruments such as a microscope, Leonardo had identified so precisely the relationship between mother and foetus that he had reached the conclusion that the latter could not exist independently of the mother: 'At this point the heart does not beat nor does the child breathe . . . and the same spirit governs both these bodies, and their wishes, fears and pains are shared, for this creature as for all other animate creatures. And this gives rise to the fact that the thing the mother desires is often found sculpted on her child's limbs, which the mother holds to herself at the time of her desire, and a sudden fear will kill both mother and child. Therefore I conclude that a single spirit governs the bodies and the two bodies are nourished as one.' Ibid., n. 36.

10. Vasari, *Le vite*, vol. 4 (1976), p. 19: 'And his imaginings were so many that, philosophizing on natural things, he tried to understand the property of plants by continuing to observe the movement of the heavens, the path of the moon, and the courses of the sun. By doing so he conceived in his mind of a concept so heretical that it did not conform to any religion, as it gave greater esteem perhaps to being a philosopher than to being a Christian.' This passage was deleted from the second, 1568 edition of the *Lives* (see *Lives of the Artists*, p. 559, note). Together with other 'amendments' made by Vasari to his account of Michelangelo's tomb of Julius II (see Forcellino, *Michelangelo*), this deletion is one of the most important acts of censorship made by Vasari to bring his work into line with the new, post-conciliar climate, which had considerably restricted the intellectual freedom of the Italians, thereby completely changing the cultural mores of the country. For different reasons, the

two greatest Italian artists, Michelangelo Buonarroti and Leonardo
da Vinci, represented two intellectual models that were regarded as
subversive by the Catholic Counter-Reformation and post-Tridentine
theology: Leonardo because, owing to his scientific curiosity, he had
constantly broken the barriers to intellectual speculation imposed by the
theologians of the Counter-Reformation; Michelangelo because, in the
last part of his life, he had grown close to a group of reformers who tried
to negotiate with Lutheran theology and within the space of a few years
were declared heretics and persecuted by the Catholic church. Sadly,
though, in that reformed climate Michelangelo had conceived one of his
most important monuments: the tomb of Julius II in the church of San
Pietro in Vincoli, where the two statues of *Active Life* and *Contemplative
Life*, allegories of Charity and Faith standing on either side of Moses,
evoked the idea of salvation 'by faith alone'. It was Vasari who saw to
it that the monument was safe from theological criticism; and, since
the marble could not be altered, he changed his description by making
a mirror appear in the hands of *Active Life* instead of the lamp (or vase
of oil) that Michelangelo had carved, and thus showing the allegory of
Charity in a less risky theological light. Above all, in the second edition
of his *Lives*, Vasari undertook to build a rigid hierarchy of artistic talent
that entirely benefited Tuscany and the Medici duchy, and also to chan-
nel individual artistic personalities onto ground where there was less
possibility of conflict with the new Counter-Reformation theology. The
censure of his anatomical studies certainly saddened Leonardo, who
devoted more energy to them than to all his other activities, including
painting, but the issues at stake were too important to be taken lightly
by the pope: in December 1513 Leo X promulgated the bull *Apostolici
Regiminis*, which condemned as *detestabile set abominabiles haereticos et
infedele* those philosophers who argued in favour of the mortality of
the soul; among other things, the bull also reaffirmed that the soul
did not derive from matter but was divinely ordained and infused into
the body. It was hardly surprising, therefore, that the criticisms made
against Leonardo by his disloyal collaborators were taken extremely
seriously by Leo X and by those in charge of the Roman hospitals where
he carried out his dissections. On these points, the exposition made by
Laurenza, *Leonardo nella Roma di Leone X* is very clear (pp. 14 ff.).
11. Shearmann, *Raphael in Early Modern Sources*, p. 186.
12. Vasari, *Lives of the Artists*, pp. 296–7 = *Le vite*, vol. 4 (1976), p. 35.
Vasari's account, as usual, is a softened fable that is spread over the

events and conceals the extremely harsh reality of those months. The reality emerges without pretence from the letters exchanged between Michelangelo, Sebastiano del Piombo and other major players – poisonous letters that ooze rivalry and highlight the merciless struggle to obtain the most important art commissions that would enable them to leave their mark on Rome, a city that was rising up from its golden ashes. Leonardo's studies on varnishes are also mentioned by the Anonimo Gaddiano: 'In the Great Council Hall in Florence he started to paint the cartoon of the battle of the Florentines when they routed Niccolò Piccinino, captain of Duke Filippo of Milan, at Anghiari. He started to work on it in that place, as can be seen today, and with varnish' (Frey, *Il Codice magliabecchiano*, p. 112). Indeed, in Rome Leonardo continued to focus on his scientific studies and, in addition to anatomical research that was dangerously close to theology, he devoted his time to studying geometry, working in the Belvedere, as is recorded in a note made in Codex Atlanticus: '*De ludo geometrico*, finished on 7 July at the 23rd hour, in the study provided for me by the Magnifico, 1514' (fol. 244v, ex 90v–a). The treatise, which was once again abstract and speculative in nature, set out to demonstrate the possibility of transforming a curved surface into a rectilinear one, and vice versa.

13. On the laborious progress of the *Libro della pittura*, see Leonardo da Vinci, *Libro di pittura*.

14. The passage in Codex Arundel, fol. 1r (p. 115r in Pedretti and Vecce's edition), is accurately commented on by Vecce, *Leonardo*, who underlines the cultural preparation of Leonardo's guest, who was in turn a great intellectual and patron (p. 115). At this time Baccio Martelli offered lodgings also to the sculptor Giovan Francesco Rustici, who had been commissioned to cast the statues of the Baptistery door facing the presbytery.

15. Antonio de Beatis, *Itinerario di Monsignor Reverendissimo et Illustrissimo il cardinal de Aragona mio Signore, incominciato da la città di Ferrara nel anno del Salvatore MDXVII del mese di maggio et descritto per me Donno Antonio De Beatis clerico Melfictano con ogni possibile diligentia et fede*, Ms. X.F. 28, fol. 77, Biblioteca Nazionale Vittorio Emanuele III, Naples. The passage was made known to Leonardo scholars only with the publication of Luigi Volpicella, 'Il viaggio del cardinale d'Aragona', *Archivio storico per le provincie napoletane*, 1 (1876): 106–17. Before this finding, it was widely acknowledged that the *Saint Anne* in the Louvre was the work of pupils, a hypothesis supported by Vasari, who only mentioned a cartoon

and not a painting of the subject. As in many other instances, the errors or ambiguities of Vasari influenced for centuries the understanding of works of art that now seem the quintessence of an artist's work.

16. On the painting, see the description by Zöllner, *Complete Paintings and Drawings*, p. 248; Forcellino, *Gli ultimi giorni di Leonardo*; and Antonio Forcellino, 'Leonardo a Roma', in *Raccolta Vinciana*, 36 (2015): 133–61. On the sensual character of the painting, see Carlo Pedretti, *Leonardo*, Capitol: Bologna, 1979: 'The ascetic, emaciated prophet of the evangelical tradition was transformed into an hermaphrodite satyr' (p. 46); Kemp, *Marvellous Works of Nature and Man*, p. 341: 'At worst it has been characterized as the effusion of an aging homosexual, perhaps in one sense it is but if this is all it is, it would have no more value than an obscene graffito.' See Pietro C. Marani, 'The Hammer Lecture, 1994: Tivoli, Hadrian and Antinous: New Evidence of Leonardo's Relation to the Antique', in *Achademia Leonardi Vinci*, 8 (1995): 207–25. On the dating, see Edoardo Villata, 'Il San Giovanni Battista di Leonardo, un'ipotesi per la cronologia e la committenza', *Raccolta Vinciana*, 27 (1997), pp. 187–236, here p. 187; and Edoardo Villata, 'Ancora sul San Giovanni Battista di Leonardo', *Raccolta Vinciana*, 28 (1999), pp. 123–58, here p. 123. Villata suggests a dating early in the century – a hypothesis with which Delieuvin, *La Sainte Anne*, disagrees (pp. 246 ff.). On the influences of the painting, see Pietro C. Marani, 'Il San Giovanni di Leonardo: Qualche nuova ipotesi sulle manipolazioni antiche la sua genesi e la sua fortuna', in *Leonardo a Milano*, edited by V. Merlini, Skira: Geneva/Milan, 2009, pp. 45–59.

17. Leonardo da Vinci, *Libro di pittura*, vol. 1, ch. 25, p. 149. The English translation is taken from Leonardo da Vinci, *On Painting: A Lost Book (Libro A)*, reassembled by Carlo Pedretti, University of California Press: Berkeley, 1964, p. 113.

18. Letter of Sebastiano del Piombo to Michelangelo, 2 July 1518, in Shearmann, *Raphael in Early Modern Sources*, p. 325. On the competition between Raphael and Michelangelo during the time Leonardo was in Rome, see Antonio Forcellino, 'Sebastiano del Piombo entre Miguel Angel y Rafael, tra Michelangelo e Raffaello', in *Maestros en la sombra*, Fundación Amigos Museo del Prado: Madrid, 2013, pp. 61–92 and Rona Goffen, *Renaissance Rivals: Michelangelo, Leonard, Raphael, Titian*, Yale University Press: New Haven, CT, 2002.

19. For a complete analysis of the painting and its critical fortune, I refer to the work of Delieuvin, *La Sainte Anne*, with up-to-date bibliography.

20. A complete and annotated census of the copies and variants of *Saint Anne* is in Delieuvin, *La Sainte Anne*.

21. Vasari, *The Lives of the Artists*, p. 294 = *Le vite*, vol. 4 (1976), pp. 30–3. The essential bibliography on the painting is Giovanni Poggi (ed.), *Leonardo da Vinci: La vita di Giorgio Vasari nuovamente commentata*, Pampaloni: Florence, 1919; Carlo Pedretti, *Studi Vinciani*, Droz: Geneva, 1957; Roy McMullen, *Mona Lisa: The Picture and the Myth*, Macmillan: London, 1976; David A. Brown and Konrad Oberhuber, 'Monna Vanna and Fornarina: Leonardo and Raphael in Rome', in *Essays Presented to Myron P. Gilmore*, edited by S. Bertelli and G. Ramakus, La Nuova Italia: Florence, 1978, pp. 25–86; Kemp, *Marvellous Works of Nature and Man*; Sylvie Béguin, *Léonard de Vinci au Louvre*, Musée du Louvre: Paris, 1983; André Chastel, *L'Illustre incomprise: Mona Lisa*, Éditions Gallimard: Paris 1988; Pietro C. Marani, *Leonardo: Catalogo completo dei dipinti*, Cantini: Florence, 1989; J. Shell, 'The *Gioconda* in Milan', in *I leonardeschi, fortuna e collezionismo*, edited by M. T. Fiorio and P. C. Marani, Electa: Milan, 1991, pp. 148–62; F. Zöllner, 'Leonardo's portrait of Mona Lisa del Giocondo', *Gazette des Beaux Arts*, 6 (1993): 115–38; Zöllner, 'Leonardo da Vinci's portraits', here pp. 240–1; Daniel Arasse, *Léonard de Vinci: Le rythme du monde*, Hazan: Paris, 1997; S. Kress, 'Memling triptychon das Benedetto Portinari und Leonardo's Mona Lisa', in *Porträt, Landschaft, Interieur*, edited by C. Kruse and F. Thürlemann, Gunter Narr Verlag: Tübingen, 1999, pp. 219–35.

22. On the *Madonna of the Yarnwinders*, see Martin Kemp and Thereza Wells, *Leonardo da Vinci's Madonna of the Yarnwinder*, Artakt and Zidane Press: London, 2011.

23. Codex Leicester, fol. 9r. The English translation is from *The Literary Works of Leonardo da Vinci*, vol. 2, p. 171. Commentary in Capra, *L'anima di Leonardo*, p. 121.

24. This slightly modified translation is from Walter Pater, *The Renaissance: Studies in Art and Poetry: The 1893 Text*, edited by Donald L. Hill, University of California Press: Berkeley, 1980, pp. 98–9.

25. Sanuto, *I Diarii*, vol. 20, p. 105.

26. Vecce, *Leonardo*, p. 332.

27. *The Literary Works of Leonardo da Vinci*, vol. 2, p. 393.

28. In Bertrand Jestaz, 'Francis Ier, Salai et les tableaux de Lionard', in *Revue de l'Art*, 126 (1999): 68–72. 'Pietredorain' is the literal translation of the Italian name Salaì di Pietro d'Oreno.

29. The wealth that Leonardo brought to Salai was inventoried by the

notary after his early death; see Janice Shell and Grazioso Sironi, 'Salai and Leonardo's Legacy', *Burlington Magazine*, 133 (1991), pp. 47–66. Detailed comments on the testament can be found in Forcellino, *Gli ultimi giorni di Leonardo*, pp. 257–65.

30. Uzielli, *Ricerche*, series 1 (first edn), p. 208. The English translation is from *Leonardo's Notebooks*, selected by Irma A. Richter, edited by Thereza Wells, Oxford University Press: Oxford, 2008, pp. 363–4.

PLATE CREDITS

tempera on panel, 84.4 × 66.2 cm. London, National Gallery. Photo: National Gallery / Wikimedia Commons / Public Domain

Plate 8 Leonardo, *Annunciation*, 1472–5 (?), oil and tempera on poplar, 100 × 221.5 cm. Florence, Galleria degli Uffizi. Photo: Web Gallery of Art / Wikimedia Commons / Public Domain

Plate 9 Leonardo, *Study of Drapery for the Right Arm of the Angel of the Annunciation*, 1472–5, pen and ink, 78 × 92 mm. Oxford, Governing Body, Christ Church, Inv. JBS 16. Photo: By permission of the Governing Body of Christ Church, Oxford

Plate 10 Leonardo, *Study of Drapery for a Seated Figure*, c. 1475, brush and grey tempera, lead white highlighting on grey prepared linen, 265 × 253 mm. Paris, Musée du Louvre, Département des Arts graphiques, Inv. 2255. Photo: RMN / Wikimedia Commons / Public Domain

Plate 11 Leonardo, *Madonna of the Carnation*, 1472–4, tempera and oil on poplar, 623 × 485 cm. Munich, Alte Pinakothek. Photo: © 2017. Photo Scala, Florence/bpk, Bildagentur fuer Kunst, Kultur und Geschichte, Berlin

Plate 12 Beato Angelico, San Domenico Altarpiece, detail, 1424–5, tempera on panel. Fiesole, Church of San Domenico. Photo: © Leemage / Contributor / Getty

Plate 13 Leonardo, *Benois Madonna*, 1472–5, oil on panel, transferred onto canvas, 49.5 × 31 cm. St Petersburg, Hermitage. Photo Scala, Florence

Plate 14 Leonardo, *Study of a Young Woman Bathing a Child*, c. 1472–5, pen with touches of wash on white paper, 184 × 111 mm. Oporto, Museu de Belas Artes, Inv. 99.1.1174. Photo: By permission of the Faculdade de Belas Artes. Universidade do Porto

Plate 15 Leonardo, *Sketch of Bernardo di Bandino Baroncelli*, hanged December 1479, pen and ink, 192 × 78 mm. Bayonne, Musée Bonnat, Inv. 659. Photo: Wikimedia Commons / Public Domain

Plate 16 Leonardo, *Saint Jerome in the Wilderness*, 1475–80, oil and tempera on walnut, 102.8 × 73.5 cm. Rome, Pinacoteca Vaticana. Photo: © Leemage / Contributor / Getty

Plate 17 Giovanni Bellini, *Saint Jerome in the Desert*, 1479, tempera on panel, 151 × 113 cm. Florence, Galleria degli Uffizi. Photo: © 2017. Photo Scala, Florence – courtesy of the Ministero Beni e Att. Culturali e del Turismo

Plate 18 Leonardo, *Adoration of the Magi*, 1481–2, oil on panel, 243 × 246

cm. Florence, Galleria degli Uffizi. Photo: © 2017. Photo Scala, Florence – courtesy of the Ministero Beni e Att. Culturali e del Turismo

Plate 19 Leonardo, *Portrait of Ginevra Benci*, 1478–80, oil and tempera on poplar, 38.8 × 36.7 cm. Washington, DC, National Gallery of Art. Photo: National Gallery of Art / Wikimedia Commons / Public Domain

Plate 20 Leonardo, *Study of a Woman's Hands*, 1478–80, 215 × 150 mm, metalpoint over charcoal on pale-buff prepared paper. Windsor Castle, Royal Library, Inv. 12558r. Photo: Wikimedia Commons / Public Domain

Plate 21 Leonardo, *Study for the Background of the Adoration of the Magi* with perspectival projection, 1481, metalpoint reworked with pen and ink, and traces of white, 165 × 290 mm. Florence, Gabinetto dei Disegni e delle Stampe degli Uffizi, Inv. 436 E recto. Photo: Web Gallery of Art / Wikimedia Commons / Public Domain

Plate 22 Leonardo, *Head of a Bearded Man, Possible Self-Portrait*, c. 1510, red chalk on paper, 333 × 213 mm. Turin, Biblioteca Reale, Inv. 15571. Photo: Web Gallery of Art / Wikimedia Commons / Public Domain

Plate 23 Leonardo, Preparatory sketch for the *Adoration of the Magi*, 1480–1, metalpoint reworked with pen and ink, 285 × 215 mm. Paris, Musée du Louvre, Cabinet des Dessins (R.F. 1978). Photo: © Print Collector / Contributor / Getty

Plate 24 Leonardo, *Adoration of the Magi*, 1481–2, oil on panel, 243 × 246 cm. Florence, Galleria degli Uffizi, detail. Photo: © 2017. Photo Scala, Florence – courtesy of the Ministero Beni e Att. Culturali e del Turismo

Plate 25 Leonardo, Drawing of the casting mould in metal armature for the equestrian monument to Francesco Sforza, 1491–3, red chalk, 210 × 290 mm. Madrid, Biblioteca Nacional, Codex Madrid II (MS8936), ff. 156–157. Photo: © 2017. Photo Scala, Florence

Plate 26 Leonardo, *The Virgin of the Rocks*, 1483–5, oil on panel transferred onto canvas, 197.3 × 120 cm. Paris, Musée du Louvre. Photo: Art Resource / Wikimedia Commons / Public Domain

Plate 27 Leonardo and assistants, *The Virgin of the Rocks*, 1495–1508, oil on poplar, 189.5 × 120 cm. London, National Gallery. Photo: The Yorck Project / Wikimedia Commons / Public Domain

Plate 28 Leonardo, Preparatory drawing for the pointing hand of the angel in *The Virgin of the Rocks*, c. 1483, black chalk heightened with lead white on grey prepared paper, 153 × 220 mm. Windsor Castle, Royal Library, Inv. 12520r. Photo: © 2017. DeAgostini Picture Library/Scala, Florence

Plate 29 Leonardo, *Portrait of Cecilia Gallerani (Lady with Ermine)*, c. 1489–90, oil on walnut, 55 × 40.5 cm. Kraków, Muzeum Narodowe, Czartorisky Collection. Photo: Frank Zöllner / Wikimedia Commons / Public Domain

Plate 30 Antonello da Messina, *Portrait of a Man*, 1475–8, oil on panel, 25.5 × 35.5 cm. London, National Gallery. Photo: The Yorck Project / Wikimedia Commons / Public Domain

Plate 31 Leonardo and assistants, *Portrait of a Musician*, c. 1485, tempera and oil on walnut, 44.7 × 32 cm. Milan, Pinacoteca Ambrosiana. Photo: © 2017. Photo Scala, Florence

Plate 32 Leonardo, *Portrait of a Woman (La Belle Ferronière)*, 1490–5, oil on walnut, 63 × 45 cm. Paris, Musée du Louvre. Photo: © 2017. Photo Scala, Florence

Plate 33 Leonardo, *The Skull Sectioned*, April 1489, pen and brown ink on black chalk, 188 × 139 mm. Windsor Castle, Royal Library, Inv. 19057r. Photo: © 2017. Photo Ann Ronan/Heritage Images/Scala, Florence.

Plate 34 Leonardo, *Anatomical Drawings of the Heart and Coronary Vessels*, c. 1513, pen and brown ink, 288 × 413 mm. Windsor Castle, Royal Library, Inv. 19073r-RL19074v. Photo: Royal Collection Trust / © Her Majesty Queen Elizabeth II 2017

Plate 35 Leonardo, *Proportions of the Human Figure* (from Vitruvius), c. 1490, metalpoint reworked with pen and ink, 344 × 245 mm. Venice, Galleria dell'Accademia, Inv. 228. Photo: Wikimedia Commons / Public Domain

Plate 36 Leonardo, *The Last Supper*, 1495–8, mixed technique on plaster, 460 × 880 cm. Milan, Santa Maria delle Grazie. Photo: © 2017. Photo Scala, Florence – courtesy of the Ministero Beni e Att. Culturali e del Turismo

Plate 37 Leonardo, *The Last Supper*, detail, 1495–8, mixed technique on plaster, 460 × 880 cm. Milan, Santa Maria delle Grazie. Photo: © 2017. Photo Scala, Florence – courtesy of the Ministero Beni e Att. Culturali e del Turismo

Plate 38 Leonardo, *The Last Supper*, detail, 1495–8, mixed technique on

plaster, 460 × 880 cm. Milan, Santa Maria delle Grazie. Photo: © 2017. Photo Scala, Florence – courtesy of the Ministero Beni e Att. Culturali e del Turismo

Plate 39 Leonardo, Study for *The Last Supper* (Head of Judas), c. 1495, red chalk on red prepared paper, 180 × 150 mm. Windsor Castle, Royal Library, Inv. 12547r. Photo: Wikimedia Commons / Public Domain

Plate 40 Leonardo, *Portrait of Isabella d'Este*, 1500, red and black chalk on paper (pinpricks on profile), 63 × 46 cm. Paris, Musée du Louvre, Inv. M.I. 753. Photo: RMN / Michèle Bellot / Wikimedia Commons / Public Domain

Plate 41 Leonardo, *Virgin and Child with Saint Anne and the Infant Saint John* (Burlington House cartoon), charcoal heightened with white chalk on light brown prepared paper, mounted on canvas, 141.5 × 104.6 cm. London, National Gallery. Photo: Wikimedia Commons / Public Domain

Plate 42 Leonardo, *Virgin and Child with Saint Anne*, oil on poplar, 168.5 × 130 cm. Paris, Musée du Louvre. Photo: © RMN-Grand Palais (Musée du Louvre) / René-Gabriel Ojéda

Plate 43 Michelangelo Buonarroti, *Virgin and Child with Saint Anne*, pen and brown ink reworked with charcoal, 32.4 × 26 cm. Paris, Musée du Louvre, Département des Arts graphiques, Inv. 685r. Photo: © RMN-Grand Palais (Musée du Louvre) / Thierry Le Mage

Plate 44 Leonardo and assistants, *Madonna and Child* or *Madonna of the Yarnwinder* (*Lansdowne Madonna*), oil on panel, transferred onto canvas, 50.2 × 36.4 cm. New York, private collection. Photo: © Universal Images Group / Contributor/ Getty

Plate 45 Leonardo and assistants, *Madonna and Child* or *Madonna of the Yarnwinder* (*Buccleuch Madonna*), oil on panel, 48.3 × 36.9 cm. Edinburgh, Buccleuch collection. Photo: Web Gallery of Art / Wikimedia Commons / Public Domain

Plate 46 Copy after Leonardo, *Battle of Anghiari* (*Tavola Doria*), oil on panel, 86 × 115 cm. Private collection. Photo: Web Gallery of Art / Wikimedia Commons / Public Domain

Plate 47 Bastiano da Sangallo, Copy of Michelangelo's cartoon for the *Battle of Cascina*, Norfolk, Holkham Hall, Leicester collection. Photo: Wikimedia Commons / Public Domain

Plate 48 Leonardo, Preparatory study for the *Battle of Anghiari*, c. 1503,

pen and ink, 101 × 142 mm. Venice, Galleria dell'Accademia, Inv. 216. Photo: © Mondadori Portfolio / Contributor/ Getty

Plate 49 Leonardo, *Sagittal Section of a Human Skull*, c. 1493, pen and brown ink on traces of charcoal, 183 × 130 mm. Windsor Castle, Royal Library, Inv. 19058v. Photo: Royal Collection Trust / © Her Majesty Queen Elizabeth II 2017

Plate 50 Leonardo, *Studies of the Sexual Apparatus*, c. 1493, pen and brown ink, 208 × 284 mm. Windsor Castle, Royal Library, Inv. 19097v. Photo: Web Gallery of Art / Wikimedia Commons / Public Domain

Plate 51 Leonardo, *The Vertebral Column*, 1510, pen, ink and traces of charcoal, 286 × 200 mm. Windsor Castle, Royal Library, Inv. 19007 v. Photo: © 2017. White Images / Scala, Florence

Plate 52 Leonardo, *The Bones, Muscles and Tendons of the Hand*, c. 1510, pen and brown ink, 288 × 202 mm. Windsor Castle, Royal Library, Inv. 19009r. Photo: Royal Collection Trust / © Her Majesty Queen Elizabeth II 2017

Plate 53 Workshop of Leonardo, *The Angel Incarnate*, c. 1503–8, charcoal on rough blue paper, 268 × 197 mm. Private collection.

Plate 54 Workshop of Leonardo, *Saint John the Baptist*, c. 1503–8, oil on panel, 55 × 40 cm. Photo: Courtesy of the Ministerio Beni e Att. Culturali e del Turismo / Galleria Borghese.

Plate 55 Raphael, *The Expulsion of Heliodorus from the Temple*, 1514, fresco. Rome, Vatican City, Vatican Palace, Stanza di Eliodoro. Photo: © 2017. Photo Scala, Florence

Plate 56 Leonardo, *Map of the Pontine Marshes*, c. 1514, pen, ink and watercolour, 277 × 400 mm. Windsor Castle, Royal Library, Inv. 12684r. Photo: Royal Collection Trust / © Her Majesty Queen Elizabeth II 2017

Plate 57 Leonardo, *Saint John the Baptist*, oil on walnut, 69 × 57 cm. Paris, Musée du Louvre. Photo: C2RMF / Wikimedia Commons / Public Domain

Plate 58 Leonardo, *La Gioconda*, c. 1503–16, oil on poplar, 77 × 53 cm. Paris, Musée du Louvre. Photo: Musée du Louvre / Wikimedia Commons / Public Domain

Plate 59 Leonardo, *La Gioconda*, oil on poplar, 77 × 53 cm. Paris, Musée du Louvre. Infrared reflectogram. Photo: © C2RMF / Elsa Lambert

Plate 60 Workshop of Leonardo, *Saint Anne, the Virgin and the Child*, c. 1508–13, oil on poplar, 178.5 × 115.3 cm. Los Angeles,

University of California, Hammer Museum. Photo: Collection University of California, Los Angeles. Hammer Museum. Willitts J. Hole Art Collection

Plate 61 Leonardo, *The Drapery at the Virgin's Hip*, after 1513, pencil heightened with lead white on grey prepared paper, 17.3 × 14 cm. Windsor Castle, Royal Library, Inv. 12528. Photo: Royal Collection Trust / © Her Majesty Queen Elizabeth II 2017

Plate 62 Workshop of Leonardo, *La Gioconda*, c. 1503–16, oil on poplar, 76.3 × 57 cm. Madrid, Museo Nacional del Prado. Photo: Wikimedia Commons / Public Domain

Plate 63 Workshop of Leonardo, *La Gioconda*, c. 1503–16, oil on poplar, 76.3 × 57 cm. Madrid, Museo Nacional del Prado. Infrared reflectogram. Photo: © Madrid, Museo Nacional del Prado

Plate 64 Leonardo, *Embryological Studies*, c. 1510–14, pen, watercolour, brown ink, 304 × 220 mm. Windsor Castle, Royal Library, Inv. 19102r. Photo: Wikimedia Commons / Public Domain

Plate 65 Leonardo, *A Standing Masquerader*, charcoal, c. 1517–19, 215 × 112 mm. Windsor Castle Royal Library, Inv. 12576. Photo: © 2017. DeAgostini Picture Library / Scala, Florence

Plate 66 Leonardo, *Cats, Lions and a Dragon*, c. 1516, pen and ink over black charcoal, 270 × 210 mm. Windsor Castle, Royal Library, Inv.12363r. Photo: Royal Collection Trust / © Her Majesty Queen Elizabeth II 2017

INDEX